D1296135

The
in

Art and Cinema in the

Image Dispute
Age of Photography

EDITED BY
DUDLEY ANDREW

WITH THE ASSISTANCE OF
SALLY SHAFTO

UNIVERSITY OF TEXAS PRESS, AUSTIN

Requests for permission to reproduce material from this work should be sent to
Permissions, University of Texas Press, P.O. Box 7819, Austin, TX 78713-7819.

∞ The paper used in this publication meets the minimum requirements of American National
Standard for Information Sciences—Permanence of Paper for Printed Library Materials,
ANSI Z 39.48-1984.

Designed by Henk van Assen, Austin TX

Library of Congress Cataloging-in-Publication Data
The image in dispute: art and cinema in the age of photography /
 edited by Dudley Andrew.—1st ed.
 p. cm.
 Includes bibliographical references.
 ISBN 0-292-70475-5 (cloth: alk. paper).—ISBN 0-292-70476-3 (pbk.: alk. paper)
 1. Photography, Artistic. 2. Photography—Philosophy. 3. Art and photography.
 4. Cinematography. I. Andrew, James Dudley, 1945– .
TR 183.145 1997
701'. 1—dc21 96–22106

Contents

III

VISION AND INTERPRETATION AFTER PHOTOGRAPHY

A Preface to Disputation

DUDLEY ANDREW

What are we to make of this contest between the interests of verbal and pictorial representation? I propose that we historicize it, and treat it, not as a matter for peaceful settlement under the terms of some all-embracing theory of signs, but as a struggle that carries the fundamental contradictions of our culture into the heart of theoretical discourse itself.

W. J. T. Mitchell, *Iconology*

W. J. T. Mitchell's 1986 book *Iconology: Image, Text, Ideology* stands as a plateau from which we can survey the troubled past of image theory and from which we hope to launch our own targeted probes.[1] Mitchell persists in the long tradition of opposing images to words, but in the important passage with which we begin, he declares himself prepared to abandon the analysis of essential differences between these forms of knowledge and communication in favor of a history of their competition in Western society. We will follow him. For even when they involve canonized intellectuals, the disputes this anthology chronicles and occasionally stages appear more cultural than purely philosophical. Although philosophical reflection is now regarded as thoroughly historical, a particular kind of discourse occurring in a time and at a place, only fifteen years ago a book bearing this title would likely have concerned itself more directly with "essential" aesthetic issues. In the meantime philosophers like Richard Rorty have made such speculation appear clumsy, even naive.

We join Mitchell and an increasing number of newly historicized theorists who have retreated from forthright philosophical engagement, having realized that our language, like that of Plato and later thinkers who dared to address the power of images, surely rigs the contest to its own advantage. Western intellectuals, from the Greeks to Gotthold Lessing to Nelson Goodman, have ever granted the uncanny attraction of images, but only to demote their claims to special or even equal treatment. While entranced by them, Plato still wanted to banish images, and Lessing thought painting suitable only to the lower functions of art, essentially to description as opposed to analysis and drama. In our day, Goodman brashly deflates images to the point where they seem to comprise a conventional notation that

makes them ordinary and without privileged access to the world or to our minds.[2] Curiously, his coolly philosophical suspicions stand in league with the more passionate diatribes of Marxists and feminists, who have to be counted among the chief iconoclasts of our era.

Evidently most philosophical positions are devoted to the "logos" embedded in the very term "icon-ology." They disdain or beware the religious function that "icons" have so often served. Yet do they not thereby beg the question of the image's status, by forcing it to submit to their "logic" and by repudiating at the outset the lure of its difference and of its body? How can the language of philosophy fairly adjudicate a dispute that involves precisely the scope of language and of philosophy? The Western tradition—consolidated and culminating in Hegel—maintains a tender but often patronizing affection for images as part of the prehistory of philosophy. Images seem to embody thought sensuously, immediately, and engagingly, but in a childish and uncritical manner. Philosophy, Hegel taught, replaced images as Western culture gradually matured. By virtue of its historically countenanced mission, then, philosophy, at least its main traditions, proudly kneels to no law or power higher than the rules of thought and language. Religion, on the other hand, might be said to begin on its knees, groping toward a power it aims to locate, to corral, and perhaps to begin to comprehend. The image after all is thought to traffic in religious power.

Historicism, like hermeneutics, was born of this dispute between faith and suspicion, defining itself as a particularly forgiving descriptive human science. To speak about images as a historian or anthropologist means to surrender essential claims made by images or by language and to chronicle instead the shifting contours of the debate between them. Whatever quasi-magical properties images may harbor would tend to resist the philosophical project of understanding their meaning. Just as anthropology and history hope to give religion its due, while keeping track of the way other discourses in culture accommodate or repudiate religion in return, so in this volume we aim to evoke the power and scope of the image in the secular age of modernism, while watching it be hemmed in, disciplined, or romanced by discourse, our own discourse included.

In this project our essays stand in constant dialogue with Walter Benjamin, who, more intricately and earlier than other thinkers, strove to relate a new image culture (for which cinema appears to be the privileged apparatus) to a modernity that involves new forms of subjectivity and social organization. In the discussions

we had while preparing these essays we let Benjamin's ambivalence about cinema—even the contradictory character of his chief essay on this art—encourage us to examine multiple aspects of the complex he addressed. And in projecting his speculations toward the image culture of our own times, we found the following categories highly convenient:

1 The image and ontology

After photography, philosophers have had to reckon with the automatic production of likeness, with unintended and accidental images and with unanticipated inclusions within images. In his first major essay, "The Ontology of the Photographic Image," André Bazin suggests that photographs might be treated "like a phenomenon in nature, like a flower or a snowflake whose vegetable or earthly origins" significantly affect our relation to them.[3] As things in nature, the photographic arts are perhaps not arts at all, but proleptic sensorial assists. And our use of them, as well as our attitude toward them, cannot compare with that which earlier eras accorded the painted and drawn images they lived with. At a nearer temporal extreme, today's and most certainly tomorrow's digitally produced simulations for computer and video screen claim no earthly or vegetal origins and pose new questions that, before being sociological and aesthetic, are fundamentally ontological.

2 The image and psychology

In fact Bazin's celebrated essay about ontology begins with this speculative clause: "If the plastic arts were put under psychoanalysis. . . ." Writing in the shadow of Jean-Paul Sartre, whose 1937 *L'Imaginaire* he extensively annotated,[4] Bazin recognized more than Sartre himself did the detours of illusion and belief in the smooth corridors of the technologically produced image. Sartre's remarkable phenomenology of levels of consciousness would have been unthinkable without the intervening phenomenon of an image that was at the same time an object. Since Sartre, every considered meditation on the haunting nature of photographs—up to and including Roland Barthes' *Camera Lucida*[5]—turns on the quivering psychological status of photographs and the even more consternating status of moving pictures. The modern era may be bracketed by the birth and death of this specific psychological structure of belief: before photography images were deciphered as products of human artistry. After cinema, in the digitalized videosphere we have entered, images are taken as autoreflexive, spun out by computer algorithms.[6] Cinema and

photography dominated an era between these extremes, an era during which the physical world was recruited to participate in its own deciphering.

3 The image and aesthetics

Lessing's *Laocoön* marks the plateau of image aesthetics at the end of the classical period.[7] Photography and motion pictures initiate new criteria, if not for beauty in visual representation, then at least for appropriateness. These criteria incorporate the temporality and authenticity of subject matter, on the one hand, and, on the other, they involve such psychological notions as hypnosis and distraction in spectatorship. Where Lessing presumed that pictorial arts were doomed to haunt the spatial dimension, motion pictures require a poetics that is at once spatial and temporal, narrative and pictorial. Where his classicism promoted purity of forms, modernism thrives on mixed forms (motion pictures for one, but also photomontage and cubist poetry, to take examples found within this volume).

4 The image and semiotics

Our century has seen iconography superseded by semiotics; Erwin Panofsky has given way to Roland Barthes. The former relies on erudition, glossing paintings and other visual representations that are distant from us in time and culture. Panofsky tried to be a medium through which, for instance, today's spectators could adopt the Middle Age or early Renaissance world view when approaching, say, a painting by Dürer.[8] Barthes, on the other hand, has been partly responsible for promulgating semiotics, a discipline and a technique by which to read what is terribly close and familiar: advertisements, fashion, food, photography. Technology has flooded us with representations such that we need to develop reflexes of reading in order to cope with a superabundance of signification. Semiotics might be thought of as a critical strategy responding directly to the technology of image production in the modern age. But photographs, because they are in part auto-generated, present enormous problems for those who would control the reading of them. Everything in a photo is potentially significant, even and especially that which has escaped the control of the photographer pointing the camera. Here the indexical function of the photo comes to the fore, outweighing its iconic function. The photographic plate is etched with experience, like the unconscious; and like the unconscious, it invites a symptomatic reading of the images that escape from it to reach the surface. As was the case with psychoanalysis, the structural study of latent

meaning had eventually to give way to strategies of reading that are stimulated by excessive signification—in other words, poststructural reading strategies.

5 The image and poststructuralism

Machines of the visible produce images today that no longer respond fully to decipherment or hermeneutics. In the case of standard television, such images are drawn from our own reservoir and return to us in an effortless circuit and in an utterly obvious manner. More "difficult" images today, many produced by what used to stand as an artistic community, seem unconcerned with us, seem to arise within an inhuman world of technology that scarcely cares for us as it passes us on its way to other machines. If reading images seems superfluous or inadequate, either because the source to which reading returns us is uninspired (ourselves) or inhuman, what should we do with what we see in culture? Gilles Deleuze has provided the most extended response in his *L'Image-Mouvement* and *L'Image-Temps*.[9] These books treat cinema as a thinking machine, spinning off options that in the first half of the century imitated human thought and in the second half began to generate new thinking possibilities altogether. Deleuze does not read images; he sees with images, using them as a source for what can yet be thought, not as a record of what has already been thought. Deleuze heads a phalanx of thinkers (Paul Virilio is another[10]) for whom the machinery of image production in our century should not be curved into the warm space of humanism but should spur the production of inhuman thought, expanding the human while it expands the thinkable. Deleuze and Virilio invest images—technologically produced ones especially—with a power that other philosophers (Nelson Goodman or, from a different school altogether, Jacques Derrida) would drain from them. The posthuman source of this power might be thought by some to replace for us the transhuman religious source that images hold in other cultures or held in other eras. Just look at Francis Bacon's Crucifixion triptychs, illustrated in a later chapter of this volume, a particularly apt icon of our era that Deleuze has paid homage to.

6 The image and the politics of representation

The image has often been taken to be an energy source, even an explosive, that is censored or requisitioned by those in power. Before technology brought on a proliferation of pictures, authorities often commissioned, and more often governed, the display of images. Today images seem impossible to police, in democratic

societies at any rate. And yet debates over violence, particularly violence against women, often turn on the questionable freedom to expose what are considered particularly dangerous pictures. A less direct but more pervasive debate concerns the racial, gender, and class politics at play not just in the use of representations but in the very structure and conditions of image production and reception. Such aspects of our image culture as the empowered versus unauthorized gaze, exhibitionism versus voyeurism, framing versus exclusion, deeply affect social behavior beyond the protected border of representations.

Of course, "the politics of representation" is precisely what "the image in dispute" must be about. And the cultural evolution from classical to modern conceptions of the image (as well as from modern to postmodern ones) identifies our point of departure, though not necessarily our terminus. Struck by Benjamin and largely adopting his (decisively nonevolutionary) problematic, we determined to keep in play the ontological, psychological, aesthetic, semiotic, and political aspects of a complex whose center continues to shift. We trust that as we delve into the recent past, probing for that elusive center, we are at the same time sketching the concerns and something of the character of the next century.

From the outset this volume was designed to benefit from a productive ratio of the planned and the unexpected. All its contributors participated in the 1992 Obermann Faculty Research Seminar, "The Image in Dispute: Visual Cultures in Modernity," held at the University of Iowa's Obermann Center for Advanced Studies. I sought a range of topics and of expertise diverse enough to open up multiple aspects of the image and multiple disciplinary approaches to its study. Multiple, I insist, but limited. Aside from the opening essay in which John Peters took upon himself the task of placing Walter Benjamin's unsettled view of the image in quite a large intellectual context, you won't find direct discussion of classical aesthetic or moral issues, for modernism (and the technology that is its hallmark) altered the terms of these debates. Less still will you find here consideration of electronic imaging or much about the "videosphere" that has come to take the place of the "modernity" we focus on. Our goal was to highlight a series of textual, imagistic, and social phenomena that developed alongside modern technologies of representation, promoting new roles for the arts and perhaps new sorts of subjects, image consumers. We are the heirs of modernism, some of us spoiled by its largesse, some rebellious against its dubious ethics, others addicted to its obsessions, and all of us schooled in its skills. Whatever the next century brings—in terms of new align-

ments, new ethics, new requirements, and new possibilities—will be brought in response to the culture we are at pains to understand in these pages.

Although Jacques Aumont was finally unable to be present to discuss his chapter, the essay translated here and his books on the image were indispensable in orienting our weeks of discussion. James Lastra and Timothy Corrigan participated in individual sessions while the rest of the contributors met regularly to discuss first the general topics dear to Walter Benjamin and second our own specific theses.

In the months following the seminar, our essays were reformulated in response to the experience and debates of the summer. The attentive reader should be able to monitor an actual development of ideas that open onto one another, open into the project of this volume, and, most important, open onto the future where the terms of image and discourse will undoubtedly become ever more consternating, enticing, and consequential under the pressures of technological dependence and change.

I am anxious to acknowledge the graceful and resourceful assistance of Sally Shafto in getting this volume ready for publication. And I speak for all who participated in the project in warmly thanking Jay Semel, director of the Obermann Center for Advanced Studies, and his legendary assistant, Lorna Olson. Jay not only approved the project and gave it space and money; he helped define it and select its participants. Then he followed what he had put in motion with a benevolence that is the virtue of those who understand ideas and love to play with them. His pride joins mine in recognizing this project as deriving from the University of Iowa's tradition of wide-ranging interdisciplinary practice. With this in mind, let me point to three edifying models who, in my years here, did most to foster this tradition in me as in so many others and who, therefore, are the first addressees of this book: Angelo Bertocci, Sam Becker, and Esco Obermann. May they fully enjoy it.

Notes

1 W. J .T. Mitchell, *Iconology: Image, Text, Ideology* (Chicago: University of Chicago Press, 1986).

2 Goodman's fullest explication of his position comes in *The Languages of Art: An Approach to a Theory of Symbols* (Indianapolis: Bobbs Merrill, 1968).

3 André Bazin, "The Ontology of the Photographic Image," *What Is Cinema?* ed. and trans. Hugh Gray (Berkeley: University of California Press, 1967), 1:13.

4 Jean-Paul Sartre, *The Psychology of the Imagination*, trans. Bernard Frechtman (Westport, Conn.: Greenwood Press, 1978).

5 Roland Barthes, *Camera Lucida: Reflections on Photography*, trans. Richard Howard (New York: Hill and Wang, 1981).

6 Régis Debray, *Vie et mort de l'image* (Paris: Gallimard, 1992). See particularly the concluding chapter.

7 Gotthold Lessing, *Laocoön: An Essay on the Limits of Painting and Poetry*, ed. and trans. Edward Allen McCormick (Baltimore: Johns Hopkins University Press, 1984). This 1769 book is extensively discussed by Mitchell in *Iconology*.

8 See Panofsky's famous studies of Albrecht Dürer, such as *Dürer's Apocalypse* (London: Eugrammia Press, 1964).

9 Gilles Deleuze, *Cinema 1: The Movement-Image*, trans. Hugh Tomlinson and Barbara Habberjam (Minneapolis: University of Minneapolis Press, 1986, 1991); and *Cinema 2: The Time-Image*, trans. Hugh Tomlinson and Robert Galeta (Minneapolis: University of Minnesota Press, 1989, 1995).

10 Paul Virilio, *War and Cinema: The Logistics of Perception* (New York: Verso, 1989).

What Did Walter
Image Cultures,

To walk slowly down lively streets is a special pleasure. To be left behind by the rush of the others—this is a bath in the surf. But my dear fellow Berliners do not make it easy, however gracefully one might move out of their way. I always receive suspicious looks whenever I try to stroll as a flaneur between the shops. I think they take me for a pickpocket.

FRANZ HESSEL, "The Suspicious Character"

Benjamin See?
1890-1933

Introduction

DUDLEY ANDREW

Walter Benjamin stands at the entryway to any discussion of modernity that takes into account the shifting methods and roles of representation. He doesn't guard the gates in official uniform, but hovers around them slyly, by turns peering inside, then glaring out at those lining up to join the fun. Sheepishly he hawks some of the wares he has picked up on his jaunts. Benjamin must have thought himself a flaneur in the thoroughfares of ideas; he window-shopped in the arcades of modernity and, like any collector, proved to be highly selective in what he paused to consider. Benjamin jay-walked across ideas. His shortcuts took him to bizarre locations and provided unusual perspectives, but they cost him something too, something beyond orientation which, rather like the surrealists, he was happy to dispense with. Confined to the surface of the city of ideas, he missed many a rendezvous with those behind the scenes, with women particularly. Those he did encounter were precisely the ostentatious ones, selling their ostentation right there on the corner, not the scribblers in the attic or those seething behind walls of patriarchy and familial duty. This has disappointed many feminists, otherwise taken with his style of skipping the stop signs put up by the pompous policemen of thought.

On the other hand, in his inimitable way he would return from his meanderings with an armful of surprising ideas he had acquired, often at this or that secondhand shop. He knew the antique dealers by name. Spreading out his findings on a page, he could point to stunning connections, implications, and oppositions among fragments of thought, some of which have their roots attached, others of which he clipped where it suited him. No wonder he felt at home with Proust and put his hand to translating him. There is something both nostalgic and revolutionary in the way these men collected and manipulated experience.

Among Benjamin's favorite antique shops was one devoted to Jewish mysticism. He might have made an effective and committed Zionist, Gershom Scholem hints; he might have been, like Scholem, a scholar devoted to realizing in the contemporary world the consequences of an arcane wisdom. But after the Great War,

and after the Revolution of 1917, Judaism had to vie with socialism, surrealism, and German philology in a mind that was inventing a routine, if not quite a method, for dealing with all these at once. The routine has since acquired a name, and one that he used proleptically in the title of his own doctoral dissertation, "cultural critique."

Many of us aspire to be worthy of this project, even if we can never be as inventive, subtle, and trenchant as Benjamin was in practicing it. The apparent freedom of the flaneur is exhilarating to anyone trained in a discipline. The ambivalence of Benjamin's attitude toward history (a pessimist full of messianic hope) authorizes the adoption of extreme methods of reading texts; more important, it authorizes a new list of texts to read. Alongside his erudite studies of Proust, Kafka, and Baudelaire stand tantalizing discussions of translation, storytelling, book collecting, image production, and the nineteenth-century odds and ends that were to be laid out in the Arcades project, including—as if to suit this anthology—world expositions.

In this peculiar inventory, images have risen to a place of honor precisely after he unmoored them from the social privilege they enjoyed in the classical era. Deprived of the aura their physical distance had formerly produced around them, images after the French Revolution should be taken as ordinary products of industrial printing, bouncing to the surface of the sea of modern life, buoyed by their availability and immediacy. In the interwar years of this century, movies truly belonged to the masses in a way no texts ever had before, not the classics, nor the Bible, nor even popular fiction, all of which were hampered by the scale of illiteracy.

Yet for all their contemporaneity, images continue to exercise an ancient magic; hence Benjamin's prescient warnings about the place of images in fascism. The ambivalence he felt toward images (their extraordinary power yet their quite ordinary availability) makes Benjamin central to our debate because, due in part to his flirtations with religion and its discourses, he seems to countenance both the magic and the suspicion. John Peters lifts him above the cruder iconoclasts of former and recent times (Luther and Susan Bordo) who are appalled at how images enthrall unsuspecting souls, enticing them with the worst forms of vanity. Peters sets Benjamin alongside Søren Kierkegaard as a kind of religious thinker unwilling to suppress the lure of beauty in favor of a more virile, rationalized discourse about truth. The beauty these men had in mind would not compete with language or thought (as Hegel assumed it must); it would not deflect them from what is truly important in life; rather "veiled beauty" names the significance of what is particular,

private, and scarcely shareable. Where Luther, Hegel, and many feminists like Bordo demote images in the name of a higher, more lasting truth and ethic, Kierkegaard and Benjamin were more suspicious of the higher truths of public history than of the attractiveness of that which lives and dies privately in its own way. They were ready to bet on a certain grace flowing from what Peters calls "mortal beauty," the attachment to that which, while just itself, justifies and illuminates so much more.

Had he been able to maintain full confidence in the logic of history that his Marxism, following on Hegel, should have provided, Benjamin could have resisted the image the way his colleague Theodor Adorno did, demystifying it as a fetish object that halts analysis and misplaces investment. But history for Benjamin had become posthistorical. Where progressives may have seen "a chain of events," Benjamin's angel of history, "his face turned toward the past . . . sees one single catastrophe which keeps piling wreckage upon wreckage and hurls it in front of his feet" (*Illuminations*, 257). Inspired by this figure taken from Klee's *Angelus Novus*, Benjamin approaches catastrophe by scavenging for images within its debris. Their luminosity tempts and permits him (and us) to pick through history for reflections, illuminations, and unexpected projections. Images are elements of an unconscious historiography, an asynchronous—perhaps even messianic—one, and it is the only sort of historiography Benjamin could have faith in, given the bankruptcy of modernism.

A touchstone throughout this volume, Benjamin and his moment (1892–1940) dominate its first section. His method of superimposing fragments achronologically to achieve rude shocks of (historical) recognition has more or less infected us all. My reading of *Jules et Jim*, for example, following on questions of promiscuity and fidelity central to John Peters, takes cinema as precisely an intermediate form between image and writing, a form therefore exactly congruent with the ambivalent Benjamin whom this film indirectly and surprisingly evokes. The century of cinema, in my view, offered a fragile period of détente during which the logosphere of the nineteenth century with its grand novels and histories has slowly given way—under the pressure of technology, of the ascendancy of the image, and of unfathomable world crises—to the videosphere we are now entering, where, we have been assured, neither grand narratives nor the genius of creativity can be said any longer to function. The cinema, I argue, lies between these extremes quite like storytelling and translation, the humble workaday literary occupations Benjamin lauded.

Jules et Jim spans the disastrous transition from the belle époque to the ascendancy of the Nazis, passing through the Great War and the modernism of the twenties. This was Benjamin's era, and it is the era explored in the remaining essays of this section. While teaching us to rummage through the fragments of this history, Benjamin nevertheless missed much of what there was to see. He invented the terms and the frame of analyses that he never thought to perform. For instance (and a crucial instance it is), he scarcely played out the effect of modernity on women or, more important, the effect that women wrought on the "gallery of images" that public life has turned into. And so Anke Gleber imagines the conditions required for the female flaneur to step out onto the streets of Berlin and Paris, taking possession of history in her own way, visibly or not. Consumerism, travel, and entertainment—all of which we learn from Benjamin how to credit—changed and were changed by the increasing presence of women in public spaces. The breakdown of traditional hierarchies that Benjamin noted in the domain of art can be seen to affect gender roles that start to blur in the reflected light of early cinema.

Lauren Rabinovitz drives the question of gender back into the nineteenth century where, in his Arcades project, Benjamin had already identified the powerful constellation of technology, mobility, class, gender, and image. Where Benjamin tried to keep all these elements in play, she "racks focus" to isolate the issue of gender in the fairgrounds a half century past the Parisian arcades. Rabinovitz maps the experimental "engendering" of social space across the topography of the Chicago World's Fair, whose explicitly modernist mission was to provide the living image of utopia in a corner of a real city. Cinema would soon become the miniature site where utopic and real spaces merge; it would also be a site particularly tempting to women. No wonder it found its first home within the giddy atmosphere of fairs and expositions where the realms of science and entertainment were intentionally conflated.

New technologies of image production may have helped wrest social and imaginary space from a moribund aristocracy, but only by serving a distinctly political function. Sabine Hake draws our attention to the rhetorical use of photographs that Benjamin touches on in his brief account of the medium. While we might otherwise be inclined to appreciate as eloquent emanations of their time the extraordinary work of John Heartfield and August Sander, Benjamin has taught us to consider not just their photographs but the cold process of their photo machines. What ought he have said about the dehumanizing role of this medium in direct social management? As he knew better than anyone, the age of mechanical reproduc-

tion is equally the age of mechanical social life. And if one definition of modernism includes the breakdown and (rationalized) reformulation of categories like art, gender, and science that were formerly deemed natural or God-given, then the technologized image is intimately involved in parsing society anew.

Serving apparently opposite political agendas, Heartfield's discursive collages and Sander's "typical" portraits offered evidence about modern life, as well as ways of reading it. John Peters provides the appropriate terms with which to think about such photographs when he sets appearance as pure "*Schein*" over against the integrity of what comes from beneath the skin. Heartfield and Sander ultimately serve rather than escape ideology with their photographs, for they employ this medium to turn up evidence of what they already believe. Thus the work of photography reveals itself to be ambivalent like the thought of Walter Benjamin, who celebrated it with his small history. Photography exposes veiled, mortal beauty, whatever that may be worth. This first section of *The Image in Dispute* asks repeatedly about the value of the fleeting and the mortal, about the value of photography, cinema, women, about the work of modernity itself.

Beauty's Veils

The Ambivalent Iconoclasm of
Kierkegaard and Benjamin

JOHN DURHAM PETERS

The eyes that lose themselves to the one and only beauty are sabbath eyes.

T. W. Adorno, Minima Moralia

An appreciation for the full richness of the iconoclastic stance is rare in cultural studies or the art world today. Those suspicious of images—especially sexually explicit ones—are often seen in such precincts as suffering from phobia, illiberal tendencies, or in need of a refresher course on the U.S. Constitution. If Jesse Helms did not exist, a new target for righteous indignation about censorship and sexual repression would have to be invented (one, alas, would not be hard to find). But Helms and his ilk, or the curious coalition against pornography, do not exhaust the range or depth of reasons for giving the image and its powers a wary respect. A philosophy of iconoclasm needs redeeming from its current sorry state.

Iconoclasm—the smashing of images—is a major theme in the history and culture of European religion, art, politics, and thought. This term exploits the felicitously multiple senses of *image*—as idol, statue, picture, sight, or vision. Iconoclasm is a primal act of cultural and religious politics. In its Hebrew and Protestant forms, it aims to expose as a human product what others seem to treat as an incarnation of the divine. Tearing down Phoenician "groves" in the Hebrew Bible or destroying Catholic art from churches in the late sixteenth-century Netherlands, for instance, aimed not only to eradicate a rival, but to show that a supposedly mutual relation of adoration and blessing was in fact a fantastical projection. The prophet Isaiah complained: "Their land is full of idols; they worship the work of their own hands, that which their own fingers have made."[1] The most subjectlike of all objects is an image of a subject. Iconoclasm is a protest against the confusion of subject and object, no less for an Isaiah than for a Marx, Freud, or Adorno. It attacks reification—loving things as persons and using persons as things. It unmasks an imagined mutual relationship as a unilateral product of the worshiper's own longing.[2]

The dyad of adoring subject and image/idol funds iconoclastic wrath, ancient and modern: idolatry (fixing the absolute in concrete form, the idol), necrophilia (loving dead matter), fetishism (taking the arbitrary part for the whole), objectification (treating a subject as an object or object as subject), masturbation (eros without an other), and rape (interphysicality without intersubjectivity). For the Hebrew prophets, the worship of idols is always figured as adultery, a wandering from the father-spouse,[3] and for iconoclasts since, a similar rhetoric of sexual abomination persists in attacks on the image.

Modern critique—the task of exposing systematically distorted relations between subject and object—is thus iconoclastic to the core. Hegel, Feuerbach, Marx, Nietzsche, Freud, Lukács, and Adorno all expose our communion with gods, commodities, dreams, or screen stars as projections and reifications. The projected other is the surreptitious work of the alienated self. The real other, like the God of Abraham, Isaac, and Jacob, cannot show itself as an image since an image, at best, is an object masquerading as a subject.

Critical discourses more generally, beyond this high lineage of critical theory, are profoundly suspicious of public imagery. Cultural Marxism was long the chief iconoclast of public splendor. The sheen of beauty—in advertising, fashion, cinema, or mass culture—was seen as, at best, a spoonful of sugar to help the domination go down and, at worst, an addictive drug. In the 1970s and 1980s, feminism, taken more as a social movement than in its many theoretical currents, has probably been the chief secular agent of iconoclasm. Beauty, some feminists teach, is violence by other means. The ways we look at each other are acts of power. The male gaze makes women into meat. Mass-mediated ideals of beauty are both cause and effect of anorexia, plastic surgery, photo doctoring, and self-mutilation. Beauty is not the touch of grace; it is an effect of power.[4] Recently, the center of iconoclastic gravity in intellectual life has shifted to representations of race and ethnicity and, to a lesser extent, of homosexuality, which alone among critical currents has never lost appreciation for beauty as such.

The iconoclastic inheritance, then, is not the exclusive franchise of the political or religious right; it is likewise a part of the left. Further, though the chief target of what Paul Ricoeur calls "the hermeneutics of suspicion" is usually taken to be the sacred, beauty has been an equal casualty.[5] Everything in religion that Marx, Nietzsche, and Freud and allies attacked abounds in beauty: regression, elitism, suspension of the critical faculties, the spell of archaic powers. Inasmuch as the aim of

critique is emancipation, how to explain the deep ambivalence of critical thought about something that most holds us? No debate is so vexed today as that about portrayals of human beings in their beauty and suffering.

Our public culture abounds with images of gorgeous and miserable strangers, splendid demigods modeling fast food and pathetic children dying of hunger. Before images of human beauty, we are torn between rapture and suspicion; before those of human suffering, between pity and callousness. We are moved but fear being manipulated. The relevant cultural backdrop to the intellectual history of modern iconoclasm is the industrialization of the image since the early nineteenth century. Not even Pompeii, long a symbol of Roman lewdness, could rival the past century and a half's supply of erotica. Nor could a late medieval penitent hope to gaze upon as many images of pitiable suffering as we. Images inviting *eros* and *agapē*—sexual love and compassion—meet modern men and women at every turn.[6]

To discern what is at stake in image-smashing, we need to nourish current debates with older aesthetic, ethical, and political dimensions. Largely forgotten today are two contradictory older wisdoms: the mania of beauty and the discipline of principled looking away. Odysseus, on meeting the young woman Nausicaa, says, "Wonder takes me as I look at you."[7] No people knew visual delight like the Greeks. For Hegel, the beauty of the Greeks was unselfconscious. To see a beautiful man or woman was to glimpse divinity and even to be stunned by madness. Physical beauty, like victory in athletic contests, was a gift from the graces. Alcibiades, famed as the most beautiful in a culture that prized beautiful men, called his body a "windfall from the gods."[8] In beauty alone, Plato all but said, is the universal revealed sensuously. Personal beauty was uncorrupted by representation or objectification—by the image.

In a very different temper, Job checks himself, saying: "I have made a covenant with my eyes: how can I think upon a maid?"[9] Jesus likewise taught that one can commit adultery by looking.[10] No tradition knew a discipline on the wandering eye like the Jewish. In contrast to the Greek, which tends to see the beautiful other immediately "in the flesh," the Hebrew tradition constantly sees beauty as an image, something mediated and re-presented. The person looked upon risks becoming an idol, a false god, an object that escapes the ethical protection of a relation of mutual obligation. Shame overwhelms me as I look at you. The second Mosaic commandment against graven images was, again, long interpreted as a shield against idolatry

cum adultery ("a-whoring after strange gods"). Imagelessness observes the ethical commandment to treat subjects as subjects and objects as objects.

If what one might call the Hellenic position of luxuriating in the splendor of grace and beauty is deemed irresponsible or frivolous in critical currents today, the Hebraic is largely seen as repressed. The morality of not looking is taken as uptight, self-deceptive, and impossible, a subtle sort of prurient interest that skulks about, making fetishes of its own obstacles. In recent debates, censorship and selectivity are often conflated; prudence becomes prudery. The ideal of mental or spiritual purity, like that of chastity, has largely vanished from contemporary public culture. Those who seek it are said, at best, to be "in denial." Self-repression leads to other-repression. Prudes build closets. Chastity is a form of chastisement, sublimity the effect of sublimation. And so it goes.

However telling this assault may be, it dismisses the prospect of an ethics of (not) looking too quickly. Ethical impulses and imperatives linger today in our ambivalences about the image, even if they are inarticulate. The clash between rapture and refusal, astonishment and askesis, is, I believe, the best nexus to clarify the intellectual stakes of the image in modern culture. Though one could explore philosophical grounds for circumscribing images of both beauty and suffering, I will focus on the former. In what follows, I argue that modernity's boasted candor in representation leads to ethical and aesthetic troubles. There can be a poverty, as well as wealth, in explicitness.[11]

Some things cannot become images without an alteration of their being. The sight of a beautiful stranger on the street, however seductive, is secured by the ethical fact of public decorum, the check of a mutual gaze. The objectification of the other and the squandering of the self can be kept to a minimum when held within an intersubjective relationship. The image of a beautiful stranger in film or photography, in contrast, suspends all such obligations and decorum. To treat such an image as either object or subject would be equally wrong. Such images dwell in a liminal zone between life and death, person and thing. But only certain kinds of beauty can be reproduced. The beauty gradually disclosed through the time of a shared life—mortal beauty—cannot show itself to strangers. Such knows only intimate access. Modernity greatly expands our access to images of instantly beautiful others, inviting an attitude of neglect toward beauty's less flashy kinds that escape reproduction by the image. The danger of the mechanically reproduced image, in short, is beauty without history. Though a wrinkle on a face may be a defect for a stranger, it is a whole history of laughter for a lover or relative.

Søren Kierkegaard (1813–1855) and Walter Benjamin (1892–1940) stand betwixt and between bedazzlement and responsibility, aesthetic celebration and moral-political duty. Kierkegaard's *Either/Or* spans the abyss between the aesthetic and the ethical; Benjamin's oeuvre spans the force field between art and politics. Both know the madness and truths of *Schein* (appearance), its allure and deceits. Both are instructively ambivalent tour guides to the image realm of modernity, philosophical flaneurs who plunge headlong into the variegated worlds of Copenhagen, Berlin, and Paris with reckless abandon and scrupulous circumspection. Few writers record the exploding image world of the nineteenth and twentieth centuries better than Kierkegaard and Benjamin. Both write phenomenologies of modern experience for mobile European men, probing its peculiar emotional register: melancholy, thrill, dread, anxiety, boredom, intoxication. Both are physiognomists of finitude; both probe transformations in the conditions of experience before the "unlimited panorama of abstract infinity" of modern media and life.[12] Yet these are no typical *Bilderstürmer* (iconoclasts) who grimly smash images to reveal their nullity; ambivalence sets them apart. Beauty must be veiled because nothing unveiled is quite beautiful. More than disdain, love for the image moves their iconoclasm. There is a principle of thrift, even of consecration, that moves their care for the beautiful.

In this essay, I cannot fully explore the philosophy of the image in Kierkegaard or Benjamin.[13] Kierkegaard's reflections on the theater, music, journalism, mirrors, direct and indirect communication, spyglasses, and crowds and Benjamin's on phantasmagoria, lithography, panoramas, serial literature, photography, film, wax museums, department stores, flanerie, commodities, and above all his method of "dialectics at a standstill" all present a rich lode for further analysis. Their common resistance to Hegelian *mediation* (*Vermittlung*), I will argue, informs their resistance to communication *media*. The mortal individual obstructs the system's attempt to totalize the world as image.

Hegel is perhaps the archetypal ambivalent iconoclast. With Kant and Schiller he agrees that appearance (*Schein*) is far more than illusion or deception; it can be a vehicle for the expression of *Geist*, or spirit. In his philosophy of art, the beautiful images of the past—Greek sculpture, above all—must give way before "the concept" (which knows no images). The art of the ancient Greeks is fixed in its splendid materiality, innocent of sin and agony, a lovely but lost stage in the adventures of *Geist*. The next step, "Christian-romantic art," tears down the temple of the old gods, expresses not sensuousness but spirit, and must cast out *Schein*.

Hegel's method—phenomenology, the study of the logic of *Schein*—is likewise ambivalent toward the image. His *Phenomenology of Spirit* (1807) is at times a slide show, at times an encyclopedic time-lapse film of the self-education of history. It projects before consciousness an image of a particular style of thought or historical moment that considers itself complete, only to dialectically surpass the image, leaving it behind as a "determinate negation," a negation with a content. Hegel shows images with one hand and annuls them with the other. As Horkheimer and Adorno note, iconoclasm is the modus operandi of Hegel's dialectic. "Determinate negation rejects the defective ideas of the absolute, the idols."[14] Each moment may be a false summit, a premature conflation of universal and particular. Yet the goal is that "appearance [*Erscheinung*] becomes identical with essence."[15] When the summit is finally attained (in the last paragraph of the *Phenomenology*), absolute knowing is recollected as "a gallery of images" [*Galerie von Bildern*].[16] Is this fulfillment or annihilation? Is the procession of images a bad dream or the epitome of a successful totality? Hegel's interpreters have been battling each other ever since.

Whereas Hegel's odyssey never gets sidetracked long in lotus land, the dialectic in Kierkegaard and Benjamin is subject to an almost infinite dilation. Hegel, like Goethe's Faust, seems to have made a pact that he will never find a moment so fine he would wish to say, "Linger a while, thou art so beautiful."[17] Kierkegaard and Benjamin, however, do linger. Both play with aborted dialectics: Kierkegaard's dialectic often never begins and oscillates wildly between options, and Benjamin often stalls dialectical flows to a "standstill" part way through. Kierkegaard's *Either/Or* already announces in its title a critique of Hegelian "mediation" as an ultimate synthesis and resting point. As Johannes Climacus, one of Kierkegaard's pseudonyms, says in "Concluding Unscientific Postscript," "The systematic Idea [i.e., Hegel] is the identity of subject and object, the unity of thought and being. Existence, on the other hand, is their separation."[18] Kierkegaard thought the project of reconciling appearance and essence was mad.

Benjamin's fight about mediation was not with Hegel but with one of the twentieth century's foremost Hegelians. Wrote Adorno to Benjamin in 1938: "Let me express myself in as simple and Hegelian a manner as possible. Unless I am very much mistaken, your dialectic lacks one thing: mediation."[19] Benjamin thought juxtaposed images themselves could do the work of critical theory—exposing utopian or revolutionary fault lines in culture and society—but Adorno insisted on the need for a theoretical frame of dialectical interpretation. The renunciation of mediation in its many senses—arbitration, representation, dialectical synthesis,

coming between—and the fascination with that which escapes totalization makes the work of Kierkegaard and Benjamin mutually resonant and suggestive for debates about the status of the image in the culture of modern Europe.

Whatever the differences between the Christian irony of the one and the messianic Marxism of the other, both think about the image in terms of history and desire, the public gaze and private acquaintance, limitlessness versus singularity. For both, some forms of beauty must be veiled. Kierkegaard, in some of his pseudonyms, suggests that "the aesthetic" can lead to infinite despair; and Benjamin, at once celebrating and lamenting the waning of beautiful semblance (*schöner Schein*) in the modern world, explores how the longing for loveliness can be in league with death. The beautiful undergoes a process of mortification. The fragile contents of mortality—invisible to passersby—need shelter, as we will see.

Kierkegaard's *Either/Or* (1843) is a virtuoso performance of the dialectic of visible splendor in public and unadorned morality in private—"the aesthetic" and "the ethical." Within "the aesthetic" stage, one chooses simply by mood, inclination, or the whim of the moment. The aesthetic is fickle stuff: the *either* of the title.[20] "Aesthetics is the most faithless of all sciences. Anyone who has truly loved it will in a way become unhappy; while anyone who has never done so is and will remain an ox."[21] Within the ethical stage, such indifference is impossible; the contrast of aesthetic and ethical can be made only from the ethical point of view, since the aesthetic would see the ethical as simply another option to be tried out. The two modes are incommensurable. The choice is stark—but only from the ethical point of view. Contra Hegel, appearance and essence are ever out of whack.

Not by accident, *Either/Or*'s chief topics are seduction (the aesthetic) and marriage (the ethical)—erotic relations between men and women. Part I is a brilliant mishmash written by a young aesthete: the variety and color of presentation are meant to enact the fickleness and restlessness of the aesthetic. Part II is a rather platitudinous discourse on marriage in the form of letters by one Judge William. As Part I performs the wit, whimsy, boredom, and nihilism of an aesthete, Part II enacts the difficulty of rendering morality in aesthetic terms. Seduction is all about seeing, appearance, and the splendors of *Schein*, while marriage defies public depiction, as only its participants are privy to its content.

In the "diary of the seducer" toward the end of Part I we peer over the shoulder of a narcissistic pleasure seeker, Johannes the seducer, who approaches his "object" with the inevitability of a mathematical limit approaching infinity. When the

affair is consummated, he loses all interest and abandons her. At one point, Johannes beholds a young woman who has entered a shop where he happens to be:

As yet, she has not seen me; I am standing at the other end of the counter, far off by myself. There is a mirror on the opposite end of the wall; she is not contemplating it, but the mirror is contemplating her. How faithfully it has caught her image, like a humble slave who shows his devotion by his faithfulness . . . Unhappy mirror, which assuredly can grasp her image but not her; unhappy mirror, which cannot secretly hide her image in itself, hide it from the whole world, but can only disclose it to others as it now does to me. What torture if a human being were fashioned in that way.[22]

She is looked upon, but does not look. The ability to conceal an image from the whole world is, in the seducer's warped opinion, the essence of humanity; yet the mirror, like *Schein* or sculpture, has no inwardness. The young woman is mirror-like in her blissful lack of awareness of her own beauty: were she to play the coquette, the seducer would lose interest. Lack of self-consciousness on her part is a condition of his attraction. The seducer—and the young woman—both confront the harsh fact that beauty as subject and as object seem incommensurable.

Women's subjectivity is clearly a problem for the seducer, who is at his most outrageous when he turns in mock-philosophical earnest to the subject of "woman." Anyone who feels no need to study this topic, he claims, "is no aesthetician. What is glorious and divine about aesthetics is that it is associated only with the beautiful; essentially it deals only with belles lettres and the fair sex . . . My eyes never grow weary of quickly passing over this peripheral multiplicity, these radiating emanations of womanly beauty" (*E/O*, 1:428). For the seducer, "woman" is a sheen of appearances to be contemplated. For the seducer, who happens to be a Hegelian of sorts, woman, considered philosophically, is, like nature, a being-for-another. As in Hegel, man is spirit, woman sensuousness.[23] Her chief characteristic as being-for-another is virginity—which cannot know itself but can only be known by another. Virginity can carry no internal image of itself. But the act of knowing compromises it, as virginity is precisely the unknown (in the full biblical sense). "Therefore it can be said that woman in this state is invisible. It is well known that there was no image of Vesta, the goddess who most closely represented true virginity. In other words, this form of existence is aesthetically jealous of itself, just as Jehovah is ethically jealous, and does not want any image to exist or even any idea of one. This is the contradiction—that which is for-another is not and, so to speak,

first becomes visible through the other" (*E/O*, 1:430–431, translation slightly altered).

The seducer brings us to the historical core of the iconoclastic impulse, uniting the Hebrew and the Greco-Roman prohibitions on images. The virgin is at once invisible and a "radiating emanation." As Goux suggests, Vesta is "the principle of absolute virginity, principle of interiority and centrality . . . a limit to re-presentation, as she has no way to make herself known except by means of presence. It is only the forgetting of being which causes representation to take place. . . . Is not Hestia [the Greek Vesta] the being, the abiding, the stable, which, contrary to 'what is,' cannot be treated objectively: cannot, that is, be beheld as an image?"[24] The seducer desires virginity, but once he has known it, it is no longer there. It is inaccessible. To see virginity is to profane it, to make it something other than it is. It must be left in its being—precisely what the seducer cannot do. The aesthetic turns out to be a recipe in despair: the seducer is subject to the terrors of the asymptote. He ever leans toward "the object" in a spell of vertigo, never quite reaching it. The woman—or "the object"—is at best a pawn in a philosophical drama about the fleetingness of time and of pleasure. The seducer suffers from Goethe's plaint: "In pleasure I thirst for desire."[25]

Marital love has neither of these bad moments, according to the very different voice of Judge William in Part II of *Either/Or*. The difference between romantic and marital love, he says, is that the latter is unportrayable: its history is inner and not capable of publication in generalized media. Marital love's features are its "inner history," that is, its existence in time. Unlike the seducer, who fancies himself a knight doing battle with dragons and ogres to win the fair maiden, the husband must fight nothing but time and must possess eternity in time. "Possession" in marriage is a given: now it needs to be filled with an inner history. "And though this [filling of time with eternity] cannot be portrayed artistically, then let your consolation be, as it is mine, that we are not to read about or listen to or look at what is the highest and the most beautiful in life but are, if you please, to live it" (*E/O*, 2:139). Ethical practice dissolves the disembodied aesthetic. "For this reason, too, it is obvious that this love cannot be portrayed. It always moves inward and spends itself (in the good sense) in time, but that which is to be portrayed by reproduction must be lured forth, and its time must be foreshortened" (*E/O*, 2:140). The flattening of time in reproduction anticipates Benjamin.

The virtues of marriage consist precisely in their continuity, in their fullness of remembered interpersonal history. As the judge writes to Johannes, "What you

abhor under the name of habit as inescapable in marriage is simply its historical quality" (*E/O*, 2:140). "Woman's beauty increases with the years; her reality is precisely in time" (*E/O*, 2:431). Marriage, like music and poetry for Hegel, has its meaning in its ability to cradle time. It is, like revealed religion, a nonrepresentational kind of art.

From the seducer's point of view, he continues, marital habit profanes the "visible, sacred symbols of the erotic" whose sense depends on artistic bravura, while marriage is overwhelmed with plodding punctuality, even time-discipline. Yet time is the seducer's problem too: the impossibility of preserving love in time. For long-term lovers to "see" each other (and here the judge emphasizes the visual aspect of infatuation) in the same way they first did, they must resort to artifice, which can only fail. Love, from an aesthetic viewpoint, leads inevitably to despair. "The source of your unhappiness is that you locate the essence of love simply and solely in those visible symbols." Repetition is impossible when novelty is prized: the longing that it be the first time all over again (which is the telos of the seducer). "But true love has an utterly different value; it does its work in time and therefore will be able to renew itself in these external signs and has—this is my main point— a completely different idea of time and of the meaning of repetition" (*E/O*, 2:141). Once I longed for my first love, says the seducer; now I just long for that longing. Both repetition and originality are impossible for the seducer. His time is out of joint.

In marriage, the couple lives in "both hope and recollection" (*E/O*, 2:142). The seducer is voracious for attractions, craving a surfeit of stimulus: his apprehension of time is, in Benjamin's sense, empty and homogeneous.[26] The judge writes:

For you [the seducer], a turbulent sea is a symbol of life; for me it is the quiet deep water. I have often sat beside a little running stream. It is always the same, the same gentle melody, on the bottom the same green vegetation that undulates with tiny ripples . . . How uniform, and yet how rich in change! So it is with the domestic life of marriage . . . like that water, it has melody, dear to the one that knows it, dear to him precisely because he knows it. It is not showy, and yet at times it has a sheen that nevertheless does not interrupt its usual course, just as when the moon shines on that water and displays the instrument on which it plays that melody. (*E/O*, 2:144)

The seducer's fear that spontaneity will give way to duty upon marriage is due, says the judge, to a "misunderstanding of the historical" in marriage. As he notes, romantic fiction ends with a marriage: but that is where another history begins,

only one not communicable to anyone but its intimates. The everyday can transfigure itself into the extraordinary if seen with the proper optic: with the remembered fullness of time. Only few are privy to shared memories.

Cupid's arrow, for the seducer, is Zeno's arrow. With a quote from Hegel about "bad infinity" (or serial regress) and "accidental infatuations," the judge tells of a man who looks out the window together with his fiancée only to see another woman rounding the corner—with whom he instantly falls in love. As he chases her, he sees yet another (*E/O*, 2:26). "The apparition of these faces in the crowd / Petals, on a wet, black bough," wrote Ezra Pound of passing through the Metro station.[27] To walk through a multitude in the aesthetic mode is to fall in love anew each second, an experience captured by writers such as Poe, Whitman, Baudelaire, Aragon, and Benjamin and exploited by advertising, cinema, and the mass media generally. (This may be a genre historically characteristic of men, as Anke Gleber argues in this book.) Desire is, as the seducer says, sophistical and arbitrary. It can be sparked by evasion, by an image, a pose, a name, a gesture. The mobility of the libido, the effervescence of the crowd, the hypnotic power of falling in love is the essence of Kierkegaard's understanding of the aesthetic and that which the ethical rebels against.

Marriage as a form of love is unreasonable. Though the institution itself may be universal, its particular contents are always highly partisan and selective. Kant (who, like Kierkegaard, never tried it out) thought marriage a concession to our animality: a law such as "tell the truth" applies to all rational beings whereas "do not commit adultery" applies only to creatures having sex organs. Kant's low estimate of our embodiment meets a lively response in Kierkegaard and, as we shall see, in Benjamin. In love, as Kierkegaard says in *Fear and Trembling*, the particular is higher than the universal. The impossibility of public justification is the essence of love: "The moment a lover can answer that objection [i.e., why he fell in love with one person among countless possibilities] he is *eo ipso* not a lover; and if a believer can answer that objection, he is *eo ipso* not a believer."[28] One chooses one among many. There is something absurd about wedded life to a moral system, like Kant's, that makes universalizability the test of the good: one cannot wish that all rational beings would marry one's spouse. The generalization of marriage is called adultery.

In this brief exegesis, I have argued that Kierkegaard resists Hegelian mediation—the dream of a synthesis that incorporates but negates all particularities—by insisting on the unsurpassability of mortal singularities and the public unportrayability of individual life histories. Seduction is his image of the image—a Tantalus torture, since the radiance of virginity is only present as image, never as "possession."

Marriage, in contrast, is an ethical zone of intersubjectivity and shared history. Nothing can mediate a relationship of mutual inwardness. There are no images in paradise. Where subject meets subject, no images can be made.

For Kierkegaard, the pretense of a totalized system (Hegel) is not only ethically suspect (since it forgets our mortality) but aesthetically suspect as well (since a publicly accessible gallery of images would be fit only for seduction, not for remembered inner history). Benjamin had other ideas about the seductions of the image, while also being a sworn enemy of specious totalities: he thought, in his later work, that the siren call of images could be reclaimed politically rather than ethically as a form of shock treatment to arouse the proletariat from its slumber. Benjamin's "empathy with the inorganic" leads him again and again to the particularities of embodied life in the capitalist world, to the disgraces (and possible redemption) found in the exchange between humanity and matter, and in the cessation of time. The corpse—the human being become matter—is a central theme in each of Benjamin's major works.[29] Benjamin commits the classic sin for the iconoclast: treating objects as subjects. Instead of pressing onward and upward on the dialectical spiral as Adorno adjured him, Benjamin lingered, even loitered, at "the crossroads of magic and positivism," wishing the beautiful moment to stay awhile.[30]

Like Kierkegaard, Benjamin examines the chasms and communions between subject and object. The commerce between the human world and the thing-world is his site of study. This theme pervades his wide-ranging analysis of Goethe's novel, *Elective Affinities* (1809), which, again, concerns marriage and adultery.[31] A happily married noble couple, after receiving an old friend of the husband and the niece of the wife for extended visits, fall in love with the friend and niece, creating an ultimately tragic quartet. The child born to the couple, begotten in an act of mental adultery by each, is in the express image of the friend and niece! (Goethe knew about both enraptured appreciation and the ethics of looking away.) As the chemical metaphor of the title suggests, the material and the human worlds attract each other. Matter pulls people as the dead attract the living.[32]

The niece, Ottilie, a beautiful *Jungfrau*, embodies *schöner Schein*. Benjamin takes the prime condition for readerly participation in the novel to be the conviction that she is indeed beautiful.[33] Her beauty, says Benjamin, is itself *Schein*, a kind of apparitional semblance. In the narration, Ottilie's beauty is not banished but is necessarily veiled (*GW*, 299). Her light is neither the blinding light of a Lucifer nor the sober light of reason but twilight—a light that is on the verge of passing away (*GW*, 318, 325). Her beauty draws its power from its dis-appearance. Its inconspicu-

ousness is like the purling brook to which Judge Wilhelm likens marriage. But Ottilie, like a Greek sculpture or the seducer's young woman looking in the mirror, is oblivious to her own beauty; she simply shines.

One scene in the novel illustrates the transfixing power of the image—its ability to convert life into matter via "mortification"—that so interested Benjamin. The company recreates tableaux from history and painting ("*Kunstmummerei*") with live actors, props, and costumes. On Christmas Eve, Ottilie is reluctantly cast as "the mother of God." No one moves or breathes. Ottilie is caught at the moment of lifting the veil on the sleeping child. "At this moment the image [*Bild*] seemed caught and transfixed [*festgehalten und erstarrt*]. Physically blinded, mentally stunned, the villagers around seemed to have just turned their dazzled eyes and, in their curiosity and delight, to be taking another look, more in amazement and pleasure than in admiration and veneration."[34] Ottilie, cast as the Virgin in this proto-photographic moment, becomes a living *nature morte*. Her bedazzled spectators admire, but her subjectivity threatens to disappear.

Ottilie is most beautiful when most frozen. Ottilie, who dies in anorexic penance for the inadvertent death of the child who resembled her, is buried in a glass-covered coffin so that her appearance may remain (*GW*, 310–311). Before photography, Goethe again recognizes a complicity between the desire to capture an image and the fixity of death. Ottilie is an image of Goethe's "eternal-feminine" in its most tragic form.

In a discussion of extraordinary subtlety, Benjamin describes *Schein* as the necessary covering [*Hülle*] of beauty; and it is a law of beauty "that it only appears [*erscheint*] as such in veiled form. This does not mean, as the banal dicta of philosophy teach, that beauty is itself *Schein*" (*GW*, 327).

Beauty is not *Schein*, not a covering for another. It is itself not outward appearance [*Erscheinung*], but thoroughly essence—of such a kind, to be sure, which remains identical to itself only under concealment [*Verhüllung*]. Though *Schein* may everywhere else be delusion, beautiful semblance [*der schöne Schein*] is the covering for the necessarily most veiled. For the beautiful consists in neither the covering [*Hülle*] nor the veiled object: it is rather the object in its covering. Uncovered, the object would only turn out to be infinitely inconspicuous [*unscheinbar*]. This is the basis of the age-old intuition that a veiled object is transformed in being unveiled, that it can remain "identical to itself" only under veiling. (*GW*, 327)

There is no essential beauty in nakedness: "In the naked human body a being above all beauty is reached (the sublime) and a work above all mere creations (that of the

Creator)" (*GW*, 328). Benjamin notes that Goethe refuses to unclothe his three main female creations—Helen, Mignon, and Ottilie (329). Beauty is veiled; sublimity is nude. Ottilie's veil is her body (330): her beauty lies in her mortality (she is still lovely in death).

The proposition that beauty is the veiling of something mortal prefigures many of Benjamin's more famous insights ten years later about the aura and its dispersion through mechanical reproduction. That (female) beauty must be veiled expresses the grimmer side of iconoclasm. So does, but in a tone more of *jouissance* than fury, the smashing of the aura surrounding the work of art and the conversion of art from private cult value to public exhibition value. The aura of a work of art, says Benjamin, consists not only in its uniqueness and permanence, but in its relation to tradition. To expose a "sacred" object does not just mean opening it up to the light of day: it entails a fundamental alteration of its being. An exposed object ceases to be sacred, as its sanctity consists precisely in its enclosure. In the case of the work of art, mechanical reproduction separates the work from its interpretive and proprietary tradition. The work's historicity is lost, its embedment in a tissue of relationships to dates, places, owners, to the tradition that gives it authority. The cracks in the paint, the fingerprints on the frame, the defects that attest to its aging process—all these are obscured in reproduction. Its mortal core is what defies replication. Kierkegaard could have written these lines by Benjamin: "The whole sphere of authenticity [*Echtheit*] is outside technical—and not only technical—reproducibility. . . . the technique of reproduction detaches the reproduced object from the domain of tradition."[35]

Benjamin celebrated this loss as revolutionary in his essay on the work of art, treating it more ambivalently elsewhere. Benjamin contrasts two modes of circulation: a private, sacred one (the art work in its cultic secrecy) and a public, profane, political one (the world of reproductions). This essay, like much of Benjamin's work, treats the modulations of experience in alternate media or embodiments. It is thus reminiscent, though with different valences (especially political ones), of Kierkegaard's meditations on (unportrayable, historic) marriage and (visible, repetitive) seduction. For Judge William, it is the shared memory of the partners that gives marriage its invisible inner history—uncovered to the public "aesthetic" gaze, its contents would seem, in Benjamin's terms, "infinitely inconspicuous." Likewise, the aura of a given art work rests delicately on an esoteric tradition. "Insofar as art aims at the beautiful and, on however modest a scale, 'reproduces' it, it conjures it up (as Faust does Helen) out of the womb of time. This no longer happens in the case of technical reproduction. (The beautiful has no place in it.)"[36]

Beauty in this sense is tied to time and to a dying body: Helen may even be more beautiful than the immortal goddesses. Human longing feeds on death. Odysseus admits to his demigod lover Calypso that Penelope, his long-lost wife at home, cannot match her in beauty or form, and yet he longs for Penelope nonetheless. Like Freud, Proust, Joyce, Woolf, and many others, Benjamin studies the ways life histories attach to objects and others; for him the junk of memory and the kitsch of dreams show how the accidental can become the absolute in our lives (cf. *E/O*, 1:300). Our bodies have their own "traditions," their secret histories that cannot be reproduced—that is, cannot be open to public inspection.[37] The flaneur sees beautiful women passing on the street and falls in "love at last sight." But the flaneur, like Kierkegaard's seducer, is blind to veiled beauty, the lovely imperfections that escape general vision:

He who loves is attached not only to the 'faults' of the beloved, not only to the whims and weaknesses of a woman. Wrinkles in the face, moles, shabby clothes, and a lopsided walk bind him more lastingly and relentlessly than any beauty. This has long been known. And why? If the theory is correct that feeling is not located in the head, that we sentiently experience a window, a cloud, a tree not in our brains but, rather, in the place where we see it, then we are, in looking at our beloved, too, outside ourselves. But in a torrent of delusion and ravishment. Our feeling, dazzled, flutters like a flock of birds in the woman's radiance. And as birds seek refuge in the leafy recesses of a tree, feelings escape into the shaded wrinkles, the awkward movements and inconspicuous blemishes of the body we love, where they can lie low in safety. And no passer-by would guess that it is just here, in what is defective and censurable, that the fleeting darts of adoration nestle.[38]

Benjamin describes an attraction by defect,[39] a radiance arising from inner history. No mediation or publicity can communicate this "delusion and ravishment" to noninitiates.

That mortality escapes representation is a point of Benjamin's analysis of stories. The story is parasitic on the mortality of the narrator: it draws its strength, like a flame, from the narrator's life. The modern newspaper, in contrast—whose mode of presentation Benjamin calls "information"—treats human mortality statistically. Hence it cannot give rise to experience that can be shared mouth to mouth. "Information" has lost touch with boredom, labor, and travel. It is part of a social order taught by war to obliterate the body in storms of steel. Information does not enter tradition; news events are constructed so as not to enter into the reader's experience. News offers no recesses for the self to take refuge in. "It is not the object of the

story to convey the event per se, which is the purpose of information; rather, it embeds itself in the life of the storyteller in order to pass it only as experience to those listening. It thus bears the marks of the storyteller much as the earthen vessel bears the marks of the potter's hand."[40]

Photography is an enigma since it seems able both to capture the individual contingency of death or birth—and reproduce it without end. Photography, like the writings of Baudelaire and Proust, registers the shocks that frail bodies undergo in modern times. It is, in other words, an art of recollection. It reveals correspondences that would otherwise remain obscure and hidden. Each photograph evokes lost passages of memory, the contingent corridors of time found nowhere but in a personal history. The wonder of photography for Benjamin is its ability to reveal a "tiny spark of contingency," a trace of having-been-there invisible to noninitiates.[41] Photography stores memories no less than a madeleine does for Proust. The camera is a witness to human finitude, to the lostness of the past, to the fact that the Messiah has not yet arrived. In Benjamin's philosophy of history, every second is the portal through which the Messiah may enter, such that each photograph, as a document of a time seemingly now lost, may bear the secret traces of history's struggle to prepare for the Messiah's coming. Time, as the bearer of contingency, and photography, as the keeper of moments, reveal images not in nakedness, but in the inconspicuous way suited to a nonmessianic world where humans are still mortal and nature laments.

A photograph reveals both the unrepeatableness of the past and the fact that it is still present. It is more than mere memory with all its distortions and embellishments; it presents past time and past light in its eerie otherness. Photography is central to Benjamin's philosophy of history because it seems to escape the relentless march of time and the resistance of reality to our wishes. A photograph is an artifact of hope: it attests that history could be changed, that the present might be otherwise. A photographic image bears witness that history might change its course, that the past is not lost but only dormant. The photographed past is available only as image, not time. In photography, history lies like a corpse in the grave, awaiting resurrection.

Photographic images, in short, reveal our fundamental and contradictory yearnings both to extend time forever and to stop it at will. Images, as Benjamin insists, are always bound up in the question of redemption, itself a question of the philosophy of history. An image seems to make good on the wish to alter the forking paths of history, to allay the grief for paths not taken. The uncanniness of a

photograph lies in its power to revive a moment lost to time in the present. A photograph is a refuge against the impossibility of repetition. For it reveals that the past is past only in fact: in yearning the past comes forward to meet us. In revealing a once-was, a photograph invites us into a might-yet-be. It discloses the art of bending time.

The image should be treated with care, then, because it bears the dangerous power of stopping—or containing—time. The French revolutionaries, as Benjamin notes, shot at the clocks to keep the great moment from passing. Faust assured Mephistopheles in the same way that "The clock may stop, the clock hand fall, / And time be done and past for me!" when the longing to linger overtakes him.[42] Time's halt is a cause for celebration—or for Judgment Day. The flow of time, from Goethe's *Faust* and the dialectics of Hegel and Adorno, is protection against reification; Adorno never quite forgave Benjamin the ambition of developing a political-intellectual method of dialectical imagery that would bring time to a halt. For Adorno, music was the model of a successful aesthetic totality that avoided the dangers of fixity, precisely because it dissipated itself in time and defied reference to anything fast or fixed. Music casts down idols, the temptation to fix the absolute, and yet it discloses inklings of happiness, time out of time.

Benjamin, in contrast, cast himself into the heart of reification, wandered in the strange land of Egyptian hieroglyphics, seeing the sights, visiting the mummified corpse beneath the splendor. Just as the commodity becomes animate, a thing capable of carrying on fantastical interpersonal exchanges with a client (in fetishism), the living human can become a commodity, on display but denied subjectivity (in prostitution). The couplet of commodity and prostitute, which structures Benjamin's unfinished work on the arcades of Paris, straddles the borderline between organic and inorganic, subject and object, human and thing. His compassion for the object keeps him from ever being anything but a reluctant iconoclast.

Philosophy has always been nervous about appearance, or what the German idealists and romantics called *Schein*. For Plato, appearance was both a seducer of the senses and the mutually reflected beauty of two souls as they come together in philosophy. For Plato, philosophy—itself a kind of love—drives one into the heavens on the chariot of the soul. Kierkegaard and Benjamin, in their eros-sophies, wander in a world in which authenticity is achieved by charade, and the laboring body's survival requires a pact with dead matter. Time heals all wounds for Hegel, but Kierkegaard and Benjamin treasure the scars as evidence of what humanity can wrest from a world like this. Scenes from a marriage, the enigma of faces in an

unlabeled photograph, the historical properties of the object—such images elude the claims of a public history, narrated as progress, knowable to all. Hegel's dialectic runs aground on the unrepresentable—not the unrepresentability of the sublime or the absolute, which he celebrates, but of the inconspicuous incarnation, the unnoted coming of the Messiah.

The spell of remote beauty is as old as desire.[43] Distance and death have always been the two great obstacles to love, the two great conditions of desire. But the explosion of images since the early nineteenth century—images still and moving—poses novel ethical and aesthetic problems. The ability of photography and allied forms of mechanical reproduction to fix images in time and transport them across space alters the conditions of desire and love. The image can reveal to curious passersby what, in a world without images, would be found in the beloved alone (the intimate details of embodiment). Certain kinds of image and image apparatus—of beautiful others distant from us in space or time, models, screen stars, pinups, centerfolds, the beautiful people populating the culture industries—tease our finitude, offering a mirage of fleshly presence. Such public beauties invite us to exit our web of quotidian commitments, but their promise of immediacy and reciprocity— however sweet its minutes and hours—can never be redeemed. The aesthetic splendor of the modern image is out of step with its ethical burden. Its infinite lightness does not absolve us from mortal gravity. Though appearance is subject to infinite multiplication, the flesh is not.[44]

To be sure, beauty has long been described as a yank on our finitude, wrenching the immortal soul from its mortal flesh, as in Plato's tale of the divinely inspired mania that occurs upon seeing one's beloved (in the *Phaedrus*). The sight of the beloved awakes a frenzy in the lover. The soul sprouts feathers and the prickly heat the lover feels in every pore is simply, says Plato, the soul's yearning to fly to its place of origin. Yet Plato's lovers could meet and touch in the flesh (though he would not approve) in a way quite impossible for those in love with images of the beautiful dead (Ottilie, Greta Garbo, Montgomery Clift). And just as Plato complained that writing ruined the art of memory, I argue that the mass image alters the inner history of love. Love-struck Pygmalion persuaded the Greek gods to bring his lovely statue of Aphrodite to life, but the rest of us know no gods—except audiovisual media—to give life to a lover formed out of our own projections, to make a subject of an object.

To be in love with inaccessible beauty may be human, but to be in love with

reproducible beauty is peculiarly modern. The image's conquest of scale and time widens the gap between adoring subject and adored object in novel ways. Ancient ideas of love (*eros, philia, agapē*) all presuppose the singularity or mortality of the beloved. Singularity—whether in a work of art or an individual human being— vanishes with multiplication. The beauty of the other's skin can be caught immediately as an image, but not their ethical-historical beauty. Modernity escalates, in short, the age-old war of *agapē* and *eros*. Nothing less is at stake in our disputes about the image.

The multiplication and preservation of mortal beauty via imaging techniques and technologies ups the skirmish between the ethical command to care for the other and the aesthetic command to glory in beauty and revile ugliness. If ethics, as Emmanuel Levinas suggests, concerns one's infinite obligation to the face of the other,[45] what happens when the face is a photograph—or is extraordinarily attractive or repulsive? Is delight or disgust in the other's appearance a distraction from ethical obligation? That beauty takes human form is an enigma for ethics. It can be expressed in a formula: many faces, few beautiful ones. Yet time confers a beauty that the camera cannot touch; it only stores traces for initiates.

Apparitions of beautiful strangers have accosted generations of modern people on city streets, theater displays, magazine covers, posters, shop windows, cinema, and television. Some of these images seem to promise free and ready love, an escape from history, law, duty, property, biography, or personality. The image invites us to imagine an immediacy of attainment indifferent to time, space, class, or acquaintance. The image is structurally similar to lust in that it wills all obstacles away. Lust is not an emotion not only of moral but political significance, since it fantasizes extant social relations into nothingness, as if our relations with each other knew no mediation.[46] Lust is utopian—and dangerous—in annihilating the embedded world of obligation. Lust, with intoxication, represents the revolutionary energies Benjamin found in the dreamworlds of mass culture. And yet no fleshly other is there in the image, only his or her death mask. Yon sweetly inviting face does not yearn for thee, though it seem to meet thy gaze; like Ottilie, it shines from the grave. The image is haunted. Before the image world, we become the mirrors that Kierkegaard's seducer feared—all reflection, no inwardness. We become lovers of ghosts, mate with the dead, have unlawful congress with the immortals.

I have explored grounds for the prohibition of images, making a case that tries to navigate between love for *Schein* and respect for restraint. The image evokes anxieties about hubris, fetishism, prostitution, necrophilia, adultery, and lust. The

image seems to invite deviations from the ethical ideal of a relationship governed by the mutual recognition of subject and subject, an ideal found at once in Isaiah and in Hegel: in the spell of the image, we find all manner of border forms neither quite subject nor object, ghosts, idols, matter, the dead and distant. Iconoclasm is the ethical's vengeance upon the aesthetic. But Kierkegaard and Benjamin, again, are no reactionaries, though they try to borrow strength from wherever they can, knowing that a world without prohibitions would be both boring and corrupt; they swim, rather, in the eddies between the whirlpools of rapture and refusal. For both, images of mortal beauty must be veiled, not only because public beauty can tempt us with fantasies of timelessness which belong to the grave, but because they can obstruct unmediated inner histories. To represent is to mediate a relationship that must remain particular. The image grants premature access to forbidden zones.

Yet the tenderness of Kierkegaard and Benjamin moderates their iconoclasm. Images of beautiful others with whom we share no history or commitments ask us to fall in love with things that never vanish, to prize perfection over warts and wrinkles, or to idealize the other in an almost embalming embrace. Images of beautiful strangers emanate from the spirit world. We are tempted to marry the perfect dead and to flee, rather than cherish, the aging of those around us. The lesson of Kierkegaard and Benjamin is to delight in the splendor of the image and to renounce its denigration of our finitude. Disputes about the image involve more than the role of the visual in modern culture; they turn on the ancient longing for immortality and the way it can corrupt us.

Notes

I am grateful to the Project on the Rhetoric of Inquiry for support in the writing of this paper and to colleagues in the 1992 Obermann seminar "The Image in Dispute: Visual Cultures in Modernity," especially Dudley Andrew, to students in my 1995 seminar on the public sphere, and to Roberto Moya-Rodriguez and Doug Johnson for helpful comments. Kenneth Cmiel helped me discover my thesis, and Peter Simonson rescued me with a final reading.

1 Isaiah 2:8, King James version.

2 For recent reflections on iconoclasm, see Jean-Joseph Goux, *Les iconoclastes* (Paris: Seuil, 1978); Jean-Joseph Goux, "Vesta or the Place of Being," trans. William Smock, *Representations* 1, no. 1 (February 1983): 91–107 ("Vesta, ou le sanctuaire de l'être," in *L'interdit de la représentation* [Paris or Montpélier, 1984], 63–87); Philippe Lacoue-Labarthe, "L'im-

présentable," *Poétique*, no. 21 (1975): 53–95; Martin Jay, *Downcast Eyes: The Denigration of Vision in Twentieth-Century French Thought* (Berkeley: University of California Press, 1993); Azade Seyhan, *Representation and Its Discontents: The Critical Legacy of German Romanticism* (Berkeley: University of California Press, 1992); Josef Chytry, *The Aesthetic State: A Quest in Modern German Thought* (Berkeley: University of California Press, 1989); Allan Megill, *Prophets of Extremity: Nietzsche, Heidegger, Foucault, Derrida* (Berkeley: University of California Press, 1985); and Peter Sloterdijk, *Kritik der zynischen Vernunft*, 2 vols. (Frankfurt: Suhrkamp, 1981).

3 See, for instance, Ezekiel (e.g., 23:37), Hosea, and Micah for the figure of God as the husband of the people Israel. On the association of the sin of idolatry with adultery and murder in Jewish traditions, see Harry Austryn Wolfson, *Philo* (Cambridge: Harvard University Press, 1948), 1:16. Given the temple prostitution prevalent in ancient Mediterrean religion, there is more than a metaphor linking idolatry and adultery.

4 An analysis in this vein is Susan Bordo, *Unbearable Weight: Feminism, Western Culture, and the Body* (Berkeley: University of California Press, 1993). Anke Gleber's chapter in this volume deals with this literature in much greater depth. Martha C. Nussbaum is a telling exception. See, e.g., *The Fragility of Goodness* (Cambridge: Cambridge University Press, 1986), chap. 6.

5 Paul Ricoeur, *Le conflit des interprétations. Essais d'herméneutique* (Paris: Seuil, 1969).

6 For an analysis of images of the suffering other, see Luc Boltanski, *La souffrance à distance: Morale humanitaire, médias, et politique* (Paris: éditions Métailié, 1993).

7 Homer, *Odyssey*, 6:161, Richmond Lattimore translation.

8 Plato, *Symposium*, 217a, Martha Nussbaum translation.

9 Job 31:1.

10 Matthew 5:28.

11 George Steiner, *On Difficulty and Other Essays* (New York: Oxford University Press, 1978), 61–136.

12 Søren Kierkegaard, "The Present Age" (1846), in *A Kierkegaard Anthology*, ed. Robert Bretall (Princeton: Princeton University Press, 1973), 269.

13 Fuller treatments are found in such sources as Douglas E. Johnson, "Kierkegaard's Optics" (Department of Communication Studies, University of Iowa, 1995, typescript); Rolf Tiedemann, *Studien zur Philosophie Walter Benjamins* (Frankfurt: Suhrkamp, 1973); Susan Buck-Morss, *The Dialectics of Seeing: Walter Benjamin and the Arcades Project* (Cambridge: MIT Press, 1991); Bettine Minke, *Sprachfiguren: Name, Allegorie, Bild nach Walter Benjamin* (Munich: Wilhelm Fink, 1991); Winfried Menninghaus, "Das Ausdruckslose: Walter Benjamins Metamorphosen der Bilderlosigkeit," in *Für Walter Benjamin: Dokumente, Essays und ein*

Entwurf, ed. Ingrid and Konrad Scheurmann (Frankfurt: Suhrkamp, 1992), 170–182; and Gertrud Koch, "Mimesis and *Bilderverbot*," *Screen* 34, no. 3 (Autumn 1993): 211–222.

14 Max Horkheimer and Theodor W. Adorno, *Dialectic of Enlightenment*, trans. John Cumming (New York: Continuum, 1972), 24.

15 G. W. F. Hegel, *Phänomenologie des Geistes* (Hamburg: Meiner, 1952), 75.

16 Ibid., 563.

17 "Verweile doch! Du bist so schön!" J. W. Goethe, *Faust* part I (Stuttgart: Reclam, 1982), line 1700.

18 "Concluding Unscientific Postscript to the 'Philosophical Fragments': An Existential Contribution by Johannes Climacus" (1846), in *A Kierkegaard Anthology*, ed. Robert Bretall (Princeton: Princeton University Press, 1973), 205.

19 Theodor W. Adorno, "Letters to Walter Benjamin," in *Aesthetics and Politics*, ed. Perry Anderson et al. (London: Verso, 1977), 128.

20 This apparent depreciation of the aesthetic is a bee in Adorno's bonnet in his 1933 work *Kierkegaard: Construction of the Aesthetic*, trans. Robert Hullot-Kentor (Minneapolis: University of Minnesota Press, 1989). For all its brilliance, this book belongs to a long debate between two traditions, dialectical mediation versus pietistic immediacy: the outlines of Adorno's critique of Kierkegaard are quite similar to Hegel's critique of Schleiermacher. Adorno uses the notion of a ban on graven images in his critique on 131–137. One ought to compare Adorno's critiques of Kierkegaard and Benjamin.

21 Johannes de Silentio [Kierkegaard], *Fear and Trembling*, trans. Alistair Hannay (London: Penguin, 1985), 123 n.

22 Søren Kierkegaard, *Either/Or*, ed. and trans. Howard V. Hong and Edna H. Hong (Princeton: Princeton University Press, 1987), 1:315. Hereinafter cited parenthetically as *E/O* with volume and page.

23 See G. W. F. Hegel, "Vorlesungen über die Ästhetik," *Werke* (Frankfurt: Suhrkamp, 1970), 14:401–412; and Lacoue-Labarthe, "L'imprésentable."

24 Goux, "Vesta," 99, 103.

25 "Und im Genuß verschmacht ich nach Begierde." Goethe, *Faust*, part I, line 3250.

26 Walter Benjamin, "Theses on the Philosophy of History," in *Illuminations: Essays and Reflections*, trans. Harry Zohn, ed. Hannah Arendt (New York: Schocken, 1969), 253–264.

27 Ezra Pound, "In a Station of the Metro" (1916), in *American Literature: The Makers and the Making*, ed. Cleanth Brooks, R. W. B. Lewis, and Robert Penn Warren (New York: St. Martin's Press, 1973), 2:2061.

28 Entry from Kierkegaard's journals, quoted in Bretall, ed., *A Kierkegaard Anthology*, xxi.

29 Menninghaus, "Das Ausdruckslose."

30 Adorno, "Letters to Walter Benjamin," 129.

31 This novel is the explicitly displayed intertext of Truffaut's *Jules et Jim*, a film Dudley Andrew discusses in a subsequent chapter in relation to Benjamin.

32 *Scheidekunst*—the name for chemistry in Goethe's day—literally means "science of divorce."

33 Walter Benjamin, "Goethes Wahlverwandtschaften" (1924), in *Die Wahlverwandtschaften* by Johann Wolfgang Goethe (Frankfurt: Insel, 1972), 311. Hereinafter cited parenthetically as *GW*. In the quoted passages, my very preliminary translations stay unartfully close to the original. See also Fredric Jameson, *Marxism and Form: Twentieth-Century Dialectical Theories of Literature* (Princeton: Princeton University Press, 1971), 65ff.

34 Goethe, *Die Wahlverwandtschaften*, 162–163. I have quoted from Judith Ryan's translation in *Goethe's Collected Works* (New York: Suhrkamp, 1988), 11:204.

35 Walter Benjamin, "The Work of Art in the Age of Mechanical Reproduction," *Illuminations*, 220, 221.

36 Walter Benjamin, "On Some Motifs in Baudelaire," *Illuminations*, 187.

37 In his discussion of German tragic drama (*Trauerspiel*), Benjamin writes: " 'Thou shalt not make unto thee any graven image'—this is not only a warning against idolatry. With incomparable emphasis the prohibition of the representation of the human body obviates any suggestion that the sphere in which the moral essence of man is perceptible can be reproduced. Everything moral is bound to life in its extreme sense, that is to say where it fulfills itself in death, the abode of danger as such. And from the point of view of any kind of artistic practice this life, which concerns us morally, that is in our unique individuality, appears as something negative, or at least should appear so." Benjamin, *The Origin of German Tragic Drama*, trans. John Osborne (London: Verso, 1977), 105. This is the thesis of the present essay.

38 Walter Benjamin, "One-Way Street," trans. Edmund Jephcott, *One-Way Street and Other Writings* (London: NLB, 1979), 52; this passage is from the section significantly called "To the Public: Please Protect and Preserve These Plantings."

39 I owe this phrase to Robert Newman.

40 Benjamin, "On Some Motifs in Baudelaire," 159. See also Benjamin, "The Storyteller: Reflections on the Work of Nikolai Leskov," *Illuminations*, 83–110.

41 Walter Benjamin, "A Small History of Photography," trans. Kingsley Shorter, *One-Way Street*, 240–257.

42 "Die Uhr mag stehn, der Zeiger fallen, / Es sei die Zeit für mich vorbei." Goethe, *Faust*, trans. Charles E. Passage (Indianapolis: Bobbs-Merrill, 1965), lines 1705–1706.

43 Denis de Rougemont, *Love in the Western World*, rev. ed., trans. Montgomery Belgion (New York: Pantheon, 1956).

44 The suspicion that the body—its unique inheritance and memories—can be reproduced is the key question informing recent anxieties about DNA, cyborgs, and artificial humanity.

45 Emmanuel Levinas, *Totality and Infinity: An Essay on Exteriority*, trans. Alphonso Lingis (Den Haag and Boston: M. Nijhoff, 1979), esp. sec. IIIB.

46 Roberto Mangabeira Unger, *Passion: An Essay on Personality* (New York: Free Press, 1984).

Jules, Jim, and Walter Benjamin

DUDLEY ANDREW

As the century winds to its conclusion, film scholars return more and more often to primitive cinema and the nineteenth-century environment that was its incubator, or else they speculate on the coming millennium after films will have spooled themselves out to be replaced by various electronic substitutes. In this period of the "pre" and the "post," I keep my eyes fixed steadily, obstinately, on cinema. More and more I look to its most heady moment, the New Wave, because there, if anywhere, cinema stands up as an intermediate form that bridges the centuries, spanning two distinct functions of art, two modes of storytelling, and two very different sets of morals. Unknown to the nineteenth century, perhaps to be neglected in the twenty-first, cinema will forever be recognized as the key cultural phenomenon of the one hundred years in between. It is precisely its "in between" status, most clearly visible during the New Wave, that I hope to characterize, even to celebrate.

Walter Benjamin (1892–1940) recognized better than anyone the transitional nature of cinema, taking it as the heir of nineteenth-century written narrative and of a vastly expanding industry of popular pictures (cartoons, postcards, and so forth). In the 1930s film was patently the preferred entertainment of the masses, and yet authorities were still in a position to control it—and to control the masses through it. Benjamin's enthusiasm for cinema anticipates Eric Rohmer's two decades later: cinema's rapport with its public appeared so natural and self-regulating that Rohmer would call it "classic."[1] To Benjamin cinema revived the healthy practice of casual storytelling that had been suppressed by two centuries of the imperious novel. Where the latter might be thought to germinate in the alienated brain of a creative genius locked away in the privacy of his or her study and to culminate in the privacy of the reader's room, storytelling accentuates social literary exchange. Storytellers pride themselves on artistry, technique, agility, and wit, as they pass down cultural experience that has been represented through narrative. In the evolving life of the culture they address, storytellers inflect their tales to make them relevant to current concerns. In Benjamin's mind, the quotidian story, unlike

the timeless novel, is an ongoing part of social life rather than a gem treasured away in a private or even public library.

Cinema could be thought to approach Benjamin's curious promotion of storytelling if only because of its prolixity and mass appeal. Several thousand films a year find billions of eager spectators, who keep track of them mainly by their genres and stars, certainly not by the names of authors, directors, or other creative forces responsible for them. Those "creative forces" themselves—producers we most often call them—monitor the popularity of their products and let stars and genres fluctuate with taste. Standard tales and current events, often clumsily reworked and entwined, guarantee the perpetuation of the narrative form and presumably contribute to the health of the society that weekly is entertained and instructed through it.

This analogy with storytelling derails, however, with cinema's industrial status and accompanying class divisions. Where the storyteller comes out of the society addressed, film producers (studio magnates or governmental bureaucrats, as you choose) invariably represent a class and interests at variance with the masses watching their movies. Hence the danger Benjamin forecast of a fascist use of the cinema, which is "rendering politics aesthetic."[2] Benjamin stood ambivalent before the cinema, because it both represented and yet failed to represent the authentic culture of the people. While he may have been happy that the cinema diminished both the individual creator and the sycophant class of critics that kowtowed to artistic genius—the legacy of bourgeois art forms like the novel and painting—he could never be complacent about the venal producers of popular culture and the vile way they profit financially and ideologically from controlling mass audiences through mass images.

Just as the illusion of the movies depends on a shutter that makes the image alternately present and absent, so Benjamin's essay on the work of art simultaneously holds out and retracts the value of the technologically produced picture. His oscillation seems in tune both with his personal misgivings about his vocation as a writer and with his public qualms about the vocation of the humanist in this century. Benjamin was drawn to activities that in effect hold out art and then retract it, activities that stand just to the side of art and make use of it, such as translation, collecting, storytelling, surrealism, criticism, and photography. His famous declaration that the aura of art had been dispersed in the mass culture of capitalism is a self-declaration about the plight of the intellectual since Baudelaire's day. In fact, it is a declaration of the bankruptcy of authority and authorship in a world that

had only recently abandoned the gold standard in finance, and Latin and Greek in education.

All the same, Benjamin took himself for a genuine author in search of authentic experience in this age, an author committed to precision, analysis, and direction who found himself lost (happily or anxiously) not in the singular aura of the image but in the multiplicity of its attractions, its meanings, and its uses. In front of the cinema, in front of the mass of viewers free to entertain in their own way what passes before them on the screen, Benjamin had to feel rather useless. (As an intellectual himself, he never considered writing screenplays.) He claimed that the masses were experts at the movies and that his own clerical caste had become, therefore, worse than useless in relation to both.[3] Writers and intellectuals may have lorded it over images in previous times, but in our century of amplification and mass reproduction images are apt to lunge out of every writer's zone of control.

Jules et Jim (1962) brings into focus the world and concerns of Walter Benjamin through the period of its setting, its innumerable cultural references, and its allegorical design. The characters of Jules and Jim represent Benjamin's new type of demoted intellectual who fails—gloriously no doubt—to capture a life force that continually escapes every zone of control imaginable. This is the crowning film of the New Wave ascendancy, standing as a supremely confident expression of an art form at the height of its ambition. Herein lies the paradox: how can one square Benjamin's authorless popular cinema with New Wave auteurism? The New Wave, after all, began as a critical and historical approach to a medium that Benjamin believed had no use for either critics or historians.

And yet he would surely have condoned their determination to resuscitate a moribund cinema culture, restoring to the movies their former naturalness and their concern with contemporary mores. What seems troublesome—and curious—is that the New Wave revolt was carried out in the name of the "auteur." This drama is well known: under the sign of the author, *Cahiers du Cinéma* forced open the claustrophobic institutions of literature that had held the cinema and a genuinely popular culture hostage.[4] The guerrilla warfare begun in 1954 by Truffaut, Godard, and Rohmer stands out today as a superb spectacle. The armies take their positions. Decked out in gaudy uniforms, the regnant forces parade cumbersomely into the open. We know they will be picked off by the young critics who have posted themselves strategically about. This legendary overthrow has always been narrated as the defeat of nobly born "metteurs-en-scène" (supported by a phalanx

of scriptwriters) at the hands of partisans of auteurism, who recruited the speed of images flying like arrows from their longbows to penetrate the heavy armor of literature worn by the establishment.

Benjamin would have supported a revolution aimed at toppling something as patronizing as the "cinéma de qualité," but the founding premise of the insurgents, the "auteur policy" that strutted as such a radical idea, he would just as surely have deemed retrograde. The paradox of this "retrograde revolution" lies in its peculiar opposition of "auteur" to "literature." Surprisingly it is seldom recalled that while the New Wave attacked the establishment for trafficking in literary adaptation, they flew a literary banner of their own. In the devastating coup de grâce of "A Certain Tendency in French Cinema," Truffaut aimed the *caméra-stylo* of Bresson's *Journal d'un curé de campagne* (1950) at the heart of the Aurenche-Bost team who had scripted a mendacious version of the same novel a few years before.[5] Truffaut proved incontestably that the sanctity of the vocation of the author and of the mission of art had utterly bypassed standard cinema in passing from Georges Bernanos to Bresson and from literature to a cinema prepared to mature in bringing this novel to the screen.

Truffaut called on Bernanos just as Godard called on D. H. Lawrence, Malraux, and Sartre.[6] They used their literary heroes both to shame the cinema of their day, which traduced these and all great novelists, and to protect their rear guard in a quiet, defensive war against another, less evident enemy: the disorganized, unaccredited, and unnumbered images beginning to pour out of television screens in France as elsewhere. Their mission was to overthrow an outdated literary cinema without relinquishing the field to the uncouth, proliferating common image. Television, supported by an explosion of advertising and press photography, threatened to drown French culture in devalued images, and the New Wavers, on the brink of inheriting that culture, grabbed onto well-known authors to buttress their position.

When they began to make films, the New Wavers invented stylistic strategies to retard the image entropy they could sense all around them. The famous freeze-frame that ends *Les 400 Coups* (1959) signifies exactly this anxiety, as Raymond Bellour has pointed out,[7] for it attenuates something average, meditating on a picture of a mere moment on a beach. This snapshot of an anonymous boy (a nonprofessional) taken by the open sea sometime late in 1958 was held out to a country glutted with studio shots of Gérard Philipe in nineteenth-century costume. With that closing shot Jean-Pierre Léaud's face "*en vérité*" ascended to the universal status of the literary. And his character, Antoine Doinel, would have approved, for in the

solitude of his cramped bedroom he had lit a candle in homage to Balzac. Truffaut raises Doinel's little life to the stature of Balzac's in that freeze-frame, an icon to which film history has forever after lit its own candle.[8]

In its adolescent ascendancy the New Wave explicitly promised to free the flow of images that had been logjammed in the good taste of the establishment, but as auteurists opposed to the bad taste of indiscriminate TV, they also tacitly promised to direct—that is, take responsibility for—images that were if anything held more precious than ever. The openness of the New Wave to contemporary culture and spontaneous modes of seeing stands in tension with the more classical desire to halt the passage and the passing of images, and to attach them to a worthy and accountable source. Even in this, its quintessential moment of triumph and ambition, the cinema hesitated between an old and a new sensibility, just as Walter Benjamin had done twenty-five years earlier, when he wrote with such ambivalent fascination about the cinema.

At its outset *Jules et Jim* hardly seems hesitant, opening as it does in the first years of the century with unfettered expectations. But in the passage from one world war to another, its characters undergo disappointment and dissolution. When Jim tells Catherine near the end, "We thought we could invent love; we thought we were pioneers; but we failed in everything," he could as well be speaking of the failure of modernity and of the cinema, its mouthpiece. Truffaut adopts a tone far quieter than either the haughty bravura of the belle époque or the romantic self-pity of the 1930s, a modest tone suitable for what he always took to be a modest art, the cinema as impure purveyor of popular narrative and imagery.

The rise of the cinema coincides with the decline of an outdated artistic nobility. Although serious artists have been tempted to employ it for the most recondite of designs (Léger, Man Ray, Duchamp, Cocteau, and others picked up cameras as they did clay or paint), the cinema—tied as it is to photography and the novel—discovered itself congenitally casual. This at least was Truffaut's constant view, and one he insisted his composer Georges Delerue adopt in toning down his ambitious music, the way he toned down the photography: "If at any moment one becomes aware of the beauty of an image," he said, "the film is spoiled."[9] It was this self-conscious beauty that Truffaut despised in Antonioni. Championing prose over poetry, and a style of "filming beauty that hasn't the air of doing anything special," he fearlessly punctured the preciosity that inflated so many of Antonioni's "meaningful" compositions, refusing to "rise to their bait," which he found "indecent" because so direct and exposed.[10] Truffaut championed a swifter, more natural cinematic

expression, one that unashamedly appeals to audiences and, in the process, mixes styles without apology. The art of this century, he believed, should not try to substitute for religion, the way the art of the nineteenth century had, and the way Antonioni's up-to-date painterly modernism still does; it should be content instead with its intermediate, dilettantish status. After all, as early as 1936 Walter Benjamin had already proclaimed originality to be an illusion, and he had blasted the cult of artistic genius that Antonioni's interviews would later project. We should wait for no genius today to peer through the heart of things and thereby redeem us, especially in cinema.

What, then, of auteurs? Truffaut had spent a decade identifying them—geniuses of the cinema capable of bringing into momentary focus (for our pleasure more than our instruction) the small human values and issues that circulate around us. Auteurs, he well understood, are the progeny of nineteenth-century novelists. Those novelists today would have been filmmakers, spurning fawning adaptations in their quest to produce representations as swift and sharp as the postwar age, novels so relevant to the sensibility of the times they would have been popular, in just the way the New Wave films were popular. If Truffaut seems occasionally to diminish the scope of cinema, it is only because he had the highest regard for modesty. With this in mind, let me heretically raise Truffaut up over Antonioni and, for the sake of argument, over his cohort of the time, Godard, by lifting the meek Jules above Jim, the overreacher.

Jules et Jim bears the weight of lives lived, most immediately those of Henri-Pierre Roché (1879–1961), its septuagenarian author (and the Jim of the tale), and the young François Truffaut (1932–1984), the director who so resembles the timid Jules. The credits and exuberant first section are as full of crazy exploits as was the life of the rambunctious Truffaut at the birth of *Cahiers du Cinéma*. The pugnacious articles he shot off for that journal, his tender rapport with André and Janine Bazin, his adulation for a hero like Roberto Rossellini, for whom he tried to set up numerous projects that never got off the ground—this was a time of infinite hope, a communal hope shared by his compatriots at *Cahiers* and renewed daily it seems, at the Cinémathèque Française. That belle époque of cinephilia spilled across 1958, the year Truffaut and Chabrol and Rivette found funding for their first features. But three years later Truffaut sensed himself a professional with duties, many of which were distasteful and thankless. By 1961 he could predict that the cinema, fickle like the character Catherine, would frequently withhold its favors or would favor others; yet in the manner of Jules he was determined to live with the conse-

quences of his youthful obsession, witnessing the aging of his love, watching the cinema become more willful and cruel as the years passed.

Both Truffaut and his character Jules stand in awe of ungoverned energy, whether in images or in women. Both fight the temptation to tie down what they know to be valuable only when free. Jeanne Moreau's character, Catherine, has the first word, off-screen in the dark, later to emerge out of a statue. She appears and disappears across the film and across three decades, the very image of the fleeting image that words, and particularly writing, can never grasp. The credits effectively reproduce this tension, as names are laid across a burst of short scenes, some picturing the characters played by the actors listed, others indicating an infinite reservoir of life that this tale draws from.

Jules et Jim conducts us on a journey from exhilarating, unrestricted imaginative energy to the disappointment of rule-bound plot and limited interpretation. Few films dare to so highlight this continuous descent. We are dropped from a dizzying cyclone of shots, harnessed only by a rapid-fire narration, to a series of quick illustrative clips, and then into the diegetic mode where short scenes elaborate the carefree life of the principals. This rush of scenes rests for a moment when Catherine is introduced, only to bounce downhill again, kicked by her impulsiveness as the trio cavorts in Paris, abruptly moves to the sea, and more abruptly returns. With cruel irony, Jules thinks to have pinned her down in marriage at the very moment that the Great War breaks out in a barrage of images that fully upsets the plot he had scripted for himself. *Jules et Jim* then continues its dangerous downward spiral toward age and death.[11] The narrator tells us in a conclusion that restates the perpetual battle between the freedom of the image and the authority of the word that "Catherine had always wanted her ashes thrown in a high wind from the top of a hill . . . but it was not permitted."

Elemental and volatile, Catherine is associated with fire and water, both of which threaten to consume her in the story (when she leaps into the Seine and when the flame she sets to old love letters spreads to her dress). In one of the film's densest images, she pours vitriol—liquid fire—sizzling down a drain. Jules and Truffaut would capture without domesticating the elemental power of this woman and the evanescence she, like the image, represents. They continually frame her, then let her go. Imperceptibly at the ends of several scenes, and flagrantly on one occasion, Catherine's image is literally frozen into a photographic pose to be held in eye and mind, to be remembered, as though she were being returned to the statue from which she emerged. In the preterite tense of its earnest yet casual narration *Jules et*

Jim adopts the tone of photography, believing life can be understood on the run, when clicked off and admired in its most telling instants. Truffaut has been reproved for accenting the nostalgia that he and many believe to be congenital to the cinema. He films knowing that nostalgia is a characteristic of the emulsion of filmstock.

1 A frozen triangular figure in *Jules et Jim*. Courtesy British Film Institute.

Although consumed by time and loss, *Jules et Jim*—the film as well as its title characters—is without morbidity, for loss instigates the soothing arts of preservation. When Catherine dramatically jumps into the Seine a voice-over immediately frames this "event." In fact she is doubly framed, for the voice speaks mainly of Jim's reaction to her: "The sight of Catherine plunging into the river made such a strong impression on Jim, that he did a drawing of it the next day . . . though he never normally drew." Even their undramatic, daily experiences are lifted into art by these friends, flowing, for example, into Jim's autobiographical novel that Jules then translates into German. Jules draws the face of his German lover on a table that Jim immediately tries to purchase from the café owner. They value the life of their sketches as much as the life they sketch. How apt, then, that their encounter with Catherine should be heralded by that statue in Greece and that the visit to the

statue should have been provoked at a further artistic remove, in the lantern slide Albert projects for them. Paintings (Picassos among them, naturally) crop up, as do plays and novels and innumerable tales (a tale about a Chinese king, about a wounded soldier—Apollinaire evidently, about the shape of the earth, about a woman on a ship). When Thérèse recites the litany of her lovers (a litany she plans to publish for the "European edition" of the *Sunday Time[s] Magazine*), she illustrates in words what her puffing locomotive figuratively showed us early in the film: the thrill of motion and its utter inconsequence. This degraded parody of the film's main theme is respected in Catherine's song "Le Tourbillon de la vie," which, dead center in the film, spins like a centrifuge to precipitate meaning out of incessant change.

2 Jules sketches "Lucie." From *Jules et Jim*. Courtesy British Film Institute.

As its earliest critics recognized, *Jules et Jim* projects a metaphorical argument between the love triangle that rules the plot and the circular patterns of the style. The triangle is wittily figured throughout the film, most memorably in the scene by the beach when one after the other, Catherine, Jules, and Jim, throws open the shutters to greet in Euclidian form the glorious dawn. The complexity and lasting feeling of the film, however, come from the incorporation of these triangular motifs within sweeping camera movements. The fabled lyricism of *Jules et Jim* flows not

only from the movement of characters (on bicycles along a sinuous country road, Jim rolling over and over with Sabine in the grass, Jules and Sabine imitating a horse and cart on the porch) but also from the graceful curve of objects (the café table Jim would like to purchase, rocking chairs, fishbowls, and oval portraits), and of course from unforgettable dizzying camera spins (twice when Thérèse puffs her cigarette backwards). A brilliant figure unites the sharp triangle and forgiving circle, the huge hourglass that appears at critical moments, meting out as well the lives of characters who would savor every grain of sand that falls, measuring the one hundred minutes we have been allotted to share with them all.[12]

Embraced by the expansive frame of the Franscope lens and the generosity of Georges Delerue's luscious score, the film's abundant characters, art forms, figures, and events wind down toward death but not toward oblivion. Jules makes sure of that. He survives as the loving witness to the reckless life he shared with Catherine, who went beyond him in extremity, who needed to find out what is "*au-delà*," and who plunged with Jim from the broken arch of a bridge as Jules, helpless, watched and remembered.

In her boundless leap toward the immediate Catherine stands opposed to Jules, a figure of modesty and mediation, an entomologist tending his pond. Truffaut esteemed modest, careful observation, raising it to a precept of knowledge, where it sits somewhere between the more agonistic intellectual endeavors of originality (Catherine) and discovery (Jim).[13] More sure of his taste than of his inventiveness, Jules never leaves Catherine once he has glimpsed her image. He even compromises his youthful passion just to remain within the penumbra of her fluorescent sexuality. Keenly affected by all that passes around him, he accepts the most contradictory of situations and then mills them into the language of memory.

In the film's final sequence Jules, leaving the cemetery, is released from the burden of his attachment to Catherine. He saunters down the hill seemingly light of foot but nevertheless looking toward the bleak future lying in front of Europe. The narrator's nonchalant voiceover removes us to an even further point in time, that of the composition of these reflections. Because of this distance, and the narrator's pursuit of the characters across their full adult lives, *Jules et Jim* legitimately adopts an air of bittersweet wisdom.

Would such wisdom have been possible without the Great War that interrupts the zaniness of an utterly spontaneous existence? Undercutting the upbeat adolescence of the belle époque, the war also punctuates with cruel irony Jules' *idée fixe* of marriage to Catherine. For out of their bed tumbles a flood of violent images,

wildly juxtaposed, spread out surreally on the Scope frame, and accompanied by ghastly sounds. Abandoned on the Eastern front, Jules retreats to a corner of a bunker to write. No longer the self-possessed flaneur, he writes now in the face of futility, with no hope his letters will be delivered, but writing all the same, like a spider suspended above danger on the threads of the words his pen exudes. Only from the distance of reflection and in the grace of style can one talk of value, and perhaps too of wisdom.

Ever after Jules will renounce force, tending only to what he has gathered around him, his wife and child, his garden and pond. In this he has been praised for his tolerance but belittled for his meekness—just what is said of Truffaut when the inevitable comparison to Godard crops up. Wasn't Truffaut too accommodating to his material and too ingratiating to his audience ever to make a movie of the strength of *La Chinoise* (1967) or *Sauve qui peut (la vie)* (1980)? Look at their ways of treating the material they adapt. Truffaut prefers impure transpositions, an "intermediary form, alternating dialogue and reading out loud, a sort of filmed novel . . . a cinematographic book rather than the pretext of a literary film."[14] Godard on the other hand wastes no time on intermediary forms. Inspired by Maupassant in *Masculin-Féminin* (1966) and Shakespeare in *King Lear* (1987), Godard refuses us the comfortable recognition of those authors whom he adopts. Truffaut conversely wants us to be acquainted with the narrator of Roché's *Jules et Jim*. Permeating the film with Roché's sensibility, he thereby hopes to enlarge himself in the process.[15] He wants to turn his life into a novel, composed largely of other novels he has read.[16] And if this effort reminds us of a "*recherche du temps perdu,*" we may note with satisfaction that the character Jules is modeled directly on Marcel Proust's German translator, Franz Hessel (1880–1941).

"Translation" and "adaptation," as cultural practices and as private virtues, admirably suit Truffaut and his projects. They also suit the cinema, a medium Bazin believed oxymoronically to be essentially impure, that is, without essence,[17] the premier medium of Benjamin's age of mechanical reproduction. The author of "The Task of the Translator" would have seen in Truffaut and in the character of Jules some of the passionate diffidence of the flaneur, a term Benjamin revived to describe his close friend and collaborator, the same Franz Hessel. With evident pride and affection, and surely with a great deal of identification, Benjamin entitled his review of Hessel's 1928 *Spazieren in Berlin* "Die Wiederkehr des Flaneurs."[18]

Long before ever meeting Benjamin, Hessel had been Roché's unassuming German friend, playing Sancho Panza to Roché's dashing Don Quixote as the novel

and the film would have it.[19] Jules' eyes were "round with wonder and brimming with humor and tenderness," Roché writes.[20] Through his physiognomy as much as his gestures, Oskar Werner "translates" this personality to the screen. When it came to women, Hessel, we are told, was sincere but maladroit; a Ganymede figure, he was a confidant and consoler more than a wooer. Following Roché's translation of Hessel into Jules, Truffaut presents this character as most comfortable in his rustic chalet where he meticulously chronicles the habits of insects.

4 The real Lucie (Luise Bücking) with Franz Hessel. Courtesy Carlton Lake Collection, Harry Ransom Humanities Research Center, University of Texas at Austin.

Perhaps such personality traits are the prerequisites for the task of translation, where respect and generosity coax the spirit of a text one cares about out into the open so that others may meet it.[21] A translator is first of all a consummate listener, a consoler and a confidant of the original. Hessel was known as one who instinc-

tively recognized genius. He understood Picasso in the early years, and he gave Proust to the German-speaking world. But he was most at home with female genius, and his devotion to Helen Grund (1886–1982), the Catherine of the film, was legendary. She came into his life as in the film, just after a trip Hessel and Roché took to Greece where they had indeed been stunned by the smile of an Attic statue. Grund, a student of Käthe Kollwitz (1867–1945), had heard of Hessel in Germany before she met him at the Dôme cafe on her first visit to Paris. By all accounts she was a very modern woman and passionate to the core. Hessel immediately surrendered to her his life.[22]

Jules' absolute allegiance to Catherine undermines his modernity, particularly in comparison with Jim, who remains committed to a free, rather offhand existence. Like Hessel, Jules exhibits the regressive traits that Benjamin associated with "the collector." As a flaneur he could maintain a distant, casual, optical relation to the world and to women, while the collector is essentially haptic, caressing his acquisitions, never so happy as when surrounded by just them, to the point of suffocation. Jim, sauntering along the Rhine or leaping out a window to freedom, is modern in comparison. But modernity brings with it skepticism and irony, sapping faith and ambition, and so Jim relinquishes his old-fashioned dream of becoming a novelist and takes up flanerie as a vocation instead. After the war he queried his old teacher, Sorel, on what profession he should take up. "*Un curieux*," he is told. "That's not an occupation." "Not yet an occupation," Sorel replies. "Travel, write, translate . . . learn to live anywhere. Start right away. The future belongs to the curious."

5 Helen and Franz Hessel (Catherine and Jules) in 1920. Courtesy Carlton Lake Collection, Harry Ransom Humanities Research Center, University of Texas at Austin.

6 Henri-Pierre Roché (Jim), soldier and flaneur, in 1916. Courtesy Carlton Lake Collection, Harry Ransom Humanities Research Center, University of Texas at Austin.

7 *Opposite:* Marcel Duchamp (*left*), Francis Picabia, and Beatrice Wood in 1917. Courtesy Carlton Lake Collection, Harry Ransom Humanities Research Center, University of Texas at Austin.

The future, that is, belongs to the unattached and to those who will increasingly define themselves by their patterns of consumption. Henri-Pierre Roché—libertine, art dealer, traveler—was content to be forgotten behind all the exciting people he knew in New York and Paris: Man Ray, Marcel Duchamp, Pablo Picasso, Brancusi, as well as Gertrude and Leo Stein. An art student as a turn-of-the-century youth at the Ecole des Beaux Arts, he habituated chic cafés, writing his first published essay about "La Closerie des Lilas." There he met Paul Fort, "Le Prince des poètes," and some of the "free women" of the day, who eventually included Beatrice Wood, Helen Grund, Marie Laurencin, and innumerable others.

Jules et Jim dramatizes the excitement of a world in the process of erasing borders and leveling values in the interest of free interchange. Roché himself was a diplomat and art dealer, moving around Europe and then to Washington and New York to exchange ideas, trade agreements, paintings, and money.[23] His peripatetic characters translate German, French, and English phrases for each other. They coexist as Catholic, Protestant, and Jew because religion, like everything else since Einstein, has been relativized. Among intellectuals, and particularly in the avant-garde, mobility has outrun the laws that formerly held it in position. One senses this acutely in the realms of art and love, which at the outset of the century escaped the constraints and the hierarchies by which they previously had been ordered. Sheer color and line now mock the titles attached to paintings by the fauves and cubists. And Catherine, Jim sighs, had "wanted to invent love." They saw themselves as pioneers in a new age. "But pioneers must be humble," Jim continues, owning up to something he should have learned from Jules. "Let's face it, we failed in everything."

In the end Jules outlasts the others not only because he is humble, but also because, despite his initial flirtation with modernity, he adheres to certain absolutes. It is he who stops the merry-go-round of free love by designating a taboo: "Pas celle-là, Jim," he says on the landing outside his apartment as they prepare to meet Catherine for a night on the town. Truffaut went so far as to burn this interdiction into the emulsion as a graphic inscription, *"pas celle-là."* Catherine—*"celle-là"*—is declared unexchangeable, unreproducible, absolutely different: she is sheathed in an aura. And consequently those who love her must renounce the independence of

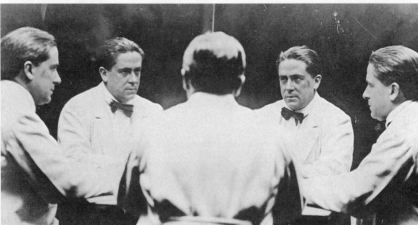

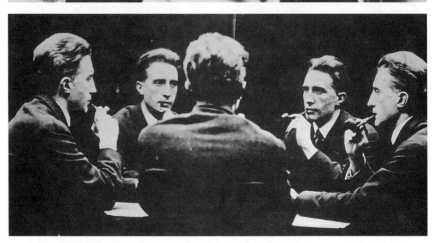

8, 9, 10 *Top to bottom*: pluri-photographs of Roché, Picabia, and Duchamp in 1917. Courtesy Carlton Lake Collection, Harry Ransom Humanities Research Center, University of Texas at Austin.

modernity to become the servants of her regality. "You speak of her as though she were a queen," Jim says. "But she is a queen," Jules agrees, making them from time to time a gift of her presence. She will be cruel and faithless while demanding fidelity. Jules gives her his life.

In his obeisance before Catherine, Jules resembles not just Hessel before Helen Grund, but also Hessel and Benjamin before Proust, and Truffaut before this novel by Roché. Humiliation attends the translator whose work invariably comes up less than what it serves. Still, translation may be the name for something rare, something like friendship that, as the narrator says toward the end, happily "hasn't an equivalent in love," whose exclusions, obsessions, and self-destruction the film and Jules finally put to rest.

Aptly, the idea of the translator remains a hybrid of the old and the new. A form of artistic reproduction akin to the photograph, translation makes original writing promiscuously available, albeit in a somewhat degraded form. Sentiments and experience are perhaps exchangeable from culture to culture and language to language. The film puts this question up front when Jules asks Jim about the odd gender of certain nouns in French and when Catherine translates—with a key embellishment—a passage from Goethe's *Elective Affinities*. The translation of books, like the sampling of art and of sexual partners, occurs in a culture of consumption where values come from reception rather than production. Exchanging partners and texts seems free and unproblematic in the modern period, at least until Catherine appears. But when she does, the mobile translator surrenders his freedom and attaches himself to what he believes to be beyond him, to the magic of a creative impulse: an image with an aura.

Catherine's elision from the film's title suggests her role as imagistic pretext for the literary response to life that the title characters, Jules and Jim, insist upon. Her dramatic suicide plunge testifies to her recognition that what counts is Jules' watching her self-destruction, watching and then writing. And if we concur with the order of names in this title, ("Jim et Jules, alors?" tries Thérèse upon meeting them. "Mais non, Jules et Jim!"), it is because this century increasingly prefers Jules to Jim, Sancho Panza to Don Quixote, modest servants of literary transaction to romantics who dream of original creation.

In our agnostic and fluid century, Jules too becomes an anachronism, since modernity itself remains vulnerable to history. "I wanted my film to mark the end of an epoch," Truffaut said. "This is the end of people like Jules and Jim, the end of intellectuals. Books are being burned." [24] Catherine, true to her elements, plunges a

final time into water and then is consumed by flames in the crematorium. Who can forget in this context the loss of modernism's beloved companion, Walter Benjamin, who killed himself rather than enter an era where his precious library would no longer matter were it to survive the Nazi pyre. Franz Hessel, it must be mentioned, died shortly thereafter, in January of 1941, broken in health from his internment at Les Milles, a camp the French set up for *"ennemis citoyens."*

And so *Jules et Jim* confounds every hasty definition of the modern. Insofar as Catherine represents image, instinct, and the life force of the unpredictable, she seems to bear within her the ethos of the New Wave, a movement dedicated to countering the old-fashioned literary *"cinéma de qualité"* with inventive, robust, and absolutely fresh mise-en-scène. The first reviews of the film defended Catherine as a modern woman, and defended more the film's audaciously modern treatment of her.[25] Yet even then the enfant terrible Truffaut confessed about himself that "by temperament I am not modern at all, and am more interested in recovering ideas from the past. I have the impression," he went on, "that there was a time when cinema was unbelievably vibrant and spontaneous: I run after this, after a lost secret, rather than toward the future."[26]

The irony, of course, is that the medium to which Truffaut devoted himself and in which he searched for that secret came to displace the books that hide the secret.[27] All three characters watch their world go up in flames on a movie screen, and a very special screen it is, that of the *Studio des Ursulines,* a mecca since the twenties for avant-garde cinema, the theater where, among other films, Buñuel's *Un Chien Andalou* premiered in 1928. Although such screens controlled the tempo of culture in the Third Republic, today this movie theater, and movie theaters in general, are themselves in danger of becoming sites of nostalgia. And so *Jules et Jim,* precisely by insisting on the resources of the medium of cinema, may appear quaint rather than audacious, while the image culture it celebrates and contributed to has smothered it in a great glut of images and a still newer wave of technology.

Jules et Jim emerged out of a belle époque of French cinema, and many find Truffaut to be in decline ever after. The sedateness of his later work, its propriety, seems to long for an exuberance that may have been lost with Catherine. But *Jules et Jim* had already staged this decline, had predicted the end of the era and possibly the end of cinema. The twenty-nine-year-old director took on the wistfulness of his eighty-year-old source, and could already feel himself building and living within something like *La Chambre verte* (*The Green Room,* 1978).

Let me close on the images of *La Chambre verte*, by Truffaut's own admission his most personal film.[28] Once more candles are lit, not to an effigy of Balzac, but this time to "his dead," to photographs of Maurice Jaubert whose music we hear as we watch, to Henry James, whose story this film is in the process of adapting as we watch, and to others on whose identity Truffaut's necrologists can speculate. This funerary use of photography recalls the first sentence in André Bazin's *What Is Cinema?*: "If the plastic arts were put under psychoanalysis, the practice of embalming the dead might turn out to be a fundamental factor in their creation."

Truffaut felt most at home in this glory age of photography, the age of Henry James, this turn of the century when cinema took wings from both photography and fiction. Through James he represented the end of a sensibility that he relished and projected. He was content to be its acolyte, translating, adapting, lighting candles to a fading way of life while glimpsing a different, less friendly future already born. Following Bazin, Benjamin, Hessel, and Jules, he devoted his life to common servitude to the commonplace. He devoted himself to cinema.

Amid millennial images all around us that project, through an inhuman light, holographic or digital pictures of the century to come, I have deliberately invoked the timid image of François Truffaut, who could think of that future only by thinking of the century past and of the cinema that has conveyed us with such grace from one era to the other.

Notes

1 Eric Rohmer's first major essay for *Cahiers du Cinéma*, "Vanité que la peinture," deals explicitly with cinema's classicism. It has been translated in the collection of his essays, *The Taste for Beauty*, trans. Carol Volk, comp. Jean Narboni (Cambridge: Cambridge University Press, 1989).

2 Walter Benjamin, "The Work of Art in the Age of Mechanical Reproduction," in *Illuminations: Essays and Reflections*, trans. Harry Zohn, ed. Hannah Arendt (New York: Schocken, 1969), 242.

3 Ibid., 234.

4 Dudley Andrew, "On Certain Tendencies of the French Cinema," in *A New History of French Literature*, ed. Denis Hollier (Cambridge: Harvard University Press, 1989), 993–1000.

5 François Truffaut, "A Certain Tendency of the French Cinema," in *Movies and Methods*, ed. Bill Nichols (Berkeley: University of California Press, 1976), 226. See also Andrew, "On Certain Tendencies of the French Cinema."

6 See my introduction to *Breathless*, by Jean-Luc Godard (New Brunswick: Rutgers University Press, 1989).

7 Raymond Bellour, "L'Entre images" (lecture delivered at the conference Painting and Photography in the Light of Cinema, University of Iowa, Iowa City, April 3, 1991. See Bellour, *L'Entre images* (Paris: La Différence, 1990), 113.

8 The cover illustration of Alan Williams' recent history of French film, *The Republic of Images* (Cambridge: Harvard University Press, 1992), carries this shot.

9 Ann Gillain, ed., *Le Cinéma selon François Truffaut* (Paris: Flammarion, 1988), 132.

10 Ibid., 239. As for poetry, Truffaut claimed that his own instinct was to toss the poems people sent him into the garbage unread. Poetic prose, on the other hand, such as Cocteau's, was another matter.

11 Joseph MacBride has linked the dramatic structure of *Jules et Jim* to that of *The Magnificent Ambersons*. See his *Persistence of Vision* (Madison: Wisconsin Film Society Press, 1968), 64. Truffaut was utterly attached to this film, as Jean Gruault mentions in "Le Secret perdu," *Le Roman de François Truffaut* (Paris: Editions de l'Etoile, 1985), 88.

12 Many of these formal elements are pointed out in an outstanding early review of the film that has continued to guide my view of it. See Roger Greenspun, "Elective Affinities," *Sight and Sound* 32, no. 2 (Spring 1963): 78–82.

13 In a telling admission, Truffaut said, "Je crois énormement à la modestie des apparences, même si on doit l'appeler 'fausse modestie,' j'aime bien la 'fausse modestie.' " *Le Cinéma selon Françcois Truffaut*, 132. In another place he said, "The filmmakers I like have in common a modesty" and "From the beginning I said right out loud that I was not an innovator" (*Cahiers du Cinéma*, nos. 190 [May 1967] and 316 [October 1980] respectively), in *Truffaut by Truffaut*, trans. Robert Erich Wolf, comp. Dominique Rabourdin (New York: Abrams, 1987), 200–201.

14 *Le Cinéma selon François Truffaut*, 128.

15 See François Truffaut, "Henri-Pierre Roché revisité," in *Carnets: les années Jules et Jim*, by Henri-Pierre Roché (Marseille: André Dimanche, 1990), xvi.

16 *Cahiers du Cinéma*'s necrological issue is aptly title "Le Roman de François Truffaut" (October 1984). The cover photo shows Truffaut holding a still camera, thus linking in a single image Truffaut, photography, and the novel.

17 André Bazin, "In Defense of Mixed Cinema" (translation of "Pour un cinéma impur"), in *What Is Cinema?* vol. 1, comp. and trans. Hugh Gray (Berkeley: University of California Press, 1967).

18 Benjamin's essay came out in 1929 in *Die literarische Welt*. For a detailed account of Franz Hessel's rapport with Benjamin, see Anke Gleber, *The Art of Taking a Walk: Flanerie, Litera-*

ture, and Film in the Culture of the Weimar Republic (Princeton: Princeton University Press, forthcoming). In her essay Gleber notes that Benjamin and Hessel first met through Charlotte Wolff.

19 For more details concerning the historical background behind the fictional characters of the novel and film, see Henri-Pierre Roché, "Pierre, Franz, Helen," *Carnets*, xxv–xxxiii. See also Carlton Lake and Linda Ashton, eds., *Henri-Pierre Roché: An Introduction* (exhibition catalog, Harry Ransom Humanities Research Center, University of Texas at Austin, 1991). See as well Barbara Ungeheuer, "Helen Hessel," *Femmes Fatales: 13 Annäherungen*, Ines Böhner, ed. (Mannheim: Bollman Verlag, 1996): 71–80.

20 Henri-Pierre Roché, *Jules and Jim*, trans. Patrick Evans (New York: Avon, 1967), 9.

21 Truffaut spoke of his desire not to displease the old friends of Roché who might be able feel Roché's presence through the style of the film. *Le Cinéma selon François Truffaut*, 132.

22 I owe the incubation of this essay to a conversation I had several years ago with the Proust scholar Walter Strauss, who was kind enough to share with me a letter he had received from Helen (Grund) Hessel. In it, she confirmed that she had indeed been the prototype for Catherine in *Jules et Jim*: "A propos de *Jules et Jim*, je crains [de] vous décevoir en vous disant que je n'ai rien fait d'autre que de vivre cette histoire. J'étais cette jeune fille qui a sauté dans la Seine par dépit, qui a manqué le rendez-vous, qui a épousé son cher Jules si généreux et qui a passé par les extases et les désastres d'un amour éperdu et perdu. Oui, elle a même tiré sur son Jim. . . . Voilà. Pour moi cette expérience est à la fois rassurante: j'ai vécu, et un peu *uncanny*: je suis morte et je vis encore."

23 During the war Roché even authored a chapter concerning international commerce; see "Notes au jour le jour sur le voyage de la commission industrielle américaine en France," in *Le Commerce franco-américaine* (Paris: Berger-Leurault, 1917), 259–287.

24 *Le Cinéma selon François Truffaut*, 140.

25 This was the topic addressed by several Parisian reviews just after the film's premiere.

26 *Le Cinéma selon François Truffaut*, 141.

27 Three years after *Jules et Jim* Truffaut would pit a remnant of living books (readers) against a world characterized precisely by TV antennas, the world of *Farhenheit 451*.

28 Conversation with the author, Los Angeles, April 1978.

Women on the Screens and Streets of Modernity

In Search of the Female Flaneur

ANKE GLEBER

Following the course of modernity in the nineteenth and twentieth centuries involves, among other things, tracing the footsteps of the flaneur as he strolls through the streets of nineteenth-century Paris, appears in Charles Baudelaire's metropolitan poems, and structures Walter Benjamin's perspective in his project of the Paris Arcades. An overlooked, yet pivotal figure of modernity, the flaneur both defines and is defined by his perception of the outside world. He experiences city streets as interiors; he views traffic, advertising displays, and the world of commodities as *Denkbilder*, as images that evoke reflection. Both a product of modernity and its seismograph, he represents the *man* of the streets. While flanerie manifests itself for Benjamin as a form of sensory experience shaped by the exterior "shocks" of modernity and corresponding to the conditions of modern perception, for Siegfried Kracauer it names the experience of "distraction" found in Weimar culture.[1] By way of flanerie—a mode of movement that is at the same time a process of reflection, a manner of walking with an attendant presence of mind, and close attention to images—the flaneur transcends modern alienation through an epistemological process of intensive perception. He is at once a dreamer, a historian, and an artist of modernity, a character, a reader, and an author who transforms his observations into literary, or more precisely, latently filmic texts. Collecting scenes and impressions, he then relates them through stories and histories of the city and its streets. Surrounded by visual stimuli and relying on the encompassing power of his perception, the flaneur moves freely in the streets, intent solely on pursuing this seemingly unique and individual experience of reality.

What is of interest to me here is that, within the domains of literature, culture, and public life, this unbounded, unrestricted pursuit of perception has been mainly ascribed to men. It is no accident, for example, that Heinrich Heine and Ludwig Börne, writing of their times in *Letters from Berlin* (*Briefe aus Berlin*) and *Depictions from Paris* (*Schilderungen aus Paris*) respectively, take their point of departure from their own physical and tangible presence as men in the city, who evoke and

facilitate their flaneuristic reflections by observing a contemporary public in the streets. In his exemplary tale of scopophilia and physiology, *The Cousin's Corner Window* (*Des Vetters Eckfenster*), E. T. A. Hoffmann initiates a male protagonist into the "principles of the art of looking." In *The Deserted House* (*Das öde Haus*), his narrator abandons himself to what he calls "my old inclination . . . to stroll the streets by myself and delight in every copper engraving on display, in every notice, or to look at the figures approaching me." Such unabashed and unadulterated plea-sure in the sights, views, and images of the street seems related to the experience of *male* spectators. Moving through and perceiving public spaces emerges as a uniquely gendered practice, associated with male authors and protagonists. If this art of taking a walk takes many shapes throughout the nineteenth and twentieth centuries—symbolist forms, impressionistic paths, and surrealist sensitivities—all these excursions and experiments are reserved for male perception and authorship, as is apparent from the following series of texts.

Baudelaire perceives the streets and passersby of Paris in *A une passante* and *Paysage* as cityscapes in their own right that bring with them their own aesthetics. Edouard Dujardin, an impressionist author and bourgeois dandy of the 1880s, records the various aspects of the city, rendering its exteriors, sights, and light ef-fects in the sensitive nuances of a seeing-as-reading-as-writing that predates the mode of interior monologue. After the turn of the century, Louis Aragon passes through the decaying arcades of Paris in the 1920s, experiencing the city in an ever increasing intensity and accelerated manner, as a veritable medium of surrealist intoxication. Aragon attempts to fix these sensations in an *écriture automatique* closely modeled on and imprinted by the labyrinths of the "passages," the capitalist commodity arcades. In this succession of flaneurs each shares a fascination with im-ages as icons of a modern mythology and an intoxication with the light and struc-tures of the city. Each of them, however, can indulge this experience of the street only by first freely roaming, unimpeded, unintimidated, as a male spectator moving in a space reserved for the eyes of male pedestrians. In their intense pursuit of sub-jectivity and perception, these flaneurs and their gazes are neither restricted by in-security, convention, modesty, anxiety, or assault, nor by barriers erected through the controlling or commodifying presence of an other.

The possibility of a female flanerie, however, would seem to be absent from the cities of modernity. When in 1929 Benjamin announces "The Return of the Flaneur," he fails to acknowledge his awareness of the numerous women whom he passes and comes across every day in the streets of Berlin and Paris.[2] While the Berlin architect August Endell describes, in great and minute detail, the beauty of

the big city in his work of that title (*Die Schönheit der großen Stadt*), women walkers remain absent from his closely watched streets. Kracauer, an eminent critic and observer of Weimar culture and public spaces, also moves through his reflections in *Streets in Berlin and Elsewhere* (*Straßen in Berlin und anderswo*) without registering the women he encounters in these public spaces as equal elements of and stimuli to the *Denkbilder* of his society. Benjamin's friend Franz Hessel,[3] deriving and formulating an aesthetic project in his *Walking in Berlin* (*Spazieren in Berlin*), explicitly cautions against walking with women, claiming that they represent a potentially distractive influence upon the flaneur's solitary wanderings.[4] This conspicuous absence and predominant oversight within male culture moves this female historian and critic to search for the traces of an alternate form of flanerie, one that might eventually inscribe the presence and potential of a female flaneur in the history of perception. The following scenes from literary and filmic texts may suggest ways to rethink the status of a female flaneur in the streets of the city. These speculations on an absence seek to conjure an appearance, to assist us in reconsidering female scopophilia in movement or in moving images, and to theorize about the presence of women in public spaces, the female spectator, and a gendered definition of "modernity." In so doing, I hope to sketch a concept of female flanerie that may in turn help to reshape the way we think about the spaces of modernity.

The female flaneur has been an absent figure in the public sphere of modernity, in its media and texts, and in its literatures and cities. Even when she is noticed, her presence in the streets is marked as marginal. From her very first steps, her experience is limited and circumscribed. This is why female flanerie has no more been considered than its expression in language—and in a concept of its own—has been sayable. In its German usage, the term *Flaneuse* bears associations of the "typical" female, of "necessarily" menial occupations such as those of the *Friseuse* (female hairdresser) or *Masseuse* (female massage practitioner), the latter two carrying contingent, sexually suggestive and discriminatory connotations. Since the term "flaneuse" comes with this dubious baggage, since it invites unwanted, unwarranted associations, I will try to circumvent it wherever possible. Alternatively, finding another name for the "female flaneur," or "woman walker," as Meaghan Morris has suggested,[5] has not yet worked to inscribe her presence in any visible or speakable form into the texts or language of flanerie. As a potential form of female existence, the female flaneur has not been noted as an image that the canonical authors of flanerie would expect to come across in the streets or as a concept that would give the female flaneur a figure and a term of her own. In the texts, theories,

and versions of flanerie mentioned above, we do not and cannot expect to encounter a "flaneuse" in the street. The female flaneur has remained absent from debates over the status of the image and the perception of modernity.

The question of the presence and representation of women in the streets, however, is not academic, accidental, or marginal. On the contrary, it suggests a pivotal constellation that may help to articulate questions concerning prevailing structures of power and domination in Western society as a direct function of the (gendered) distribution of leisure, time, and status—that is to say, the economic, psychological, and physical autonomy and self-assurance of that society's subjects. Since the nineteenth century, flanerie, the phenomenon that Benjamin theorizes and Baudelaire celebrates, not only has been the privilege of a bourgeois, educated, white, and affluent middle class but also, above all, has remained one of male society. During the same period that their male contemporaries discovered the space of the city as flaneurs and travelers, experienced urban spaces constituted by ever new and changing stimuli, and approached them with innovative technologies of perception such as the medium of photography and a mobilized gaze, women speak of a different approach to and involvement with this modernity. These women struggle foremost against the very secluded position that excludes them from the options reserved for men. Rather than celebrate their indulgence in multiple scopic possibilities, women have long wished for admission to the coveted realms of the spectacle, a right of way into the new spaces of flanerie and toward an experience of the images of modernity. Only when chaperoned by companions, disguised in men's clothes, or covered by other means of subterfuge was this entrance even partially and tentatively possible, as a trial and exception. George Sand's efforts to overcome these obstacles give vivid evidence of the difficulties and prohibitions facing women of her era. Sand realized that she could never fully approach and appreciate the outside world so long as she remained a woman who, in habit and behavior, adhered to contemporary conventions of femininity. Instead, she enters the world as a female flaneur in disguise, functionally outfitted for that purpose in male clothes, pants, and boots. She immediately revels in the first moments of this escape from the constrictions of a culturally constructed "femininity" that used to control and restrict her every attire and attitude:

With those little iron-shod heels, I was solid on the pavement. I flew from one end of Paris to another. It seemed to me that I could go around the world. And then, my clothes feared nothing. I ran out in every kind of weather, I came home at every sort of hour, I sat in the pit at the

theatre. No one paid attention to me, and no one guessed at my disguise. . . . No one knew me, no one looked at me, no one found fault with me; I was an atom lost in that immense crowd.[6]

The fiction of male identity—constructed here through its exterior trappings—grants Sand the temporary entrance into a realm of considerable, if relative, freedom, opening up a seemingly unlimited, previously utopian mobility as well as the promise of omnipresent adventure. The realities of many more women's lives during this period, however, were to remain determined and limited by rather different material pressures and psychological factors. This tendency is evident in the public spaces of the nineteenth century and can be traced in its texts. In his treatise *La Femme* (1858–1860), Jules Michelet testifies to the myriad spatial impediments and obstacles to women's liberty and mobility:

How many irritations for the single woman! She can hardly ever go out in the evening; she would be taken for a prostitute. There are a thousand places where only men are to be seen and if she needs to go there on business, the men are amazed, and laugh like fools. For example, should she find herself delayed at the other end of Paris and hungry, she will not dare to enter into a restaurant. She would constitute an event; she would be a spectacle: All eyes would be constantly fixed on her, and she would overhear uncomplimentary and bold conjectures.[7]

Many of these obstacles would remain in women's way long into the twentieth century. In texts and films from Weimar Germany, idle women are depicted and regarded as prostitutes, and even feminists as late as the 1970s still hesitate to enter nocturnal streets and restaurants on their own.[8] While the nominal and official presence of women in public seemed to increase gradually, it was only with the end of the nineteenth century that (the bourgeois) woman was permitted by society's conventions to walk its streets freely. As Anne Friedberg notes in her search for the origins of female flanerie, "The female *flaneur* was not possible until a woman could wander the city on her own, a freedom linked to the privilege of shopping alone. . . . It was not until the closing decades of the century that the department store became a safe haven for unchaperoned women. . . . The great stores may have been the *flaneur's* last coup, but they were the *flaneuse's* first."[9]

The territories of such preliminary and rudimentary forms of "flanerie"—the preoccupied strolling and shopping of a female consumer—have to be regarded, in view of the vast terrain of existing real city spaces, as decidedly circumscribed and distinctly derivative. Limited excursions of shopping in a prescribed ghetto of

consumption amount to little more than secondhand distraction, never approximating the flaneur's wide-reaching mode of perception, unimpeded by aims, purposes, and schedules. The conflation of shopping and strolling noted by Friedberg necessarily relativizes what initially appears as a first instance of the "empowered gaze of the *flaneuse*."[10] Reduced in its potential to the purposefully limited and capitalistically promoted license of shopping, the early "department store flaneuses" who "roam" the interiors of capitalist consumption represent little more than a bourgeois variant of domesticized "flanerie." They replicate forms of female presence that proletarian women had long since presented in the streets before them. Women workers and housewives had always already entered the streets without ever becoming flaneuses in their own right. Instead, the street presented itself to them as a space of transition en route to functional purposes: they would face the street in doing the shopping rather than "going" shopping, in running errands rather than jogging their imagination, in picking up their children, not experiencing free-floating impressions, in making their ways straight to the workplace, not idling without ever arriving.

The public presence and exterior excursions of these working women are commonly bound by functions that do not allow for the flaneur's leisure of "getting lost" or his impulse of "losing himself" in the spectacle of the street. Beyond the immediate sphere of their duties, proletarian women—like agrarian wives—in effect rather live "outside" the city, regardless of where they actually work, as they are limited to households that remain preindustrial and formative of their imagination in this way. To compensate for such confinement, women project all their endeavors into their domestic interiors and become—unwillingly—complicitous with their exclusion from exteriority as well as from new directions of technology, production, and perception.[11] This very confinement excludes women from being exposed to the shocks and images of the street, and bars them from developing any immediate sensory relationship to the phenomena of modernity as they are being registered in the street. Other, less domestic manifestations of female presence in the street, such as the figures of the prostitute and the bag lady, only further underline the disempowered status of female subjects in the public sphere. The overall absence of a female flaneur is the result of a social distribution of power which prescribes the exclusion of women from public presence.[12] Due to the precarious presence of women in the street, the question "To whom do the streets 'belong'?" pertains more to women than to men of any class, race, or age. Whether the streets belong to the leisured or the working class of society, to its dandies or demonstrators, pedestrians

or flaneurs, the free and unimpeded movement of women undergoes additional peril. The street does not "belong" to women. They cannot take possession of it freely without also expecting to be impeded by public judgments or conventions that cover and prescribe their images, effectively rendering them objects of the gaze. The female flaneur is considered to be absent, "invisible": she is not presumed to have a presence in the street.[13]

A few critics have taken steps to approach this assumed absence of the female flaneur, formulating a tentative presence of women in the street from specific angles and for diverse territories. As a feminist art historian, Griselda Pollock scrutinizes the social and historical circumstances of female lives that condition their exclusion from flanerie, allowing us to modify the prevailing understanding that "there *is* not and *could not be* a female flaneuse"[14] into the more cautious observation that there was not *supposed* to be a female flaneur, and that not *many* women managed or dared to exceed such prevailing prohibitions. Pollock elaborates on the specific restrictions to which women's status, gaze, and image were subjected in the public sphere: "They did not have the right to look, to stare, scrutinize or watch."[15] While women were positioned as the passively receptive objects and images to a public and active male gaze, their desire for freedom of movement can still be read in numerous women's texts of the nineteenth century, such as the writings of flanerie from adventurous female travelers and explorers who would risk the pursuit of their socially sanctioned scopophilia.[16] As one example, Pollock quotes Marie Bashkirtseff in her attempts to live in nineteenth-century Paris on her own terms. Her vivid description of the struggles she encounters in her desire for independence typifies the restrictive circumstances of the society in which she lives as a woman: "What I long for is the freedom of going about alone, of coming and going, . . . of stopping and looking at the artistic shops, . . . that's what I long for; and that's the freedom without which one cannot become a real artist. Do you imagine that I get much good from what I see, chaperoned as I am, and when, in order to go to the Louvre, I must wait for my carriage, my lady companion, my family?"[17]

In taking this investigation one step further, Pollock virtually maps the very real participation of women onto the spaces of modernity. She revisits the work of female impressionist artists who were present and at work—as painters who happened to be women—in the same locations that circumscribe the formative places and movements of impressionism: "The key markers in this mythic territory are leisure, consumption, the spectacle and money. And we can reconstruct . . . a map of impressionist territory which stretches from the new boulevards via Gare St.

Lazare out on the suburban train to La Grenouillère, Bougival or Argenteuil."[18] It turns out to be the mere presence in the same urban spaces that creates impressionable minds and transformed women artists such as Berthe Morisot and Mary Cassatt into "painters of modern life," as Baudelaire called these flaneurs, artists of either gender or origin. While the woman stroller is as evidently present on metropolitan pavements as her male contemporaries, she requires an additional measure of physical and psychological confidence: the initial courage to step out, face the threat of assault, or erase her latent misrecognition as a prostitute, in short, to undergo the constant encounter and annoyance of being made into and treated as an object. Despite these persistent, real, and material limitations on women's access to the street, the very presence of women in public spaces indicates their insistent desire and determination to locate an experience of the city on their own.

The precarious and acute status of this quest—however unchronicled and unacknowledged its struggles may have gone in our cultural memory—can be framed by the following statements from two women a century apart. On January 2, 1879, Bashkirtseff notes in her diary her experiences with the streets of Paris: "What I long for is the freedom . . . of walking about old streets at night."[19] More than a century later, the *Oxford Mail* on November 9, 1979, announces that the state of things for women in the street has not changed: "Any woman walking alone after dark *invites* trouble."[20] In regarding women's images and their relation to public space, recent feminist sociology has suggested tendencies toward a "basic asymmetry" in the gendered distribution of physical and psychological power, resulting in unequal and inimical constellations that render women the more likely victims of rape, assault, intimidation, and other forms of harassment. Such latent and manifest factors must, as Shirley Ardener declares, necessarily have "a bearing on how women use space . . . and must be considered when the question of women's use of space is discussed."[21] Women's specific use of space has historically been marked by anxieties and limitations that make them go about their daily matters in a more cautious fashion than men, assuming fewer, less expansive spaces to be open to their gaze and presence at any time. Restricted to the home, limited to functional forays into the public, forced to forego the lure of aimless strolling without a specific purpose or destination, women are unable to indulge their full fascination with the metropolis, especially at night, when any excursion in the city may mean, beyond hidden revelations in the street, the more manifest dangers of attack. This awareness is fundamentally inscribed as a perpetual anxiety, an ongoing "containment of women" that curtails their access to and movement in the street.[22] The

concomitant politics of a "women's movement" must be understood in its extended, literal implications, lifting the term "movement" from the status of mere metaphor to its immediate materiality.[23] When Adrienne Rich investigates the factors that determine the dominant socialization of heterosexual women in patriarchal societies, the material conditions of appearance and movement largely determine women's diminished existence. She asserts that the prescription of female movement is exercised as a pivotal measure by societies that have always, in one form or another, attempted to restrict women's rights and ways in order to control and contain them in secluded, subdued positions: "Characteristics of male power include the power of men: . . . to confine [women] physically and prevent their movement (by means of rape as terrorism, keeping women off the streets; purdah; foot-binding, atrophying a woman's athletic capabilities; haute couture, "feminine" dress codes; the veil; sexual harassment on the streets)."[24]

These physical and material obstacles are reinforced by means of a psychological containment that often comes in internalized forms of (self-) control. It works to impede women's mobility, restrict their gaze, censure their public presence, and stylize women's images into displays. Gertrud Koch describes the status of female images as the "desired objects of male voyeurism" and suggests that the subjects behind these objects "themselves had to hide their own desires behind their veils, the bars on their boudoir windows, their expensive and time-consuming make-up rituals."[25] While the history of this inequality in the distribution of power and positioning of women on the other side of the gaze prevails, these relations between the subjects of looking and the objects that are being looked at, between the spectator's subjectivity and a woman's status as image and object, have come to be gendered and scarcely reciprocal or reversible. Confronted with social environs in which they cannot be present as invisible or undisturbed observers, even as they themselves are made the "natural" objects of observation, women are at once excluded from public presence and spectatorship.[26] This constellation lets the absence of female flanerie appear not as any individual lack or incapacity but as a crucial blind spot of society that converges to illuminate the limitations in which conditions and conventions impose themselves on women's lives.[27] While the most obvious and explicit restrictions to women's movement have been removed in order to integrate women in the pursuit of specific business functions and adjust their traditional roles to a changing economy, their status as an overdetermined image continues to carry these same socially restrictive and restricting expectations into the present.[28] Men still habitually "check out" and evaluate women's images in a casual but con-

sistent cultural ritual that continues to make women's presence in public spaces a precarious and volatile one. Despite women's formal equality and democratic rights, the uninhibited and unobserved presence of a female person in the streets is not yet a self-evident right. Spaces that are unequivocally free, open, and safe to female movement have yet to open up psychologically. The phenomenon of female flanerie still remains an exception.

A female flaneur encounters a different degree of scrutiny and attention, evaluation, judgment, and prejudice—forms of surveillance, suspicion, and harassment that her male predecessors and contemporaries do not habitually expect to face. Even a self-confident flaneur and feminist in contemporary Berlin continues to be self-conscious in the streets, as she is forced to delineate her experience of the city by strategic deliberations and survival strategies: "Cities are no longer forbidden spaces. . . . But in the streets, we continue to move strategically, always alerted to having to justify our presence. We learn self-assertion, we practise . . . the aim-oriented walk which is to demonstrate that we are protected and bound: at least bound by an agenda, on our way to a secure location, to a job, to a clearly defined aim—and that we are not just loitering around." [29]

Pollock reinforces this point when she observes the following situation for women in the streets of modernity: "The spaces of femininity still regulate women's lives—from running the gauntlet of intrusive looks by men on the streets to surviving deadly sexual assaults. In rape trials, women on the street are assumed to be 'asking for it.'" [30] The public realities of women's public lives still necessitate navigating an obstacle course between their theoretically assured rights and the practical liberties that they can really hope to assume. Their ways and movements in the street remain oriented along and organized by "invisible fences," [31] contained by imaginary yet socially sanctioned boundaries that redistrict and restrict their "social maps" even after the most "concrete" restrictions of female roles have been removed. [32] Even acutely aware and critical female subjects have not been able significantly to change the terms upon which their images will be perceived in the street, the codes and judgments of a culture that perceives them merely as objects. As long as a woman's movement in the street involves and requires more self-determination and self-confidence than a man's, female flanerie does not really come into its own. As long as the empowered position of the male gaze prevails, females are unable to move at will.

Within this context, the period of Weimar Germany figures as a crucial time for both the formulation of a new feminist consciousness and the obstacles that women

continue to encounter in the streets to this day. Weimar Germany can be regarded as a pivotal age in these developments, as a time that witnessed an avant-garde women's movement in Berlin which sought to overturn the patriarchal vestiges of Wilhelminian society. This confrontation of the prevailing status quo with a new and liberated women's movement yielded an open moment of modernity, a dynamics that is apt to illuminate the very contradictions that both orient and impede women's movement. As Patrice Petro has pointed out, the growing visibility of Weimar women in the public sphere and in male domains of labor after the turn of the twentieth century was met with defensive reactions and exclusionary measures on the part of official organs seeking to regulate women's access to and participation in social spaces. As late as 1908, "German law prohibited women from attending public meetings or joining political organizations."[33] Such official sanctions went hand in hand with artistic and intellectual discourses that, while otherwise critical of existing ideologies, maintained their traditional blind spots toward women's public existence.

Benjamin's scrutiny of historical and cultural phenomena, for example, continues to proceed in a way that decidedly overlooks female flaneurs in the streets. As perceptive and innovative as his reflections are as they approach the shifting modernities of the nineteenth and twentieth centuries, he consistently ignores one of the major formative factors in the public sphere of those times: "His apparently gender-neutral concept of 'the masses' . . . elides any discussion of female subjectivity."[34] And this, even though the era of Weimar modernity and its theoretical debates offered the spectacle of increased female presence in the streets as well as rapid changes in gendered patterns of employment.

This open window for women's free and determined steps toward a presence in the public sphere is illuminated in a series of reflections from the memories of author and psychoanalyst Charlotte Wolff, a contemporary of both Weimar Germany and our time. In the following passage, Wolff reflects on changing and contradictory conditions of Weimar Germany, a time when traded opinions of women's roles begin to clash with women's own expectations for their lives. For the first time, a major gendered nonsynchronicity arises in society about the ways in which to define women's roles: "Who were we and all those other young women of the twenties who seemed to know so well what we wanted? We had no need to be helped to freedom from male domination. We were *free*, nearly forty years before the Women's Liberation Movement started in America. We never thought of being second-class citizens."[35] The writer certainly belongs to what she herself recognizes as an "international avant-garde" of privileged and educated bourgeois women.

Wolff not only frequented circles of Berlin intellectuals and artists but also introduced Benjamin to Hessel and strolled the streets of Berlin as a female flaneur along with her male contemporaries.[36]

Yet even women who did not partake in Weimar's theoretical debates became increasingly visible in the metropolis: they gained mobility and independence through their work outside the house; they rode cars, taxis, and subways and determined their own paths. Moreover, women in Weimar are addressed specifically as privileged audiences for the new media of photojournalism and film.[37] Weimar Germany and its metropolitan capital became the sites of a spectacle in which both the consumption and production of the female image reached new and accelerated qualities, in a way that engendered one of the first encompassing stages of a critical reevaluation of the female image by women themselves. I will seek to read some of these decisive turns from one of the pivotal artifacts in Weimar society, in order to describe moments and transformations of the female image from the point of view of a culture and medium of flanerie. Images of progressive Weimar women are already captured in the most progressive medium of their times, the moving pictures of early cinema. Cinema in fact offers us, after centuries of male flanerie, some of the first signs of the female flaneur. It shows that female flaneurs are already present in the scenes and sites of the metropolis, even if they have been overlooked. A unique document of modern scopophilia, representing the city of modernity with the most advanced medium of its times, provides a most promising point of departure in search of the ostensibly absent female flaneur.[38]

Walter Ruttmann's *Berlin: The Symphony of the City* (*Berlin: Die Sinfonie der Großstadt*), a 1927 city film from the times of the Weimar *Kino-Debatte*, shows an era passionately engaged in and defined by the cinema and its new discourse.[39] While Ruttmann's metropolitan symphony is not a production of "feminist" modernism, it does present multiple images of "new" women on the screens and streets of modernity, elucidating and illuminating, as a first step, the many facets of women's presence in modern spaces. One scene in particular provides a striking commentary on the question of the female flaneur, highlighting the predicaments that a woman-as-streetwalker may encounter. It presents a woman who literally "walks" the boulevards of Berlin and turns a street corner in order to focus her gaze on a man through a shopping window. Her assumption of an active gaze provides a critical turning point for the urban woman as spectator, as her behavior can be regarded one of the first visually recorded manifestations of the long-absent female

flaneur. In previous criticism of the film by (male) critics, this woman walker has commonly been considered a professional one, a woman who goes after her business as a "streetwalker." In 1947, Kracauer describes these street scenes of the film and comes to the following conclusion: "The many prostitutes among the passers-by also indicate that society has lost its balance."[40] By 1982, William Uricchio's perception of these scenes in his analysis of the film has not advanced much: "After several shots whose common element involves streetwalkers as a subject, a specific mating instance is presented. A prostitute and potential customer pass one another on the street."[41]

In juxtaposing these two accounts with the recent description of this same scene by a female critic, one observes a striking case of gendered spectatorship. While Uricchio repeats Kracauer's account of a scene of prostitution, Sabine Hake sees a different action taking place: "The camera almost seems omnipresent . . . following several young women on the streets by themselves: one as she is being picked up . . . , another as she waits impatiently at a corner, and yet another as she window shops on the elegant Kurfürstendamm."[42] The striking discrepancies in judging and naming these women might well provoke another look at the function and scenes of the female image in *Berlin: The Symphony of the City*.[43] A new reading of this metropolitan text might indeed discover a literal female streetwalker, a new figure of subjectivity free of any professional purposes other than her own processes of walking, seeing, and, potentially, recording these actions: a *femme flâneur*. As the critical reception of the female image in *Berlin: The Symphony of the City* reveals, however, any woman walking the streets on her own, even in the presumably emancipatory age of Weimar Germany, has first to justify, assume, and establish her stance of flanerie.[44] When a woman signals the flaneur's aimless and purposeless drifting along the streets, she risks being perceived as a "streetwalker," as the object of a male gaze.[45]

11a–d A female flaneur (not a prostitute) exchanges glances with a male flaneur in *Berlin: The Symphony of the City.*

12 Mannequins for window-shoppers in *Berlin: The Symphony of the City*.

One of the earliest scenes of the film sets the stage for this mise-en-scène of the female image. After the camera establishes the metropolis in spatial terms—trains, tracks, and telephone poles—it continues its sequence of abstract, architectural, and inanimate shots in panning forward and around a corner, past a shoemaker's store—a prime site of production for the film's ensuing fetishism—and coming to rest on the first "human" figures that the camera singles out. Following its logic of the male gaze, it finds a group of five women models, arranged behind a window. All the mannequins are frozen in a static pose, exhibiting their attire, a single slip that barely covers their puppet bodies. It is rather apparent from this scene what the intended object on display is, that the item of apparel attracts the gaze less to this showcase than to the overall assemblage of female figures. The next shot hints at a partial consequence of this display—the image status of female existence—as it cuts to the stark picture of water running under a bridge, a bridgepost erected as the marker of future death, a proleptic image of the drowning suicide that is to come as a woman's self-destructive act at the dramatic center of the film.

Berlin: The Symphony of the City revisits similar locations in many instances, focusing on window shots and the display of women's bodies as images. One of these scenes presents a full frontal view of mannequins' plastic surfaces, as we see in mirrored reflections on the women's motionless bodies inscribed, virtually imprinted, the store signs as markers of ownership. These women's artificial and simulated bodies are clearly inscribed, through the reflection of light, as both properties on display and as circulating commodities on the market.[46] However, their own gaze does not seem to be present in this scene, as their complete figures and faces have no part in this picture. While the women are *all* parts, they also in one way remain quasi-impartial and almost resistant to their display as an image. In what seems merely a nod at a fashion pose, they raise only symbolically, in a possible gesture of irony, their twisted plastic hands. A man is seen strolling by this display, maybe a flaneur, with the sufficient leisure and visual desire to pause in front of the window, contemplating the display for a moment, considering it, dismissing it, walking on. Similar scenes follow this prototypical situation of the public display and evaluation of women's images. On the runway of a fashion show—presenting the small-scale model of an artificial "street"—women circulate within the confines of their modeled and modeling walk, a form of movement that sells—in more than an exterior sense—women's bodies and images. The fashion scene is preceded by the film's most desperate act, the drama of a woman's suicide, whose jump from a bridge takes place at just that location and position which links it to the previous exhibition scene with the foreshadowing water shot.

A narrative of women's lives is suggested that seems to connect their existence and demise in the city to the ways in which their images are exhibited and exploited in this society. The film pursues an implicit logic from the first scenes with women as models, instruments, and coat hangers of capitalism, images on display as well as commodities for sale, to the crucial cluster of street scenes where a leisurely strolling woman is perceived as nothing but a marketable image that presumably takes possession of her entire body and persona. The woman in the street is herself foremost an image by social and cultural definition, a commodity trying to sell herself in more than just one sense. In a closer look at this scene, however, we discover that this presumption in fact collapses and thus hides a multitude of individual women walkers. Indeed, any scrutiny that is more attentive to women's presence finds that these scenes are not (at) all sites of prostitution but are instead comprised of at least four distinct instances of female figures, fashions, and habits in the street. The first of these women is introduced as she looks out over the street, seemingly surveying

the scene. She is shown in profile with a gray hat that leaves an open space next to her view for the spectator's own gaze to take in the long shot of a street scene surrounding her image. This attentive character is not seen again, either on her own or as companion to any of the men to follow in this sequence. Her striking image offers but a glimpse of a potential female flaneur and her scrutiny of the city, as the symphony cuts from her gaze immediately to that of yet another "other," the image of a black man surrounded by a small group of pedestrians.

Along with this sequence of visual "suspects" on the Weimar scene, the camera proceeds to capture the image of another woman who walks by slowly and wears a different hat with a band. She is introduced already in the company of a man when she appears on the scene, with no markers of a commercial transaction or solicitation defining their association. Independently of her two predecessors in the street, a third woman strolls by on the far edge of the sidewalk. She sports a white hat and a curious gaze, which she directs with admitted interest upon her fellow pedestrians in the crowd. No other signals allow us to define her specular intensity as either professional interest or aimless flanerie, leisure, or prostitution.

To complete this sequence, a fourth woman in a black hat appears, whose swaying walk seems to provoke a clichéd response from male spectators (see illus. 11a–d). Her sensual flexibility has suggested nothing if not the "coquettish," self-advertising stroll that they imagine of a prostitute. This female image is the instantly suspect one who turns the corner and gazes back at another (male) pedestrian, using the 90-degree angle through the shopping window as much as a reflective mirror as a window, a transparent surface of specularity. Her interested gaze is commonly interpreted as so provocative that it presumably causes the man to retrace his steps around the corner to join her. Yet, as we review this scene more closely without immediately attaching the label "prostitute" to the woman with the active gaze, we find the woman with the black hat in fact walking off by herself after all. It is perhaps even a different man who subsequently walks by with another woman at the other side of the window, a couple that through blind repetition and conventional viewing has come to be regarded as a successful transaction in "streetwalking." But,

13 *Opposite:* A woman in a gray hat surveys the city in *Berlin: The Symphony of the City.*
14 A woman in a white hat glances at other strollers in *Berlin: The Symphony of the City.*

in reality, the scene proves itself open to a new presence of women in the street, re-
quiring an attentive analysis to reveal an instance that confounds rather than
confirms preconceived notions of women walking and watching in the streets.

Upon closer inspection, *Berlin: The Symphony of the City* represents many
facets of the status of women in the modern city. Their walking down the street
opens a space for the female flaneur, develops the presumably nonexistent, improb-
able, and *unheimliche* presence of a woman in the street as in a photograph—that
is to say, renders it visible as a more complex spectacle and presence than conven-
tions have permitted us to see and say. In this film, women shop, stroll, go to work,
sit in cafés, and observe the crowd; still, even these manifest images of public
women are contained by male interpretations that consider progressive women as
prostitutes. Looking upon—and down on—the female figure in public places as a
professional "streetwalker" only repeats, replicates, and prescribes the clichéd image
of women walking in the street, women who are indeed very real participants in a
public spectacle. The previously limited roles of women in the streets, circum-
scribed en route to department stores and workplaces for purposes of shopping and

71

working only, are juxtaposed and directly related to an interpretation that collapses a variety of filmic figures into the one of the prostitute, a mere commodity. By way of selling herself, the figure represents an inverted function of both "shopping" and "working," the two accepted female activities in the public sphere. From the nineteenth century to Benjamin and his contemporaries, the historical spectators and participants of this *Symphony of the City*, the prostitute represents the only current, perceivable, and conceivable form of female presence in the street. The ensuing typification of this figure into a veritable allegory of the city and the female coun-

terpart of the flaneur is nothing if not the inscription of a male fantasy onto a female type who—a "streetwalker" out of need, not out of leisure—does not frequent the streets to share her subjective experience with the male pedestrian but rather is defined by the very immediate objectification and commodification of her own body.

15 A woman behind a newspaper in *Berlin: The Symphony of the City*.

Unlike the male flaneur and bearer of the gaze, the prostitute is not his female equivalent but rather the image and object of this gaze. Not free to drift along the streets, she is driven into and down the streets by pressing economic motives. She does not pursue her own sensory experience but rather seeks to divest herself of this very experience by gainful means. That "the image of the whore [is] the most significant female image in the *Passagen-Werk*" remains a blind spot in the enlightening perception of a long line of male critics and flaneurs.[47] The absence of a genuine female flaneur typifies the history of male flanerie in its indifference to female experience, especially when prostitution must be considered, as Buck-Morss suggests it was, "the female version of flanerie."[48] The work of prostitutes, however, is in no way the equivalent to a freely chosen form of flanerie. The prostitute in general is neither flaneuse nor nymphomaniac, and does not have the streets at her disposal any more than she commands the use of her own body.[49] She does not represent the new image of a self-determined female subject of the streets any more than the shopping flaneuse who has been mobilized by bourgeois consumption, or the bag lady who has been expelled into the streets and consumed by the system. Within the public facets of female lives, these women form nothing if not the

cynically distorted female images of consumption and flanerie in an age of capital-ist and sexist exploitation.[50]

In the scene succeeding the one of the strolling woman, a number of women are presented, ostensibly counterimages: perfected models strutting the runways, bourgeois ladies decorating the sidewalks, and female tableaux sitting displayed at café tables, captured frequently in the moment of restoring their made-up façades. These exhibited images illustrate the extent to which even in the presumably liber-ated age of the 1920s, "the spaces of femininity are defined by a different organiza-tion of the look."[51] Gertrud Koch describes the dynamics that contain women's own images as well as their access to the images of others: "The aim of the sanction against going alone to pubs, etc. is to remove women from the voyeuristic gaze of men, whereas the implicit cinema prohibition denies the voyeuristic gaze to woman herself."[52] With no images of female moviegoers presented in *Berlin: The Symphony of the City*, the film's instance of a female spectator as walking woman presents a specular process that approximates the "spectatrix's" filmic viewing.[53] In strolling, this *femme flâneur* fixes her gaze on the other pedestrians and takes in the spectacle of the street through the frame of a shop window. Despite this woman's singular courage, however, the prevailing scopic dynamics remain fanned out against the female pedestrian in the street, as the critical reception of this figure and her "provocative" behavior has shown. As conventions of women's images and public presence continue to objectify her, the uneasiness experienced by the female flaneur has to be regarded as far more than an isolated incident of individual paranoia or exaggerated insecurity.

The precarious status of the female flaneur expresses an epistemological condi-tion of female existence within the gendered dynamics of the gaze that Koch eluci-dates as a feminist critic of film and specularity: "Being looked at, I become the ob-ject of the other who casts his judgment at me with his glance. Every woman knows this situation which Sartre describes as an ontological one: the domination through the appraising gaze which degrades into an object the one looked at, and subordi-nates her."[54] From the perspective of woman, Sartre's "ontology" does indeed de-scribe more a male epistemological position than an "objective" philosophical one. This view of the world marks its own blindness quite strikingly when Sartre exem-plifies his definition of the "other" via his perception of a *woman* in the street: "This woman I see coming toward me [and others like her] are without any doubt objects for me."[55] No less doubtful is the consequence that many women who are faced with such massive scrutiny and daily objectification—and not only through a

male philosopher's gaze—find themselves lacking the self-evident confidence that is traditionally exercised by and attributed to their male contemporaries. Female scopophilia and flanerie have become subjected to so many historical restrictions that women may withdraw from the public sphere altogether, no longer willing or even capable of further exposing themselves to the dominant gaze of daily evaluation. A potential female flaneur may disassociate herself from an exterior world that is largely defined by the male gaze, withdrawing into domestic interiors. She may also embrace the cult of women's own bodies and appearance, assume her culturally sanctioned presence as a man's companion, or retreat into the shelter of friends and families instead of pursuing a flanerie of her own.[56]

The female flaneur's desire for her own exploration of the world ends where it encounters its limits in male pedestrians whose fantasies assault, annoy, disturb, and perpetually evaluate her in the street. Woman's socially prescribed status as an image formulates an epistemological position defined by powers that overshadow her potential as an observer. Prevailing definitions of modernity reveal their gendered bias if one considers them in light of the gaze and the case of the missing flaneuse. It seems no accident that it was a recent feminist critic who explicitly named the sense of ominous discontent that Georg Simmel had described in the early years of this century for the interiors of public transportation.[57] As Ulrike Scholvin explains, the cause of this modern anxiety lies, more than in the experience of mere anonymity as such, in a realization that is known to every woman about the extent to which a person's image and appearance is exposed to a ceaseless barrage of visual judgments within a narrow space: "It is probably less anxiety-provoking to see oneself [herself] than to realize in the eye of the other that one is being seen by him."[58] This anxiety, most common to a woman's experience, prevails even in the absence of a male gaze as she continues to be a specular object to other women who have themselves internalized the criteria of male evaluation.

Some of the working women in Berlin: The Symphony of the City appear already to have drawn consequences from and reacted against this bombardment of visual judgments. The film illustrates this predicament as it places a woman in a crowded commuter train, having her draw attention even in her attempt to find shelter from this intrusion by hiding her face behind a newspaper. The containment dominating the female image is established in this woman's ultimately futile efforts to disassociate herself from her image status in order to engage in other activities, as she continuously has to disavow her own interested, investigative, and invested gaze. This pivotal predicament of women's images becomes apparent in the

film's scenes of shop windows where females appear only in display cases and as window dolls. Woman's epistemological status is one of constant display, as the object of male desire and, beyond that gaze, as object to the internalized gaze of female competition that renders women objects of their own self-censorship. Wherever woman goes and looks, she finds her image surrounded by a (self-) critical gaze that subordinates and subjects her image value to permanent specular evaluation and assessment. As Buck-Morss explains, "[Women] make themselves objects. Even with no one looking, and even without a display case, viewing oneself as constantly being viewed inhibits freedom."[59] The film's female shoppers and strollers gazing into the shop windows of the city demonstrate how a potential flaneuse may come to direct her gaze on herself and her own image instead, as a construction that stands in competition with that of other female images that surround her reflection in the window. A woman's gaze consequently loses its potential for attentive autonomy toward the exterior world, as she turns to invest it rather into the image value of her own appearance. The filmic image of the male flaneur, reflected in the glass and superimposed on the female androids in the window, also reveals the destination of the female shopping flaneuses who pursue the perfection of their own images along the criteria of the male gaze. While department store strollers and window shoppers are predominantly women, they have not assumed the purposeless gaze of the flaneur. Shopping malls likewise have become centers of female self-consciousness rather than self-confidence as their spaces are filled with normative images of femininity, presenting only a virtual reality that constricts the flaneur's roaming scopophilia.[60]

Ruttmann's *Berlin: The Symphony of the City* provides an early echo to this prevailing predicament in scenes that position women gazing into the display windows of apparel stores. The woman confronted with these shop windows finds her real reflection in this mirror contrasted with—that is, compared and judged in relation to—the mannequins' images of a socially sanctioned "ideal" appearance that is arranged and on display in the shop windows. Through the window, the shopper's gaze meets the scrutiny of saleswomen who are styled in the fashion of the mannequins and trained in the sale of their images. Subjected to this exchange of values, the woman as buyer and as appearance before the window is rendered at once an object of the gaze projected by the sellers as well as by other shoppers for images. A competitive exchange of the gaze prevails whereby each of its female participants evaluates the other woman's image in the context of the store's images, in connection to its commodities, in the context of the store's ambience, and in comparison

and competition with her own value as an image. A woman's gaze into the shop window reveals foremost its own disappearance, as her image is refracted in infinite reflections of its own object status, before her gaze ever has a chance of meeting (with) the exterior world. In this way, the potential for female flanerie is broken into infinite refractions of commodity mirrorings. The only way out of this labyrinth, this mirror cabinet of mutually reflecting image values, seems to be a woman's decision to pursue a flanerie of and on her own, despite the odds and obstacles, to approach and redeem the exterior world in her own ways and on her own terms. In the existing reality of aggression, competition, and comparison under the specular laws of the market, there remains only the refusal, as one feminist critic has postulated, "to disintegrate under the [controlling] gaze of the other."[61] A woman's possible utopian gaze may transcend her own image only if she becomes an active spectator in her own right, "if she succeeds in holding her ground before this gaze as the subject of a self-confidence against which the *other* freezes into the object." This act of perception, with its implicit dynamics of reversing an existing objectification, presents one first step toward resisting woman's exclusive status as an image and may free up a space for her own gaze onto an exterior world of new sights and views.

This space, suggestive of all-around observation and free-floating flanerie, has already been prefigured in another realm: the scopophilia of the cinema. The film's window, with its frames through which the stroller sees her own objectification—and beyond if she dares—is replicated in the frame of the camera, yet extended upon the images of an entire world. The cinema releases the female participant and spectator in these scenes of her exclusion from the world and of her reduction to a mere image. The sites and spheres of female flanerie have been inscribed into the medium of film from its earliest times. With its exploration of the images of reality, cinema takes as its focus and premise these prevailing constructions of power and the gaze, and in this reflection opens up reservoirs of unclaimed territory by allowing an institutionalized act of perception in which even a woman is free to partake. In so doing, the spectatrix in the movie theater approximates a prototype of the female flaneur, a moving spectator in the streets. Early cinema can be seen as one of the first public places in which this new freedom and position of the gaze was available for, accessible to, and exercised by women who had before been excluded from scopic pleasure. Like very few other spaces of mainly stationary, limited, and select visual pleasure that had traditionally been accessible to women—the housewife's gaze from the windows out of her interior, the shopper's gaze into the interiors of

the department store—the mediated gaze through the eye of the camera, despite its industrial and institutional basis, grants the female spectator a relatively uncontrolled gaze by rendering and recording the reality provided by its moving pictures. Horkheimer and Adorno theorize this context: "In spite of the films which are intended to complete her integration, the housewife finds in the darkness of the movie theater a place of refuge where she can sit for a few hours with nobody watching, just as she used to look out of the window when there were still homes and rest in the evening."[62]

In the cinema's enclosed, private, and privileged realms, its spaces specifically constructed and expressly set aside for the purpose of looking, female scopophilia finds one of its first hideaways. Consequently, an initial censorship against women who go to the cinema emerges, a prohibition that characteristically, as Koch points out, "applies most strongly to the women who go alone."[63] The particular lure of the cinema's closed interiors, in combination with the promise of increased scopic stimuli, exerts an irresistible fascination for the female spectator who has been largely excluded from the streets. The darkened space of the cinema removes her from the gaze of others and at the same time allows her own gaze unrestricted and accelerated access to all the shocks and impressions of modernity, approximating and even exceeding the experience of the street. It is this onset of the cinema that finally liberates women's right to indulge their scopic desires. As Heide Schlüpmann emphasizes, "The cinema finally accepted women as social and cultural beings outside their familial ties."[64] While the move of women toward the liberating movies encountered significant initial resistance, they nevertheless embraced the new medium as a catalyst that gave way to their first legitimate and protected form of access to spectacle and perception: "While the bourgeois theatergoer continued to reject [the movies], his wife already spent her free time in the cinema. For women, the cinema as a rule meant the only pleasure they would enjoy outside the house on their own, and at the same time also more than entertainment; they brought into the cinema the claim, not delivered by the theater, 'to see themselves.'"[65]

The contested participation of women in *Berlin: The Symphony of the City* coincides with the popular arrival of cinema in the 1920s, a time when women entered a world of images that had long been denied to them in the streets. Simultaneous with their new gaze at the world on the screens, they likewise can see themselves and see for themselves in the city, the public sphere of Weimar Germany. That women embrace the spectacle through the medium of moving images reveals the extent of their desire for the perception and redemption of the images of

reality. Via the form of flanerie that film presents its spectators, stationary yet infinitely mobile in an imaginary way, the cinema transmits images of exterior reality even to the presence of women and allows them to begin to relate to the world as unimpeded, invisible, and respectable flaneurs in their own right. On the screens and streets of modernity, the arrival of female flanerie extends and responds to prevailing questions about the female spectator. With spectatorship serving as an analogy and apparent synonym for flanerie, with urban streets a realm intrinsically related to scopophilia on the screens, the female flaneur can become a prototype for gendered spectatorship in the cinema. Acknowledging female flanerie in the street—and hence extending our understanding of female spectatorship in general—may help to delineate more precisely the contemporary debates over female spectators facing the screen.

The flaneur pursues what is akin to a cinematic gaze, enacting a modern perspective that at once performs activities of the spectator with his eyes, those of the camera with his mind as a medium of recording, and those of the director with his writing and reordering of the collected images into a text of what he—or she—has seen. The eventual appearance of an ostensibly invisible female flaneur, as in *Berlin: The Symphony of the City*, is therefore able to confirm female spectatorship in many ways. In order to answer a central question of feminist film theory—"Why Women Go to Men's Films"—it would be helpful to acknowledge that there also are, and have long been, female flaneurs in modernity, women with an active desire for a specularity of their own in response to public spaces and images. To establish such a genuine "pre-filmic" disposition in the streets would go far to concede woman's scopophilia, a specular desire that exceeds and predates her becoming subject to the codified images of prevailing forms of dominant cinema. The film of the street is not merely the medium of "men's films." To be able to speak of a female flaneur would offer the new figure of a resistant gaze, an alternative approach, and a subject position that stands in opposition to women's traditional and prevailing subsistence as an image on the screens and in the streets. The figure of the female flaneur goes beyond woman's cultural construction as an image, wherein she exists primarily to be looked at and offered as a valuable visual commodity to the male spectator as consumer.[66] This figure may also help to reformulate theories of spectatorship that organize the gaze entirely along gender lines, that posit an active male spectator who seems in control of female images.

Recognizing a female flaneur would enable women to trace an active gaze of their own to a preexisting tradition of female spectatorship in the public sphere, to

an already actively looking female figure who can return the gaze directed to her. At first sight, the conventional assumptions of "woman as image, man as bearer of the look" seem to dominate the specular scene of the city and its *Symphony*, with women walking the streets only in order to be looked at and checked out by the male gaze.[67] Within this context, the discovery of a female flaneur would help to inscribe a model of resistance for women, one that would establish wide possibilities and would open new spaces for their own gaze. A stance of female flanerie allows us to formulate a position that would offer an alternative to woman's status as an image, to override her cultural "to-be-looked-at-ness." The female flaneur would provide an antidote, a new approach and paradigm that might destabilize the dominance of the male gaze and counter it with another gaze. After the long history of male flanerie and the privileged male spectatorial position it involves vis-à-vis the image, we should wish to extend and elaborate all theories of women's spectatorship and visual authorship, whether they involve the perception of modernity in the cinema or the city, on the screen or in the street. In allowing for a potential flanerie by woman walkers and bearers of the gaze, we mean to introduce an important perspective into the cultural construction of women's images and toward women's authorship of their images of the world. It is time to reconsider concepts of the image for and from the perspective of the female subject as a flaneur—that is, as a camera, spectator, and director of a text of her own.

Notes

1 Siegfried Kracauer, "Kult der Zerstreuung," in *Das Ornament der Masse: Essays* (Frankfurt: Suhrkamp, 1977), 311–320.

2 See Walter Benjamin's essay on his friend Franz Hessel's writings: "Die Wiederkehr des Flaneurs," *Die literarische Welt* 40, no. 5 (1929).

3 In his essay "Jules, Jim, and Walter Benjamin," Dudley Andrew identifies Franz Hessel as the prototype for the character of Jules in the novel *Jules et Jim* by Henri-Pierre Roché.

4 A second "Return of the Flaneur"—to rephrase Benjamin's essay on Hessel—might be located under the auspices of "New Subjectivity" in much German literature and film since the 1970s. This recent movement is also mainly discussed in terms of its male authors and directors.

5 See Meaghan Morris, "Things to Do with Shopping Centres," *Milwaukee Working Paper* 1 (Fall 1988).

6 George Sand, quoted by Janet Wolff, "The Invisible *Flaneuse*: Women and the Literature of Modernity," in *The Problems of Modernity: Adorno and Benjamin*, ed. Andrew Benjamin (London: Routledge, 1991), 148.

7 Jules Michelet, quoted by Griselda Pollock, *Vision and Difference: Femininity, Feminism, and Histories of Art* (London: Routledge, 1988), 69.

8 See Verena Stefan, *Häutungen* (Munich: Frauenoffensive, 1975); published in English as *Shedding*, trans. Johanna Moore and Beth Weckmueller (New York: Daughters Publishing Co., 1978).

9 Anne Friedberg, "*Les Flaneurs du Mal(l)*: Cinema and the Postmodern Condition," *PMLA* 106, no. 3 (May 1991): 421. Also see Friedberg, "The Gender of the Observer: The Flaneuse," in *Window Shopping: Cinema and the Postmodern* (Berkeley: University of California Press, 1993), 32–37.

10 Friedberg, "*Flaneurs du Mal(l)*," 422.

11 See Gertrud Koch, "Von der weiblichen Sinnlichkeit und ihrer Lust und Unlust am Kino: Mutmaßungen über vergangene Freuden und neue Hoffnungen," in *Überwindung der Sprachlosigkeit*, ed. G. Dietze (Darmstadt: Luchterhand, 1979), 116–138, esp. 130.

12 Susan Buck-Morss, "The Flaneur, the Sandwichman, and the Whore: The Politics of Loitering," *New German Critique* 39 (1986): 119. Buck-Morss also touches upon the question of ownership of the street (114).

13 See Janet Wolff's study on the "impossibility" of female flanerie, "The Invisible *Flaneuse*: Women and the Literature of Modernity," in *The Problems of Modernity*. As she argues, women might disavow altogether modernity because it emphasizes the "public world of work, politics and city life," a world that appears to privilege the experience of men. This prevailing "separation of 'public' and 'private' spheres of activity" may validate women's interior activities at the expense of their presence in modernity's exteriors, but it does not challenge the perception that women did not, or were not able to, participate in the "public" of male experience. The conclusion that "the solitary and independent life of the flaneur was not open to women" implies resignation, and stating that the flaneuse "was rendered *impossible* by the sexual divisions of the nineteenth century" once more excludes women from a significant realm of experience. Perpetuating the thesis of a "missing flaneuse" may too quickly foreclose our attention to instances of female flanerie and narrow the focus of a debate on women's presence in public spaces.

14 Pollock, *Vision and Difference*, 71 (emphasis mine).

15 Ibid.

16 Women writers and female travelers of the nineteenth century, especially women traveling to Paris, the city of the 1830 and 1848 revolutions, included Johanna Schopenhauer, Fanny Lewald, and Emma von Niendorf, among others.

17 Marie Bashkirtseff, quoted by Pollock, *Vision and Difference*, 70.

18 Pollock, *Vision and Difference*, 52.

19 Quoted by ibid., 70.

20 Shirley Ardener quotes this piece of contemporary evidence in her sociological study "Ground Rules and Social Maps for Women: An Introduction," in *Women and Space: Ground Rules and Social Maps*, ed. Shirley Ardener (London: Oxford University Women's Studies Committee, 1981), 33.

21 Ardener, "Ground Rules and Social Maps," 29.

22 Pollock, *Vision and Difference*, 63.

23 Also see Ardener's statement: "Foot-binding, tight corsetting, hobble skirts, high heels, all effectively impede women's freedom of movement." "Ground Rules and Social Maps," 28.

24 Adrienne Rich, "Compulsory Heterosexuality and Lesbian Existence," in *Powers of Desire: The Politics of Sexuality*, ed. Ann Snitow, Christine Stansell, and Sharon Thompson (New York: Monthly Review Press, 1983), 177–205, esp. 183–184. In her seminal essay, Rich exposes and defamiliarizes a number of "natural facts" of female existence as socially constructed factors that oppress and literally impede women's movement with crippling consequences. By extension, these material and physical restrictions ultimately result in the "horizontal segregation of women in employment" and the "enforced economic dependence of wives" (184), all aimed at restricting women's movement and reach in an extended and immediate sense.

25 Gertrud Koch, "Why Women Go to Men's Films," in *Feminist Aesthetics*, ed. Gisela Ecker, trans. Harriet Anderson (Boston: Beacon, 1985), 108. To the extent that these factors describe and prescribe women's point of view and access to public space, they are neither "abstract nor exclusively personal, but ideologically and historically construed." Due to their historical seclusion and lack of mobility, women have remained in particular ways within these prescribed "spaces of femininity," rendered the "product of a lived sense of social locatedness, mobility and visibility, in the social relations of seeing and being seen" (Pollock, *Vision and Difference*, 66).

26 In a society organized around and dominated by the male gaze, any "presence" of women is and continues to be "sexualized." There is no representation of the female image that is neutral to and removed from issues of gender and power. For these and similar formulations, see the discussion of related arguments in feminist film theory in *New Vocabularies in Film Semiotics: Structuralism, Post-Structuralism, and Beyond*, ed. Robert Stam, Robert Burgoyne, and Sandy Flitterman-Lewis (London: Routledge, 1992), 176.

27 Ulrike Scholvin, a feminist critic in contemporary Berlin, makes the following observation concerning this problematic production of the female image by a male gaze that does not reflect the desires or subjectivity of its object: "The cities into which we carry our projections in order to lose ourselves in them are blocked with images our wishes have not produced."

Döblins Metropolen: Über reale und imaginäre Städte und die Travestie der Wünsche (Weinheim: Beltz, 1985), 8 (translation mine).

28 For one recent investigation, see Susan Bordo, *Unbearable Weight: Feminism, Western Culture, and the Body* (Berkeley: University of California Press, 1993), as well as Naomi Wolf's popular success *The Beauty Myth: How Images of Beauty Are Used against Women* (New York: Doubleday, 1991). Both of these critical investigations continue an ongoing line of feminist reflections on the normative codings that govern and concern many aspects of the female image. See also Wendy Chapkis, *Beauty Secrets: Women and the Politics of Appearance* (Boston: South End, 1986); Robin Tolmach-Lakoff and Raquel Scherr, *Face Value: The Politics of Beauty* (London: Routledge, 1984); Nancy C. Baker, *The Beauty Trap: Exploring Woman's Greatest Obsession* (New York: Franklin Watts, 1984); Lisa Schoenfielder and Barb Wisser, *Shadow on a Tightrope: Writing by Women on Fat Oppression* (Iowa City: Aunt Lute Book Company, 1983); Kim Chenin, *The Obsession: Reflections on the Tyranny of Slenderness* (New York: Harper and Row, 1981); and Susie Orbach, *Fat Is a Feminist Issue* (Middlesex: Hamlyn, 1979).

29 Scholvin, *Döblins Metropolen*, 7. She goes on to describe her own experience as a woman and flaneur in the 1980s: "We fall into the habit of appraising our environs with quick glances without attracting and holding on to other gazes; we learn to distinguish which places are accessible to us" (8).

30 Pollock, *Vision and Difference*, 89.

31 Ardener, "Ground Rules and Social Maps," 12.

32 Susan Buck-Morss, a current critic of this "politics of loitering," speaks for women who have begun to read and uncover these invisible confines of the system, contemporary feminists who may be in a position to declare that "the politics of this close connection between the debasement of women sexually and their presence in public space [is] clear." See "The Flaneur, the Sandwichman, and the Whore," 119.

33 Patrice Petro, *Joyless Streets: Women and Melodramatic Representation in Weimar Germany* (Princeton: Princeton University Press, 1989), 69.

34 Ibid., 74.

35 Charlotte Wolff, *Hindsight* (London: Quartet, 1980), 106.

36 "Walter [Benjamin] and Franz Hessel, whom I had introduced to each other, became close friends. They collaborated in the translation of Proust and Balzac into German, which strengthened their bond." Ibid., 71.

37 See Petro, "Weimar Photojournalism and the Female Reader," *Joyless Streets*, 79–139.

38 Anne Friedberg suggests a similiar expansion of women's space in rethinking Wolff's deliberations via a new scrutiny of the texts of modernity: "Someone . . . who wants to produce a

feminist sociology that would include women's experience should also turn to literary texts by female 'modernists.'" *"Flaneurs du Mal(l),"* 430.

39 In the United States there is a longstanding mistranslation of the film's title, *Berlin: Die Sinfonie der Großstadt,* perhaps due to the Museum of Modern Art's translation as *Berlin: The Symphony of a Great City.* I have decided to opt for the more accurate English translation: *Berlin: The Symphony of the City.* The definite article modifying "City" is significant because Berlin was of course the most modern and important city in Germany at that time. While some scholars translate *"Großstadt"* as "Big City," this is redundant, since the German term means a city with a population of over 100,000 inhabitants and since in English "city" similarly implies a population of a certain size. On the Weimar *Kino-Debatte,* see Anton Kaes, ed., *Kino-Debatte: Texte zum Verhältnis von Literatur und Film 1909–1929* (Tübingen: Niemeyer, 1978).

40 Siegfried Kracauer, *From Caligari to Hitler: A Psychological History of the German Film* (Princeton: Princeton University Press, 1947), 186.

41 William Uricchio, "Ruttmann's *Berlin* and the City Film to 1930" (Ph.D. diss., New York University, 1982), 209.

42 Sabine Hake, unpublished manuscript, generously provided by the author. Also see Hake, "Urban Spectacle in Walter Ruttmann's *Berlin: Symphony of the Big City,*" in *Dancing on the Volcano: Essays on the Culture of the Weimar Republic,* eds. Thomas W. Kniesche and Stephen Brockmann (Columbia, S.C.: Camden House, 1994), 127–142.

43 Other investigations of the film have also neglected the gendered experience of these streets, instead isolating formal and compositional questions. See Matthew Bernstein, "Visual Style and Spatial Articulations in *Berlin, Symphony of a City* (1927)," *Journal of Film and Video* 36, no. 4 (Fall 1984): 5–12; Jay Chapman, "Two Aspects of the City: Cavalcanti and Ruttmann," in *The Documentary Tradition,* ed. Jay Leyda (New York: Norton, 1971); Jiri Kolaja and Arnold W. Foster, *"Berlin, the Symphony of a City* as a Theme of Visual Rhythm," *Journal of Aesthetics and Art Criticism* 23, no. 2 (Spring 1965); and Thomas Kuschel, "Die Darstellung des Menschen und seiner Gesellschaft in den Filmen *Berlin: Die Sinfonie der Großstadt* von Walter Ruttmann und *Vorwärts, Sowjet!* von Dziga Wertow unter Berücksichtigung der künstlerisch-formalen Gestaltungsmittel," *Filmwissenschaftliche Mitteilungen* 6, no. 1 (1965).

44 Cf. Atina Grossman, "The New Woman and the Rationalization of Sexuality in Weimar Germany," in *Powers of Desire,* ed. Snitow, Stansell, and Thompson, 153–171, as well as Cornelie Usborne, *The Politics of the Body in Weimar Germany: Women's Reproductive Rights and Duties* (Ann Arbor: University of Michigan Press, 1993).

45 Buck-Morss, "The Flaneur, the Sandwichman, and the Whore," 119.

46 Cf. Luce Irigaray, "Women on the Market," *This Sex Which Is Not One*, trans. Catherine Porter (Ithaca: Cornell University Press, 1985).

47 Buck-Morss, "The Flaneur, the Sandwichman, and the Whore," 122 and 119.

48 Ibid., 120.

49 Regarding a specular meditation on related concerns in the filmic medium, see Jean-Luc Godard's *Vivre sa Vie* (1962).

50 Buck-Morss, "The Flaneur, the Sandwichman, and the Whore," 119.

51 Pollock, *Vision and Difference*, 84. Koch describes this dynamics between the looker and the objects of his look in the following way: "Woman is subjugated to the dominant gaze before she can even begin to measure herself against man, to measure her gaze against his. All she can do is look demurely at the ground, to strip her expression of all meaning in order to deny and avoid the aggression of his gaze, or to take refuge behind the mask which conceals the gaze." This cultural strategy is especially apparent in the restrictions governing women's entry into privileged spaces of seeing, such as pubs and cinemas, where they must be accompanied by others, mainly men. "Why Women Go to Men's Films," 109.

52 Koch, "Why Women Go to Men's Films," 108.

53 For reflections on and approaches to the female spectator, see "Spectatrix," ed. Janet Bergstrom and Mary Ann Doane, *Camera Obscura: A Journal of Feminism and Film Theory*, special issue, nos. 20–21 (1989).

54 Koch, "Von der weiblichen Sinnlichkeit und ihrer Lust und Unlust am Kino," 125.

55 Jean-Paul Sartre, *L'être et le néant: Essai d'ontologie phénoménologique* (Paris: Gallimard, 1957), 310. The French reads: Cette femme que je vois venir vers moi [et autres passants] sont pour moi des objets, cela n'est pas douteux."

56 Cf. the resigning conclusion to Stefan's autobiographical *Häutungen*.

57 Georg Simmel, "Die Großstädte und das Geistesleben," *Die Großstadt: Vorträge und Aufsätze* (Dresden: Jahrbuch der Gehe-Stiftung, 1903).

58 Scholvin, *Döblins Metropolen*, 66 (emphasis mine).

59 Buck-Morss, "The Flaneur, the Sandwichman, and the Whore," 125. Also see John Berger, *Ways of Seeing* (New York: Penguin, 1977).

60 "In the shopping mall, the *flaneuse* may have found a space to roam . . . like the *flaneur*, with the privilege of just looking—but what is it she sees?" Friedberg, "*Flaneurs du Mal(l)*," 429.

61 Scholvin, *Döblins Metropolen*, 66.

62 Max Horkheimer and Theodor W. Adorno, *Dialectic of Enlightenment*, trans. John Cumming (New York: Herder and Herder, 1972), 139.

63 Koch, "Why Women Go to Men's Films," 108. Attempts at censoring the female gaze follow the logic of restricting women's movement and perception through the "traditional sanction

against unaccompanied women in public meeting-places like pubs, streets, stations, etc. [in order to protect them] as a man's private property from the gaze of other men."

64 Heide Schlüpmann, *Die Unheimlichkeit des Blicks: Das Drama des frühen deutschen Kinos* (Frankfurt: Stroemfeld/Roter Stern, 1990), 13.

65 Ibid., 16.

66 Laura Mulvey's remarks on the gendered construction of dominant cinema apply to the cultural dynamics of public spaces as well: the "socially established interpretation of sexual difference . . . controls images, erotic ways of looking, and spectacle." "Visual Pleasure and Narrative Cinema," *Screen* 16, no. 3 (Autumn 1976): 6.

67 Cf. Berger, *Ways of Seeing*, 45–64.

The Fair View
Female Spectators and the 1893
Chicago World's Columbian Exposition

LAUREN RABINOVITZ

> During the 1870s and 1880s spectator entertainment grew from its rudimentary pre–Civil War forms into more and more elaborate spectacles: circuses, minstrel shows, vaudeville, light musicals, sports, road shows . . . and other forms that evinced the growing taste for representations—dioramas, panoramas, models of Niagara, Dublin, Paris and Jerusalem. . . . The climax of this aesthetic of replication—though by no means the end of it—was, one might say, the whole of the Chicago Exposition of 1893.
>
> **Miles Orvell, *The Real Thing: Imitation and Authenticity in American Culture, 1880–1940***

No single event encapsulates the onset of American modernity more than the 1893 Chicago World's Columbian Exposition. Occurring in the midst of a deep economic depression and widespread labor strife, the World's Columbian Exposition heralded a new American power of corporate capitalism and imperialism. Of course, the irony of such braggadocio was lost on most fairgoers, who responded to the fair as though it were a tonic for the economic ailments of the current bank recession. Accounts of the fair from both official and unofficial sources avoid the partially completed edifices and empty buildings abandoned due to bankruptcies or the financial collapse of investors. Fair critics, journalists, and tourists similarly ignored the labor required to build the 633-acre city and the daily work required to keep it thriving. Instead, travelers' diaries as well as the more commercial accounts that were dependent upon new serial modes of image reproduction like chromolithography—souvenir albums, guidebooks, photographs—focus on the Exposition's rhetoric of display that signified futuristic modernity. By serving as guides and by delivering important lessons for how to understand the fair, Exposition commentaries proclaim the ways that the Exposition ushered in the emergence of a modernist society.

Within this environment, "pre-cinema" was present as a new apparatus for seeing. Proto- or pre-cinema exhibits were on display in two places: a single peephole kinetoscope was at the Edison Manufacturing Company's phonograph exhibit in the Electricity Building, and Eadweard Muybridge's lecture-demonstrations of

animal motion studies occurred regularly at his specially built Zoopraxigraphical Hall on the Midway.[1] Localized in these formations at the fair, these exhibits seemingly contradict the ways they have been traditionally represented in film histories as the paired pre-cinematic apparati of science and commerce. In these instances, Muybridge's projection of photographic animal motion studies with a Zoopraxiscope represents cinema's origins in a purely scientific practice, and Edison's peephole kinetoscope for individually viewing stage acts represents commercialized entertainment. In such standard accounts of cinema's origins, cinema sources in technology and industry are traced through a series of inventions back to the camera obscura; they construct a teleology of scientific progress expressed through industrial management.

At the Exposition, however, Muybridge's lecture-demonstrations were part of the entertainment arena at the Midway whereas Edison's kinetoscope was situated within the dominant scientific discourse of the Electricity Building. Edison's kinetoscope, a rapidly moving strip of photographs of the human body directly addressing the viewer, was initially meant to be viewed by an individual looking through a peep-hole while a phonograph record played. So little has been recorded about Edison's machine at the Electricity Building (indeed, there is some dispute over whether it actually appeared in the south corner of the building and for how long) that it is impossible to isolate its reception.

Muybridge's Zoopraxigraphical Hall lectures consisted of projected images of larger-than-life-size photographs of the phases of animals in motion—galloping horses, birds in flight—giving the appearance of motion through the projection. It is not really known whether he included the full range of photographic subjects that he elsewhere used in his lectures, where the human bodies were naked or near naked to reveal the articulations of bodily movements. In these examples, the men usually engaged in athletic feats such as boxing, fencing, throwing a ball, or physical labor such as blacksmithing or bricklaying. The women were naked or in translucent, diaphanous drapes that provided an erotic veiling while still making the contours of the body available for view. These women waltzed, curtsied, flirted, got in and out of beds and hammocks, and opened parasols.[2]

Muybridge's theater at the Exposition, however, did not do well. Given the paucity of specific detail about which motion studies Muybridge actually included in his lectures as well as claims that Muybridge's educational illustrated lectures could not compete with neighboring shows (the Moorish Palace and the Street of Cairo) that featured sexually titillating female dancers, one might conclude that

Muybridge showed only his animal motion studies.[3] Whatever his program material, Muybridge responded to the commercial failure of his hall by selling his motion studies as souvenir engravings, plates, and phenakistascope disks mounted on handles as fans. Muybridge's solution was to turn a rather unpopular, didactically "educational," and technologically produced display into a market of commodities.

What emerges from any investigation of the localized instances of proto-cinema at the Exposition is that they were not very important to those who produced the fair or to those who recorded their responses to the fair. One fair chronicler even goes so far as to reflect that the audiences for what he calls the "germ of the movies" were both "relatively small and indifferent."[4] The marginalization of such sites within this kind of reception seems both curious and surprising to today's historians, except that the historical meanings of such "pre-cinema" installations were produced in more complex ways than through an obvious or simple definition according to the function of the emerging technologies. The ways in which fairgoers learned about "the cinematic" at the Exposition had little to do with the emergent apparatus now associated with the origins of cinema. Fairgoers learned about a new modernist, cinematically situated spectatorship because it was part of the overall discursive formation of visual culture and the social practices acting upon the observer's construction of knowledge.

At stake in recognizing such a historically specific spectatorship is an opportunity to reformulate cinema's cultural origins and its claims upon a historical audience composed of diverse, heterogeneous groups. As Jonathan Crary argues in *Techniques of the Observer*, revolutions in the nature and function of the visual sign do not happen independently from the remaking of the subject. The standardization of cinema and of photography "must be seen then not simply as part of new forms of mechanized reproduction but in relation to a broader process of normalization and subjection of the observer."[5] Cinema is dependent on social formations that one can trace at the fair, which contains them.

Crary argues that a new kind of observer was made in the nineteenth century through a radical abstraction and reconstruction of optical experience redefined as subjective vision. He reconfigures Michel Foucault's notions of surveillance and spectacle as overlapping, coinciding regimes of power: "[Surveillance and spectacle] were the techniques for the management of attention, for imposing homogeneity, anti-nomadic procedures that fixed and isolated the observer."[6] The autonomization of sight was a historical condition for the rebuilding of an observer fitted for such grand spectacular consumptions as the department store or the exposition.

According to Crary, such claims occurred through forms of power that depended on an abstraction and formalization of vision. But Crary fails to realize that an autonomy of vision that depends upon an empowered body as the source of knowledge does not axiomatically authorize all social bodies as equivalent sources of knowledge. The techniques of surveillance and spectacle—of seeing and being seen—were deployed culturally as *gendered* practices, producing distinctly modern responses to the confusion and threat of class and gender changes brought on by working-class women's unprecedented entrance into the public sector. What is important here is how the empowerment and regulation of observer knowledge as identified by Crary was itself a technique of power within the cultural formation. Amid the localities in which concrete acts of vision occurred, the construction of gendered subjects of visual knowledge became a significant means of cultural hierarchy, a technique by which subjects assumed both social and self identities.

More than an archive for the origins of modern consumer culture, the Exposition was important because it became a ground for the practices that constituted modern spectatorship. The relevancy of gender is evident in the ways that mobile spectatorship functioned within the Exposition. The Exposition rewarded the autonomization of sight as a distinctly modern experience while it simultaneously reaffirmed social differences through visual experiences.

The flaneur, to many Americans, may have suggested that America promised to become what it would in fact become, not a network of independent homesteads and small towns, but the world's foremost industrial consumer society, producing and consuming the greatest number and concentration of spectacles, products, and images, and containing the greatest diversity of human types.

 Dana Brand, *The Spectator and the City in Nineteenth-Century American Literature*

Sexual liberation for women under capitalism has had the nightmare effect of "freeing" all women to be sexual objects (not subjects). It must be admitted that women have collaborated actively in this process.

 Susan Buck-Morss, "The Flaneur, the Sandwichman, and the Whore"

The figure most frequently discussed as emblematic of the subject made over into a modern spectator is the flaneur. The flaneur was a wandering gentleman observer who looked into the faces of the nineteenth-century urban crowd and put *his* experience to literary form. In common usage, the flaneur was someone who ambled or

strolled through city streets and observed life around him. Walter Benjamin identified the Parisian flaneur of the 1830s as a "panoramically situated" spectator who goes "botanizing on the asphalt."[7] Benjamin's flaneur, who emphasized the randomness of his experience, wrote to make it appear as if he could interpret the crowds around him.

Several critics have extended Benjamin's discussion of the flaneur as a new mode of spectatorship, one that absorbs a "ceaseless succession of illusory commodity-like images."[8] In particular, Susan Buck-Morss has concluded that Benjamin was interested in the flaneur because he was a figure of a modern spectatorial consumer: "In the flaneur, concretely, we recognize our own consumerist mode of being in the world."[9] For Benjamin, the flaneur was a dialectical figure who presented himself as open to everything but who actually saved himself from the chaos of randomness through his pretensions to epistemological control. By reducing the city to a panorama or scale model, he transformed urban diversity into a series of miniaturized, accessible images that could be collected, organized, and consumed.

Although most critics have thus far tied the flaneur to the rise of European urban modernism in the early nineteenth century, Dana Brand has convincingly shown that the flaneur was also transplanted from London culture to U.S. cities in the middle and late nineteenth century. Brand not only argues that the flaneur was an English form of modern consciousness but that the flaneur's transplantation to the United States is part of this country's tenuous urbanism and cosmopolitanism in the middle nineteenth century.[10] Brand challenges literary critics who have especially favored the western frontier as a symbol for the anti-urban recapturing of a premodern innocence in nineteenth-century American literature and emphasizes instead the flaneur's American presence as especially important for rethinking the origins of modern subjectivity in American settings.

But it is equally important to think of the flaneur as a gendered subject—that is to say, as a male subject for whom the streets were accessible, unrestricted public spaces that posed no physical danger or taint of disrespectablity. As Anne Friedberg, Susan Buck-Morss, Janet Wolff, Elizabeth Wilson, and Anke Gleber have noted, sexual difference complicates the politics of loitering: "The female flaneur was not possible until a woman could wander the city on her own."[11] For a woman to assume flanerie in the nineteenth century was to risk being viewed as a prostitute: "The flaneur was simply the name of a man who loitered; but all women who loitered risked being seen as whores, as the term 'street-walker' or 'tramp' applied to women makes clear."[12] Yet, as Gleber skillfully argues, the prostitute was not simply a

flaneuse because "the prostitute . . . does not have the streets at her disposal any more than she commands the use of her own body. . . . [She is] nothing if not the cynically distorted female image of consumption and flanerie in an age of capitalist and sexist exploitation."[13] For example, the flaneur maintains a purposeless gaze whereas the prostitute's gaze must always be purposeful. Gleber argues that even a prostitute's physical mobility on the streets was limited since she was still subject to the controlling gazes and attentions of male passersby, to prejudgment and to prejudices, as well as to police actions or the threat of police harassment, which disciplined the prostitute to regulate and to limit her appearances and movements. In other words, she could neither assume the cloak of anonymity associated with the flaneur nor transcend the techniques of power that regulated her. And to some degree every female flaneur shares with the prostitute the onus of "surveillance, suspicion, and harassment that her male predecessors and contemporaries do not habitually expect to face."[14] These techniques included everything from scrutinizing looks to sexual assaults to police encounters and arrests.

The fate of the ambulatory woman on the city street provides an important context for understanding the historical and material conditions of gendered spectatorship at the Chicago Columbian Exposition. Since, as Elizabeth Wilson argues, so many (male) writers characterized the big industrial cities of Europe and America by their promise of sexual adventure outside the constraints of family, women's very presence on those streets was a visual symbol of that promise.[15] Prior to the 1890s, women's appearances in public were necessarily codified and regulated according to a well-defined set of conventions. If loitering and alone, she risked being regarded as a prostitute, the visual symbol of the temptation of sexual adventure—but now condensed in a market economy to a bodily icon of economic exchange. The respectable woman appeared in public only escorted by a gentleman, and they strolled only within the temporal and spatial terms of the promenade, an elite ritual of public social exchange in which bourgeois couples paraded up and down the street nodding to each other, seeing and being seen. City life was organized through rigidly gendered spaces that attempted to assign order to the increasingly disorderly city by mapping women's containment onto such rituals of public appearances as the promenade and thus posing control of women as the solution to moral and political order.

In the late nineteenth century, however, massive population and employment shifts remade the physical institutions of modern city life into sexually integrated spaces. In the 1880s and 1890s, the female urban labor force expanded at a rate twice that of the increase in the female population.[16] Chicago, in particular, attracted

women workers at a rate of increase three times as great as the rate of increase of the female labor force for the nation as a whole.[17] As Theodore Dreiser noted in his novel *Sister Carrie*, "In 1889 Chicago had the peculiar qualifications of growth which made such adventuresome pilgrimages even on the part of young girls plausible. Its many and growing commercial opportunities gave it widespread fame, which made of it a giant magnet, drawing to itself, from all quarters, the hopeful and the hopeless."[18] Among the rapidly increasing numbers of women who migrated or immigrated to Chicago in the last two decades of the nineteenth century, a sizable number boarded or lodged in urban houses or apartments where they lived apart from family, relatives, or employers. Popularly known as "women adrift," they symbolized a modern urban individualism of self-seeking women who traversed urban spaces. They appeared alone in the city in such large numbers that their public wanderings were a new mobile visible signifier of an independent female sexuality, threatening the status quo of gender roles and relations whereas the flaneur did not.

The popular idea that urban spaces, the city streets, and the crowds allowed for and even authorized degrees of power and control for the flaneur does not extend to a flaneuse, who was differentiated at the time by the designation "woman adrift." Even this designation signifies these women as wandering but also as lost and, therefore, requiring saving. Implicit in the popular term is the middle-class belief that women adrift on the street were, in fact, "pure and passive orphans threatened with sexual danger."[19] Indeed, the "woman adrift" was an important reinscription and containment of a more radical figure since these women's presence and visibility indicated that the city offered women freedom and a certain amount of independence. As Elizabeth Wilson says, "Yet the city, a place of growing threat and paranoia to men, might be a place of liberation for women. . . . True, on the one hand it makes necessary routinised rituals of transportation and clock watching, factory discipline and timetables, but despite its crowds and the mass nature of its life, and despite its bureaucratic conformity, at every turn the city dweller is also offered the opposite—pleasure, deviation, disruption."[20] But the term's frequent and common usage in turn-of-the-century planning reports, social welfare studies, and government commissions remade the working girl, lured by the pleasures and independence of the city, into the bodily signifier for the dangers of the city. Her presence symbolized the possibility of what was most feared or desired by others. By remaking her as a potential victim in need of constant supervision and protection, reformers and civic leaders sought to reassert the rigidly gendered geography and social practices that had sustained the image of the city as orderly.

The popular stereotype of "women adrift" filled not only numerous dime novels and romances by the turn of the century but even extended to the fictional literature about the World's Columbian Exposition. For example, in *The Adventures of Uncle Jeremiah and Family at the Great Fair*, the young Fanny leaves her downtown Chicago hotel and family to shop alone and to wander the city's streets, only to be taken in by a "confidence man" who appears to be a gentleman. He suggests that they walk over to his mother's and sister's house so that she may meet them and get their advice on Chicago's best shopping. Fanny's younger brother Johnny, who has already encountered his own street danger in a gang of youthful thugs, espies Fanny but sees nothing wrong. It is only Johnny's friend, the street-wise Chicago lad Louis, who recognizes the confidence man and the house of their destination as an infamous brothel. He understands the semiotics of the Chicago street, and he warns Johnny. The two boys together rescue Fanny before she can enter the house.[21] Even the female tourist who is alone and strays from the confines of the department store takes the same risks as the woman adrift, and she narrowly escapes enslavement as a prostitute. The moral is quite clear: the city streets are not safe places. The gentleman in the crowd may be a procurer, and the house that sports an elegant, cultured facade may be a house of prostitution. The city poses sexual danger for the unaware or naive woman who misreads the signs.

In this regard, Chicago proper in 1893 provided an antithetical space and visual culture to the well-planned, safe, and highly readable spaces of the World's Columbian Exposition. Chicago streets seemed especially dangerous to the middle class because they promoted physical contact between white citizens and immigrants from a variety of foreign cultures. As one Wisconsin woman visitor to the fair wrote home in 1893: "I hardly know what to say of the city. It was worse than the confusion of tongues at the Tower of Babel. Humdrum noises and confusion existed all day and all night long."[22] The figure of Babel, connoting "polyglot" cultures and incomprehensibility, permeates the literature.

If racial and ethnic diversity was a hallmark of Chicago in 1893, a proliferation of guidebooks produced for the burgeoning tourist market mediated the confusion and fear that characterized the reception of such diversity, unchecked on Chicago's streets, and purposively tried to organize it according to the strict division of gendered public spaces that was the familiar landscape of the flaneur. Rand McNally Company, in particular, recommended a new kind of urban flanerie, strolls that never completely immersed the visitor in the city but rather allowed the visitor to consume it through a series of visual impressions, to "keep him or her at arms'

length, only cautiously entering the city at all."[23] The ideal was to remake the city as a safely gendered panorama by offering men and women separate spheres in which to circulate.

For men, the guides proposed a "nocturnal ramble" through the "Bad Lands of Chicago"—its gambling and drinking district, the Chinese quarter and opium dens, the Jewish and Italian ethnic neighborhoods, and cheap hotels and brothels.[24] Although the flaneur-turned-tourist still wandered the city streets, his ramble was no longer purposeless and had an itinerary that was expressly not for partaking of any of these offerings but solely for visually consuming the "haunt[s] of color and habitat."[25] The guidebook expressly stated: "If you are in search of evil, in order to take part in it, don't look here for guidance. This book merely proposes to give some hints as to how the dark, crowded, hard-working, and sometimes criminal portions of the city *look* at night."[26]

Whereas any woman's appearance in "the Bad Lands" typified her as a prostitute, the guidebook provided an alternative by mapping out proper spaces in which female tourists should wander the city environment. It offered "suggestions as to Shopping" and described department stores, shopping bazaars, and parks as appropriate venues for women's strolls.[27] For example, when a group of Missouri schoolteachers visited the fair, the only other parts of the city to which they traveled were nearby Washington Park, Lincoln Park, the boulevard along Lake Shore Drive, and what was described as "a very circumspect pilgrimage" to the downtown skyscrapers.[28] As James Gilbert notes, "The guidebook imposed more regularity on the urban experience and expanded the safe places for men and women to visit."[29] For women, the model was to restrict her public wanderings to an activity that could both time her appearances according to a regularized schedule and contain her visibility as a symbol of conspicuous display within strict urban geographic boundaries. The guidebooks even included the name and address of a commercial service that existed solely to aid women in following this practice; the Women's Directory, Purchasing, and Chaperoning Society on Van Buren Street provided escorts to help women who were unfamiliar with Chicago to negotiate the city streets and stores in the appropriate ways.[30] Such regularity configured the city as a public space with geographically gendered boundaries and prescribed negotiations that served as models for spectatorial negotiations of the Exposition itself.

These women as shopping spectators (whether they ambled alone, were accompanied by men, or walked in groups of women along city streets) were hardly flaneurs in any proper sense of the term. Although for Anne Friedberg the female

shopper is an unqualified flaneuse, Gleber rightfully counters that theirs is an "ersatz flanerie," dramatically contained within tightly cordoned-off spaces of restricted mobility. Moreover, their act of gazing is circumscribed to peering into windows. They are provided specific models for consumption, are given highly regulated and standardized modes of circulation through department store spaces, and are surveyed constantly by floorwalkers.[31] In this situation, the identity of the female shopper is dependent upon viewing herself as constantly being viewed, upon forms of surveillance and self-censorship: "Women in capitalist society—all women—impersonate commodities in order to attract a distracted public of potential buyers, a mimesis of the world of things which by Benjamin's time had become synonymous with sexiness."[32] These words aptly characterize the best-known figure of a female shopper from the period, Sister Carrie. Carrie, the protagonist of Theodore Dreiser's naturalistic 1900 novel about one young girl's struggles through the moral confusion of the turn-of-the-century city, hinges her fate on her desire for nice clothes as she walks through The Fair, a Chicago downtown department store: "Not only did Carrie feel the drag of desire for all of which was new and pleasing in apparel for women, but she noticed, too, with a touch at the heart, the fine ladies who elbowed and ignored her, brushing past in utter disregard of her presence."[33]

In this way, Dreiser attaches importance to clothes, to a woman mimicking a store mannequin, as a prerequisite for visibility. Carrie's *invisibility* to other women in contradistinction to the "fine ladies" around her is an indication of her nonexistence, an acknowledgment that ignites a new desire in her for "what the city [holds]—wealth, fashion, ease—every adornment for women . . . for dress and beauty."[34] Once Carrie takes command of the society of consumption, she feels that her existence is real: "To stare seemed the proper and natural thing. Carrie found herself stared at and ogled . . . With a start she awoke to find that she was in fashion's throng, on parade in a showplace—and such a showplace."[35] Carrie's "rise" to a status of visibility is dependent both upon her spectacularization and her self-identity as an object of spectacle.

For Dreiser, himself a journalist for the *Chicago Globe* in the late 1880s and early 1890s, as well as for other journalists, guidebook authors, and travel writers, the flaneur as a strolling spectatorial consumer served as an important predecessor for their claims to urban knowledge. Like the flaneur, the writers in the 1890s invented "a cityscape intended as a kind of literary cosmetic to be dabbed upon experience itself."[36] But their subjective construction of knowledge was continually being displaced by photographic representation and its concomitant autonomization of visual observation. While this is certainly true for Dreiser's mode of narrational

observation, it is most apparent in the journalistic genre of the urban sketch practiced in the 1890s.

One of the most widely read journalists in the country (and an important literary model for Dreiser), George Ade wrote street fables for the daily *Chicago Record* from 1893 to 1900. For Ade, the dense varieties of Chicago life and its many potentials for pleasure were the same as for the flaneur. Like many of his predecessors, Ade specialized in the urban anecdote, transforming the struggles of the working classes, the disparities of wealth and poverty, and the tensions and uncertainties of modern city life into slang-filled, psychological profiles. In Chicago's daily routines, Ade saw regular disappointments, moral downfalls, and social hypocrisy. In the well-heeled tradition of flanerie, Ade often rendered the abundantly fascinating dangers of the city in the bodies of women.

For example, in "The Stenographic Proposal," it is the female "type-writer" who tempts the young male stenographer every day through her mere presence. For she is a respectable woman adrift, the daughter of an upper-class civic leader who recently bequeathed his family only his debts.[37] The stenographer's disappointment is that she agrees to marry her boss before he has an opportunity to propose marriage. The scenario of the employer's proposal is played out as a primal scene, a conversational exchange silently observed and recorded by the stoic stenographer from an open doorway. He masters his sense of the loss of the object of his desire by writing down the conversation in shorthand.

Ade's outlook may be similar to that of the flaneur's. But he no longer writes from the vantage point of the thick of the crowd. He offers up the city and its inhabitants as characters largely from the distance of an implied visual frame. His vantage point is that of the voyeur, the stationary unseen invisible spectator who is described as "a guilty eavesdropper."[38] He watches and listens, an observer whose position is more like that of the cinema spectator.

In another sketch, entitled "From the Office Window," Ade's protagonist is just such a cinematically situated observer.[39] He is a young Chicago office clerk promoted to an office with a window that allows him to see four windows in the building wall opposite him. Ade's clerk is heir to the flaneur as the interpreter of urban life around him but, more significantly, father to the cinema spectator as he learns the semiotics of the sun's reflections and shadows on the windows across the court. He has been repositioned and distanced from the thick of the action through the imposition of the glass, which serves both as a frame for a series of images and as a partition that removes him from physical immersion in the events being depicted, keeping him especially apart from the dangers of female sexuality. His social

anonymity and invisibility are heightened, but at the expense of mobility, as he becomes a stationary *seeing* observer for whom life as a panorama rolls by and is theatrically framed as though for his vision.

First he watches an old man in the lower two windows. As he listens to the man whistle, he notes that the man's emaciated body, slow-moving gestures, and out-of-date tunes cannot signify newness or modernity. So Ruggles shifts his attention to the upper two windows, where he observes an elderly woman introducing two policemen-suitors to a young girl. Rather than watch the repetitive motions of the old man at labor, he observes daily the sexual scenario of competitive courtship in front of him in the two upper windows. Work and sexual pleasure are here contrasted as the two poles that the city has to offer a young man. Rather than *listen* to the old man, he is charmed by *watching* the silent narrative unfold. But then the young girl disappears from the scenario, and "for a time Ruggles looked in vain for the girl."[40] Her loss prompts his transfer to another office "half across the continent" for nearly a year.[41] When he returns, he "slipped into his old seat with a feeling of comfort and satisfaction. The wall and the bit of sky seemed to welcome him."[42] Here Ruggles plays out the scenario of the cinema spectator, whose relationship to the images before him is figured as a sequence of possession and loss of the female body connected to the possession and loss of light-reflected images. His return to the symbolic "theater of cinema" is represented as pleasurable, and his "sigh of relief that nothing had happened" since his absence—his hope that the narrative waited just for him—is disappointed by the appearance of the girl looking older, "not quite so merry-faced," and with a baby in her arms.[43]

"From the Office Window," like many of Ade's other stories, incorporates both the aggressiveness of female sexuality and illicit sex as a representation for the attractions and dangers of the urban environment. But since the stories are narrated from a safe distance of male spectator invisibility, there is no possibility of any kind of contamination or taintedness. James Gilbert summarizes: "[Ade] emphasizes his detachment, his vaguely aroused interest, his safe separation through the glass. With his unproven assumptions and his wink at the reader, Ade underscores this point of view and suggests a literary syntax in which to place the most tragic events. Even scandalous incidents in the lives of others could be counted as mere curiosities."[44] The inscribed spectator is not subject to the danger of becoming objectified and consumed by the gaze of another. Gilbert notes the significance of this observational position: "[Ade's stories] provide a glimpse of something illicit; he lights a flicker of salaciousness and then quickly extinguishes it . . . Diversity, poverty, dan-

ger inhabit the city, he says, but they can be transformed or evaded."[45] The new modern figure of consciousness required a different kind of legitimization, one that conferred upon him the authority for reasserting the social hierarchy that was continuously being challenged in a City of Babel. The voyeur's power of surveillance endorses his position of visual superiority while it extends the pleasures of a consumerist mode of knowledge formerly associated with the elitist flaneur to a new range of the masses of the middle class.

In the history of the imagination, 1893 was . . . a remarkable time, and nowhere more so than in Chicago. That year perhaps a tenth of the American population packed its bags and caught the train for a pilgrimage to two Chicagos: the shining white city of the World's Columbian Exposition on Lake Michigan, and the smoky gray city which hosted it. Their voyage made this the most significant tourist event in American history at a point when tourism itself was only a recent possibility for many people, and still an improbability for most.

James Gilbert, *Perfect Cities: Chicago's Utopias of 1893*

At the fairs the crowds were conditioned to the principle of advertisements: "Look, but don't touch," and taught to derive pleasure from spectacle alone.

Walter Benjamin, *Das Passagen-Werk*

If metropolitan Chicago was unpleasurable and even criminally threatening to the female tourist and if a proper feminine tourist immersion in it meant the more restricted ambulatory mode of shopping, then the World's Columbian Exposition attempted to counteract and expand upon feminine purposes for being "on the streets." For white middle-class women, in particular, the Exposition promised the freedom of the city and the unlimited possibility of the boulevard promenade. Neil Harris summarizes the Exposition's meaning: "There was an obsession with demonstrating the orderly management the expositions enforced on the perils of social congestion. These fairs were designed to be safe, clean, peaceful, and easy to move through."[46] Harris and James Gilbert address the Exposition as a late nineteenth-century rationalized but heterogeneous public space, like that of the museum or department store, for the specular consumption of commercial commodities.[47] Along with historians Alan Trachtenberg, Robert Rydell, and John Kasson, they define the Exposition as a signal event representative of the shift or rupture in American society that characterizes the origins of modern experience and particularly of experience rooted in a new mode of vision.[48] But they all ignore the cen-

trality of gender in making up that vision. What is integral to its definition of the modern is how the Exposition constructed a socially sanctioned public space for women's participation, promising the possibility of mobile spectatorship in a safe urban environment.

The 1893 Chicago World's Columbian Exposition was a fabricated environment, a world of consumer capitalism that contained an encyclopedia of objects and peoples. It housed dynamos, reapers, trolley cars, and commodities of industry and commerce. Harris describes the object-filled displays that showed off the industrial and technological wealth of the western world: "[The interiors of] the fair buildings were little more than huge sheds, filled with bazaars, pavilions, tents, booths, heaping on their shelves and cabinets the latest products of art, science, and industry. Some of the pavilions were organized by nations or states; others, by corporations which were like small empires themselves."[49] These pavilions, imitation neoclassical and Renaissance palaces, were arranged in a carefully laid-out plan of axial boulevards, grand vistas, giant fountains, statuary, and lagoons.

These were the buildings and spatial arena photographed repetitively for commercial albums and guidebooks as the official views that pictorially produced analogies to the department store interior and even inscribed preferred vantage points from which to view both the great interiors and the grand court.[50] Even when a visiting journalist like North Dakotan Marian Shaw was "disappointed" at her first views of the Exposition because the entrance she used from the train station was behind several buildings and in a service area, she knew enough to walk toward Lake Michigan to the "broad, beautiful avenue" where she then emphasized her better view of the grounds as the *real* one.[51] Shaw, like so many other journalists who covered the fair, lapsed into metaphors of a heavenly afterlife to describe the Court of Honor. This Court of Honor that became the focus of so many travelers' descriptions was, as Harris says, "the Sunday clothes of the exposition where monumental planning received its consummation."[52]

Photographs of the fair encouraged a similarly singular reading of the fair experience centered on the Court of Honor as a celestial city of orderly open spaces, brilliantly reflected light on pools of water, and white buildings—or as a ceremonial center for black masses of crowds gathered together. They occasionally depicted a lone observer posed along a railing or sight line so as to extend a pictorial vantage point for panoramic viewing. Such a unified photographic vision was made possible because the Exposition's commissioners carefully regulated the taking of

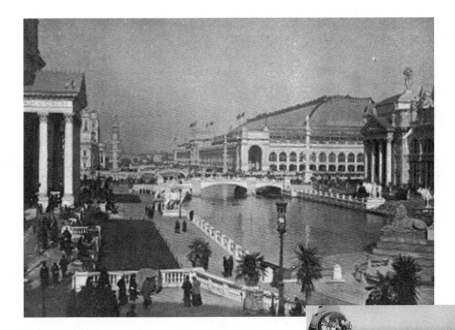

pictures on the grounds. They pictured the fair for souvenir albums, official records, and other types of discourse that promoted the Exposition within the codes of visualization for ceremonies, pageantry, and urban advertisements.[53]

The photographs reproduced the architecture as a monumental backdrop or set piece designed to be exploited for visual pleasure. While the whole of the fair's plan also had to function as an arrangement for people to move through and in which to live and work, it was primarily represented and promoted as a spectacle. Photographs repeatedly offer wide-angle views of empty or nearly emptied spaces, heightening the atmospheric show of the buildings and sculptures. This effect is especially intensified in the number of photographs taken at night whose highly theatricalized drama depends on the contrasts of light and dark in displays of both the electrical

16 "Like a Glimpse of Venice." The South Canal, 1893 Chicago World's Columbian Exposition. From *The Columbian Gallery: A Portfolio of Photographs from the World's Fair* (Chicago: Werner Co., 1894).

17 Charles Dudley Arnold, "Southeast Corner of the Manufactures Roof Promenade," Chicago World's Columbian Exposition. Courtesy Avery Architectural and Fine Arts Library, Columbia University.

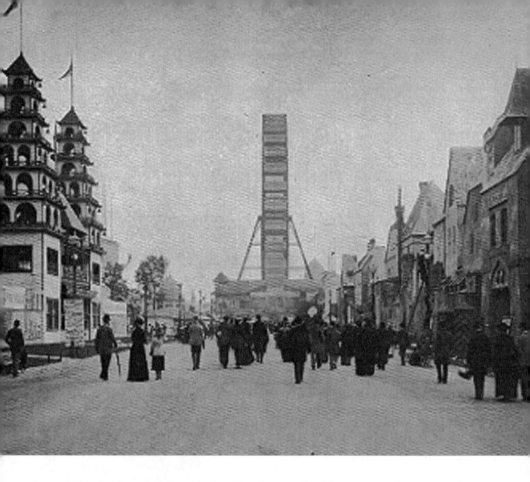

illuminations and fountain jets. In other words, this was not a city portrayed as a functioning site for commerce and industry but rather for visual consumerism and specifically for flanerie. Even its parts frequently functioned in relationship to this overall purpose. For example, the moving sidewalk at the fair, touted as a new technology for urban pedestrianship, was located as a promenade along the beach of Lake Michigan, its purpose not for improving circulation through the fair but for affording better panoramic views of the Court of Honor. The "dream city" extended to the entirety of the city the notion of the arcade as an urban architectural space designed specifically for flanerie.

The sections of the fair beyond the Court of Honor maintained this unified sense of purpose and urban visuality. The Wooded Island, designed by Frederick Law Olmsted, was a romantic park in its imitation of the natural environment, a

18 "The Midway Plaisance." From *The Columbian Gallery: A Portfolio of Photographs from the World's Fair* (Chicago: Werner Co., 1894).

space for leisurely promenades. It housed the Ho-o-den Villa and teahouse sponsored by the Japanese government. It represented an urban escape valve and the personal need for solace in nature strolls. As described by Marian Shaw, "No sound of traffic or labor disturbed the quietness of the scene. But for the crowd of pleasure-seekers wandering through the broad avenues, we could scarcely have realized that it was a city of the living."[54] The Wooded Island allowed for a bifurcated split of the utopian city by constructing nature (and simultaneously the Orient) itself in opposition to civilization and by contrasting silence as welcome relief from the sounds of the city.

Located along the western end of the Exposition grounds, the Midway Plaisance was a container for the elements of carnival and circus that always sprang up around international expositions as well as for those elements of racial and ethnic difference and sexual adventure that so thoroughly marked the new modern city. The Midway was a broad avenue that connected the Court of Honor with the tent cities and sideshows of commercialized popular culture that camped outside the fairgrounds. The Midway was organized in three distinct sections, although there were numerous restaurants, cafés, and small theaters in each section.[55]

The exhibits and their juxtapositions defined exotic cultures as a combination of scientific visual anthropology, tourist concessions, and salacious sexual entertainment. For example, the Moorish Palace featured a series of "authentically" designed and decorated rooms along with a wax museum of popular figures, the guillotine that executed Marie Antoinette, and "the Persian Palace of Eros with a ground floor bazaar for trade and an upstairs 'trade for the bizarre.'"[56] The *Pictorial Album and History of the World's Fair and Midway* describes the spectatorial pleasures therein: "Old men and wicked youths haunted the little den called a theater and watched, in a bleary-eyed ecstasy, the Oriental athletes of the stage as they danced, toyed with the cigarette, and by their smiles gave a Persian-Parisian charm to the anomalous entertainment."[57] The *Chicago Daily News* drama critic Mrs. Lillie Brown-Buck (who wrote under the pseudonym Amy Leslie) described the degree to which she understood such spaces as exclusively gendered in her description of her single visit to the theater: "A writhing Scheherezade [*sic*] in two shades of pink floated about the miniature stage by a series of muscular dislocations most alarming to a citizen of less sinuous education. I never beheld quite such an exhibition and I beheld this particular one about two minutes . . . I am not up in the Sodom and Gomorrah of it but it has worried me a trifle."[58]

Although both Harris and Rydell have demonstrated that the Midway was a

way of extolling exoticism and of incorporating racial difference by emphasizing a social Darwinian geographical hierarchy of races, Gilbert argues that the coherence of the Midway was based upon "the unfamiliar . . . couched in familiar terms; what was foreign was made acceptable and commonplace. The tourist was reassured that what he or she viewed was authentic and, at the same time, fantasy."[59] Marian Shaw, the journalist from North Dakota, described it as a combination of "all peoples, tongues, nations and languages assembled for a summer holiday . . . [but] typical only to a certain extent. They represent some phases of foreign life, but it is life in its most whimsical aspect."[60] Amy Leslie said, "There is a spice of adventure, something rakish and modestly questionable about this legalized harlequinade of other people's habits . . . Girls blush a little, not very much, and pellucid grangers . . . act devilish when mentioning a prospective tour through this licensed street of preferred iniquity."[61] To women journalists who wrote disparagingly of the noise, crime, and dirt of Chicago proper, the polyglotism of the Midway was unthreatening and even amusing, an example of the confusions of the city remade into spectatorial pleasures.

For example, The Street in Cairo featured replicas of Egyptian buildings, Egyptian mummies, and other museum treasures as well as camel and donkey rides. The *Pictorial Album and History of the World's Fair and Midway* describes its reception: "People went wild with delight. They slipped into the Old World through a gate and reveled in the novelties of camel and donkey riding, of wedding marches in the air, of sword bouts, bazaars, and theaters. Flitting through the hurly-burly of strange creatures, one beheld veiled women, who saw but could not be seen . . . People who had only read about the veiled women of the Orient here had an opportunity to study the reality of costume."[62] The album suggests a heterogeneous space of spectatorial address unified by the promise of sensory pleasures and the consumption of the unusual and the fantastic.

But Shaw offers a perspective that begins to reassign mixed value to the space according to visual and auditory markers codified according to feminine social values. She remarks on the pleasures of mimesis and models: "In the street of 'Old Cairo' may be seen a perfect representation of the narrow roadway and picturesque architecture of the old Egyptian city . . . Many curiosities and antiquities are offered for sale in the bazaar. In this street may be witnessed the curious ceremonies of an Egyptian wedding and a birthday festival."[63] But she notes with displeasure the auditory sensations that she links to overtly racist typology: "[The donkeys are] driven by barefooted, yelling little Arabs, who, clad in long, dirty white garments

resembling night gowns, scream and hoot and pummel the long-suffering beasts . . .
[The] little howling Cairo-street Arab can far surpass [the young American] . . . as
regards variety and intensity of the shrill sounds that issue from his barbarous little
throat."[64] Unpleasant sounds become attached or mapped onto bodies that are un-
derstood as primitive, unrefined, or, in her own words, "barbarous." Auditory ex-
perience supports the observer's visual reading of a hierarchy of races and especially
of the unpleasurable social experience of their mingling in a crowd.

Even though it was figured like Chicago proper as a City of Babel, the Midway
Plaisance could still be remade as a safe, coherent space through emphasizing its
negotiation as a *visual* spectacle rather than as *auditory* sensations. For example,
Theodore Dreiser wrote about women's experiences of the Midway when, as a
reporter for the *St. Louis Republic*, he escorted to the fair twenty-four Missouri
schoolteachers who had won a contest sponsored by the newspaper. Dreiser em-
phasized the ladies' safety even in exploring the more prurient parts of the Mid-
way.[65] He implies that even the Midway's polyglot avenue was safe for women visi-
tors who were themselves remade into "harmless" objects of specular consumption
as part of the experience.

It is in such written descriptions and participants' accounts rather than in the
formal photographs that one begins to see the importance of the fair thoroughfares
and especially of the Midway as a new socially sanctioned urban space for involving
both men and women in the visual pleasure of their own participation in public
spectacle. *Chicago Daily News* critic Brown-Buck observed this phenomenon, her
insight due perhaps to her career as an actress and her sensitivity to social behavior
in theaters: "A certain unusual configuration observable in the floating populace is
in the main due to the celebrations involving cosmopolitan interests. The presence
of spectacle in various stages of perfection and development, and a couple of bur-
lesque troupes, together with assembling nations. Girls, girls, girls!"[66] Elsewhere,
she more succinctly quoted a woman whom she overheard on the Midway Plaisance,
"'Let's go to the forestry and see nature. This is like a theater.'"[67] Journalists like
Dreiser and Brown-Buck suggest a particularly pronounced gender inflection to
women's participation at the Exposition that made the space itself into a safe urban
stage—a theatrically spatialized extension—of a newly available flanerie for women.

The hawkers, too, learned to follow new codes of visual spectacle. Because fair
authorities wanted to regulate and control a sound environment initially marked by
auditory volume, excess, and confusion, they outlawed the oral selling of wares.
The author of a souvenir photograph album describes the situation:

A special feature of the Midway was its noise, the volume and variety of which first astonished and then pleased the visitor. The street was a Babel without a tower. Vendors of common and unique wares, criers for places of amusement, uncouth music on uncouth instruments, merchants in the hot kabab (sausage) trade, and traders in Oriental wares, commingled their voices and their trumpets continuously . . . The Fair authorities did not appreciate the situation . . . They issued an edict for silence.[68]

But the author also suggests that the auditory experience, which may have meant confusion or danger to some, also suggested the pleasures associated with flanerie:

The looker-on enjoyed these vocal contests. There was a breeziness and spiciness that enticed the pleasure-seeking public. Thousands stopped, listened, laughed and "caught on to" for repetition, the sententious "Ot! Ot!" of the Selabia waffle man, the winning speech of the Ottoman with his "here here! Turkish girls—pretty girls—up-stairs," and the veracious assertions of the ostrich man that "they're all alive! they're all alive!" There were hundreds of such special pleaders . . . Without them the Midway would have been lonesome.[69]

So if the Midway initially mimicked the din associated with city streets, Exposition officials remade the Midway into an auditory space that would be less offensive to women like the lady from Wisconsin or journalist Marian Shaw. As a response to the Exposition's edict of silence, Midway concessionaires hired pantomimists who continued to "hawk" entertainments and objects to crowds who now gathered around to watch these silent demonstrations.

The same souvenir album that provides such detailed, lengthy descriptions of the Midway's auditory environment, however, does not use printed language to interpret the revised setting. Instead, it portrays the remade Midway through two photographs of the pantomiming hawkers.[70] In both cases, hawkers stand in front of signs advertising foreign dancing girls ("Persian Palace Dancing Girls," "Dark-eyed Bedouin girls dancing") and appear before gathered crowds. The highly specialized, autonomous visual experience of the photograph focalizes the visual experience, mimicking the remaking of the observer that Crary identifies as one wholly given over to visual knowledge.

Throughout, the Columbian Exposition mediated the dialectical tension that characterized nineteenth-century urban life: it masked and obviated the social dangers of mixing classes, races, and ethnic groups through its highly controlled and regulated urban environment while it simultaneously celebrated the newness and excitement of modern urban life. It was an attempt "to enclose reality in manage-

able forms, to contain it within a theatrical space, an enclosed exposition or recreational space . . . If the world outside the frame was beyond control, the world inside of it could at least offer the illusion of mastery and comprehension."[71] The Columbian Exposition asserted itself as a safe cultural environment that disguised and distanced itself from the effects of the city marketplace, from the chaos and dangers of the congested street.

The effects of this assertion may be best illustrated in artists' ink drawings of the fair. Sketches drawn by ambulatory journalists (whose newspapers were barred from bringing in cameras) offer representations of people caught in the act of walking and seeing that depict the point of view of the flaneur.[72] These drawings show what the Exposition's more formal commercial portraits of the architecture and grounds could not—female observers caught in a triangle of looking relations. The women simultaneously gaze at exhibits and at passing men while other men look at the women. The Exposition's official emphasis on photographic formality and monumentality precluded and even disallowed the representation of the observer caught in the act of looking. On the occasions that photographs did depict the act of looking, the observer was located and posed for viewing the scene as panorama, thereby suggesting to the photograph's audience the preferred vantage point for placing oneself in the picture. The presence of individual bodies acts as support for the vantage point of the larger panoramic displays. The sketches represent instead the pictorial tradition of placing women as the object of the male gaze through a triangle of looking relations within the frame within which women also actively look at men.

For example, F. Robertson's drawing along the canal features a woman sitting

in a gondola in the left side of the frame.[73] Her arm is extended in a gesture of hello or beckoning, her face toward another woman standing upon a bridge over the canal at the right side of the frame. But this simple hello is doubly complicated by the presence of another man and woman whose figures loom large in the foreground. First, the man and woman function as inscribed spectator-tourists who observe this salutatory spectacle while the woman in the boat is unaware of being

19 Sketch by F. Robertson. From Lillie Brown-Buck, *Amy Leslie at the Fair* (Chicago: W. B. Conkey Co., 1893).

watched. Second, the woman who watches is made available in profile to the implied viewer while the man to her right holds her hand and watches her.

Charles Graham's "On Cairo Street" offers a vantage point from slightly above street level so that the entire alleyway and its Egyptian-styled spires are visible.[74] In the center foreground, a group of three fairgoers—two women and a man— observe the street around them. In the cluster of three, the woman to the left looks left; the man to the right looks right. The woman in the center looks ahead. They seem to be the exemplary group of tourists, an intimate social group by virtue of their physical closeness to each other within the frame while their eyeline gazes extend outwardly to the street sights of the other inhabitants and the architecture. Yet, once again, such a seemingly straightforward representation of tourism is complicated by another viewing subject. Here, formally foregrounded by location, color, and arrangement, a man in Arabic dress to the left of the group stares openly at the woman who, unaware of his look, gazes off into the left foreground. Other sketches similarly feature men in foreign dress watching women who are unaware of their gaze while they look at other men.[75]

In these images, notes Diane Kirkpatrick, there is a hint of "uneasy interactions between middle and upper class Americans and concessionaires from far away places," suggesting that even the model community was still riddled with its gendered and racial tensions.[76] Dreiser supports this tension in another of his descriptions of the schoolteachers at the fair: "Another thing that has caused considerable comment among the young ladies has been the manner in which the inhabitants of the Orient and Eastern Europe travel about the streets of the city . . . These Turks, Arabs, Hindoos, Japs, Egyptians and others fix themselves up as fantastically as possible for no other reason than to attract attention . . . As ugly as many of them are, they will smirk and grin upon observing the slightest glance cast in their direction."[77]

20 *Opposite:* "On Cairo Street," drawing by Charles Graham. From *Chicago Tribune Art Supplements in Two Parts: World's Columbian Exposition* (n.p., n.d.).

21 "Amid the Palm and Cypress, Horticulture Building." From *The Columbian Gallery: A Portfolio of Photographs from the World's Fair* (Chicago: Werner Co., 1894).

Such scenes repeatedly encode foreign, nonwhite men as both the object of women's glances and as the open (often leering) spectators of white female observers.

In a study of the Dahomey two years later at the 1895 Paris exposition Ethnographie de L'Afrique Occidentale, Fatimah Tobing Rony notes the same tension in the public spaces where visitors and Dahomeyans mixed. In public restaurants, the exposition visitors encountered Dahomeyans who looked back at them; they discovered that "the performers had eyes and voices too."[78] In these interactions, Tobing Rony sees the public playing in fascination with the very boundaries that the fairs helped to facilitate: "Even as the exposition strived to construct and address clear subjectivities . . . there were marginal spaces at the fair where one could 'straddle the fence' . . . and the very act of voyeurism [endemic to the ethnographic displays] was undermined . . . White visitors could view at the fair all that was forbidden, flirting with the boundaries of Self and Ethnographic Other, while at the same time maintaining a distance."[79] Tobing Rony concludes that the lesson here is that cinema became in the twentieth century the rational consequence of the exhibiting of "native villages" since it "eliminates this potentially threatening return-gaze of the performer, offering a more perfect scientific voyeurism."[80] It advances the modern anthropological spectacle because, through cinema, the Other can be nonthreateningly imagined whereas the utopian exposition space—in all its play—can only evoke racist tensions.

While such relationships of seeing and being seen most certainly were played out daily on the city streets and at the Columbian Exposition, the drawings are notable for the ways that they construct a *triangulated* rather than reciprocal relationship of women seeing and being seen. Women may look at both white and nonwhite men, but they do so only while they simultaneously are held as the unaware objects of other men's gazes, both passersby inscribed in the image as well as the sketch artist. The frequency of this pictorial triangle suggests two possibilities: first, that the fantastically theatricalized space itself and its spectacular displays of consumption were themselves complicit in the particular dynamics of this extension of a *sexualized* gaze to passersby made over into spectacle and, second, that the wandering sketch artists implicitly used such representational conventions because they understood the fair as an excuse and containment for that kind of authorized voyeurism. Whereas the photos promote and localize an autonomy of vision that serves the purpose of seeing the fair as a spectacle of commodities, the sketches made by journalists depict human figures as the subjects and as the objects of each other's gazes. The journalists dramatize the way that surveillance overlapped with spectacle.

What happened at the 1893 Chicago World's Columbian Exposition—two years before the invention of cinema—is the cue for what would make cinema a popular commercial entertainment. Seven years later, when cinema itself was exhibited at the Paris Universal Exposition, it still could not commercially compete with the panoramas or theatrical spectacles except in those cases where cinema was incorporated into such spectacular displays.[81] People respond popularly not to cinema per se but to cinema only when it is in the service of a spectacle. For cinema to succeed, it required more than the technology necessary to produce it and the serial images on film.

Within a study of the origins of modern spectatorship, pre-cinema installations at the 1893 Chicago World's Columbian Exposition should not be taken then as the "origins" of cinema as defined through their apparati. Rather, they are part of a larger accommodation of new technologies to available processes of vision and to subjects normalized through their places in relation to sight. The function of spectatorship at the fair and its concomitant modes of presentation served a process of ongoing mediation between Chicago's two distinct urban cities, the metropolis and the Exposition grounds. In this division of public spaces, the lines are drawn between the controlled display of commodities and attractions and the historically growing, expanding spaces of the American city as a place of habitation and work. Both spaces, in turn, are organized around ethnic and racial differences and both regulate access differently, with the Midway at the Exposition facilitating a playful reenactment of the pleasures and perils of urban living. The exposition emerges as important, then, as a substitute public sphere for women—a place that provides the kind of urbanism that women especially found lacking in the American city and where a very different kind of walking was available to women. The display of foreign cultures, in particular, and women's safe immersion in them on the Midway promoted an understanding of the Other and provided a model through which one could evaluate the more unpredictable mixing and conflict of cultures in the city proper.

The real significance, then, of spectatorship at the Exposition is its inscription and organization through new forms of visuality that cinema would adapt to and build upon. This results in the conclusion that cinema is not an invention tied to the Renaissance notion of possession but that cinema emerges at the end of the nineteenth century as a distinctly modern machine responding to new cultural issues. For cinema to succeed, it had to be articulated as a masculinist form of address even while it became necessary to incorporate a space for the female as consumer,

too. If the Exposition and eventually the movie house became new commercial so-
cial centers for observing subjects, it has less to do with the evolution of the camera
obscura and the progressive chain of representational or picturing technologies
than with the social importance of truly involving men and women in the same lo-
cale for the purposes of seeing and being seen.

Notes

1 There is some dispute over whether there actually was a kinetoscope at the fair. Charles
 Musser quotes film historian Terry Ramsaye, saying that no peep-hole kinetoscopes were
 shown at the fair. Charles Musser, *Before the Nickelodeon: Edwin S. Porter and the Edison
 Manufacturing Company* (Berkeley: University of California Press, 1991), 498–499 n. 15. In
 his history of the kinetosocope, Gordon Hendricks says that at least one machine—the
 model shown at the Brooklyn Institute—was part of the Edison phonograph exhibit. Gor-
 don Hendricks, *The Kinetoscope: America's First Commercially Successful Motion Picture Ex-
 hibitor* (New York: Arno Press, 1966), 40–45. But Musser argues that Hendricks bases his
 account on advance publicity, and so he goes with Ramsaye's conclusions, based on an inter-
 view with Norman Raff. World's Columbian Exposition historians acknowledge this dispute
 but maintain there was a single kinetoscope present. Stanley Appelbaum concludes that "re-
 ports are numerous and circumstantial" that a kinetoscope was hooked up to a phonograph
 at the Edison Manufacturing Company exhibit in the Electricity Building. He attributes the
 discrepancy in reporting to the difference between Edison's plans to have an entire bank of
 machines and the result that probably only one machine appeared. Stanley Appelbaum, *The
 Chicago World's Fair of 1893: A Photographic Record* (New York: Dover Publications, 1980),
 47. In addition, George Spoor, one of the founders of Essanay Film Manufacturing Com-
 pany, has been cited on numerous occasions as having been influenced to get into the busi-
 ness by the kinetoscope at the Exposition.

2 The obvious gender coding in the two types of activities, as Linda Williams has persuasively
 demonstrated, "was thus never purely scientific . . . [providing] an illustration of Foucault's
 point that the power exerted over bodies *in* technology is rendered pleasurable *through* tech-
 nology." Linda Williams, *Hard Core: Power, Pleasure, and the "Frenzy of the Visible"* (Berke-
 ley and Los Angeles: University of California Press, 1989), 39. Charles Musser supports this
 view in his discussion of a Muybridge lecture given in Orange, New Jersey, on February 25,
 1888. Musser cites a letter to the editor of the *Orange Journal* that questioned the "propriety
 of exhibiting semi-nude human figures to a promiscuous [i.e., male and female] assembly,"
 and Musser concludes that Muybridge intended to challenge sexual mores and to "provoke
 such a reaction from his audiences." Charles Musser, *The Emergence of Cinema: The Ameri-
 can Screen to 1907* (Berkeley and Los Angeles: University of California Press, 1990), 53.

Williams complicates the situation by noting a rhetoric of class hierarchy in Muybridge's public lectures. The patrons were upper class whereas the performers were frequently working-class mechanics or artists' models. Muybridge explained that some of his male and female models were well-respected members of society, including teachers, society matrons, the premiere dancer of a Philadelphia theater, an art instructor, a fencing master. Although Muybridge justified full nudity or near nudity as being in the service of science and art, the revelations of the bodies in his lectures offered a transgressively sexual public sight. In an incident reported during Muybridge's lecture at the Academy of Fine Arts in Philadelphia several years earlier, a gentleman and a lady walked across the front of the hall during an intermission, when a student in attendance made a cutting remark that compared the two with the naked models just seen. As the report goes, the student's remark "brought down the house." Robert B. Haas, *Muybridge: Man in Motion* (Berkeley and Los Angeles: University of California Press, 1976), 149. The story, whether true or not, implies the extension of a spectator's attention from the screen to audience members, transforming them into sexualized spectacle within the theatricalized space of the theater proper as itself a social arena.

3 Haas, *Muybridge.*

4 Appelbaum, *The Chicago World's Fair*, 102.

5 Jonathan Crary, *Techniques of the Observer: On Vision and Modernity in the Nineteenth Century* (Cambridge: MIT Press, 1990), 17.

6 Ibid., 18.

7 Walter Benjamin, quoted in Susan Buck-Morss, "The Flaneur, the Sandwichman, and the Whore: The Politics of Loitering," *New German Critique* 39 (1986): 104.

8 Crary, *Techniques of the Observer*, 21.

9 Buck-Morss, "The Flaneur, the Sandwichman, and the Whore," 104–105.

10 Dana Brand, *The Spectator and the City in Nineteenth-Century American Literature* (Cambridge: Cambridge University Press, 1991).

11 For discussions on sexual difference and flanerie, see Anne Friedberg, *Window Shopping: Cinema and the Postmodern* (Berkeley and Los Angeles: University of California Press, 1993); Buck-Morss, "The Flaneur, the Sandwichman, and the Whore," 99–140; Janet Wolff, "The Invisible Flaneuse: Women and the Literature of Modernity," in *Feminine Sentences: Essays on Women and Culture* (Berkeley and Los Angeles: University of California Press, 1990), 34–50; Elizabeth Wilson, *The Sphinx in the City: Urban Life, the Control of Disorder, and Women* (Berkeley and Los Angeles: University of California Press, 1991); and Anke Gleber, "Women on the Screens and Street of Modernity: In Search of the Female Flaneur," in this volume.

12 Buck-Morss, "The Flaneur, the Sandwichman, and the Whore," 119.

13 Gleber, "Women on the Screens and Streets."

14 Ibid.

15 Wilson, *The Sphinx in the City*, 5–6.

16 Joanne J. Meyerowitz, *Women Adrift: Independent Wage Earners in Chicago, 1880–1930* (Chicago: University of Chicago Press, 1988), 5.

17 Ibid.

18 Theodore Dreiser, *Sister Carrie* (New York: New American Library, 1961), 19.

19 Meyerowitz, *Women Adrift*, xix.

20 Wilson, *The Sphinx in the City*, 7.

21 Charles M. Stevens, *The Adventures of Uncle Jeremiah and Family at the Great Fair: Their Observations and Triumphs* (Chicago: Laird & Lee, 1893).

22 Mable L. Treseder, quoted in James Gilbert, *Perfect Cities: Chicago's Utopias of 1893* (Chicago: University of Chicago Press, 1991), 126.

23 Gilbert, *Perfect Cities*, 69.

24 *Rand McNally & Co.'s Handy Guide to Chicago and the World's Columbian Exposition* (Chicago: Rand McNally & Co., 1893), 104–111.

25 Ibid., 105.

26 Ibid., italics mine.

27 Ibid., 68–72.

28 Theodore Dreiser, "Last Day at the Fair," *St. Louis Republic*, 23 July 1893, 6; reprinted in *Theodore Dreiser, Journalism*, ed. T. D. Nostwich (Philadelphia: University of Pennsylvania Press, 1988), 1:135.

29 Gilbert, *Perfect Cities*, 68.

30 *Rand McNally & Co.'s Handy Guide to Chicago*, 72.

31 For an extended discussion of the historical dimensions of this experience, see Susan Porter Benson, *Counter Cultures: Saleswomen, Managers, and Customers in American Department Stores, 1890–1940* (Urbana: University of Illinois Press, 1986).

32 Buck-Morss, "The Flaneur, the Sandwichman, and the Whore," 125.

33 Dreiser, *Sister Carrie*, 26.

34 Ibid., 27.

35 Ibid., 289.

36 Gilbert, *Perfect Cities*, 55.

37 George Ade, "The Stenographic Proposal," in *In Babel* (New York: McClure, Phillips & Co., 1903), 257–265.

38 Ibid., 259.

39 George Ade, "From the Office Window," in *Stories of the Streets and of the Town: From the Chicago Record 1893–1900* (Chicago: Caxton Club, 1941), 167–171.

40 Ibid., 170.

41 Ibid.

42 Ibid., 170–171.

43 Ibid.

44 Gilbert, *Perfect Cities*, 50.

45 Ibid., 51.

46 Neil Harris, "Great American Fairs and American Cities: The Role of Chicago's Columbian Exposition," *Cultural Excursions: Marketing Appetites and Cultural Tastes in Modern America* (Chicago: University of Chicago Press, 1990), 118.

47 Ibid.; Gilbert, *Perfect Cities*.

48 Alan Trachtenberg, *The Incorporation of America: Culture and Society in the Gilded Age* (New York: Hill & Wang, 1982); Robert Rydell, *All the World's a Fair: Visions of Empire at American International Expositions, 1876–1916* (Chicago: University of Chicago Press, 1984), 38–71; John Kasson, *Amusing the Million: Coney Island at the Turn of the Century* (New York: Hill & Wang, 1978), 11–28.

49 Harris, "Great American Fairs," 120.

50 See Peter B. Hales, "Photography and the World's Columbian Exposition: A Case Study," *Journal of Urban History* 15 (May 1989): 247–273. Summaries of photographic representations of the Exposition may be found in Diane Kirkpatrick, *The Fair View: Representations of the World's Columbian Exposition of 1893* (Ann Arbor: University of Michigan Museum of Art, 1993), and Julie K. Brown, *Contesting Images: Photography and the World's Columbian Exposition* (Tucson: University of Arizona Press, 1994).

51 Marian Shaw, *World's Fair Notes: A Woman Journalist Views Chicago's 1893 Columbian Exposition* (St. Paul: Pogo Press, 1992), 15.

52 Harris, "Great American Fairs," 120.

53 Hales, "Photography and the World's Columbian Exposition," 247–273.

54 Shaw, *World's Fair Notes*, 23.

55 The closest section to the White City included the German and Irish villages, Blarney Castle, a Colorado gold mine, a log cabin, the Japanese Bazaar, the Libby Glass Works, the International Congress of Beauties, the South Sea Islanders Village, a panorama of the Swiss Alps, and the Hagenbeck Animal Show. The middle section included the Ferris Wheel, the Moorish Palace, the Street in Cairo, the East Indian Palace, the Algerian and Tunisian villages as well as Eadweard Muybridge's Zoopraxigraphical Hall, and a scale model of the Eiffel Tower. The section farthest to the west included the Austrian Village of Old Vienna, the Chinese Village, the American Indian Village, Sitting Bull's log cabin, a panorama of the Volcano of Kilaueau, the Lapland Village, the Dahomey Village, the Bedouin Encampment, and an ostrich farm.

56 *Pictorial Album and History of the World's Fair and Midway* (Chicago: Harry T. Smith & Co., 1893), Prints and Photographs Collections, Chicago Historical Society, Chicago, Illinois.

57 Ibid.

58 Lillie Brown-Buck, *Amy Leslie at the Fair* (Chicago: W. B. Conkey Co., 1893), 39–40.

59 Gilbert, *Perfect Cities*, 118.

60 Shaw, *World's Fair Notes*, 56.

61 Brown-Buck, *Amy Leslie at the Fair*, 99.

62 *Pictorial Album and History of the World's Fair and Midway.*

63 Shaw, *World's Fair Notes*, 58.

64 Ibid.

65 Theodore Dreiser, "Third Day at the Fair," *St. Louis Republic*, 20 July 1893, 4; reprinted in *Theodore Dreiser, Journalism*, 1:128.

66 Brown-Buck, *Amy Leslie at the Fair*, 66.

67 Ibid., 100.

68 *Pictorial Album and History of the World's Fair and Midway.*

69 Ibid.

70 Ibid.

71 Miles Orvell, *The Real Thing: Imitation and Authenticity in American Culture, 1880–1940* (Chapel Hill: University of North Carolina Press, 1989), 35.

72 See, for example, Brown-Buck, *Amy Leslie at the Fair*, 48; *Chicago Tribune Art Supplements in Two Parts: World's Columbian Exposition* (n.p., n.d.).

73 Brown-Buck, *Amy Leslie at the Fair*, 48.

74 *Chicago Tribune Art Supplements.*

75 Ibid.

76 Kirkpatrick, *The Fair View*, 21.

77 Theodore Dreiser, "Last Day at the Fair," *St. Louis Republic*, 23 July 1893, 6; reprinted in *Theodore Dreiser, Journalism*, 1:136.

78 Fatimah Tobing Rony, "Those Who Squat and Those Who Sit: The Iconography of Race in the 1895 Films of Felix-Louis Regnault," *Camera Obscura* 28 (1992): 272.

79 Ibid., 272–273.

80 Ibid.

81 Emmanuelle Toulet, "Cinema at the Universal Exposition, Paris 1900," *Persistence of Vision* 9 (1991): 10–36.

Faces of Weimar Germany

SABINE HAKE

The notion of physiognomy, in contrast to its object of study, leads a masked existence. Among the critical terms in circulation today, it sounds anachronistic, if not outright obscure and suspicious. Associations with phrenology, chiromancy, and other pseudosciences of the nineteenth century predominate. Whenever the name Lavater is mentioned, it is either with slight bemusement or the condescension that betrays its continuous relevance.[1] The ancient desire to establish analogies between outward appearance and inner self and to interpret facial features as the expression of social, cultural, and national characteristics appears to be fatally bound to the anti-Enlightenment tradition. Physiognomy promotes conservative values in its choice of physiology over sociology. And it reveals a biologist, if not racist, agenda in its insistence on reading the body as the primary marker of difference. These affiliations isolate it forever, at the beginning of the twentieth century, from the artistic and political concerns of the avant-garde—at least that is how it seems.

On the following pages I shall examine more closely the function of physiognomy in Weimar photography. Given its unexpected return to public discourse after World War I, I am interested in how different representational practices such as photography utilize physiognomy's underlying assumptions and how the image creates the conditions under which representing the body becomes synonymous with representing society. The critical assumptions that enter into this process, providing the "modern" physiognomist with the horizon and the means of interpretation, remain for the most part hidden and undefined. Therefore the meaning and truth value attributed to physiognomy must be problematized and its changing function as a social, aesthetic, and scientific category mapped before its discursive function in photography can be discussed. Because of the strong interest among Weimar artists and intellectuals in studying social physiognomies, this process of mapping is inextricably tied to social and political concerns. While the focus of my investigation will be on photographic images rather than social stereotypes, representations cannot be separated from social practices; concern for physiognomy

influences everyday perceptions of self and others and helps to legitimate social and racial prejudice and discrimination. At the same time, images cannot be reduced to the way they are instrumentalized in social and scientific discourse. Images both make possible and resist external determination and need to be examined in the context of specific representational practices and their relevance at a particular historical juncture. Precisely because the use of physiognomic concepts for purposes of political hegemony and control has been studied in some detail, their appearance in cultural practices that on the surface contradict everything physiognomy stands for demands closer attention. Weimar culture, with the underlying tensions between progressive and reactionary modernism, offers a particularly rich field for investigating the unexpected return of physiognomy and its changing currencies.

In the German context, references to physiognomy can be found, among other places, in sociological writings on the modern metropolis (Georg Simmel), in the morphology of world history (Oswald Spengler), in the first contributions to an emergent film theory (Béla Balázs), in metaphysical speculations on the body (Ludwig Klages, Rudolf Kassner), and in a new theory of temperaments (Ernst Kretschmer). Traditionally physiognomy stands in opposition to the modern, to what Baudelaire calls "the transitory, the momentary, and the contingent."[2] It operates as an instrument of order and control. In the context of Weimar culture, the importation of an "antiquated" concept such as physiognomy into the spaces of modernity destabilizes these alliances and provides a means of both normative thinking and critical analysis.

Not surprisingly, the categories of old versus new, or progressive versus reactionary, dissolve upon closer examination and give way to a more complicated involvement with difference. Physiognomy becomes a new/old way of defining boundaries—between the visible and the hidden, between tradition and innovation, between self and other. Its primary goal is certainty or, rather, resistance to the loss of certainty. The fear of losing all distinctions of class, gender, and race can only be countered with a return to the body as the repository of identity and truth. Physiognomy as a representational practice claims that this body is still accessible to experience, that this truth can still be found. Its set of analogies offers stability in a time of radical change and promises authenticity in a society ruled increasingly by anonymous power structures. In the form of social stereotypes, physiognomy thus becomes part of the negotiation of social and ethnic differences. Bringing together specific images, perceptions, and attitudes, the passionate appeals to physiognomic concepts show how the conflicting forces in Weimar culture are in fact negoti-

ated—whether in a particular body of work, through a modern mass medium, or in relation to a new social class. Constituted in the encounter of individual and society, physiognomy emerges as a powerful way of theorizing the in-between; therein it functions as a discursive rather than classificatory category. Situated at the intersection of representation and interpretation, physiognomy also possesses the characteristics of a symptom. Instead of speaking itself, it draws attention to what it hides and reveals in hiding. For the purposes of this essay, then, physiognomy will be used as an interpretative tool and a heuristic device. Its emphasis on shifting boundaries and changing fields of interpretation not only explains the attraction of such a concept for many artists and intellectuals but illuminates the (repressed) discourse on physiognomy in Weimar culture as a whole.

Since photography plays such a crucial role in the rise of "modern" physiognomy, I propose to take a closer look at two photo books that are often used to illustrate histories of the Weimar Republic, August Sander's *Antlitz der Zeit* (Face of the Time [1929]), with a preface by Alfred Döblin, and Kurt Tucholsky and John Heartfield's *Deutschland, Deutschland über alles* (Germany, Germany above All Others [1929]). In bringing together such vastly different and seemingly unrelated works, I hope to show the pervasive presence of physiognomic thought in Weimar photography and thus shed some light on its functioning. Published in the same year, both works stand for diametrically opposed tendencies in Weimar photography, the movement toward "straight" photography and the interest in photomontage as a political weapon. Sander, the portrait photographer from Cologne, and Heartfield, the communist propagandist, belonged not only to a different generation of photographers (Sander was born in 1876, Heartfield in 1891) but also used photography to very different ends. Sander's professional training and experience made him conceive of photography as a trade. Committed to traditional values, he responded to the experience of social change with a realist aesthetic. Heartfield, by contrast, explored the power of image-word combinations in the revolutionary struggle. While the portraits in *Antlitz der Zeit* convey Sander's clear sense of what may be called, for lack of a better word, photographic ethics, *Deutschland* consists for the most part of archival material gathered by Heartfield, the former Dada *monteur*, for didactic and propagandistic purposes. In Sander, a strong belief in artistic creativity is coupled with an almost scientific interest in classification, whereas Heartfield relies on construction, rather than composition, as the main strategy for introducing political perspectives into photography.

Their strong interest in the social dimension of photography distinguishes

Antlitz der Zeit and *Deutschland* from other photo books published in the late twenties. The proponents of the so-called New Photography, who disseminated their ideas through avant-garde journals and exhibitions, wanted to liberate the image from the fetters of naturalism and pictorialism and rejected social concerns as an obstacle to the exploration of formal relations. In shows like the 1929 Film- und Foto exhibition in Stuttgart, organized by the *Deutsche Werkbund*, they presented their visions of a beautiful world. In order to move beyond the anthropocentric perspective and focus on the things themselves, the photographers wanted to become completely detached from the persons and situations depicted. Albert Renger-Patzsch's *Die Welt ist schön* (The World Is Beautiful [1928]) articulates this functionalist aesthetic under the rule of the machine already in its programmatic title. Other works include Franz Roh and Jan Tschichold's *Foto-Auge* (Photo-Eye [1929]), Werner Graeff's *Es kommt der neue Fotograf!* (Here Comes the New Photographer! [1929]), and Helmar Lerski's *Köpfe des Alltags* (Everyday Heads [1929]). After the subjectivism of much expressionist art, this new generation of photographers demanded that the machine finally be regarded as an artistic tool and technology be embraced as the foundation of modern art. However, by glorifying technology as inherently democratic, progressive, and functional, they separated technical possibilities from their social applications, ignoring questions of power—hence the cooptation of New Photography by advertising and mass publishing and its participation in what might be called the cult of functionality.

Antlitz der Zeit and *Deutschland* resist such developments through an almost stubborn interest in questions of representation and referentiality. A proponent of "straight photography," Sander sharply opposes the pictorial style that, in trying to elevate photography to an art form, excels in imitations of (obsolete) painterly techniques and effects. Where the proponents of New Photography offer highly self-reflexive comments on the new medium, Sander shows little interest in formal or technological innovation. And where they explore the visual beauty of everyday objects, Sander introduces a human perspective that is traditional in the best sense of the word. Heartfield's work defies contemporary trends for different reasons. Continuing in the spirit of Dada, his photomontages question traditional notions of art and introduce a clear political agenda. Less interested in the production than in the reception of images, Heartfield uses social stereotypes to analyze Weimar class society and further the revolutionary struggle.

These qualities account for the marginalization of Sander in histories of Weimar photography written by progressive critics, and they explain the singling

out of Heartfield as the main representative of leftist photomontage. In fact, their unique position allowed Sander and Heartfield to speak from the margins of their time and to pursue their untimely projects despite the flight from referentiality among many members of the avant-garde. With Döblin and Tucholsky as their allies, both attempted, in their respective ways, to preserve the common ground on which artistic and social concerns could meet.[3] Both used the new medium in a way that recalled older traditions of social iconography.[4] And consciously or not, both used images of the body to draw attention to the interrelatedness of discourses to which physiognomy bears witness even in its most trivial applications.

The artistic commitment of Sander and Heartfield and their belief in the discursive function of photography complicates an assessment of their work, especially where the meaning of physiognomy is concerned. From the perspective of today, their images are as much part of the history of photography as they are historical documents inviting idealized or nostalgic readings of Weimar culture. Much has to do with the fact that the photographic image escapes meaning. As image, it is polysemous and indeterminate. It requires the presence of other images, or of language, in order for its elements to be deciphered and its meanings to be fixed; it also depends on interpretative communities to assume its rightful place as representation and commentary. Whereas these reading formations change over time, the individual photograph finds itself thrown back onto the discourses of essence and truth. Even in the context of the photo book, with its claims of semantic stability, the conditions necessary for explicitly social or political readings cannot be maintained. Where the Weimar contemporary recognized a peasant in his Sunday suit, later generations of readers might see only an old man in an old-fashioned costume. Where those growing up during the twenties knew how to read the markers of class society, today's readers might find only the peculiarities of a bygone era. Thus the physiognomic categories on which the work of Sander and Heartfield rests have lost much of their evidence to themselves in the process of historical reception; what remains are the rituals of fashion and self-presentation and, of course, an understanding of physiognomy guided by its discursive function. At the same time, these images acquire new meanings through their status as historical documents, which brings out the conservative side of photography: the moment frozen in time, the body preserved for eternity, the face immortalized by the snapshot. As the portraits of Weimar society become linked to the temporality and transitoriness of all things human, the original reading formation that emphasizes their social and political relevance disappears in the abyss of forgetting. This process affects everything from

the relationship between image and text to underlying assumptions about photography and society. Consequently, my remarks attempt to reconstruct physiognomy as a representational practice from inside Weimar Germany. Physiognomy will not be questioned from the perspective of its obvious shortcomings but examined in the framework established by the format of the photo book, the self-reflexive comments by Sander, Döblin, and Tucholsky, and the contemporary reception of their works.

August Sander's *Antlitz der Zeit* has been praised as a "physiognomic gallery"[5] and "a collective portrait of his society, a physiognomy of his time."[6] The choice of words is more than revealing. It underscores the close ties between physiognomy and art—the references to "gallery" and "portrait"—and draws attention to photography's growing significance as that visual medium through which modern society encounters itself. Moreover, the appeals to "his society" and "his time" foreground two aspects of Sander's approach to portraiture, the transformation of the individual into the typical and the extraction of the representative from the ephemeral. Published in 1929 by Kurt Wolff, *Antlitz der Zeit* presents the first results of this ambitious undertaking.[7] It was already clear that Sander's compendium of sixty photographs marked the beginning of a unique experiment. Under the heading "People of the Twentieth Century," the project was to include representatives of all generations, classes, and professions and to give an accurate impression of German society during these crucial years. However, Sander's goals were not simply those of the collector or archivist. Theoretical assumptions and critical judgments guided the process at every stage, beginning with his explicit and implicit references to physiognomy.

Already the book's title, *Antlitz der Zeit*, evokes physiognomy in a way that is both illuminating and misleading. By speaking of *Antlitz* (which, despite the book's usual translation, should be rendered as "countenance") rather than *Gesicht* (face), Sander situates his project at the intersection of two critical paradigms. On the one hand, he appeals to a venerated tradition in the humanities that prefers the subtleties associated with *Antlitz* to the seemingly unmediated effects of *Gesicht*. On the other hand, he invokes a long-standing if slightly questionable practice, identified with the name of Lavater, of reading faces as the expression of an inner self. Yet by speaking of an *Antlitz der Zeit*, Sander shifts the focus from representation to representativeness. Physiognomy as a method of interpretation is extended into the social realm, and the visible traces of the body are enlisted in a sustained argument

about social and sexual identities, self-presentation, and visual perception. The goal is no longer simply to portray a select group of individuals but to create a composite face—a face whose physiognomy is of a theoretical rather than iconographic nature. With society thus equated with a body, and its historicity captured in a face, Sander's project assumes a highly speculative quality. Not surprisingly, *Antlitz der Zeit* has been called "one of the most truly abstract bodies of work in the history of photography."[8] This tension between documentation and interpretation, between individual faces and the face of the time, has accompanied the work from its inception to its many editions and reprints. It is the main reason for its ongoing critical reception, and the main reason too for its enduring fame.

Perhaps to prevent misreadings, Sander has commented publicly on the conjunction of physiognomy and photography in his work. In his fifth radio lecture for *Westdeutscher Rundfunk* in 1931, he describes the book as "a physiognomic definition of the German people of the period" and concludes: "It is possible to record the historical physiognomic image of a whole generation and—with enough knowledge of physiognomy—to make that image speak in photographs."[9] These ambitious claims reveal what Sander perceives as photography's primary function in society, namely to facilitate communication and promote tolerance: "Today with photography we can communicate our thoughts, conceptions, and realities to all the people on earth."[10] With this utopian dream of a community without boundaries, photography is elevated to the status of a universal language and its technical features translated into essential qualities. Its liberating effect, Sander notes, is strongest in relation to the body: "The field in which photography has so great a power of expression that language can never approach it, is physiognomy."[11] The grand promises of reconciliation and the emotional appeals to the "family of man" behind his reflections on photography originate in a deep sense of crisis that is, to a large degree, a crisis of language. Here the old concept (physiognomy) and the new medium (photography) are called upon to transcend classes and nationalities and to establish the basis for a new, enlightened internationalism. Photography, far superior to linguistic discourse, captures reality in all its nuances and complexities and overcomes all differences in education or social background. By privileging the image over the word, Sander concludes, photography breaks through the opposition of surface and depth and reinstates the body as the original mediator between the social and the individual.

As a result, his photography endows the body with the characteristics of a discourse. Made available to critical analysis through the new medium, the body pro-

vides the categories through which the dream of photography as a universal language can be realized. The blind spots in such a program are not difficult to find. There are few references to the political conditions under which the project was conceived and its conceptual framework developed. Unaware of his personal biases and receptive to the old myth of identity and its pronouncements on noble character traits and beautiful features, Sander claims that "every person's story is written plainly on his face."[12] The conditions under which individuality becomes typicality are never defined, suggesting a natural process rather than a critical intervention. Finally, the notion of a universal language implies the existence, even on the most superficial level, of a vocabulary and a grammar. Whether these are to be found in photography's formal characteristics or in the thematic registers of portraiture remains unclear. The comparisons to language, then, serve largely metaphorical purposes. Sander's comments on photography as a site of truth must be read in similar ways. Their significance, he argues, can only be grasped once critical attention shifts from the single portrait to the entire project. Then the arrangement of the plates, with the resultant continuities and differences, defines the threshold of interpretation: "The historical image will become even clearer if we join together pictures typical of the many different groups that make up human society. . . . The time and the group-sentiment will be especially evident in certain individuals whom we can designate by the term, the Type."[13] By introducing the concept of social types, Sander escapes the biologistic determinism of traditional physiognomy and grounds his speculations on the essence of photography in social reality and the functioning of social stereotypes. Whereas the assumptions about character and creativity in the artists' portraits still conjure up natural processes, the attention to the staging of identity, from gesture to fashion, firmly grounds his endeavor in social processes.

Alfred Döblin's preface to *Antlitz der Zeit* confirms the function of physiognomy as a means of demarcation. The famous writer-physician introduces the notion of leveling, defined as the shaping of the individual by outside forces, in order to capture what photography only shows in the spaces between images: the emergence of the modern body and, concomitantly, of the body of modernity. Döblin, whose novel *Berlin Alexanderplatz* (1929) addresses similar issues, describes this process in all its violence: "What do I mean by leveling?" he asks: "The equalizing, the blurring of personal and private differences, the disappearing of such differences under the influence of a greater power; thus the two powers, death and human society."[14] Döblin's graphic description of the process, including the comparison to death as the ultimate moment of leveling, points to a hidden antagonism between individual and society. Later references to casting (an artistic technique) and ero-

sion (a natural process) also suggest that leveling can be alternatively described in terms of conflict or compromise. Such qualities, Döblin argues, make leveling a perfect metaphor of the social process and of photography. What he calls realist photography is informed precisely by the wish to capture the effects of leveling on the human body. This attention to what is no longer there originates in a distinctly modern configuration. Physiognomy, in the traditional sense, highlights difference, whether in relation to character, occupation, or nationality. In its modern-day variant, however, physiognomy makes visible the decline of (bourgeois) individualism; the exemplary is replaced by the typical. Thus pronouncements on external features and corresponding inner qualities give way to effects associated with the socialization process and the relationship to work.

The formal qualities of the portraits, as well as their selection and presentation, must be approached through this changed definition of physiognomy. While leaving room for some variation, Sander firmly lays down the rules of lighting, framing, and mise-en-scène. Standardization establishes the conditions under which the individuals are transformed into representatives of their class or profession. Similarity makes possible the differentiation between the images, and the elimination of stylistic idiosyncrasies brings to the fore actual distinctions in society. Most important, the realist tradition provides the artistic conventions through which these traits and traces can be fixed in images. Rejecting studio photography, with its emphasis on dramatic effects, Sander uses natural light and soft contrasts. While there are no signs of external manipulation, with the exception of the cover, some prints are cropped for publication. Most people are photographed frontally, in marked distance to the camera. This external arrangement demands a similar internal detachment on the part of the photographer striving to bring out the medium's inherent potential. Only then can the new medium recover the constants of human existence behind the experience of social change; only then can the image be deciphered. Döblin describes Sander's photographic realism precisely in these terms, for "with a certain distance the distinctions disappear, with a certain distance the individual ceases to exist and only the universals apply."[15]

The photographic apparatus establishes connections across space and time that are not possible to everyday perception. Vision as the primary sense transcends spatio-temporal and social boundaries and produces a sense of intimacy that is both fictitious and real. Framing is an expression of this vacillation between closeness and distance. Its spatial dynamic informs the presentation of groups and individuals. Depending on the number of people depicted, Sander's compositions vary from full-body shots to chest shots. The foregrounding of external appearances as a social

and aesthetic production, and the underlying assumptions about self-presentation and self-determination, are most pronounced in the artists and intellectuals. This problematic distinction between individuals and social types continues in the practice of naming. Repeatedly Sander abandons his generic titles ("Shepherd," "Industrialist," "Catholic Priest") for friends and persons of high social standing who are identified by name or initials. Such variations shed light on the qualities attributed to specific groups in society. They also reveal the social hierarchies that Sander restages in his typical middle-class choices, including the idealization of women as mothers.

As a photographer working in the realist tradition, Sander does not hide the fact that his photographs are staged. Instead of celebrating the moment and taking advantage of the medium's ability to grasp the ephemeral, he draws attention to the social scenarios that inform photographic portraiture. With the conditions of production thus foregrounded, role playing assumes its rightful place in modern physiognomy. Staging and masking emerge as its most effective strategies. Their accessories bring out the typical in each individual and, increasingly, become the last refuge for "modern" individualism through the secondhand identities provided by the cinema and the illustrated press. Whether it is the cut of a jacket, the position of a hat, or the shape of a bracelet, fashion betrays the personal tastes and social alliances of the sitter. Haircuts, gestures, and body positions reveal as much about his or her sense of self as they contribute to the making of social types. Made possible by these elements, the vacillation between the typical and the individual takes place against sparse backdrops and in neutral settings. The mise-en-scène is unobtrusive, and in most cases the composition of the frame directs most attention to the face. Sometimes the surroundings give an indication of the occupation, working environment, or social standing of those portrayed. The frequent outdoor settings privilege public rather than private personas. While these choices may be influenced by Sander's preference for natural light, they also articulate class difference in spatial terms. The majority of peasants are photographed outdoors, whereas workers and craftsmen appear in the interiors defined by their work. By contrast, the representatives of the middle class are shown against a neutral background, which draws attention to their relative independence from external determinations.

Most important, Sander creates an atmosphere of mutual consent that makes photographic portraiture a collaboration rather than an act of aggressive or voyeuristic intrusion. With few exceptions, the subjects maintain eye contact with the photographer. Their reactions to the act of being photographed are almost un-

avoidable, given Sander's use of large glass negatives that require long exposure times. The range of individual responses can be measured in the tributes paid to public expectation and social decorum, in the nuances of role playing, from studied facial expressions to the smallest details of clothing, and in the staging for the camera of the relationships between couples, relatives, and friends. More often than not, these scenarios bring out the discrepancies between self-image and actual class position. Among the looks aimed at the camera one finds what, in the narrative context of the photo book, is to be read as the sincerity of the old peasant and the arrogance of the humanist scholar; the shy smile of the female high school graduate and the pride of the proletarian mother holding her baby. In those cases where public and private identities coincide, people seem to be least self-conscious but also most self-aware. The painter, the sculptress, and the composer personify this rarefied condition. Conversely, where profession has become the only way of attaining a self, Sander draws attention to the details of alienation; note, for example, the subject of "Police Officer" (no. 35), whose identity has been reduced to an oversized handlebar mustache, or of "Pianist" (no. 53), whose staged confidence is undercut by his overly erect position and formal attire.

Since the publication of *Antlitz der Zeit*, Sander's photographs are regularly included in illustrated books on Weimar culture. Some of them, like "Pastry Chef," have almost achieved the status of icons. While increasing Sander's artistic reputation, the circulation (even fetishization) of specific photographs has prevented a more detailed examination of the way the photographs function within the work.[16] His social physiognomy tends to be identified with specific images, and not with the selection and presentation of the full constellation. Yet it is precisely in the continuities and contiguities imposed by the book format that its critical intentions must be located. Sander's physiognomic project emerges from the relationship between images and not through the images themselves. Support for such a claim can be found in his elisions and emphases. Sander's work concentrates geographically on Cologne and its surroundings. While some photographs are taken as early as 1912, the great majority are dated around 1928 and 1929. As a result perhaps of his own rural upbringing, Sander shows a great fondness for the independent, landowning peasant but has little regard for farm laborers. Craftsmen by far outnumber members of the industrial proletariat, and women appear almost exclusively as mothers and wives. While rural lifestyles are portrayed in some detail, the new class of white-collar workers stands on the margins. The world of radical politics is represented by communists, among others by Erich Mühsam, whereas National

Socialists remain suspiciously absent.[17] The focus on the older generation comes from Sander's desire to capture in their faces the last traces of an existence that, if only in retrospect, seems unfettered by social mediations. As already mentioned, the book includes a large number of artists, including Hans Poelzig, Paul Hindemith, Jankel Adler, Willi Bongard, and Gottfried Brockmann. These examples could be dismissed as the result of external circumstance, as flaws in the chronicler's work. However, the intrusion of the personal also defines the conditions under which the photographs can be read and establishes the framework in which the categories of distinction can be applied. The uncharted territories in the "face of the time," in other words, make the faces of Weimar Germany decipherable.

Sander's historical narrative advances through similar imbalances. *Antlitz der Zeit* begins with an old peasant from the Westerwald and closes with an unemployed man, standing destitute at a Cologne street corner. What links these two men is the accessibility of their faces to interpretation. The peasant's rugged face exudes earthbound solidity, and his impeccable Sunday suit conveys a strong sense of tradition and propriety. By contrast, the unemployed man—with his collarless shirt, torn jacket, and shaven head—reenacts the loss of all attributes of social distinction. Therefore, he turns away from the camera in painful recognition of his depersonalization.

Placed at the beginning and the end, these two images suggest a narrative of decline, of dehumanization at the price of technological progress. Agriculture is

22 "Peasant from the Westerwald." From August Sander, *Antlitz der Zeit: 60 Aufnahmen deutscher Menschen des 20. Jahrhunderts* (Munich: Schirmer/Mosel, 1976).
23 "Unemployed Man, Cologne." From August Sander, *Antlitz der Zeit: 60 Aufnahmen deutscher Menschen des 20. Jahrhunderts* (Munich: Schirmer/Mosel, 1976).

confirmed as the foundation of life, while all modern society is found lacking, unable to take care of the most basic human needs. Between these two "marginal" photographs (marginal in the sense of margins and marginality), Sander presents his views on social change. Imaginary in its coordinates but undeniably real in its effects, the trajectory moves from the country and the small town to the big city. In the process of modernization the old crafts are replaced by service-related professions, and the authenticity of rural living gives way to the functional anonymity characteristic of large metropolitan areas. With the disappearance of identifiable social types, the mass individual triumphs as the model of modern living. Toward the end, exchangeability rules: the businessman could very well be a physician, and the literary critic could pass for an art historian. Later eternalized by Sander as the "last man," the unemployed becomes the representative of a world in which identification by profession was still possible.

As photo historians like Ulrich Keller and others have argued, this historical narrative brings out the categories of social analysis on which the physiognomic project of *Antlitz der Zeit* is based. Sander uses profession, rather than class, as the main category of classification. But as his larger project, "Citizens of the Twentieth Century," also shows, his definition of profession is modeled on the medieval guilds (*Stände*), which explains some of the inconsistencies in the initial selection of images. The guild model refers back to a time when the crafts were firmly embedded in the social fabric of families and communities. An expression of his own traditionalism, Sander's dependence on such an anachronistic category brings to the fore the drama of social change; the external point of reference makes visible the collapse of the old order. Through its resistance to the new, *Antlitz der Zeit* escapes classification as a conservative or progressive project. Sander's indifference to class makes him blind to the actual power of the workers. Yet the recognition of change, even if it is a change experienced as loss, protects his book from nostalgic appropriation. Signs of the new times, after all, are omnipresent and must be accepted. By taking the romanticized figure of the peasant as his point of departure, Sander overcomes the discursive limitations of photography and reintroduces the notion of physiognomy into the spaces of modernity. From the perspective of an earlier social unity, the process of de-individualization becomes glaringly obvious.

A few examples may help to clarify this dynamic of loss and belatedness. The notion of the guild inspires an extensive meditation on the preindustrial crafts ("Master Locksmith" [no. 14]; "Master Upholsterer" [no. 15]) while marginalizing those professions associated with modern industries and bureaucracies and trades ("Young Businessman" [no. 38]). "Engineer" (no. 37), as the representative of the

techno-industrial complex, is placed between the two customs officials and the young businessman and thereby excluded from the educated middle class. Similarly, the subject of "Industrialist" (no. 45) becomes part of the power elite but has no relationship (whether as patriarch or exploiter) to the workers who, in turn, are grouped with the peasants. Obviously Sander is less concerned with analyzing the oppositions in modern society than with presenting the victors and victims of the historical process.

Sander's physiognomic project functions as a medium of remembrance and a means of resistance against the equalizing forces of modernity; therein lies its documentary value. At the same time, the story of each individual, couple, family, or group intersects at all points with the transformation of classes and professions over the course of almost two decades; from this emerges the work's fictional quality. Döblin introduces a third set of categories when he compares Sander's work to sociological and scientific endeavors. His comments are worth quoting at length:

You have in front of you a kind of cultural history, better sociology of the last thirty years. How to write sociology without writing, but presenting photographs instead, photographs of faces and not national costumes, that is what the photographer accomplished with his eyes, his mind, his observation and last but not least his photographic ability. Only through studying comparative anatomy can we come to an understanding of nature and the history of internal organs. In the same way this photographer has practiced comparative photography and therefore found a scientific point of view beyond the conventional photographer.[18]

This quote summarizes everything that is problematic in Sander's physiognomic project: its entanglement with sociology, its debt to the classificatory systems of anatomy, and its infatuation with comparison as the principle of universal equivalence. Because these issues are never fully addressed, they can be turned into a productive force; because they never interfere with the goals of portraiture, they can be used in a critical fashion. The tension between documentation and imagination, between chronology and narrative, keeps Sander's social analysis in suspension, producing an effect not dissimilar to the shifts of focus in photography itself.

Responding to some of these concerns, the contemporary reception of *Antlitz der Zeit* concentrated on the way Weimar society was represented in the photographs. While the book did not become the kind of commercial success that the publishers had hoped for, it provided a forum for addressing larger questions of representation and social change. As a medium with an inherent tendency toward

realism, photography seemed particularly suited to document the rise of white-collar workers, the radicalization of the working class, and the emancipation of women. In the place of dry statistics and vague descriptions, the images showed real human beings whose faces prompted questions and whose glances sparked the imagination. As Döblin notes, "Many of these pictures invite us to tell whole stories; they invite us to do so, they provide a material for young authors that is more stimulating and yielding more than many newspaper reports." [19] However, Sander's decision to foreground occupation in the definition of social identities caused heated controversies. Leftists rejected his guild theory as obsolete and demanded a social typology based on class. Conservatives blamed him for exposing, and thus accepting, the conditions of decline; one reviewer called the book "a physiognomical document of anarchy, of inferior instincts and indiscriminate greed, rather than a document of uplift, enthusiasm, let alone essence." [20]

These rather typical statements confirm that Sander's plan to show social change through the differences between individual faces had strong political implications. As long as a human body could be linked to a particular class position, conservative critics argued, social peace was guaranteed. Here physiognomy appeared at its most reactionary, justifying social and racial discrimination through recourse to the body's inherent features. But the idea of a body that still exhibited the traces of physical labor also intrigued many left-liberal intellectuals. Praising the diversity of social types, while excluding themselves from such typologies, they time and again commented on Sander's sharpness of observation. Tucholsky called *Antlitz der Zeit* "the cultural history of our country in photographs," and Thomas Mann hailed it as "a treasure-trove for lovers of physiognomy." [21]

For some critics—and their positions, if read against the grain, correspond with my definition of physiognomy as a differential—the provocation of Sander's physiognomic project lay above all in its failure. In their view, the modern body had already become indecipherable. The aura of false immediacy surrounding photography only underscored the growing difficulties in linking a particular social position to a particular body. The conservative critic quoted above saw this crisis in interpretation as a sign of cultural decline, while the more progressive critics welcomed the emergence of a postindustrial work force freed of all markers of (old-fashioned) difference. In the opinion of Eugen Szatmari, *Antlitz der Zeit* proved that "today's life has almost completely erased the physiognomic signs of occupations, particularly in the intellectual professions." [22] Class difference disappeared into the functional and became inaccessible to the camera, whereas the modern

body triumphed as the willing recipient of the phantasmagoria offered by modern consumer society. And indeed, by using physiognomy as an organizing device rather than a rigid system of classification, Sander created a multitude that, in its isolated components, was at once too specific and too indeterminate. His self-reflexive use of the medium prevented idealization, and his realist style defied the impoverished aesthetics of racial purity. Not surprisingly, in 1934, the Reich Chamber of Visual Arts ordered the destruction of the publisher's printing blocks. While other taxonomic projects were initiated, designed to prove the superiority of the Aryan race, all available copies of the book were destroyed, for *Antlitz der Zeit* had made clear that the "ideal-typical German" did not exist.

So far, I have shown how Sander's own practices support the notion of physiognomy as a boundary and how his images negotiate the tension between what is accessible to visual representation and what is no longer visible in society. With the peasant portraits as the foundation on which interpretation becomes possible, every sign of difference poses a threat to the old categories. In this sense, the work conveys a pervasive sense of loss: the loss of traditional society which relies on the identity of body and class as a safeguard against political instability; the loss of the separations between the sexes and generations that are the cornerstones of patriarchy; and, finally, the loss of photography as a remedy for the crisis associated with language. The sequence of images reenacts this loss once more and makes possible its critical analysis. Sander's traditionalist views throw into relief the degree of social change that finds expression in the faces of the young and the ambitious. This equalizing force of mass society and urbanization results in the shift from the face, as the center of the old physiognomic project, to the new scenarios of self-stylization. And it is here, in the failures of physiognomy, that the conditions of modernity become visible.

I want to conclude by mentioning one particular photograph that, in its very resistance to the physiognomic project, summarizes some of the issues discussed thus far. I am referring to the young middle-class couple, professionals as the caption indicates (no. 48). The man and the woman could be in their late twenties, childless, financially secure, probably office workers, perhaps liberals. She is seated in a chair, while he leans against a side table, holding her in a protective gesture. Their fashionable dress and short haircuts identify them as modern city-dwellers. The similarity of body positions and facial expressions produces an almost unwarranted harmony; sexual difference has been diffused by companionship. Their pretty plumpness suggest a complacent, passive attitude that is ameliorated only by

the functional clothes. This reading, however, is destabilized by the presence of a golden bracelet on the man's right wrist (the punctum, in the terminology of Barthes), which conjures up much darker scenarios of narcissism. With these associations, the most modern photograph in *Antlitz der Zeit* tolls the end of traditional physiognomy. The markers of character have been replaced by fashion and attitude, and the new professions are no longer accessible to visual representation. That which defines a person's identity remains present only in its absence.

At first glance, *Deutschland, Deutschland über alles,* the second work to be discussed here, seems to pursue very different goals. The provocative gesture with which its authors borrow the first line of the German national anthem for their collaborative project clearly announces their commitment to political art and the politics of appropriation. Similarly, the choice of a photomontage for the cover design expresses their distrust of documentary photography and eliminates from the outset all hopes that social reality can be grasped through mimetic representation. Where faces no longer convey a truth and where reality has moved into the functional (to invoke Brecht), the formal techniques of Dada montage must be summoned to break through the deceptive surfaces of photography. Thus, in contrast to *Antlitz der Zeit,* which introduces itself by means of example ("The Bricklayer's Mate"), the cover of *Deutschland* deconstructs the face of Germany. The nation is represented by a grotesque head made up of monochrome paper cutouts. Set against a yellow background, the book's title spills from the man's mouth into the left side. The words consist of black, white, and red letters, the colors of the defeated empire. Like the name of Kurt Tucholsky, they are printed in Gothic script, the preferred typeface of German nationalists. Already on the formal level, the Wilhelminian Empire remains omnipresent. The insignia of the old order have survived the threat of revolution and now make up the face of the new republic. They appear in layers and oppositions, giving the face an almost schizophrenic quality, and include a Wilhelm II

24 "Working Middle-Class Couple." From August Sander, *Antlitz der Zeit: 60 Aufnahmen deutscher Menschen des 20. Jahrhunderts* (Munich: Schirmer/Mosel, 1976).

25 Cover of *Deutschland, Deutschland über alles*. Photomontage by John Heartfield (Berlin: Neuer Deutscher Verlag, 1929). Courtesy Special Collections Department, University of Iowa Libraries. © 1996 Artists Rights Society (ARS), New York/VG Bild-Kunst, Bonn.

mustache, a fencing mask like the one worn by members of the reactionary frater-nities, and a decorative sash in patriotic colors. The elegant top hat barely hides a spiked helmet, an indication that the rising bourgeoisie shares its power with the military elite. These oppositions continue in the upper body where the epaulettes

and the *Pour le mérite* medal on the right are juxtaposed with the stiff collar and black tie on the left. The provocation of *Deutschland*, then, begins already on its cover as the three power elites of Imperial Germany—the aristocracy, the military, and the bankers and industrialists—come together to form the head(s) of the Weimar Republic. Their real-life models return later, under the same title, in what looks like an official parade, overwhelming in their numbers and frightening in their preoccupation with public order and ceremony.

Deutschland is the product of a rare collaboration between a writer and a photographer. Both were driven by the same goal, namely to unmask the face of the ruling class and draw attention to the power structures that oblige the republic to the old empire. Where Sander's social physiognomy adheres to the tenets of realist photography, Heartfield and Tucholsky combine images and texts in order to challenge the official picture of Germany and, in so doing, to make a critical intervention. Where Sander focuses on occupation as an indicator of social change, Tucholsky and Heartfield use the notion of class to analyze the internal contradictions in Weimar society. "A single image was supposed to materialize: GERMANY," Tucholsky explains. "We want—as much as possible—to extract the typical from snapshots, posed photographs, all kinds of pictures. And all the pictures together will add up to Germany—a cross-section of Germany."[23] The term "cross section" (*Querschnitt*) recalls the so-called cross-section film, a nonnarrative genre based on the associative montage of documentary footage, often with urban or industrial themes; Walter Ruttmann's *Berlin, die Symphonie der Großstadt* (1927), discussed in an earlier chapter in this volume, is probably the most famous example. In its interpretation by Tucholsky, "cross section" acquires a political meaning often missing from these films with their aestheticizing of political noninvolvement. For him, "cross section" means a cutting through the layers of society; his main interest is provocation, not proportionate representation. Tucholsky's reference to "maggots" acknowledges that this approach invariably results in casualties. But as his comment on the difficulties of extracting the typical also suggests, though unwittingly, one of the casualties might be the theory of montage itself. As I will argue, the photographs, in their very indeterminacy and because of their close relationship to the object world, prepare the ground for a return of physiognomy in the context of photomontage. Oscillating between the typical and the individual, the images stand in the way of intentionality and instrumentality. The faces begin to speak, telling their life stories and resisting their functionalization in a political polemic.

In its use of diverse materials, *Deutschland* resembles a museum and a construction site. Taking advantage of new media technologies, while at the same time

rejecting society's obsession with the eternally new, Tucholsky and Heartfield rely heavily on available sources. Of the 181 photographs only 10 are photomontages, with "The Parliament" being the most famous one. Many texts had already been published in the *Weltbühne*. Some photographs appeared previously in the *Arbeiter Illustrierte Zeitung* (*AIZ*), often together with Tucholsky poems, the so-called *Bild-Gedichte*; the best-known example is probably "Mother's Hands." Originally from the archives of the *AIZ* and other news agencies, the majority are wire-service photographs of (presumably) little artistic value. Their material can be grouped in three thematic groups: the institutions of power, dominant ideology, and the working class. These topics determine the organization of the material and provide the basis for the main forms of argumentation: opposition, conflict, and contradiction. The juxtaposition of texts and images gives rise to what Tucholsky calls *Tendenzfotografie* (tendentious photography), "a very funny and politically extremely effective means." Tendentious photography functions like "dynamite and ammunition in the struggle of the souls" and can become "an extraordinarily dangerous weapon"—for instance, in the comparison of political physiognomies.[24] However, Tucholsky emphasizes repeatedly that its effectiveness depends on the text-image relationship.[25]

The theory of montage provides tendentious photography with its essential techniques. Montage in the form practiced by Heartfield and Tucholsky establishes

relationships between seemingly disparate elements; it undermines widespread notions and increases suspicion; it challenges the self-evident and brings out the repressed; and it combines textual and visual sources. Like thesis and antithesis, the text-image relationship articulates the contradictions that for the authors are the beginning of critical analysis and the prerequisite of political awareness. Yet their dynamic remains characterized by a certain epistemological instability. Whenever language, including official rhetoric, is problematized, photography, given its uncanny closeness to the real, is placed outside of ideology;

26 Heartfield's "The Parliament." Photomontage from Tucholsky, *Deutschland, Deutschland über alles* (Berlin: Neuer Deutscher Verlag, 1929) 138. Courtesy Special Collections Department, University of Iowa Libraries.
© 1996 Artists Rights Society (ARS), New York/VG Bild-Kunst, Bonn.

27 Heartfield's "Animals Looking at You." Photomontage from Tucholsky, *Deutschland, Deutschland über alles* (Berlin: Neuer Deutscher Verlag, 1929) 63. Courtesy Special Collections Department, University of Iowa Libraries. © 1996 Artists Rights Society (ARS), New York/VG Bild-Kunst, Bonn.

it becomes equated with "the naked truth." Conversely, when the image appears in dispute, the text establishes the context in which the deceptive nature of photography can be revealed. Then writing, with its greater critical possibilities, positions the image in a causal or temporal sequence, breaking through the false surface of authenticity.

The critical reception of *Deutschland* addressed some of these inconsistencies but linked them to the authors' political analysis rather than to the problematic status of the image.[26] The didactic use of image-text relations was received with considerable skepticism, and much of the controversy focused on one particular photomontage, titled "Animals Looking at You," which was added by Heartfield without Tucholsky's knowledge. Objecting to the defamation of the generals—and not, as Tucholsky argued in a private letter, to that of the animals—the *Börsenblatt für den Deutschen Buchhandel* initially refused to print an advertisement for the book. A few literary critics welcomed *Deutschland* as an interesting formal experiment, but the majority dismissed the mixture of satire and sentimentality as a sign of Tucholsky's deeply troubled relationship to Germany. Some leftist critics accused the ironic essayist and *Weltbühne* critic of staging unjustified attacks on the republic and indirectly helping the reactionary opposition. Others claimed that Tucholsky, caught up in his own ambivalences, failed to recognize the changes that had already taken place in German society. Unaware of the growing influence of the industrial bureaucracy, critics argued, Tucholsky remained fixated on the more visible representatives of the old empire, the Prussian officer, the corrupt judge, and the depraved aristocrat. Responding to these charges, Tucholsky once described *Deutschland* as deliberately anachronistic.[27]

However, these accusations of failure do little to clarify the problems in the project's conception. Once repeated in the scholarly journals, they become a tedious exercise in the formulation (a posteriori) of correct leftist politics.[28] Only a reading that approaches the work as a site of conflict, rather than as an attempt to overcome conflict, can yield new insights. Such a reading must be symptomatic; it must begin with the issues that have been ignored in the almost exclusive attention to the politics of montage. And, indeed, a closer look at the photographs reveals unexpected inflections. It is physiognomy that haunts *Deutschland*, contaminating the images as well as the accompanying texts. The more its existence is denied in favor of montage as the sole principle of organization, the more its tacit assumptions interfere with the political argument of montage. Traces of physiognomic thought can be found in the choice of "typical" faces and the pronouncements on photography and truth. Physiognomic ideas provide the basis on which montage becomes possible, but they enter into the process unmediated. They give expression to a paradigmatic opposition in Weimar Germany's divided physiognomy, the aristocratic Prussian officer (or judge) and the proletarian mother, without questioning essentialist notions about gender. They draw attention to the petty bourgeois and his

narrow world of beer halls and shooting clubs without recognizing the biologist nature of such characterizations. And they present bodies and faces without considering the social and cultural scenarios that inform even documentary photography.

The return of physiognomic concepts in a canonized leftist text has to do with the authors' attachment to a time when power was still identified with individuals and the faces of classes accessible to representation. Like Sander, Tucholsky remains caught within a discourse of the "authentic" that projects into the photograph an almost irresistible power. Only the protagonists have changed: the peasant, embodying a primordial harmony between individual and society, has been replaced by the class-conscious worker who is called upon to restore this quality in a future, classless society. In both cases, the choice of one particular social type as the matrix of authenticity produces blind spots and weakens the critical potential of physiognomy. Putting a trust in the image that is naive at best, Tucholsky maintains elsewhere: "Because everybody is what he looks like and because we cannot read what nature has written so clearly on the human face, snapshots are able to reveal brutally what the eyes cannot recognize as quickly."[29]

To be sure, he is not unaware of the medium's shortcomings. In his texts for *Deutschland*, he frequently comments on the cult of appearances and insists that the photographic image always be treated as a construction of reality. Sometimes Tucholsky uses visual tropes to question photography's privileged access to the real; at other times he admits the difficulties of visualizing class difference. Some examples foreground problems of representation, while others draw attention to the difference between everyday perception and the detached perspective of the camera. The dramatic contrasts and graphic effects in the image of a subway station make Tucholsky wonder: "It doesn't look like this at all—only the photographer ever sees it like this."[30] Photography, he seems to say here, arrests the flow of time and makes visible the hidden beauty of the ordinary. It is significant that Tucholsky chooses dead objects, conventional signs, and deserted urban settings whenever he speculates on the artistic possibilities of the medium. As soon as people enter into the frame, the challenges to the epistemological status of photography are denied and the image becomes part of a larger political argument.

The different status accorded to the human body is nowhere more evident than in the representation of women. Reflecting on the image of a fashion queen, Tucholsky turns her sexual appeal into a critical means for exploring the relationship between photography and history: "This Picture will look very strange in 1982. It shows a fashion queen . . . just something to do with advertising. So far, so good.

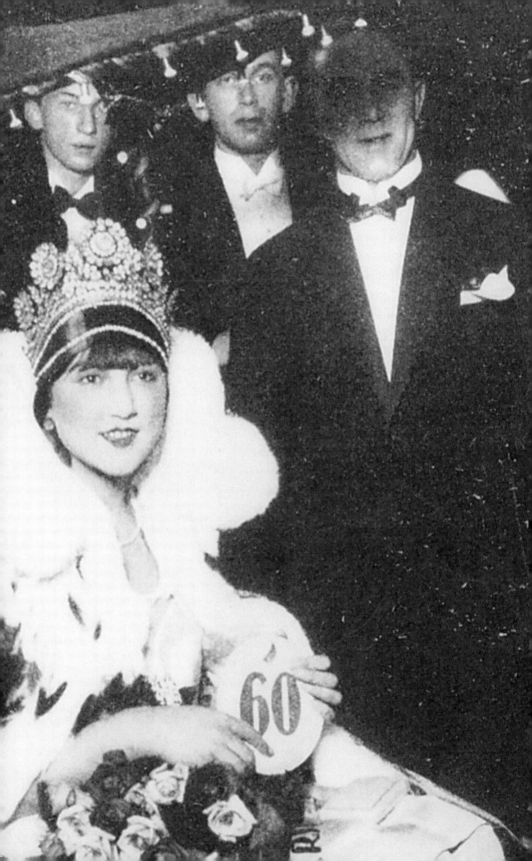

But our grandchildren will look at this picture with the same mixture of anger and nostalgia with which we look at faded photographs from 1911 and 1913, those little years before the great war."[31] In truth, the image resonates with meaning. Unlike the more conventional portraits of proletarian mothers, this snapshot of twenties' girl culture still appeals because the camera is part of the formal composition. Unaware of this self-reflexive quality, Tucholsky equates the strangeness of the scene with the resistance of the modern woman to physiognomic interpretation. Her association with fashion—in other words, with the production of images of the self—threatens his belief in a social typology that at once depends on and excludes images of women. They can be admitted into the realm of representation only as essential qualities. Female beauty and eroticism are equated with the ephemeral, whereas female suffering and sacrifice come to symbolize the eternal values of life.

These tensions between text and image draw attention to the body as the unreliable marker of sexual and social difference. Whenever important aspects of the image are ignored or misrepresented in the text, the mechanisms of denial are at work. Behind the contempt for the image lurks a fear of the indeterminacy associated with visual representation. In order to contain this threat, Tucholsky simply ascribes meanings to the images. But instead of making this intervention an integral part of the image-text relationship, he uses the apparent failure of the new medium to confirm the superiority of language. As a result, montage deteriorates into mere illustration. In "Such Terrible Scenes," Tucholsky offers a misreading that is particularly illuminating. He describes a photograph in order to prove its openness to interpretation but, in fact, only confirms what he sets out to criticize. The text is worth quoting at length:

And just look at these peoples' faces! They have brutality and crudity written all over them. No one could deny that these two people are the image of brute irrational violence. They will show

28 Opposite: Heartfield's "Fashion Queen." From Tucholsky, *Deutschland, Deutschland über alles* (Berlin: Neuer Deutscher Verlag, 1929) 182. Courtesy Special Collections Department, University of Iowa Libraries. © 1996 Artists Rights Society (ARS), New York/VG Bild-Kunst, Bonn.

29 Heartfield's "Such Terrible Scenes." From Tucholsky, *Deutschland, Deutschland über alles* (Berlin: Neuer Deutscher Verlag, 1929) 36. Courtesy Special Collections Department, University of Iowa Libraries. © 1996 Artists Rights Society (ARS), New York/VG Bild-Kunst, Bonn.

no mercy. The solid citizen's blood will have to flow. Probably their pockets are full of stolen gold fillings and jewelry. The practiced physiognomist can tell at a glance, and the judge can tell without even looking, that here the revolution had brought the lowest elements to the top. As a matter of fact, the two gentlemen in the picture are police agents in disguise.[32]

The photograph in question shows two darkly dressed men in profile, one with a hat, the other with a soft cap. Standing in what could be a public building, they stare through broken windows onto the street below. Two assumptions about physiognomy are simultaneously challenged and confirmed by the accompanying text. Based on the premise that a (contemporary) reader would identify the two men as revolutionaries, Tucholsky points to the deceptiveness of first impressions: the "revolutionaries" are police agents after all. However, the facial features of the men are hardly recognizable, in spite of Tucholsky's invitation to "look at these peoples' faces" and in spite of his conclusion that their faces "have brutality and crudity written all over them." Unless this discrepancy is part of a more treacherous reflection on social prejudices, Tucholsky ends up undermining his own intentions. The equation "revolutionary = brutal face" is simply replaced by that of "brutal face = police agent"—but the underlying assumptions about the body that govern both equations are accepted without further investigation. His example only shifts the negative association to the other side of class difference and makes physiognomy a category used on and against the representatives of power.

To conclude, in *Antlitz der Zeit* and *Deutschland*, photography provided the means through which physiognomy could rise again from its shadow existence in dubious philosophical treatises and popular instructional manuals. It was through the conflation of signifier and signified that photography turned the images of the body into a discourse—a discourse on difference. That reconstituted body could then be divided into distinct categories and hierarchies; analyzed on the basis of its difference to other bodies; and evaluated along the lines of gender, class, race, and nationality. This process contained within itself liberating as well as repressive qualities, depending on the context in which physiognomy was used. As Allan Sekula notes:

The techniques for reading the body's signs seemed to promise both egalitarian and authoritarian results. At the one extreme, the more liberal apologetic promoted the cultivation of a common human understanding of the language of the body: all of humanity was to be both subject

and object of this new egalitarian discourse. At the other extreme—and this was certainly the dominant tendency in actual social practice—a specialized way of knowledge was opening harnessed to the new strategies of social channeling and control.[33]

In the two very different works discussed, physiognomy functions as a boundary that protects against the equalizing forces of modernity; here the conservative concept has a progressive effect. Physiognomy establishes an identity and defines a paradigm on the basis of which social experience, including the experience of social change, becomes visible and hence intelligible. Rather than offering a system of classification, physiognomy draws attention to the gaps and fissures that are created in the process. Often this effect takes place against the photographers' intentions. Where physiognomy is inflected by obsolete social categories (e.g., Sander's emphasis on profession), it draws attention to the existence of different paradigms of interpretation. And even where physiognomy remains a blind spot in the practices of montage (e.g., Heartfield and Tucholsky's social stereotypes), it makes visible the incommensurabilities produced by change—but on the level of discourse, not representation. Thus, in *Antlitz der Zeit* the peasant becomes the figure through which traditional society enters the stage of representation one last time. In *Deutschland* the workers and their living conditions define the critical framework against which the truthfulness of images is measured. Both works share a concern with social determinations that leave little room for the categories of race or nationality. If the portraits in *Antlitz der Zeit* are shrouded in an air of nostalgia, there is enough evidence of Sander's pervasive sense of loss. If the representations of Germans in *Deutschland* are often unfavorable, and at times outright slanderous, Tucholsky and Heartfield's polemic nonetheless remains within the confines of Germanness; they need no "other" to claim any uniqueness or unity for Germany.

By contrast, the reactionary applications of physiognomy—and I am thinking here of many similar photo books published during the Nazi period—focus on categories that exclude and pass judgment, that establish boundaries between self and other. While repressing ambivalences within the self, this kind of "reactionary" physiognomy strives for idealized representations of a fictitious difference. Its categories are predominantly racial and, hence, biological. Their function is to eliminate all other categories, especially those of gender and class. This kind of "reactionary" physiognomy is saturated with moral categories that barely hide their instrumentalization in economic and political crises. That is why their images always appear in isolation: one stands for all, the ideal replaces the real. Of course, the

opposite is true in *Antlitz der Zeit* and *Deutschland*. Here physiognomy develops its critical potential in the spaces between photographs, between photographs and captions, between photographs and texts. Or it appears, unrecognized and unreflected, in the idealized images of women or the grotesque bodies of the class enemy. The larger context provided by captions, commentary, and critical reception turns such shortcomings into points of resistance, into disturbances within the work. Physiognomy operates as a function of many differences and not, as is true for its reactionary applications, as a standard based on which differences are attributed without further doubt. This requires that the constant slippage of meaning in the photographic image be recognized and made part of the entire project. In the case of Sander, such self-reflexivity takes the form of direct eye contact between the photographer and the person portrayed, and it leads to a foregrounding of those aspects that participate in the production of social identity. For Tucholsky and Heartfield, this self-reflexive quality resides in writing and the ongoing dialogue between image and text. In both works, the complexity of the individual is never entirely abandoned for the argumentative power of the typical. This very openness protects them from succumbing to the aesthetics of an idealized totality.

As I hope to have shown, the appeal to physiognomy raises questions of representation and interpretation. The very different projects of Sander and of Heartfield and Tucholsky originate in a similar desire for recognizable social types and, implicitly, a social order that is still accessible to visual perception. Two critical strategies, the shift from an anthropocentric physiognomy to a social typology and the awareness of the limits of photography, laid the foundation for a productive approach to modern society and the discourse of the body. The two works under discussion make use of this possibility especially in their shortcomings. For them, physiognomy represents one of the last vestiges of an imaginary time when body and soul were still one, and the first signs of the new order where the other remains precisely that—the other. To them, physiognomy offers a tool for remembering the past and an auxiliary in anticipating the future. It turns visual representation into an important means of critical analysis. It brings the long overdue recognition of the visual but also draws attention to the growing fetishization of the image. And it makes possible a collaboration between old desires and new technology. *Antlitz der Zeit* and *Deutschland, Deutschland über alles* suggest that the probing of physiognomy within the unstable configurations of Weimar society puts an end to speculations about the inherent meanings of noses, eyes, mouths, chins, skulls, and foreheads. Their portrayal of German society at a particular historical juncture emphasizes those aspects of physiognomy that question, rather than affirm, the dis-

courses of the body as the expression of an inner self. Physiognomy in modernity becomes a discourse, a discourse from the vantage point of belatedness.

Notes

1 Physiognomy, as it is used today, refers back to the fragments on physiognomy written by the Swiss theologian Johann Kaspar Lavater, *Physiognomische Fragmente zur Beförderung der Menschenkenntnis und Menschenliebe* (1775–1778). Outward appearances, Lavater argues in the tradition of the ancient philosophers, are the manifestation of an inner self, with beauty signifying virtue and ugliness vice. The affinities between body and soul, physical being and moral disposition, he claims as the foundation of love and understanding between human beings and exist in the individual as well as in entire families and nationalities. While character traits manifest themselves in gestures, movements, and more permanent features, the face for Lavater and his followers remains the primary object of physiognomic study.

2 Charles Baudelaire, *The Painter of Modern Life and Other Essays*, trans. and ed. Jonathan Mayne (London: Phaidon, 1964), 3.

3 With the exception, of course, of similar projects in painting and the graphic arts. These include, among others, George Grosz's drawing portfolios for the Malik Verlag, *Das Gesicht der herrschenden Klasse* (1921) and *Der Spießer-Spiegel* (1925) which, like *Deutschland*, rely on exaggeration, contradiction, and satire to unmask the representatives of the ruling class. And they recall paintings by Otto Dix, who, like Sander, emphasizes the importance of occupation in the definition of social types; hence the striking similarities between Sander's "Secretary at a Radio Station" and Dix's portrait of the monocled Sylvia von Harden.

4 According to Robert Kramer, *Antlitz der Zeit* belongs to an older tradition, primarily in woodcut and engraving, of portraying a society through its typical representatives. Examples include the medieval *Ständebuch* (book of trades), where social groups are distinguished on the basis of their trade or guild; the *Totentanz* (Dance of Death) and the *Narrenschiff* (Ship of Fools), with their respective social iconographies; and the various forms of the *Spiegel* (mirror), where social conventions and human vanities are often ridiculed through grotesque exaggeration. See "Historical Commentary," *August Sander: Photographs of an Epoch 1904–1959* (New York: Aperture, 1980), 11–38.

5 Walter Benjamin, "Kleine Geschichte der Photographie," *Gesammelte Schriften*, ed. Rolf Tiedemann and Hermann Schweppenhäuser (Frankfurt: Suhrkamp, 1980), 1:380 and 381. Referring to its didactic values, Benjamin described *Antlitz der Zeit* as "an atlas of instruction" (*übungsatlas*). All translations are mine unless noted otherwise.

6 Jefferson Hunter, *Image and Word: The Interaction of Twentieth-Century Photographs and Texts* (Cambridge, Mass.: Harvard University Press, 1987), 135.

7 The photographs are part of a larger project, published posthumously as *August Sander:*

Menschen des 20. Jahrhunderts, text by Ulrich Keller (Munich: Schirmer/Mosel, 1980), translated into English as *Citizens of the Twentieth Century: Portrait Photographs 1892–1952*, ed. Gunther Sander, trans. Linda Keller (Cambridge, Mass.: MIT Press, 1986). Some of the photographs have been published previously under the misleading title *Menschen ohne Maske*, introduction by Golo Mann (Munich: Schirmer/Mosel, 1971). On Sander's project and its critical reception, see Claudia Gabriele Philipp, "August Sanders Projekt 'Menschen des 20. Jahrhunderts': Rezeption und Interpretation" (Ph.D. diss., University of Marburg, 1987).

8 Susan Sontag, "Melancholy Objects," *On Photography* (New York: Farrar, Straus, and Giroux, 1977), 61.

9 August Sander, "Photography as a Universal Language," trans. Anne Halley, *Massachusetts Review* 19, no. 4 (Winter 1978): 677 and 678. Sander's later physiognomic project also extends to landscapes, as suggested by the series *Deutsche Lande—Deutsche Menschen* (1933–1934) and *Rheinlandschaften: Photographien 1906–1952* (1975).

10 Sander, "Photography as a Universal Language," 675.

11 Ibid.

12 Ibid.

13 Sander, quoted by Anne Halley, "August Sander," 666.

14 Alfred Döblin, preface to *Antlitz der Zeit: 60 Aufnahmen deutscher Menschen des 20. Jahrhunderts*, by August Sander (Munich: Schirmer/Mosel, 1976), 7. It should be noted that the available English translation of Döblin's preface, "About Faces, Portraits, and their Reality" (1929), trans. Marion Schneider, in *Germany: The New Photography 1927–33*, ed. David Mellor (London: Arts Council of Great Britain, 1978), 55–59, is not always accurate.

15 Döblin, preface, 11.

16 For a very illuminating discussion of the portfolio arrangement and its sociopolitical implications, see Keller's preface to *Citizens of the Twentieth Century*, 23–63.

17 By contrast, *Citizens of the Twentieth Century* contains an entire section on National Socialists. Erich Mühsam, the poet who was involved in the short-lived 1919 Worker's Council government in Munich, is also depicted in Hans F. G. Günther's infamous anti-Semitic treatise, *Rassenkunde des deutschen Volkes* (1922). In Sander, Mühsam appears in a group identified as "Revolutionaries," whereas Günther introduces him as a "German Jew (Communist leader), Oriental-Nordic type." For a short commentary, see Halley, "August Sander," 670.

18 Döblin, preface, 11.

19 Ibid., 15.

20 Quoted by Keller, preface to *Citizens of the Twentieth Century*, 54.

21 Kurt Tucholsky, "Auf dem Nachttisch" (1930), *Gesammelte Werke in 10 Bänden*, ed. Mary Gerold-Tucholsky and Fritz J. Raddatz (Reinbek: Rowohlt, 1987), 10:83; Thomas Mann to Kurt Wolff, quoted by Kramer, "Historical Commentary," 11.

22 Quoted by Keller, Preface to *Citizens of the Twentieth Century*, 42.

23 Kurt Tucholsky, *Deutschland, Deutschland über alles: Photographs Assembled by John Heartfield*, trans. Anne Halley, afterword and notes by Harry Zohn (Amherst: University of Massachusetts Press, 1972), 2 and 3. Originally published as *Deutschland Deutschland über alles: Ein Bilderbuch von Kurt Tucholsky und vielen Fotografen. Montiert von John Heartfield* (Berlin: Neuer Deutscher Verlag, 1929; facsimile reprint, Rowohlt: Reinbek, 1990).

24 Tucholsky, "Die Tendenzfotografie" (1925), *Gesammelte Werke*, 4:105.

25 Tucholsky on the importance of captions: "In my *Deutschland, Deutschland über alles* I have attempted together with Heartfield to develop a new technique of captions for images, a technique which I now frequently see in illustrated magazines. The reader must be taught to see with our eyes, and the photograph will no longer only speak: it will scream." *Gesammelte Werke* 8:140.

26 On the work's reception, see Hans J. Becker, *Mit geballter Faust: Kurt Tucholsky's "Deutschland, Deutschland über alles"* (Bonn: Bouvier, 1978), esp. 79–87.

27 See Kurt Tucholsky to Herbert Ihering, 18 Oct. 1929, *Ausgewählte Briefe 1913–1935*, ed. Mary Gerold-Tucholsky and Fritz J. Raddatz (Reinbek: Rowohlt, 1962), 131.

28 P. V. Brady criticizes Tucholsky for his nostalgic tone: "Compared with the *Kriegsfibel* [by Brecht], Tucholsky's *Deutschland, Deutschland über alles* seems to fail through having too many targets, too many techniques, too many conflicting impulses." See "The Writer and the Camera: Kurt Tucholsky's Experiments in Partnership," *Modern Language Review* 74, no. 4 (1979): 869–870.

29 Peter Panter [Kurt Tucholsky], "Ein Bild sagt mehr als 1000 Worte," *Uhu* 2 (1926): 75.

30 Tucholsky, *Deutschland*, 107.

31 Tucholsky, *Deutschland*, 176.

32 Ibid., 29.

33 Allan Sekula, "The Traffic in Photographs," *Photography against the Grain: Essays and Photo Works, 1973–1983* (Halifax: Press of the Nova Scotia College of Art and Design, 1984), 86.

Traditional Arts
This Century's

I am living at the living Villa Borghese. There is not a crumb of dirt anywhere, nor a chair misplaced. We are all alone here and we are dead. . . . The cancer of time is eating us away. Our heroes have killed themselves, or are killing themselves. The hero, then, is not Time, but Timelessness. We must get in step, a lock step, toward the prison of death. There is no escape. The weather will not change. . . . This is a prolonged insult, a gob of spit in the face of Art, a kick in the pants to God.

HENRY MILLER, *THE TROPIC OF CANCER*

II

and the Shock of Image

Introduction

DUDLEY ANDREW

The cover of this volume pits two moments that might be taken as bookends of modernity against each other, dramatizing the fate of the art image in this century. Lyonel Feininger's "Pink Sky: A Street in Paris" (1909) glows with the giddy release of energy brought on by the mechanical technologies of locomotion and cinema, even though it represents an ambulatory scene and was painted by hand in the old manner. The famous cartoonist, master of the lithograph and of such newspaper strips as *Kin-der-Kids* and *Wee Willy Winky*, rather suddenly turned away from mechanically reproduced images and embraced the elite medium of oil on canvas. In a painting that was taken very seriously, Feininger depicts a rush of characters forming an hourglass as they hasten pell-mell with no concern for one another—and perhaps no concern for themselves. With neither psychology nor narrative motivation leading it, the composition is directed by the architecture of the street, which advances from the backdrop to play a dominating role. Massive cliffs of buildings govern the flow of the figures in the urban valley below, channeling their Brownian movement. Feininger paints everything in solid colors, separating figures, props, and buildings like plastic colorform cutouts. Each element, each color, rings as a clear note to produce, in ensemble, a thoughtlessly pleasing suite, a haphazard visual symphony in a city. These figures behave like statistics, heading without hesitation to destinations where other figures no doubt are just now departing. Paris has become in our century an immense railroad station of activity, and as in a railway station, life here is geared to the relentless advance of the precision clock found in the central lobby. As the sun sets, the characters in this painting disperse, unaware of the privileged, photographic moment they participate in.

"Pink Sky" signals the induction not just of popular subject matter but of a popular visual sensibility into a rapidly evolving European art culture. This caused a certain amount of friction, to be sure. For example, Henri Matisse was made uncomfortable at the 1911 Paris Salon des Indépendants by Feininger's "Green Bridge," an explicit companion to "Pink Sky." The distinguished fauvist

felt intimidated by Feininger's novelty and freshness and insisted that his own painting be moved to another room altogether, distancing himself from the popular style.

Yet in 1906, a few years before "Pink Sky," Feininger had been taken up by Delaunay and other prophets of dynamic aesthetics who welcomed him in part because he was a mass-market graphic artist. In this guise he assisted at the incubation of cubism in the Montparnasse cafés of that era. Later he would be the very first artist hired by Walter Gropius when the Bauhaus got under way after the war. Seen in this environment, "Pink Sky," though indebted to Parisian comic street movies—indeed, because indebted to movies like *The Pumpkin Race* (1907) and *The Runaway Horse* (1906)—exemplifies the research of painters into the space and time of everyday objects and scenes: for instance, a violin or a woman descending the stair. The cubist idea would alter not just painting but an entire way of understanding art and culture. This is what Apollinaire believed, as Jennifer Pap documents. Importantly, in the same year that he proclaimed the ascendancy of a new kind of visuality for the century, Apollinaire also helped found *Les Amis de Fantômas* in honor of the thrilling film serial that had all Paris in its grip. Its creator, Louis Feuillade, succeeded in transforming the streets of Paris into a mysterious web of intrigue. This is the Paris and the art world that "Pink Sky" opens onto—one where hierarchies have fallen and where ordinary experience is not only a subject worth representing but also the most fertile ground for aesthetic research.

The refreshing energy and optimism that runs down Feininger's Paris street darkens on our cover to a black and white moment from the final sequence of *Breathless* (1960). Michel Poiccard staggers away from us, down another Parisian street, a bullet in his back. He expires behind the mask of his face, and news of his death will no doubt be teletyped in neon from the top of the same newspaper building that had earlier warned the public he was at large. Michel Poiccard was indeed at large, treating himself like a cartoon character not responsible for his situation. Impulsive and inconsequential, he flattened morality, art, and psychology into a collage of borrowed words, gestures, and facial expressions. He might have stepped out of a Roy Lichtenstein or an Andy Warhol painting, artists whose subjects and techniques speak to a culture saturated by the movies and by images in general. Godard has done more than ingest the history of cinema. In *Breathless*, he masticates such artists as Renoir, Faulkner, Mozart, and Klee, swallowing and digesting them boorishly. The insolence of *Breathless* befuddled and annoyed critics, who were of course the first casualties of its "democratic" insouciance. Indifferent

to the achievements and the project of culture, whimsical toward life (and here, in our cover image, toward death), *Breathless* insults art in a way Walter Benjamin would surely have condoned.

Or would he? Estera Milman places Benjamin's great essay on the work of art dead center between "historical dada" (1918–1923)—whose significance he grasped even if he was ignorant of its complex past—and dada's repeated resurrections after 1950 (in Robert Motherwell's anthology, in Lawrence Alloway's manifesto, in the British Independent Group, in pop art, in Fluxus and Doom). At stake is the meaning and function of "democratic" artmaking and art consumption, the same issues Feininger's painting raises, though now discolored and soured in hue. As for *Breathless*, Peter Wollen treats the early Godard as a pop art figure on the scale of Warhol; and Godard himself has recently avowed his debt to Rauschenberg. Yet, in a typical gesture, Godard also rejects *Breathless*, castigating its hero as more fascist than anarchist (dada). Just so, the politicized avant-garde today excoriates pop art for its pretense to being revolutionary; in fact, pop art's works and actions foster a continuity with museum culture rather than insisting on completely new conditions of production and display.

Benjamin had proclaimed a fully revised role for art in the mass culture of a technological society (and technology has insinuated itself much more deeply in our culture, and specifically in the art sector, than Benjamin could ever have imagined); yet the institutions of art—the market and museum, including criticism and self-representation—remain decidedly hierarchical, though inflected by irony naturally.

In the course of dismantling the venerable mission of representation for the fine arts, photography and cinema released them to take on other functions. Milman focuses on the task—visible in cubism, dada, and neo-dada—of providing a greatly expanded visual lexicon to counter the suffocating language spoken by ideology, a lexicon moreover taken from everyday materials. At the antipodes of this project stands the prelinguistic, seemingly presocial expressions of action painters and of all those who take the act of painting to be singular, silent, and fundamentally private. Where pop art descends from a social heritage (jokes, wit, and calls to revolution are nothing if not social), much body and performance art ignores culture, groveling in elemental experience. Francis Bacon's paintings, as Robert Newman takes them up, are in this sense not just about bodies; they are somehow bodies themselves. This is something painting can aspire to after photography, for now one paints the body not to defeat time and death but as a scandal. Manet and

Duchamp gave us shocking nudes, but nothing like the body as painted by Bacon. Beyond representing figures, beyond representing emotion, Bacon paints sensations, directly corrosive ones. His Crucifixion triptychs announce their own "catastrophe," writes Newman, citing Gilles Deleuze. Indeed they announce the catastrophe of art in the age of mechanical reproduction by lodging the singularity of sense experience within an overloaded cultural narrative that is obviously inadequate to it.

As far as the traditional arts go, then, the cold technologies of image production have utterly displaced their assigned social and aesthetic roles; in mass culture the politics of art, once so heady and utopian, has turned schizophrenic. As the three cases treated here make plain, artists have responded to, but have also helped produce, the deflation of such standard values as the individual, depth, and contemplation. All three of these cases find art attempting to address culture from a place outside art. All three raise questions about the use or value of critical discourse, at the same time that each engenders a new kind of writing: Apollinaire's cubist ekphrasis; the debates and manifestos endemic to (neo)dada; and Deleuze's figurative philosophy spinning down the orifices of the bodies of Bacon's paintings.

The chapters in this second section of *The Image in Dispute* form an appropriately discontinuous chronicle of what we might term "the *state* of art in the age of mechanical reproduction."

The Cubist Image
and the Image of Cubism

JENNIFER PAP

The twentieth century demands an understanding of the visual experience in its multiplicity. How do we speak of a modern viewer? Many influences in the modern world have changed viewing practices. A series of visual inventions—the camera obscura, the panorama, the cinema, to name a few—have continued to relate the subject in new ways to the viewing experience and, implicitly, to the world. The cinema itself literally places the viewer in a physical situation that differs greatly from that of, for instance, the viewer in the museum, another modern invention. Roland Barthes speaks of a "madness" in photography if its "realism is absolute and, so to speak, original, obliging the loving and terrified consciousness to return to the very letter of Time: a strictly revulsive movement which reverses the course of the thing, and which I shall call, in conclusion, the photographic *ecstasy*."[1] The viewer's love and terror are aroused as she or he is pulled into a new experience of time and compelled to respond.

I have mentioned new contexts and new forms of image-making, but within the realm of painting itself the twentieth century begins with a major shift in visual practice. From the cubist treatment of the space of the canvas, the object, and the representational process arise tremendous disturbances to customary viewing practice. New visual technologies introduced new experiences for viewers, but cubism, within the (once) familiar space of the painted canvas, forced viewers out of their accustomed ways of relating themselves, through art, to the external world. This new painting moved away from imitative forms, multiplied perspective and light sources, insisted on a conceptual rather than a perceptual reality, questioned the separation of figure and ground, and generally opened the question of how and what painting could represent. The viewer, accustomed to painting that offered a window on the world, faced a series of problems about the artist's idea of an object, and the accessibility of that object to the viewer's gaze, touch, or knowledge.[2]

Richard Shiff has written of the different ways of knowing called up by modernist image-making practice, a practice that emphasizes, according to him, touch

over vision. Vision, we might think, offers the viewer a better apparent command of things seen than touch does of things felt; thus, this new painting of "touch" would reduce the spectator's sense of control. In Shiff's view, modernism has replaced the metaphor of painting as a window onto reality with the "metonymic exchange between an artist's or a viewer's human physicality and the material, constructed physicality of an artwork."[3] Thus he describes a transition in the viewer's experience from vision to touch, and from a sign pointing to a prior reality to a confrontation of different bodily experiences, each one equally real and present. Exchange, clearly, will influence viewers as they view. If we add to this the changed representation of the human body in cubist painting, we see that the physical being of spectators was challenged along with their habits of viewing.

What will emerge from this challenge? What new sense of who we are will come from images that situate us in new ways, or seem not to situate or define us at all? David Freedberg suggests that certain art forms might reveal an aspect of our response to images that we generally seek to repress. He sees an opportunity to discern a root visual response that is common to everyone when we look at modern, nonrepresentational art, for an art devoid of narrative content disallows our use of the veils of customs and social discourse that repress our first response and shape it into something else. Modern art, as it leaves representation and narrative behind, forces us to acknowledge our visceral response:

We are arrested by size or color or the suggestion of smell, or nauseous agglomeration of surface texture. It might be felt that to describe such things calls for the terms of formalist criticism, but that would be to diminish and etiolate such responses. To allow them their full role is, again, to acknowledge the role of sensation in knowledge. We see jagged edges, spikes, texture, flakiness, and we respond in more visceral ways than refined criticism is usually capable of being articulate about.[4]

I wish in particular to pursue Freedberg's suggestion that there are kinds of language we bring to our viewing process that veil an entire part of that process. The story told in the painting, or our familiarity with the discourse of art critics or art historians, "distract" us from "the role of sensation in knowledge." Indeed, a knowledge involved with sensation may be troubling, resulting in a "metonymic exchange," if we remember Shiff's terms, rather than a one-way journey in which we, the viewers, use our understanding of an image to introduce us into an experience that appears fully understandable in the single glance we turn upon the image.

But there are many different kinds of language that can mediate our relation to a visual image. Images may tell their own story or contain their own language of various kinds; critical discourse (of various and diverse kinds) can guide or limit our response to visual impact; or we may confront an image through a poet's description of it.[5]

My premise in this project is that cubism, while only one among many other modern sites of profound visual transformation, repositions and redefines the viewer in fundamental ways. Furthermore, I wish to relate my exploration of the kind of languages (the language of poets and critics) that mediate the cubist image to a general problem of the relation of language and visual image as perceived at a particular time. If we use language to mediate the visual image, we do so in many different ways. The terms of such mediation imply a certain relation of word to image, of verbal to visual—a relation that is in turn highly suggestive of our self-positioning in the world, our hopes for representation and for language, and our ways of knowing.

Ekphrasis, the verbal description of visual art, is a trope that reveals the hopes of writers and their culture for various kinds of connections between word, image, spectator, and world. These hopes are based in large part upon the difference of visual representation from language. Writerly gestures toward painting often assign to the image values of permanence or an immediacy of expression that writing lacks. Perhaps another value emerges from the visual because the image constructed by ekphrasis seems to offer the reader-viewer (the two, to some extent, are joined) some access to the world as mediated by the painting, which was the subject of the ekphrasis in the first place. The root meaning of the term suggests the powerful effect of language, which makes the image speak (*ekphrasein*, to speak forth or tell). But there is another miraculous effect that follows logically from the success of the first: the wonderful immediacy of the image becomes accessible to the reader, who, now a "viewer" as well as a reader, can enter the world offered by the visual representation. As we read Baudelaire's hymn to color in Delacroix, the painting as translated in words draws the reader into a harmonious landscape that engulfs the senses.[6] In Apollinaire's descriptions of Picasso's pre-cubist work, the color of the paintings seems to pull the writer—and us—into the blue world in which the painted figures' thoughts and prayers are intelligible.[7]

But this close engagement of the reader-viewer with the image world may depend upon a certain kind of image. The cubist painting explicitly replaces the pleasure of viewing a window on the world with its own reality. The viewer is not

drawn into another world; rather the painting draws from the viewer responses to its own physical terms. Recall Freedberg's description of what happens to the viewer of a modern painting: "We are arrested by size or color or the suggestion of smell, or nauseous agglomeration of surface texture." Indeed, Freedberg wonders if such painting draws hitherto repressed responses out of the viewer. He posits a process of drawing out the viewer as opposed to what is perhaps a more traditional ekphrastic process of drawing the viewer into the painting's world. Perhaps cubism resists ekphrasis, the visual dream, and confronts viewers with a less harmonious tactile challenge. If ekphrasis allows a poet to organize, in some way, the response of the viewer (poet-viewer or reader-viewer), cubism resists this verbal mediation and leaves the viewer searching as in the more difficult viewing scenes suggested by Shiff and Freedberg.

Freedberg speaks of a (welcome) failure of language to mediate an image that is nonfigurative or at least less narrative than traditional painting. It may be that cubism resists the application of ekphrastic language not only because of its diminished narrative content, but also because of the place it makes for a new kind of language within the image itself. Ekphrasis depends upon the difference felt to exist between word and image, but cubism intertwined the figural and discursive qualities of the image in new ways, so the visual image slipped away from its secure place in opposition to language. That place where it had been different from language had put it closer to the world and to sensory experience.

Visual images often have both "discursive" and "figural" properties, to borrow the terms of Norman Bryson, who examines "the interaction of the part of our mind which thinks in words, with our visual or ocular experience before painting."[8] Cubism's relation to language (understood in some extended sense) must be viewed in at least two ways: it shook off narrative subjects that paired formal expression with an anecdotal or literary idea; it also tempted critics and viewers to rethink the idea of a language associated with painting. Cubist titles and letters or word fragments used in the painting attracted a good amount of critical attention. What is the relation of the new use of language to our experience of the figural aspects of the work or to our visual pleasure? Looking at a cubist painting, one is sometimes hard-pressed to say which word, "figural" or "discursive," would first or best describe our experience. In *Ma Jolie*, does the title, taken from words prominently painted in the lower portion of the picture, set us first to "deciphering" traces of a woman and imagining the painter's relation to the model? Or—since such a story is not readily apparent in the visual register even after knowing the

title, much less before—is the eye first struck by the basic physical properties of the forms themselves? Do the words and their potential clues for unraveling a story strike us first, or do the forms? Painted letters and words were now part of the painting, and contemporary critics described the art as "poetic" or often would relate it to ordered systems such as non-Euclidean geometries, mystical alphabets, or equations. But at the same time, the image rejected discursivity as the painters banished anecdote and literary description from their works and favored still lifes and portraits rather than mythological or historical (narrative) scenes. Language also seemed to be banished by the painters' silence in the early years; since they were reluctant to speak of their goals and wrote no manifestos "explaining" the goals of cubism, the images had to stand on their own without the bridge of some discourse to help the viewer understand.[9]

As for the figural or sensory aspects of the image, it might seem that the focus on the two dimensions of the canvas, instead of the referent beyond it, would lead to heightened physical engagement with the images themselves. But the reduction of color and the fragmentation of the object rendered that engagement difficult. Early viewers were troubled by the geometric forms (thus the word "cubism") that seemed to prevent simple visual pleasure. In fact, in most criticism of cubism, if the spectator's body is placed in relation to the viewing experience, it is mediated by a conceptual process. Charles Morice seems to believe that Braque derives equal pleasure from the sight of a stone and of a face, but he seems unable to follow the painter easily in that pleasure. "Visibly, he proceeds from an *a priori* geometry to which he subjects all his field of vision, and he aims at rendering the whole of nature by the combinations of a small number of absolute forms. . . . nobody is less concerned with psychology than he is, and I think a stone moves him as much as a face."[10]

Conceptual preoccupations about geometries in nature lead the painter to abandon familiar themes. The replacement of the face with the stone in this passage suggests not only the disappearance of a human theme, but also perhaps the disappearance of a human counterpart to the spectator. The face in the painting traditionally might have offered spectators images of themselves experiencing the world of the composition. If Braque feels joy at the sight of a stone, we might despair of being able to follow the painter into the world he paints. As in so much cubist criticism, this passage shows the artist's visual process becoming conceptual, and as it does so the invitation to the spectator to enter a new world is complicated.

For Guillaume Apollinaire and Daniel-Henry Kahnweiler, two of the most

important early critics of cubism, the presence of a new kind of language in cubist painting needed to be reconciled with their feeling that the painting led to visual pleasure for the eye. Apollinaire's early essay on Picasso's pre-cubist Blue Period work serves as a useful contrast, for it shows that he imagines a deep human consciousness that is captured in visual terms: "Picasso has observed human images that floated in the azure of our memories."[11] Here an image language is imagined to exist within human consciousness. Memory, human thought, and self-understanding are cast as floating images, unanchored and free. Memory, an activity of mind, becomes image and in so doing takes on cosmic dimensions (the azure) and the physicality of pure color, a color which clearly refers to the rich and drenched paint of Picasso's paintings of this period. The painter's vision can discern these images and make them available to us. In a second step, the poet-critic's language brings the painted forms to the reader. The essay contains few references to the physical mechanics of paintings such as titles, frames, or composition. We thus have the impression that we are not reading about paintings but about a world that the critic-narrator seems to have entered, allowing us to follow. Apollinaire creates a privileged realm where Picasso's powerful visual language and his own verbal language meld, allowing even our mental life to take on physical form and place us within an enveloping world. His own writing is drawing power from the visual: from the immediacy and depth with which, for him, the painter approaches the human condition.

Cubism was to challenge Apollinaire's critical writing and his poetry in many ways, and one way it did so was certainly in its connection of vision with a new and demanding conceptual activity. In *The Rise of Cubism* Daniel-Henry Kahnweiler confronts the new conceptual dimensions of the image in more detail than Apollinaire does. Turning to his discussion of the spectator's experience, we can see that the idea of a new kind of language within visual art involved an added challenge for the spectator. Yet Kahnweiler still finds a way to draw the image toward the visual side of the equation, arguing that the image's new, conceptual *language* becomes the facilitator of the spectator's engagement with the rhythm of the *forms* of cubist painting. According to him, elements external to the physical core of the painting, elements that have more to do with language, help build the new sensory dimensions of the image. Cubist titles and realistic details, he says, relieve the image of the need to be illusionistic. They reveal the referent of the image so that the "rhythm of form" of the painting (independent of these clues) can be brought into a dynamic confrontation—in the mind of the viewer—with the memory of the referent as it

"is" in the world. This heightens our recognition of the lyric form of the image, while keeping the visual forms free of illusionism and of the narrative, anecdotal language of painting that would point or bend the image in the direction of reality. Kahnweiler acknowledges cubist conceptual language, but ultimately links it to a visual pleasure and a connection with the world that would still seem to define the visual image as having special properties distinguishing it from language.

In a further step, he argues that cubism's forms, made accessible to us by language, help us see the world. Its ideal forms—geometric shapes—do not exist in the world, but we need them to see it:

In its works Cubism, in accordance with its role as both constructive and representational art, brings the forms of the physical world as close as possible to their underlying basic forms. Through connection with these forms, *upon which all visual and tactile perception is based*, Cubism provides the clearest elucidation and foundation of all forms. *The unconscious effort which we have to make with each object of the physical world before we can perceive its form is lessened by cubist painting* through its demonstration of the relation between these objects and basic forms.[12]

Immersion in instinctive vision is not enough to bring the spectator into the world. Physical experience of and in the world depends upon the elaboration—in our minds or on canvas—of conceptual images like those of cubism. Kahnweiler not only draws the conceptual image toward sensory experience but even makes of it a guide to sensory perception of life itself. The sensory force of the image and, by extension, of the world is possible through the mediation of language (titles), conventional codes (the sketchy realistic detail), and a conceptual process (the spectator's memory) that takes place in time, like narrative. Conscious that cubism has involved the visual with a new language, and conscious too of the difficulty of seeing this mode of painting as a bridge to experience of the world, Kahnweiler makes the intertwining of language and form into a particular means of access to the world. In this way he surpasses visual pleasure to accord a higher role to painting: ". . . the assimilation which leads to seeing the represented things objectively does not immediately take place when the spectator is unfamiliar with the new language. But for lyric painting to fulfill its purpose completely, it must be more than just a pleasure to the eye of the spectator" (*RC*, 12–13). Pure pleasure for the eye is not enough—even the physical world demands a greater understanding than simply a sensory one of the language of forms.

In a passage from *The Cubist Painters: Aesthetic Meditations* (1913), Apollinaire also confronts the question of the language suggested by cubist titles or lettering within a painting, and also, like Kahnweiler, draws this language toward the visual:

Let me add that the formulation of the title is, for Picabia, not separable, intellectually, from the work to which it refers. The title should play the part of an inner frame, as an actual object, or inscriptions exactly copied, do in the pictures of Picasso. It should ward off decadent intellectualism, and conjure away the danger artists always run of becoming literary. Analogous to Picabia's written titles, to the real objects, letters, and moulded ciphers in the paintings of Picasso and Braque, are the pictorial arabesques in the backgrounds of Laurencin's pictures. With Albert Gleizes this function is taken by the right angles which retain light, with Fernand Léger by bubbles, with Metzinger by vertical lines, parallel to the sides of the frame cut by infrequent echelons.[13]

In this passage, Apollinaire has the visual work absorb these new elements more or less on its own terms. The words of a title, the letters or inscriptions in a painting, play the role of an "inner frame"—that is, they are a formal element that gives shape to the work, but they exist within the work, not along its boundaries or outside it. Similarly, where writing was different from painting, now it is a part of it, for Apollinaire draws an analogy between titles, letters, and visual shapes in the work of Laurencin, Gleizes, Metzinger, and Léger.

It seems that Apollinaire seeks, for language and conceptual elements in painting, a role in absorbing the viewer into the composition. In much the same way, in his early essay on Picasso, he had recreated Picasso's world so that the reader-viewer could be drawn into it. The modern title pulls us toward visual experience—which is not unlike Kahnweiler's contention: the image of the inner frame suggests a forceful pulling of the eye into a concentrated point in the center of the canvas. Language is not independent from vision, explaining it; rather, it pulls us more deeply into true vision. Therefore, ironically, while the words of titles and letters in painting have made for a strong linguistic element within the image itself, the purity of this new image enables a purely visual sensory experience: "Once purified, this art would have an immense range of aesthetic emotion. It could take as its motto the remark of Poussin: 'Painting has no other end than the delectation and joy of the eyes'" (*CP*, 46).[14] His hope is that the new link with language has made the visual more purely visual.

We have seen a poet and a critic respond to a new conceptual dimension in the visual image, each of them seeking to preserve purely visual qualities distinguishing image from word. Yet the move, on the part of the new image, toward a conceptual "language" must have been felt. In poetry, for instance, cubist ekphrasis—evocative verbal description of cubist painting—is rare, suggesting the degree to which this new painting threw into question the role of the visual and its relation to language. Cubism engendered a moment of critical confusion that challenged all who wanted to respond to or explain it. In poets committed to writing about art, and involved with cubist art, we can see yet another challenge: that of the image to the implicit viewing body. Apollinaire and Pierre Reverdy, both intimately connected with cubist circles, imagined differently the relation of the viewer's body to the image, of the image to language, and of the image to the world.

Throughout the cubist moment, Apollinaire continues to make the image a powerful means of physical engagement with the world. Vision mediates self to world to self. Its redemptive value is connected to the absorption of the image into the body, the image's ability to touch and even absorb the viewer's physical being. Of Picasso in his pre-cubist period, he says that "he bruises us like a brief chill."[15] Not very differently, in *PABLO PICASSO* (1917), the poet-critic-spectator breathes in the artist's work, and writes of a plunge into an ocean that seems to be filled with images that came from the artist's (Blue Period) brush. (The fact that the later poem still contains images of the Blue Period shows how an earlier idea of the function of the image continued to inform the poet-critic's understanding.) The image, for Apollinaire, facilitates the crossing of the boundary between self and world. Perception gives the subject back a defined sense of self: the poet's signature in the mirror of "Coeur couronne et miroir" affirms that his identity can be grasped, as long as the visualization of it is "as you imagine angels and not at all like reflections." The definition of the heart in the same visual poem suggests that a form grasped by the eye (a flame) can be turned over, slightly modified, and personalized by the writing hand, to become a satisfying glimpse of the self: "My heart like an inverted flame."[16] The *form* of his calligrams shows the poet making a visual image of the world, thus allowing the eye to gain an epiphanic contact with the self. Seeing is a capturing of the self discovered in the world: "Picasso has observed human images that floated in the azure of our memories." The artist discerns forms that define us.

In "Ombre" we find what is perhaps Apollinaire's ideal image: a faithful projection of self into the world, constructed by light and the body itself, the poet's

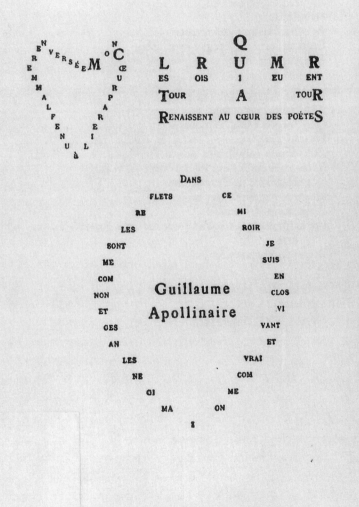

30 Visual imagery in "Coeur couronne et miroir." From Guillaume Apollinaire, *Calligrammes*.

© Editions Gallimard. Reprinted by permission.

shadow. His shadow is a companion that brings back to him his past and his friends ("Memories of my comrades dead in battle") and, in making the world present for him, becomes a bit of divine grace brought to the humble world, "A god humbling himself." This perfect image is the writing or image of his own body, a visual form that would define his place in the world, "Shadow solar ink / Handwriting of my light."[17] A nearly identical comment made by the painter Robert Delaunay is quoted by Apollinaire in "Réalité, peinture pure" (1912): "The first paintings were simply a line surrounding a man's shadow made by the sun on the earth."[18]

While Delaunay's theoretical musings and his art were supportive partners for Apollinaire's enthusiastic connecting of image, world, body, and self, the cubist image must have seemed more of an obstacle to such connections. Its intricate blend of form and conceptual language, championed by Kahnweiler, robbed form of its status as unmediated visual experience. We saw in Kahnweiler that language and conceptual activity take precedence over visual pleasure. Apollinaire also seems to accept the new forms, but by comparing the role of the title to an "inner frame," he reveals a determination far greater than Kahnweiler's to make the conceptual something purely visual. Well known as a champion of cubism, Apollinaire actually found a closer counterpart to his poetics of vision and hopes for vision in Delaunay's work. The poet-critic associates Delaunay's "Orphism" with cubism in "La Peinture moderne," a broadly generalizing essay of 1913 that finds a common spirit and search for visual pleasure in diverse French painters of the avant-garde.[19] In fact, Delaunay's work is quite the opposite of cubism as far as the relation of image and viewer's body is concerned. Kahnweiler and other cubist contemporaries repeatedly show an awareness of the conceptual work that must accompany the visual response to the cubist image. But Delaunay's theories, which Apollinaire quoted extensively in one of his articles, make the eye, thus the body, the basis of our being in the world: ". . . it is our eyes that transmit sensations perceived in nature to our soul. In our eyes the present and consequently our sensibility take place. Without sensibility, that is to say light, we can do nothing."[20] Where Kahnweiler claims that conceptual activity makes images, and then the world, meaningful, Delaunay makes experience of the present depend on the eye alone. At the heart of his practice is the law of contrasting colors, which set the eye into motion as the juxtaposed complementary tones vibrate. This movement then is associated with our experience of the world. Thus, a physical response to the colored images becomes the basis and the very core of our placement in the world.

Delaunay's painting provided the perfect counterpart to Apollinaire's casting of

the visual image as the means for joining our being with the world around us. In "Les Fenêtres," a poem written for a Delaunay catalogue and consciously imitating many of the painter's techniques, a pair of hands touches the light of an opening window that refers to the window of Delaunay's painting: "And now see the window opening / Spiders when hands wove the light." As they do so, they enter a depth of light and experience color: "Beauty paleness fathomless violets." The senses are fully engaged, as the orange opening at the end of the poem suggests: "The window opens like an orange / The lovely fruit of light."[21] Delaunay's images draw us into the world (the window) and are to be consumed (the orange).

In order to cast cubist vision as a sensory experience, Apollinaire bathed it in a light that really came from works such as Delaunay's "Les Fenêtres." A room full of analytical cubist canvases, though it would contain some patches of glowing light and some interesting use of light, would hardly strike one as luminescent. The cubists did not use light to create the volume of objects or to reveal the object or the world.[22] The multiple light sources in their painting were part of a general complicating of the painter's or viewer's perspective on an object and access to understanding. Instead of writing explicitly about the *problem* of light in the new painting, Apollinaire used metaphors of light in his response to cubism, as if to provide a means of immediate sensory access to the images that, for others, needed to be approached through conceptual processes. In the 1913 essay mentioned above, since Apollinaire has linked Delaunay to cubism in his overview of modern painting, his ending lines on light must apply not only to Delaunay but to analytical cubism as well:

With these movements, Orphist and Cubist, we arrive in the heart of poetry at light.
I love the art of the young painters because I love light above all.
And since all men love light above all, they invented fire.[23]

Similarly, in the 1913 essay "Pablo Picasso," writing on the development of cubism, Apollinaire explains the images by enveloping them in the "light" of Picasso's genius. But the (metaphorical) light is perhaps like the revelatory single light source in a pre-cubist painting, suggesting once again that Apollinaire's visual metaphors have to do with another kind of painting besides the one he is describing. Thus Picasso

has not disdained bringing into the light authentic objects, penny sheet music, an actual postage stamp, a piece of the daily paper, a piece of waxed canvas upon which chair caning is

printed. The painter's art would add no picturesque element to the truth of these objects. Surprise laughs savagely in the purity of light[24]

The objects are autonomous and elusive. As the critic says, they contain a truth already to which the painter cannot add. Perhaps it is also difficult for the poet-critic, or for the viewer, to approach the collage or enter its already sufficient world. In Apollinaire's earlier criticism, the blue of Picasso's painting was the abyss that he and the artist could enter. Painting absorbed him. But when he mentions physical attributes of the cubist canvas, they only adjoin, and do not meld with, his thoughts and personal connections with art. Thus the cubist objects do not blend into the poet-viewer's own narrative, though they might catch its light. They do not give themselves over easily to his sensory grasp.

If, on the one hand, Apollinaire's metaphors of light present the cubist image as if it still fulfilled a familiar visual role, his critical writing nevertheless acknowledges, in the same essay, a disturbance in visual form that alters the viewing body. The passage just quoted shows the visual object resisting the painter's (and the poet-critic's) attempts to influence the form of what is seen. The image, then, will not absorb the viewer but will remain intact and apart. (A disturbance for the viewer is also one for the critic's language.) Even more striking are the juxtapositions of different critical approaches in the passages that follow in the same essay, as if the poet-critic tried first one means, then another, to approach Picasso's painting and to find an access to it. Metaphorical dramas of artistic creation, symbolically related to the paintings themselves, are side by side with enumerative mentions of visual forms that can only be named, not opened up and described by the critic. We can see a challenge to the poet-critic's linguistic grasp, one that is related to the image's challenge to the viewer, such as Apollinaire, who could no longer easily "enter" the canvas. The language of criticism, confronted with an image or visual object that only speaks on its own terms, surrounds mentions of these autonomous visual objects with a narrative of the painter's experience. This passage seems to refer simultaneously to the painter's life story and to dramas suggested by a painting.

For Picasso the project of dying formed as he watched the circumflex-shaped eyebrows of his best friend stream in uneasiness. Another of his friends took him one day to the edges of a mystical land where the inhabitants were at once so simple and so grotesque that one could reshape them easily.

And then, really, anatomy, for example, no longer existed in art, it was necessary to reinvent it and to execute one's own assassination with the science and method of a surgeon.[25]

The circumflex-shaped eyebrows set into motion hint at the new form the human face takes in Picasso's cubism. If we follow Apollinaire's lead, we see the artist's despair about his troubled friend when we look at the unsettled forms of the human face in cubism. Thus, the poet-critic's narrative and the cubist image interpenetrate: a "cubist" face has motivated the artist, and we can look at a cubist portrait and imagine that we see this narrative. The circumflex shape and the stampeding movement bring cubist forms to the critic's narrative, and the narrative brings shades of meaning to the forms.

At the same time, anatomy, the human form, is being "assassinated." As we see the human drama of death and the mysticism of a new land in the painting, we must also witness the unfolding and dismembering of our own bodies. Countering this dissolving of familiar patterns, however, the essay then touches upon the artist as a tremendous force ordering (reordering) the universe, implicitly assuring us that the artwork brings order and a world with meaningful relations connecting its parts. ("A new man, the world is his new representation. . . . He is a new-born who brings order to the universe.") [26] As in the passage with the metaphor of light, this is a moment in the essay when fragments are reassembled into a framework of overriding meaning—brought into the light of the artist's vision, as it were. Then, in what may be Apollinaire's most extended and direct description of cubist paintings, a kind of cubist ekphrasis, we encounter a series of fragmentary images that *seem* to come from paintings, though we cannot be sure, and the mention of smells and events unfolding in time suggests that we are departing from strict references to actual works:

And then, there are countries. A grotto in a forest where we turned somersaults, a trip on muleback, on the edge of a precipice, and the arrival in a village where everything smells of hot oil and rank wine. It's also the walk to a cemetery and the purchase of an earthenware crown (crown of immortals), and the mention *Mille Regrets* which is inimitable. I have also heard of candelabras of pottery that had to be applied onto a canvas so that they would seem to jut out. Crystal pendants, and that famous return from Le Havre. The guitars, the mandolins. [27]

The passage begins with the suggestion of locale and memories that bring the place to life, but moves to mysterious juxtaposed references and silent objects that speak only by their presence—"the guitars, the mandolins." Rather than a unified description of the place offered by painting, this ekphrasis gives fragments, images, settings, even a title that may or may not come from Picasso's works.

Thus, the essay wavers, on the one hand, between acknowledgment of the viewer's confrontation with a collection of fragmented, autonomous, silent images mirroring the pulling apart of the human form itself and, on the other, a notion of artistic creation drawing together disparates into a meaningful whole (the universe, the world, the light) which the viewer can enter. From the metaphor of visionary light, the critic moves to objects independent of the artist's vision. From the image of art as a mystical country the artist could visit and whose inhabitants he could make anew, the essay moves to the loss of anatomy, of human form. Finally, from the artist as designer of the universe, the essay moves to short glimpses of elements of paintings known or unknown to us, a succession of associations that first seem to open up the works to us but that finally we can only reach out and touch, or imagine, tentatively seeing their beauty but never drawing it together into a metaphorical whole. If the form of ekphrasis somehow mediates or simply mirrors the viewer's potential connection with the image and the world, here the viewer-reader "sees" several possible points of access to the world of the painting, but cannot unite them in a single place or vision. The viewer's connection shifts and occurs, as Shiff suggests, metonymically, without resolution.

Between passages that still present the artist as the great visual mediator connecting us with an ordered world, Apollinaire's critical prose allows glimpses of a new visual experience demanded by cubism. Perhaps it is Pierre Reverdy who most fully explores the position of the modern viewing body, suggesting what Freedberg's and Shiff's viewers might be undergoing when they look at paintings that challenge. A very few passages show him envying the capacity of the visual image to mediate an unproblematic sensory contact with the world: "Painters have the great good fortune of being able to take in their hand the object of their artistic passion—they take possession of a guitar, some dominoes, dice, the hand lingers deliciously on the neck of a bottle."[28]

Writing specifically on cubism, Reverdy explains that the image must capture what is "eternal and constant (for example, the round form of a glass, etc.)."[29] It is as if he wishes to save the image from the contingent, accidental nature of anecdote so that it can preserve its visual strength. Reverdy desires the painter's direct engagement with the object and feels a limit in poetic language, which can give momentary revelation but not an enduring connection with the matter amongst which we live: "Old, I go on thinking that what endures in poetry is an injury to poetry itself. Poetry is a flamboyant form of life. I have written elsewhere that poetry is an art of divination, the plastic arts are arts of apprenticeship."[30] Painter and poet

experience a different temporality as well. With the sudden beauty of poetry comes its fading away. The instant of revelation does not endure: the word has come and the experience is over. By contrast, painters are apprentices who live and work in the world with objects, engage their bodies to work in time; time and experience of the world do not elude them as they do the poet. The visual example, at times, seems to serve Reverdy in giving permanence to the ephemeral epiphany of verbal creation.[31]

In a few passages, then, Reverdy writes of painting's sensory plenitude and seems to uphold the opposition of painting and writing. "Critique synthétique" (1919), which seems to refer to cubism specifically, suggests the limits of that plenitude. It opens with an image linking art and "this good smell of clean stables mixed with that of tobacco smoked by the grooms." We do not know what these things have in common, the poem tells us, but we are sure that a "rapport" exists between them. Thus art is filled with the warmth of sweet odors, and the light and the warmth of the sun is added: "Morning / With a triangular sun / In front of the door." As art takes on a presence to stir the senses, the poet savors the sound of the word for painting and reaches out to touch the paint which envelops him like the sky:

Pai i i nting . . .
Black background or other shade as long as it be all sky
With the end of my finger I announce the object which makes an image

Later in the poem, a still life with typical cubist objects seems to permit the brush of his hand on the table next to the other objects:

Everything balances
So as to be able to place a naked hand on this table without displacing anything
The bottle
The card
And the violin

But then the accessibility of the artwork to the senses fades:

It is a definition
An interrupted description

I cut the air

The canvas limits itself[32]

"Critique synthétique" first affirms art's welcoming of the body of the viewer, then leaves the hand reaching out to the image waving in the air. It speaks to Reverdy's hope for the plasticity and plenitude of the visual image—and the difficulty of finding those qualities. That difficulty is commonly felt in Reverdy's poetry, where eyes are often too disembodied to be sense organs, and vision too oblique to bring the body into full involvement with or inclusion in the world. These images set the limits of his hopes for engagement with visual images.

Reverdy cherishes the painter's sensual plunge into the world of objects, but in "Critique synthétique," and in most of his poetry, that sensual plunge is not sustained. A change has occurred between painter and canvas. If the painter lives so fully, as an artisan, touching the materials of art, the *canvas* in this poem "limits itself" against the touch of the poet-viewer. Further, vision, the painter's sense, becomes attenuated in many of the poems of *Les Ardoises du toit* and *étoiles peintes*, volumes written at the time of late cubism. The eye does not come through as a sensory organ with a body behind it, but rather as a troubled intermediary space, between inner world—mind—and outer world. In "Lumière," the second poem of *étoiles peintes*, the eye is a window with beating shutters, painfully letting the light (or the past) into a room which figures the inside of a person's head: "A little spot shines between the fluttering eyelids. The room is empty and the shutters open on dust. It's the day that enters or some memory that makes your eyes weep."[33] The eye-window connects self and world, memory and the present. But this engagement is physically threatening. Dust or a memory brings tears to the eyes, heads and hands appear disembodied and hurt by this meeting with the light: "There are trees and clouds, heads that surpass and hands wounded by the light."[34] Light for Apollinaire had bathed the object in a revelatory glow, and vision often figures the gaining of knowledge of the world, but here the eye is not a site of control. External images enter not a mind that organizes them but a troubling space of disorder. Vision itself breaks into two directions, for there is a landscape on the wall of the mind/room, suggesting a second horizon, doubling the perspective, the disappearing point, and allowing, perhaps, the sky to come closer. "The landscape of the wall—the horizon behind—your memory in disorder and the sky closer to them."[35]

"Compotier" shows this hesitation before a complete engagement with the

object. Fruits are the objects in question, presented as a verbal still life intended to accompany a still life by Juan Gris in their joint volume, *Au Soleil du plafond* (In the Sun of the Ceiling). A Cézanne apple offers us its sensuousness, while Reverdy complicates access to the fruit. A hand hesitates, hovers, and finally only fleetingly touches the fruit which threatens to trap it, leaving a bright red scar as the hand flees. In the poem's imagery, a connection is woven ("*tisse*") between mouth/subject and fruit, and the connection consists of desire ("the weft of desire weaves the dish to the lips").[36] Thus, for Reverdy, perception of the image-object is not a simple possession of it or absorption of/into it but rather the difficult construction of thought, cast as a net around the object. The net—or web—is not an instrument that grasps, but the pattern of our ideas of the object and of its own connections to the world. Like Kahnweiler, he brings concept and vision to bear simultaneously on the object, but the poet also makes the viewer's body an integral part of the new relation to the object. If the eye is joined by concept—heads are as frequently mentioned as any visual forms in the twenty still lifes of *Au Soleil du plafond*—it is also joined by hand, tooth, and mouth. The hand in "Compotier"—like the "*main nue*" that so wanted to place itself in the still life in "Critique synthétique"—fails to take the fruit. Desire remains as the connection between the fruit and the nearly invisible person in the poem; contact has only been momentary.

One is tempted to speculate that cubism specifically put into question the sensory plenitude Reverdy looked for in the visual image. As Kahnweiler and Apollinaire did, Reverdy found the visual pleasure he sought in these works, but only obliquely and in new terms. Reverdy's writing attests to the great power of the cubist image, its "eternal, constant" form and the real emotion it provokes. But something about it keeps it, and its viewer, at a distance from the world.

Indeed, Reverdy's definition of the image excludes the spectator's body:

The Image is a pure creation of the spirit.

It cannot be born from a comparison but from the drawing together of two realities more or less far apart.

The more the relations of the two realities are distant and just, the stronger the image will be—the more it will have emotive power and poetic reality.[37]

The fact that he uses the same terms to speak of the poetic and the painted image even suggests that the visual image is like a poem, less a physical manifestation than a concept:

To release, in order to create, the relations that things have between them, in order to bring them closer to each other, has in all times been the proper task of poetry. The painters have applied this means to objects and, instead of representing them, have made use of the relations that they discovered between them. A reformation follows from this instead of an imitation or an interpretation. It is an art of conception: which is what the art of poetry has always been.[38]

The image links objects thanks to the activity of mind, which, importantly, both discovers and creates these links. Given the emphasis on links between objects, the subject perceiving/creating them stands apart. No mention is made of his or her connection with the object, although Reverdy often speaks of the emotion one feels before an image that is "*juste.*" The image itself, though, does not involve the participation of the spectator/creator except for a moment of conceptualizing links which, in coming into being, relate objects but exclude the viewer. The end of "Le Livre" shows the author "who watches the world live and does not follow."[39] In many of Reverdy's poems one senses the presence of a poet-speaker who witnesses connections but stands apart, behind a wall or outside a window.

In many ways, Reverdy seems to close the gap between the poetic and the visual. Whereas Apollinaire took pains to call important new titles and letters in painting "inner frames," and in other ways as well maintained a notion of the visual as offering a stronger mediation to world experience than language did, Reverdy meets full on the intertwining of visual and conceptual properties in cubism. He claims that the painters have learned from the poets and defines the visual and poetic image in nearly identical terms. One critic has argued that he sets up the image as a nearly Saussurian sign system, insisting on relations and structure.[40] If, at times, he still dreams of the painter's touch of the object, maintaining a gap between visual and verbal creation, the conceptual nature of cubism leads him to dissolve the opposition between painting and language. Where does this take him? The comment that the painter could caress the neck of the bottle seems to promise that in viewing a painting he could share in that caress. But where is the human subject in Reverdy's "language" of the cubist image? When the poet's "*main nue*" turns to a "*main qui coupe l'air*" ("Critique synthétique"), the hope for touch becomes a fading gesture, sign of an empty, unrealized human act. In Reverdy's writing at the time of cubism, vision seems to leave the seeing subject aside. Vision is the sweep of a conceptual net—a network of ideas and connections discovered, by the mind and eye, around the seen object. But the object will not be taken into that net, into the narrative of those connections: "the dream of the poet is the immense

net with innumerable meshes that drags without hope the deep waters searching for a problematic treasure."[41]

For Freedberg, one kind of modern viewing experience allows a bodily response to emerge from the discursive veil that often cloaks our response to more traditional figurative painting. The cubist painting certainly omits narrative content, but at the same time its conceptual dimension complicates the viewer's response so that a deeply physical connection, alone, is unlikely. Still, as Apollinaire's hesitant, fragmentary ekphrasis and as Reverdy's viewer's tentative approach to the fruit in "Compotier" show, this painting did fundamentally upset the experience of viewing. By looking at two important poet-critics of cubism, I have chosen viewers who, by definition, will bring language to their response to the image—at least, to that part of their response of which we have a record. Departing somewhat from Freedberg's suggestion, I have looked at the viewer's physical experience of the image *through* their language, or languages, since they respond both as critics and as poets. In both of these strikingly different cases, the viewing body *is* implicitly and sometimes explicitly present in the language that responds to the image, and that body's hopes, failures, and distortions allow the particularly modern challenge of the cubist word-image to be felt.

When Shiff suggests a "metonymic exchange" between two "physicalities," the painting's and the viewer's, he places image and viewer on equal terms. A passage by Gertrude Stein, describing Picasso's approach to the world, suggests the loss of place and of self that such metonymic exchange would bring. She puts it in terms of the experience of the painter versus that of the writer, but for her, a modernist, painting is clearly an enterprise involving exchange between artist and world rather than the artist's complete control of a world mastered through representation:

The painter does not conceive himself as existing in himself, he conceives himself as a reflection of the objects he has put into his pictures and he lives in the reflections of his pictures, a writer, a serious writer, conceives himself as existing by and in himself, he does not at all live in the reflection of his books, to write he must first of all exist in himself, but for a painter to be able to paint, the painting must first of all be done; therefore the egotism of a painter is not at all the egotism of a writer.[42]

For Stein, Picasso clearly accepted this role. Seer and object seen each construct, effect, "speak," or touch as much as the other. In this case, ekphrasis should become the speech of the viewing body, not just of the image seen. Traditional ekphrasis

makes the image "speak forth," but a modernist ekphrasis would have to give voice to an energy running in two directions between spectator and image, so as to capture the physical *exchange* that the new image demands.

In Apollinaire's diverse responses to cubism, the viewing self, in its role as poet and critic, gives little voice to its own dissolution, being primarily engaged in assembling the fragments of the seen world into a meaningful whole. Apollinaire's ekphrastic narrator thus takes on a role similar to that of the visual artist as he defines it: giving order to the universe. At times, even when writing on cubism, Apollinaire makes the artist still give us a familiar window on the world. But his response to the visual moment of cubism takes place in many forms—explanatory criticism, poetic criticism, poems on paintings, even the war poetry that puts into question the position of the soldier-poet as spectator of a landscape of war. To grasp his *modernist* ekphrasis, one must look at this range of examples, finding those moments when the viewing subject's position seems to shift or even stumble in the face of a dynamic visual world. In spite of his tendency to grasp for a more familiar viewing scenario, the poet-critic does sometimes let the visual object enter his writing and assert its independence, its silence perhaps, and its power to decenter the spectator. At times, the critic ceases to explain and merely points in a vague gesture: "the guitars, the mandolins."

Even more fully, though, Reverdy's writing gives us a modern ekphrasis that speaks more of the spectator's body than of the images themselves. One might wonder, given this poet's involvement with painters and his substantial critical writing, at how few of his poetic passages actually describe visual representation. And yet perhaps this is perfectly easy to understand if we consider that the effect of painting needed to be registered as much as its aspect. Reverdy's poetry is deeply concerned with subjective experience of the world, and with the capacity of mind and senses to mediate a contact with material reality. His response to the experience of cubist painting—and to other disturbances, perhaps, in visual practice—is spread out through the many poems that describe an eye in a landscape, sometimes only a tentative trace of a human presence, but a trace, nevertheless, of a mind and body experiencing the flux of a new visual experience.

Notes

1 Roland Barthes, *Camera Lucida: Reflections on Photography*, trans. Richard Howard (New York: Hill and Wang, 1981), 119.

2 Reflecting this sense that as painting moved toward cubism it presented a philosophical

problem rather than an experience for the senses, André Salmon wrote of the figures in Picasso's *Demoiselles d'Avignon* (1907): "They are naked problems, white numerals on a black background." See "Anecdotal History of Cubism" (1912), excerpted in *Theories of Modern Art: A Source Book by Artists and Critics*, by Herschel B. Chipp (Berkeley: University of California Press, 1968), 202.

3 Richard Shiff, "Constructing Physicality," *Art Journal* 50 (Spring 1991): 43.

4 David Freedberg, *The Power of Images: Studies in the History and Theory of Response* (Chicago: University of Chicago Press, 1989), 435.

5 James A. W. Heffernan makes suggestive comments about how different kinds of writing can lead readers through a painting differently. Of William Carlos Williams's Brueghel poems, he says that the syntax "masters the endlessly diverting multiplicity of images in the painting by mapping an itinerary for the eye: a narrative of the viewing process itself." *Museum of Words: The Poetics of Ekphrasis from Homer to Ashbery* (Chicago: University of Chicago Press, 1993), 162. Heffernan distinguishes this from the "art historian's analysis of geometrical form—the fixed, abstract object of the synoptic gaze." Indeed, I believe art historians and poets can bend their syntax to suggest a variety of viewing processes, as it is my purpose here to show in the work of two poet-critics.

6 "Un tableau de Delacroix, placé à une trop grande distance pour que vous puissiez juger de l'agrément des contours ou de la qualité plus ou moins dramatique du sujet, vous pénètre déjà d'une volupté surnaturelle. Il vous semble qu'une atmosphère magique a marché vers vous et vous enveloppe." Charles Baudelaire, "L'oeuvre et la vie d'Eugène Delacroix, *Oeuvres complètes* (Paris: Seuil, 1968), 534. See also "De la Couleur," part of *Salon de 1846*, 230–232.

7 See Guillaume Appollinaire, "Les Jeunes: Picasso, peintre" (1905), reprinted in *Chroniques d'art: 1902–1918*, ed. L.-C. Breunig (Paris: Gallimard, 1960), 35–39.

8 See Norman Bryson, *Word and Image: French Painting of the Ancien Régime* (Cambridge: Cambridge University Press, 1981), 5, 21. For a contrast to this polarization of "discursive" and "figural" properties of the image, we might look at Meyer Schapiro's well-known piece, "The Apples of Cézanne: An Essay on the Meaning of Still-life," *Modern Art: 19th and 20th Centuries* (New York: George Braziller, 1978), 1–38. The essay is a reading against the nineteenth-century tendency to label impressionist efforts as a complete rejection of narrative content in favor of the adoration of form. For Schapiro, Cézanne's apples occupy a space between the poles of narrative and sensory experience of the image. The visual image has a sense or meaning that is not related to language, one that we sense when Schapiro describes the "connotations" of a still life as those "arising from the combined objects and made more visible and moving through the artistic conception. Not a text or an event but some tendency of feeling directing the painterly imagination will determine here a coherent choice of

a family of objects." Later he speaks of Cézanne's "contemplative view" in which "he seems to realize a philosopher's concept of aesthetic perception as a pure will-less knowing" (24–25). Following Schapiro, we might wonder whether terms describing an opposition, such as "figural" and "discursive," can apply to cubist painting.

9 Svetlana Alpers has described seventeenth-century Dutch art as the product of a visual culture. Her contention that it refused verbal discourse inspired the terms I use to describe the cubist "silence." *The Art of Describing: Dutch Art in the Seventeenth Century* (Chicago: University of Chicago Press, 1983), xxii.

10 Charles Morice, "Braque" (1908), quoted in Edward Fry, *Cubism* (New York: Oxford University Press, 1966), 52.

11 "Picasso a regardé des images humaines qui flottaient dans l'azur de nos mémoires." Apollinaire, "Les Jeunes," 35, translation mine.

12 Daniel-Henry Kahnweiler, *The Rise of Cubism* (New York: Wittenborn, Schultz, 1949), 14, emphasis mine. Originally written in German in 1915, this essay was first published in 1920. Further references to this work will be cited in the text with the abbreviation *RC*.

13 Guillaume Apollinaire, *The Cubist Painters: Aesthetic Meditations*, trans. Lionel Abel (New York: Wittenborn, Schultz, 1949), 46. Further references to this work will be cited in the text with the abbreviation *CP*. The original reads as follows: "Ajoutons que l'indication du titre n'est point chez Picabia un élément intellectuel étranger à l'art auquel il s'est consacré. Cette indication doit jouer le rôle d'un cadre intérieur, comme font dans les tableaux de Picasso les objets authentiques, et les inscriptions exactement copiées. Elle doit écarter l'intellectualisme de décadence et conjurer le danger qu'il y a toujours pour les peintres de devenir des littérateurs. Le titre écrit de Picabia, les objets authentiques, les lettres et les chiffres moulés des tableaux de Picasso et de Braque, nous en retrouvons l'équivalent pittoresque dans les tableaux de Mlle Laurencin, sous forme d'arabesques en profondeur; dans les tableaux d'Albert Gleizes, sous forme d'angles droits qui retiennent la lumière; dans les tableaux de Fernand Léger, sous forme de bulles; dans les tableaux de Metzinger, sous forme de lignes verticales, parallèles aux côtés du cadre et coupées par de rares échelons." Guillaume Apollinaire, *Méditations esthétiques: Les peintres cubistes*, ed. L.-C. Breunig and J.-Cl. Chevalier (Paris: Hermann, 1965), 89.

14 "Les possibilités d'émotion esthétique enfermées dans cet art, s'il était pur, seraient immenses. Il pourrait prendre à son compte le mot de Poussin: 'La peinture n'a pas d'autre but que la délectation et la joie des yeux.'" Apollinaire, *Méditations esthétiques*, 90.

15 "il nous meurtrit comme un froid bref." Apollinaire, *Chroniques d'art*, 38, translation mine.

16 Guillaume Apollinaire, *Calligrammes: Poems of Peace and War (1913–1916)*, trans. Anne Hyde Greet (Berkeley: University of California Press, 1980), 89. The original reads: "comme on

imagine les anges et non comme sont les reflets"; "Mon coeur pareil à une flamme renversée." Apollinaire, *Oeuvres poétiques* (Paris: Gallimard, 1965), 197. Further references to this work will be cited in the text with the abbreviation *Opo*.

17 Apollinaire, *Calligrammes*, 135, 137. "Souvenirs de mes compagnons morts à la guerre"; "Un dieu qui s'humilie"; "Ombre encre du soleil / écriture de ma lumiére" (*Opo*, 217).

18 "Les premières peintures furent seulement une ligne qui entourait l'ombre d'un homme faite par le soleil sur la terre." Apollinaire, "Réalité, peinture pure" (1912), in *Chroniques d'art*, 348, translation mine.

19 Guillaume Apollinaire, "La Peinture moderne" (1913), in *Chroniques d'art*, 351–357.

20 ". . . ce sont nos yeux qui transmettent à notre âme les sensations perçues dans la nature. Dans nos yeux se passe le présent et par conséquent notre sensibilité. Sans la sensibilité, c'est-à-dire la lumière, nous ne pouvons rien." Apollinaire, *Chroniques d'art*, 347, translation mine.

21 Apollinaire, *Calligrammes*, 27, 29. "Et maintenant voilà que s'ouvre la fenêtre / Araignées quand les mains tissaient la lumière"; "Beauté pâleur insondables violets"; "La fenêtre s'ouvre comme une orange / Beau fruit de la lumière" (*Opo*, 169).

22 One critic of cubism, Jacques Rivière, wrote that cubism had to abandon conventional use of light because of light's link to the moment—the single moment when light struck the surface of an object in a particular way. This, and its emphasis on the surface of an object, made it an obstacle to representation of the true structure or essence of things. Fry, *Cubism*, 76–77.

23 "Avec ces mouvements, orphistes et cubistes, nous arrivons en pleine poésie à la lumiére.
"J'aime l'art des jeunes peintres parce que j'aime avant tout la lumière.
"Et comme tous les hommes aiment avant tout la lumière, ils ont inventé le feu." (Apollinaire, *Chroniques d'art*, 356–357, translation mine)

24 ". . . n'a pas dédaigné de confier à la clarté des objets authentiques, une chanson de deux sous, un timbre-poste véritable, un morceau de journal quotidien, un morceau de toile cirée sur laquelle est imprimée la cannelure d'un siège. L'art du peintre n'ajouterait aucun élément pittoresque à la vérité de ces objets.
"La surprise rit sauvagement dans la pureté de la lumière. . . ." (Ibid., 367–368)

25 "Pour Picasso le dessein de mourir se forma en regardant les sourcils circonflexes de son meilleur ami qui cavalcadaient dans l'inquiétude. Un autre de ses amis l'amena un jour sur les confins d'un pays mystique où les habitants étaient à la fois si simples et si grotesques qu'on pouvait les refaire facilement.
"Et puis, vraiment, l'anatomie, par exemple, n'existait plus dans l'art, il fallait la réinventer et exécuter son propre assassinat avec la science et la méthode d'un grand chirurgien." (Ibid., 368–369)

26 "Nouvel homme, le monde est sa nouvelle représentation. . . . C'est un nouveau-né qui met de l'ordre dans l'univers" (ibid., 369).

27 "Et puis, il y a des pays. Une grotte dans une forêt où l'on faisait des cabrioles, un passage à dos de mule, au bord d'un précipice, et l'arrivée dans un village où tout sent l'huile chaude et le vin rance. C'est encore la promenade vers un cimetière et l'achat d'une couronne en faïence (couronne d'immortelles), et la mention *Mille Regrets* qui est inimitable. On m'a aussi parlé de candélabres en terre glaise qu'il fallait appliquer sur une toile pour qu'ils en parussent sortir. Pendeloques de cristal, et ce fameux retour du Havre. Les guitares, les mandolines" (ibid., 369).

28 Pierre Reverdy, *Note éternelle du présent*, quoted in Eliane Formentelli, "De la Traversée du Miroir à la main traversière: Pierre Reverdy et la peinture," *Bousquet, Jouve, Reverdy*, special issue of *Sud* (1981): 366. Thanks to Robert Urquhart for this and all translations of Reverdy's words in this chapter.

29 "éternel et constant, (par exemple la forme ronde d'un verre, etc.)." Pierre Reverdy, "Sur le cubisme," *Nord-Sud Self Defence et autres écrits sur l'art et la poésie (1917–1926)* (Paris: Flammarion, 1975), 19.

30 "Vieux, je continue à penser que durer en poésie est une injure à la poésie même. La poésie est une forme flamboyante de la vie. J'ai écrit ailleurs que la poésie est un art de divination, les arts plastiques des arts d'apprentissage." Pierre Reverdy, "Cette émotion appelée poésie," preface to *L'Oeuvre poétique de Pierre Reverdy*, by Emma Stojkovic (Paris, Flammarion, 1974), 219–220, quoted in Formentelli, "De la Traversée du Miroir à la main traversière," 364.

31 Eliane Formentelli has demonstrated this function of the visual example for Reverdy, arguing that the painting provided him, at least conceptually, "les moyens d'accès à un ordre symbolique du *lieu*." She also argues that the poems of *Les Ardoises du toit* have an "exigence optique," art stopped, suspended in time, in a way that could emulate the permanence and groundedness of painting. "De la Traversée du Miroir à la main traversière," 375–376.

32 "cette bonne odeur des écuries bien propres mêlée à celle du tabac que fument les palefreniers"; "Le matin / Avec le soleil en triangle / Devant la porte"; "La peintu u r e . . . / Fond noir ou d'autre ton pourvu que ce soit tout le ciel / Du bout du doigt j'annonce l'objet qui fait image / Tout s'équilibre / Pour pouvoir poser une main nue sur cette table sans rien déplacer / Le flacon / La carte / Et le violon"; "C'est une définition / Une description interrompue / Je coupe l'air / La toile se limite." Reverdy, "Critique synthétique," *Nord-Sud*, 149–151.

33 "Une petite tache brille entre les paupières qui battent. La chambre est vide et les volets s'ouvrent dans la poussière. C'est le jour qui entre ou quelque souvenir qui fait pleurer tes yeux." Pierre Reverdy, "Lumière," *Plupart du temps, II: 1915–1922* (Paris: Gallimard, 1969), 68.

34 "Il y a des arbres et des nuages, des têtes qui dépassent et des mains blessées par la lumière."

35 "Le paysage du mur—l'horizon de derrière—ta mémoire en désordre et le ciel plus près d'eux."

36 "la trame du désir tisse la coupe aux lèvres." Pierre Reverdy, *Au Soleil du plafond* (Paris: Flammarion, 1980), 21.

37 "L'Image est une création pure de l'esprit.

"Elle ne peut naître d'une comparaison mais du rapprochement de deux réalités plus ou moins éloignées.

"Plus les rapports des deux réalités seront lointains et justes, plus l'image sera forte—plus elle aura de puissance émotive et de réalité poétique." (Reverdy, "L'Image" [1918], *Nord-Sud*, 73)

38 "Dégager, pour créer, les rapports que les choses ont entre elles, pour les rapprocher, a été de tous temps le propre de la poésie. Les peintres ont appliqué ce moyen aux objets et, au lieu de les représenter, se sont servis de rapports qu'ils découvraient entre eux. Il s'ensuit une reformation au lieu d'une imitation ou d'une interprétation. C'est un art de conception: ce que fut de tout temps l'art poétique. Reverdy, "Le Cubisme, poésie plastique" (1919), *Nord-Sud*, 144.

39 "qui regarde vivre le monde et ne suit pas." Reverdy, *Au Soleil du plafond*, 11.

40 Formentelli, "De la Traversée du Miroir à la main traversière."

41 "le rêve du poète, c'est l'immense filet aux mailles innombrables qui drague sans espoir les eaux profondes à la recherche d'un problématique trésor." Pierre Reverdy, *Le Gant de crin* (n.p.: Librairie Plon, 1926), 13. Perhaps Reverdy would be less severe in describing the dream of the painter. The similarity in his definitions of poetic and painted images, though, suggests this passage could also apply to the capacity of the visual to grasp the world.

42 Gertrude Stein, *Picasso* (New York: Dover, 1984), 4.

Pop Art/Pop Culture

Neo-Dada and

the Politics of Plenty

ESTERA MILMAN

[Pop art] brings to mind a recent Stanford Research Institute study on the contemporary boom in American culture—a study that is as amazing as it is, unintentionally, depressing. No doubt some of you will be even more depressed than I at the disclosure that there are as many painters in this country as hunters.

Stanley Kunitz, "A Symposium on Pop Art"

On December 13, 1962, the Museum of Modern Art in New York organized a symposium to discuss a new phenomenon that had "spread quickly not only from 77th Street to 57th Street but indeed from coast to coast."[1] In his introductory comments, Peter Selz, curator of painting and sculpture exhibitions at MoMA and the moderator of the panel discussion, explains: "We chose the term 'pop art' because it seems to describe the phenomenon better than a name like New Realism . . . The term neo-Dada was rejected because it was originally coined in the pejorative and because the work in question bears only superficial resemblance to Dada, which, it will be remembered, was a revolutionary movement primarily intended to change life itself."[2]

Participants in the 1962 Symposium on Pop Art included the critic and prolific art writer, Dore Ashton; Henry Geldzahler, assistant curator of American painting and sculpture at the Metropolitan Museum of Art; Hilton Kramer, then art critic for the *Nation* and a member of the Bennington College faculty; Stanley Kunitz, a critic, editor, and poet of the New York school; and Leo Steinberg, associate professor of art history at Hunter College. Each had been invited to participate in MoMA's attempt to codify a critical vocabulary and set of defining terms for a phenomenon that was already actively involved in a dialogue with a sympathetic, broad-based public.

According to Lawrence Alloway, who is credited with having coined the phrase in the mid-fifties, "Pop art" initially referred "approvingly to the products of the

mass media" and was coterminous with the rubric "Popular art."[3] At their incep-
tion, neither term referred to a form of artistic production that borrowed its im-
agery from mass culture; rather, both delineated the actual products of the mass
media themselves, artifacts held in high esteem by the members of the British In-
dependent Group, of which Alloway was a founding member. The phrase "Pop
art" first appeared in print in the winter of 1957–1958,[4] a little more than two
decades after Walter Benjamin's seminal essay, "The Work of Art in the Age of
Mechanical Reproduction" (1936) appeared in *Zeitschrift für Sozialforschung*. The
world had changed in the interim between these two publishing events; yet for the
arts, the battle lines were still drawn along much the same borders.

Benjamin's somewhat contradictory, yet overtly utopian thesis rests on his
conviction that, through photographic reproducibility, the work of art was being
cleansed of (liberated from) its all-encompassing aura: its status, authenticity, and
mythic (reactionary) position of privilege. This perception would inadvertently be
echoed in Alloway's manifesto, "The Long Front of Culture," which appeared in
Cambridge Opinion in 1959.

The abundance of twentieth-century communications is an embarrassment to the traditionally
educated custodian of culture. The aesthetics of plenty oppose a very strong tradition which
dramatizes the arts as the possession of an elite . . . However, mass production techniques, ap-
plied to accurately repeatable words, pictures, and music, have resulted in an expendable multi-
tude of signs and symbols. To approach this exploding field with Renaissance-based ideas of the
uniqueness of art is crippling. Acceptance of the mass media entails a shift in our notion of
what culture is. Instead of reserving the word for the highest artifacts and the noblest thoughts
of history's top ten, it needs to be used more widely as the description of "what a society does."[5]

Benjamin's footnote 13 for "The Work of Art in the Age of Mechanical Repro-
duction" is primarily composed of a lengthy segment of Aldous Huxley's *Beyond the
Mexique Bay: A Traveller's Journal* (1934). As the following excerpt illustrates, Hux-
ley's perspective on the then current state of things stands in direct opposition to
Alloway's 1959 manifesto and instead concurs with elitist positions such as those
presented by Stanley Kunitz in my epigraph. Huxley is quoted by Benjamin; in
Benjamin's own words, "Aldous Huxley writes":

Advances in technology have led . . . to vulgarity . . . Process reproduction and the rotary press
have made possible the indefinite multiplication of writing and pictures. Universal education

and relatively high wages have created an enormous public who know how to read and can afford to buy reading and pictorial matter. A great industry has been called into existence in order to supply these commodities. Now, *artistic talent* is a very rare phenomenon; whence it follows . . . that, at every epoch and in all countries, most art has been bad. But the proportion of trash in the total artistic output is greater now than at any other period.[6]

Benjamin closes his footnote with the understatement "This mode of observation is obviously not progressive."[7]

The transcript for the Museum of Modern Art's 1962 Symposium on Pop Art provides access to a number of complex, historiographically specific issues, the most obvious of which is the extent to which the institution of art initially felt challenged by the critique of its own hierarchical and formalist assumptions inherent in the new art. Hosted as it was by one of the most powerful art establishments of the period, the event confirmed the ascendancy to power of what was then perceived to be an "acceptable" descriptive term and documents an adamant attempt to disempower another.

The symposium's speakers presented numerous divergent positions. Ashton reminded her peers that when Alloway initially discussed pop art, he had insisted that the original status of the mass-produced objects to which the term referred be maintained and that "assemblages of such material come to the spectator as bits of life."[8] Geldzahler acknowledged that he lived in an urban society whose primary visual data was mass-media specific and admitted that the art world was mistrustful of the new art because it was "readily acceptable."[9] That some of the curator's statements concur with those presented by Alloway in 1959 is evidenced in the following statement: "The popular press, especially and most typically *Life* Magazine, the movie close-up, black and white, technicolor and wide screen, the billboard extravaganzas, and finally the introduction, through television, of this blatant appeal to our eye into our home—all this has made available to our society, and thus to the artist, an imagery so pervasive, persistent and compulsive that it had to be noticed."[10]

Others stood in unwavering opposition to the new phenomenon and in the process came unnervingly close to echoing Aldous Huxley's less than "progressive" mode of observation. For example, Kunitz insisted that the best analogy he could think of to the overnight success of pop art was "a blitz campaign in advertising, the object of which is to saturate the market with the name and presence—even subliminal presence—of a commodity," reminding the symposium's audience that

"most of [pop art's] slogans and stratagems come straight out of the citadel of bourgeois society, the communications stronghold where the images and desires of mass man are produced, usually in plastic."[11]

However, it is important to note that the majority of the panelists defended the museum's role as validator. Discussion repeatedly returned to principles of selectivity and value employed as the institution of art "sifts" quality, the relationships between power plays and the art market and among "*low* art . . . *non*-art . . . and '*failed*' art."[12] In other words, most of the participants in the session concurred that the primary issue at stake was whether or not pop art was *legitimate* art, and, if so, through the application of which sets of aesthetic criteria would some of it eventually accrue status as "great art."

Despite the proclamation with which Selz had opened the session, at least one-third of the symposium was devoted to discussion of the then understood relationship between the "New Dada" and its historical precursor. It is these segments of the transcript, to which I will return momentarily, that provide an invaluable resource for the historian attempting to unearth the extent to which the art world of the 1960s had access to its self-proclaimed historical paradigm.

"The Work of Art in the Age of Mechanical Reproduction" addressed what the Frankfurt school critic perceived to be "developmental tendencies of art under present conditions of production."[13] Benjamin viewed his own thesis as "a weapon . . . useful for the formulation of revolutionary demands in the politics of art." The primary power contained in his critical instrument of warfare was, in his own words, that it "brushed aside a number of outmoded concepts such as creativity and genius, eternal value and mystery," concepts that he believed were endemic to fascism.[14] But these concepts, it should be noted, were aggressively defended by most of the participants in MoMA's pop art symposium. As would later be the case for many mid-century artistic activists, Benjamin advocated the integration of the mass media and the vernacular into a socially progressive artistic strategy. Interestingly enough, just as aspects of dada were to directly influence the British Independent Group and the community of North American artmakers whose cultural production was under discussion in 1962, it also provided Benjamin with one working paradigm for his 1936 thesis. He writes:

The Dadaists attached much less importance to the sales values of their work than to its uselessness for contemplative immersion . . . Their poems were "word salad" containing obscenities and every imaginable waste product of language. The same is true of their paintings, on

which they mounted buttons and tickets. What they intended and achieved was a relentless de-
struction of the aura of their creations, which they branded as reproductions with the very
means of production.[15]

Benjamin perceived "contemplation" and "evaluation" to be "schools for aso-
cial behavior during the decline of middle-class society."[16] He believed that dada
destroyed the aura of works of art (a key source of contemplation and evaluation)
by making works of art the center of scandal and thus outraging the public. While
this statement, in and of itself, implies that, despite Benjamin's relative chronologi-
cal proximity to dada, he had only limited access to the historical realities of the
World War I period, the extent to which such inevitable historiographic blinders
were already firmly in place is further illustrated by the critic's insistence that al-
though "Dadaism . . . sacrificed . . . market values . . . in favor of higher ambitions
[the movement] was not conscious of its intentions as here described."[17]

In response to cultural crises of monumental proportions experienced well
over seven decades ago, participants in Swiss and German dada became acutely
aware of the process by which their own culture had been and was being con-
structed. Most were overtly involved in sophisticated acts of cultural revisionism as
they attempted to deconstruct man-made systems held culpable for the realities of
the World War I era (language, cultural institutions—including the institution of
art—and, in particular, the mass media) and reconstitute them into alternative
structures. It was through their utopian commitment to draw attention to the fact
that culture was man-*made* and thus capable of being *unmade* (deconstructed) and
eventually *remade* (reconstituted) that members of the Berlin dada circle, in partic-
ular, exemplified the utopian tradition of the historical avant-garde to which they
had fallen heir.[18] While it is obvious that Benjamin was himself not aware of the
full complexity of dada's overt and self-conscious "intentions," it is important to
note that few, if any, of the artists of the late 1950s and early 1960s who would come
to be identified with the rubric "neo-dada" had full access to the historical accom-
plishments of their self-proclaimed predecessors.

Early in the 1962 MoMA symposium, Kramer had defined pop art as "a cha-
rade [pretending] to be about the real world [but at the same time] sanctified by . . .
the tradition of Dada." He would later in the proceedings insist that "the question
of the relationship of pop art to Dada [had] really not been taken seriously." The
critic continued: "It should be. But I think if it's going to be taken seriously, Dada
itself has to be looked at in a way that nobody has really been willing to look at it

for a long time. And that is that Dada was revolutionary *only* in its ideology not in its aesthetics."[19] In keeping with his overtly formalist intentions, Kramer then proceeded to discuss Hanover dadaist Kurt Schwitters' dependence upon cubist syntax.

Kunitz concurred with Selz' description of historical dada as a conscious attack against conformity and the bourgeoisie, cited earlier, adding that dada was a revolutionary movement born out of social passion and directed against a bourgeois society held culpable for World War I. Steinberg added that dada was revolutionary in the same way that every art movement of the last one hundred years had been revolutionary. Geldzahler suggested that, following, as it did, the "great formal revolutions of Cubism," the great excitement of dada was its "anti-formal nature."[20] In each of the aforementioned instances, the New Dada or pop art was described as being antithetical to the World War I movement. The new art was defined as devoid of alienation (Selz), interested in embracing "bourgeois symbols" (Kunitz), an art that was unique in its refusal to appear revolutionary (Steinberg), an art of formal "decisions and choices of composition" (Geldzahler).[21]

But it is in sections of the dialogue that do not consciously attempt to describe the new art's relationship to dada that we are inadvertently provided with concrete evidence of the World War I era's historiographic impact upon mid-century artmakers. For example, having accused pop art of appearing to be about the real world, while at the same time remaining dependent upon its sanctification through its "fraudulent" relationship with "the tradition of Dada," Kramer continued: "But pop art does, of course, have its connections with art history. Behind its pretensions looms the legendary presence of the most overrated figure in modern art: Mr. Marcel Duchamp. It is Duchamp's celebrated silence, his disavowal, his abandonment of art, which has here—in pop art—been invaded, colonized and exploited."[22] In her own prepared statement that directly followed, Ashton makes *indirect* reference to Duchamp when first she mentions a "bottle dryer," the artist's first official "ready-made." She continues:

[The pop artist] very often cedes his authority to chance—either as he produces his object, or as it is exposed to the audience which is expected to complete his process. The recent pop artist is the first artist in history to let the world into his creative compound without protest . . . By the time pop art appears, the artist as master image-maker is no longer assertive. He gladly allows Chance to mold his picture, as when John Cage praises Rauschenberg because he makes no pretense at aesthetic selection.[23]

Although Ashton does not refer specifically to either Duchamp or dada, the very characteristics that she chooses to list in her attempt to describe the pop artist as innovative (as "the first artist in history" to realize something) coincide almost to the letter with historical strategies adopted by both. For example, experiments with chance (informed, in this case, by utopian convictions that by uncovering precultured "laws" embedded in chance procedure the artist could press for a less cataclysmic social structure) were central elements of historical dada's response to its own crisis-driven present. So too was the willingness to "let the world into [the] creative compound." However, it is specifically to Duchampian models that Ashton refers in her statement, although in this case she attributes such paradigms to John Cage, without noting that Duchamp, in turn, had served as the composer's mentor.[24] It was Duchamp's critiques of the institution of art that had made him a particularly valuable candidate for appropriation into the Zurich dada circle in February 1918.[25] Interestingly enough, these same strategies resulted in his being singled out as the primary subject of Hilton Kramer's unmitigated disapproval in 1962.

In 1961, Cage stated:

Critics frequently cry "Dada" after attending one of my concerts or hearing one of my lectures. Others bemoan my interest in Zen. One of the liveliest lectures I ever heard was . . . called "Zen Buddhism and Dada" . . . but neither Dada nor Zen is a fixed tangible. They change; and in quite different ways in different places and times, they invigorate action. What was Dada in the 1920s [sic] is now, with the exception of the work of Marcel Duchamp, just art.[26]

Although members of the British Independent Group, the first community of mid-century artists to investigate pop, would make use of certain formal devices associated with German dada (with photomontage and assemblage being the most notable examples), they too were far more directly influenced by historical dada in Paris, and more specifically by the New York/Paris legacy of Marcel Duchamp.[27] In 1913 Duchamp had fastened a bicycle wheel to a kitchen stool in order to enjoy watching it turn. The following year he purchased a bottle rack based on his personal response of "visual indifference" to the object. Deliberately chosen in a state of "complete anaesthesia"—that is to say, in the absence of either good or bad taste—*Bottle Rack* fulfilled all requirements for what Duchamp would soon thereafter identify as the "ready-made."

Variations on the concept "ready-made" informed the works and art actions of numerous post–World War II artistic communities, including participants in

British pop and North American pop art, but Duchamp's influence on these two specific groups runs a great deal deeper than this. Although he never actively participated in either dada or surrealism, Duchamp brilliantly "allowed" himself to be appropriated by both, to become, in fact, a paradigmatic symbol of both movements. His work was deliberately open ended; it was invariably positioned through its placement within specific art contexts and was designed to be finished by the receiver as he or she so chose. Furthermore, unlike members of Berlin dada, who actively participated in a critique of cultural constructs outside the arts, Duchamp deliberately chose to speak from *within* the art structure. One of his recurrent experiments involved charting the increments by which an artifact is liberated from its original function within culture at large and is transformed into a viable candidate for appreciation, contemplation, and evaluation, accruing status as Art. Through actions such as these Duchamp made clear that the "aura" surrounding the work of art is a culturally sanctified abstraction and that Art itself is an institutional construct.

Aspects of the Duchamp legacy were to deeply impact the artistic production of Jasper Johns and Robert Rauschenberg, two artists viewed as the direct precursors to the rise of American pop art.[28] Both artists were further influenced by the practical, apolitical anarchism of their mentor, the composer John Cage, for whom, in turn, Duchamp served as paradigmatic model. Cage's own post-Duchampian experiments with chance procedure, his advocacy of a nonhierarchical value system, and his conviction that it was necessary to erase the line of demarcation that separated art from life informed the mid-century activities of the artists involved in assemblage, environments, and happenings as well as of the concurrently emerging community of North American pop artists.[29]

Each of the participants in the 1962 pop art symposium took for granted that neo-dada was a radical break with abstract expressionism. However, the influence of historical dada upon numerous pivotal post–World War II North American artists and critics, including those associated with action painting, should not be underestimated. Furthermore, access to at least some aspects of the historical accomplishments of the World War I movement that extended beyond Paris and Duchamp were in fact readily available to North American artmakers of the late forties. For example, as coeditors of the proto–abstract expressionist little review *possibilities 1* (Winter 1947–1948), John Cage, Robert Motherwell, and Harold Rosenberg accrued direct access to one retrospective personal history of Swiss and German dada through their association with Richard Hulsenbeck, who was busily

editing selected portions of his *En Avant Dada: A History of Dadaism* (1920) for inclusion in the single issue of the journal. Hulsenbeck's contribution to *possibilities 1* includes reference to Italian futurist *bruitism*, or noise music, echoed in Cage's statements and in those of his students and other younger artists whom he influenced.[30] The excerpted translation of the 1920 essay insistently defines the dadaist as a man of action, an individual "who has fully understood that one is entitled to have ideas only if one can transform them into life—the completely active type, who lives only through action, because it holds the *possibility* of achieving knowledge."[31] The statement inevitably brings to mind Rosenberg's pivotal anti-formalist essay "The American Action Painters" (1952), wherein the critic asserts that "at a certain moment the canvas began to appear to one American painter after another as an arena in which to act . . . what was to go on the canvas was not a picture but an event."[32] Hülsenbeck's personal history of dada also provided a clearly stated critique of the institution of art and of the concurrent myth of artistic privilege, offering instead the vision of a form of cultural practice fluent in the vocabularies of the mass media and thus integrated into "life itself":

To make literature with a gun in hand had for a time been my dream . . . The Dadaist should have nothing but contempt for those who have made a Tusculum of the "spirit" . . . The philosopher in the garret was thoroughly obsolete—but so was the professional artist, the cafe litterateur . . . the Dadaist as far as possible was to be the opposite of these. These men of the spirit sat in the cities, painted their little pictures, ground out their verses, and in their whole human structure were hopelessly deformed, with weak muscles, without interest in the things of the day, enemies of the advertisement, enemies of the street, of bluff, of the big transactions which every day menaced the lives of thousands. Of life itself.[33]

The excerpt from *En Avant Dada* closes with the exaggerated insistence that "in Germany Dadaism became political, it drew the ultimate consequences of its position and renounced art completely."[34] The position is echoed, in reverse, in the editorial introduction to *possibilities 1*, wherein Rosenberg and Motherwell (responding to their period's inability to accept the paradigm of a politicized art) state that "whoever genuinely believes he knows how to save humanity from catastrophe has a job before him that is certainly not a part-time one."[35]

 En Avant Dada concludes with an announcement by the editors of *possibilities 1* that the piece would be reproduced in its entirety in a planned dada anthology. Published in 1951 under the title *The Dada Painters and Poets: An Anthology*

and edited by Motherwell, it presented the most comprehensive anthology of dada to date, the first published in English. The impact of this publishing event upon numerous mid-century artistic communities cannot be overemphasized. As we have seen, within a decade the North American art press could comfortably include American pop art alongside other divergent contemporaneous movements under the new rubric neo-dada.

The January 1963 issue of *Art International* was dominated by a set of articles discussing the New Realists, Neo-Dada, *le nouveau réalisme*, Pop Art, the New Vulgarians, Common Object Painting, and the Know-nothing genre. The title page for this section of the periodical included a small reproduction of Robert Indiana's 182 × 182 cm painting *Red American Dream* (1962) and a large reproduction of *For Kate*, a very small montage of popular-press cartoon characters and canceled postmarks, assembled by Kurt Schwitters in 1947. Barbara Rose opened the lead essay in the publication with a headnote composed of a 1936 statement by Richard Hülsenbeck that predicted a future flowering, or golden age, for dada. The essay itself begins with the observation that although no one could possibly believe that World War I–era European dada was still a vital "art style," the term had been resurrected in an attempt to describe the production of such disparate contemporary artists as Robert Rauschenberg, Jasper Johns, Jim Dine, Claes Oldenburg, Allan Kaprow, Tom Wesselmann, Robert Whitman, Robert Indiana, James Rosenquist, Roy Lichtenstein, Andy Warhol, and Wayne Thiebaud, all of whom had escaped the "tyranny of Abstract Expressionism."[36] Rose then continued:

Almost half a century, a depression, a world war and the subsequent polarization of East and West, separates the *madcap* [emphasis mine] Dadaists of Paris and Berlin from their American descendants. What once seemed vanguard invention is now only over-reproduced cliché. Anti-art, anti-war, anti-materialism, Dada, the art of the politically and socially engaged, apparently has little in common with the cool detached art it is supposed to have spawned. We shall see in fact the new Dada owes little to European Dada, save an interest in the *collage* technique of Schwitters and in the ready-mades of Duchamp.[37]

Rose's essay is an attempt to correct what she describes as "popular misconceptions" that the "new Dada is an art of social protest" and that it is "anti-art."[38] Persistently describing neo-dada in formalist "pro-art" terms, the author closes the essay by tracing its genesis to Cage and in particular to the composer's 1952 multimedia event at Black Mountain College.[39] Through its reference to "a cool and

31 Installation shot of "Below Zero," Reuben Gallery, New York, December 1959–January 1960: *Figure* by George Segal; *Mountains* by Allan Kaprow; *Hanging* by Claes Oldenburg; *Canyon* by Robert Whitman; *Dog* by Red Grooms. Courtesy Alternative Traditions in the Contemporary Arts, University of Iowa. Photograph by Dick Higgins.

detached art," Rose's essay celebrates, in a sense, the codification of the art establishment's chosen set of defining principles for North American pop art. Conversely, through its rejection of a coterminous set of descriptive terms then applied to neo-dada—anti-art, antiwar, antimaterialism, in other words, those characteristics prerequisite to an art of social or political protest—the essay confirms the initiation of the subsequent historical disempowerment of the more overtly radical proponents of the New Dada. Although by early 1963 the historical trajectories for what we have come to call American pop art and for contemporaneous collectives of artmakers attempting to integrate popular culture and everyday experience into the artistic arena were already set in motion, the battle was not yet entirely over.

In the spring of 1964, an article entitled "Neo-Dada: A Critique of Pop Art" appeared in *Art Journal.* Its author, Edward T. Kelly, noted that by 1962 Alloway's use of the phrase "Pop art" had shifted from its original definition as the "parapherna-

lia of public art" to that of a referent for "the use of popular art sources by fine artists: movie stills, science fiction, advertisements, game boards, heroes of the mass media."[40] It is Kelly's intention to reinvest neo-dada and its re-described subset, pop art, with social activism and culturally critical intentions. In the process, he turns to discussion of the contemporaneous but by then overtly anti-pop collective NO!art, members of which acknowledged the debts they owed to their historical precursor.[41] Calling NO!art an "obstreperous relative of Pop Art," Kelly cites a description of the collective by one of its spokesmen, Seymore Krim, editorial director of

Nugget magazine, who insisted that NO!artists were "'hot' pop artists out for copulation rather than cool ones doing doodles before a mirror."[42]

While not entirely approving of his subject, the author offered his own description of the collective: "Although in some ways similar, the imagery of NO often goes quite beyond that of Pop Art. With a far more violently satiric iconography, NO renders the social message of Pop Art tame and harmless by comparison. In fact it has been suggested that the Pop Art movement itself was inspired by an attempt to make NO Art a more palatable commodity."[43] Kelly then insisted that notwithstanding his awareness of "widespread opposition to the term 'Neo-Dada,'" he believed that both pop art and NO!art should be defined as "latter-day versions of Dada." After citing Peter Selz' introductory remarks at the MoMA's pop art symposium in which the curator had explained that the rubric neo-dada had been rejected because, unlike the new art, dada was an attempt "to change life itself," Kelly then counters with his own observation: "Ironically, Mr. Selz's last statement concerning dada sums up precisely what I believe the Pop Art and NO artists are at least *trying* to do."[44]

But it was a pop art described as "cool" and apolitical that would win out. In the process, pop art's canon was sealed, and its (overtly conscious) formal characteristics and intentions were thoroughly separated from the "messiness" of the assemblagists and the overtly political posture of social protest groups such as the NO!art (or Doom) collective. For example, in her 1966 essay "New York Pop," the not yet politicized critic Lucy Lippard could easily state:

32 *Immigrant's NO! Box, 1963* by Boris Lurie. Collection of the artist. Photograph by Eckart Holzboog.

A second non-Pop vein, which specializes in social protest, should be mentioned, if only to dispel confusion by placing it properly outside Pop Art . . . these Assemblage, or "Doom," artists are the political satirists that Pop artists are not. They are all that Pop is not . . . They are anguished, angry, and hot where Pop is cool, detached, and assured. They omit nothing from their conglomerations of trash, paint, collage, and objects, whereas the Pop artists omit almost everything from their direct presentation, and they are essentially pessimistic where Pop is optimistic.[45]

Within a few short years, a critical vocabulary for pop art had become codified, and for many the movement had ceased to serve as an active combatant in the revolutionary politics of art. However, it should be noted that members of the group had not unwittingly fallen prey to assimilation by a culture industry that routinely deactivates its critics by incorporating them into the system (against their will), as some contemporary activist critics would argue. The images and artifacts of the first wave of critically acclaimed "mature" pop art in America were undeniably in tune with the high-art culture industry, as well as with equivalent constructs within culture at large. It should be remembered that the works' successful accrual of commodity status within these disparate contexts by no means contradicted the intentions of their makers.

Andy Warhol has been relentlessly quoted as having said that pop art is about "liking" something (a difficult position through which to approach his electric-chair series or his disaster images).[46] Claes Oldenburg has stated that "making im-

33 *Mao Tse-Tung* (1972), portfolio of ten silkscreen prints by Andy Warhol. Courtesy Permanent Collection of the Des Moines Art Center, no. 1974.93, gift of Peter Brant, Greenwich, Connecticut. Photograph by Ray Andrew.

personality the style characterizes Pop Art in the pure sense."[47] Statements such as these allowed American pop to be concurrently appropriated into various (and of-tentimes diametrically opposed) camps. For example, in the sixties, the movement could serve, on the one hand, as a high-art counter to the intense subjectivity of ab-stract expressionism (or, more precisely, to the artistic production of the move-ment's second generation of followers)—that is to say, as a detailed, assured, and di-rect presentation of a new realism. On the other hand, pop could be perceived to be a synonym for the anti-authoritarian, rebellious lifestyle of the new left.[48] This bi-valence stemmed from the fact that American pop was, for the most part, deliber-ately indeterminate and, as a result, existed as an open, nonideological subset of the dialectics of cultural politics. This aspect of pop is yet another dimension of the Duchamp legacy.

As fluent entrepreneurs of sign production, participants in North American pop art did not produce their works in service of a determinate ideological structure. In-stead they attempted to provide evidence that art was *capable* of functioning as one

34 *The Store* (1963), Installation by Claes Oldenburg, Green Gallery, New York.
Photograph by Rudolph Burkhardt.

communicative system within the myriad systems of which the postindustrial information age is constructed. In the long run, it was far less a question of the democratization of the arts through breaking down boundaries between art and culture at large (an ultimately elitist and rather naive assumption—life, after all, does not usually ask to be integrated into art) than it was a heroic assertion that the artist could actively participate in the construction of culture's complex visual lexicon.

In "The Work of Art in the Age of Mechanical Reproduction," Benjamin had noted, "Dadaism attempted to create by pictorial—and literary—means the effects which the public today seeks in film."[49] Curiously enough, it would not be not too far-fetched to suggest that Andy Warhol, one of the primary players in what would later be identified as the American Pop Art consortium, would, in all probability, have gleefully concurred with Benjamin's apparently contradictory observation that "the cult of the movie star, fostered by the money of the film industry, preserves not the unique aura of the person but the 'spell of the personality,' the phony spell of a commodity. So long as the movie-makers' capital sets the fashion, as a rule no other revolutionary merit can be accredited to today's film than the promotion of a revolutionary criticism of traditional concepts of art."[50]

Benjamin scholars are quick to point out that "The Work of Art in the Age of Mechanical Reproduction" is replete with internal contradictions. However, it is not surprising that the critic should have had some difficulty in acknowledging his own inevitable dysfunctionalism within the new, nonhierarchical worldview that he was proposing; for it is the role of the critic that is perhaps most overtly challenged by our century's repeated, albeit unsuccessful, attempts to integrate art and life.

References to the act of criticism and to the shifting role of the critic during the age of mechanical reproduction are scattered throughout the essay and could, with few revisions, have been almost seamlessly reinserted into the art-world discourse of the early 1960s. For example, Benjamin uneasily notes that "with regard to the screen, the critical and receptive attitudes of the public coincide" and that the cinema "puts the public in the position of critic."[51] Conversely, during MoMA's 1962 symposium, Hilton Kramer would insist that pop art was "a kind of emancipation proclamation for the art critic [who has been] placed by this new development in a more advantageous position vis-à-vis the work of art than they have heretofore enjoyed."[52] Although Kramer was here referring to his belief that the critic is empowered by a form of artistic production about which what is said is more important than what it is, we know that this was wishful thinking. At that

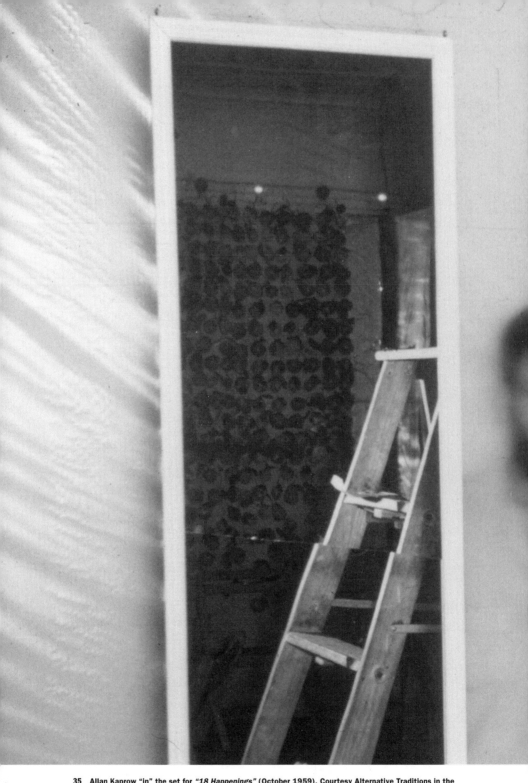

35 Allan Kaprow "in" the set for *"18 Happenings"* (October 1959). Courtesy Alternative Traditions in the Contemporary Arts, University of Iowa. Photograph by Dick Higgins.

point, the new art had already been picked up by Manhattan's Leo Castelli Gallery, the Allan Stone Gallery, the Martha Jackson Gallery, and the Green Gallery, among others, and was secure in its access to an audience and community of collectors. It was only the art museum, the art critic, and other traditional conservators of hierarchical value and normative, idealistic aesthetics that were as yet out of the loop.[53]

Benjamin had earlier been aware of the overt challenge to his own mode of cultural production inherent in the demythified form of artistic practice that he attempted to champion. Had he survived World War II, he would have realized that the success of such recurrent attacks on the institution of art are, by nature, always short-lived. For it is not only the critic who is disempowered in the process. Prerequisite to the successful demythification of subjective creative experience is the disencumberment of the artmaker from a concurrent myth, the concept of artistic privilege.

In his still much used 1966 publication, *Assemblage, Environments, and Happenings*, which aligns action painting with aspects of what had been identified as neo-dada, Allan Kaprow states, "The intellectuals' typical disdain for popular culture, for the objects and debris of mass production which appear abundantly in this [assemblage] work, is, as always, a clear instance of aesthetic discrimination: *this* is fit for art, *that* is not."[54] The sentiment seems, at least on the surface, to echo Lawrence Alloway's observations in "The Long Front of Culture." However, it is not that simple. Two pages later Kaprow writes, "As the art critic Lawrence Alloway has observed, our 'throwaway' culture has permeated deeply into the very methods and substance of contemporary creative art." While Kaprow's statement, in and of itself, suggests that something that comes dangerously close to "Renaissance-based ideas of the uniqueness of art" had, within a few short years, been superimposed over Alloway's original radical posture, Kaprow goes on to confirm his own hierarchically biased value system by stating parenthetically, "But unlike our standardized products that are made to be discarded, the work of art is unique and personal."[55] It would appear that, for the arts (as well as for the antiformalist and purportedly anti-elitist artmaker), the "acceptance of the mass media [did not] entail a [perceptible] shift in our notion of what culture is," as a younger Lawrence Alloway had aggressively maintained in 1959. As we are well aware, boundaries among art and other cultural constructs have remained intact well into our own present. For better or for worse, it is, after all, what our society persistently chooses to do.

Notes

1 "A Symposium on Pop Art," *Arts Magazine* 37, no. 7 (April 1963): 36.

2 Ibid.

3 Lawrence Alloway, *American Pop Art* (London: Collier Macmillan, 1974), 1. Although he employs an uppercase *P* in the phrase "Pop art," Alloway insists that the *a* be in lowercase. Alloway opens this volume—published on the occasion of the mounting of the Whitney Museum of American Art's American Pop Art Exhibition, which he curated—by making reference to Robert Watts' *Addendum to Pop* (1964 and 1971). Watts' piece was an attempt to copyright the words "Pop Art" in anticipation of taking the term off the market. Legend has it that Watts disapproved so strongly of the New York art world's response to pop that he withdrew his works from the Castelli Gallery and situated himself firmly within the overtly utopian Fluxus collective.

4 Lawrence Alloway, "The Arts and the Mass Media," *Architectural Design*, February 1958, 84–85.

5 Lawrence Alloway, "The Long Front of Culture," in *Modern Dreams: The Rise and Fall and Rise of Pop* (Cambridge, MIT Press, 1988), 31. The essay first appeared in *Cambridge Opinion*, no. 17 (1959).

6 Aldous Huxley, quoted in Walter Benjamin, "The Work of Art in the Age of Mechanical Reproduction," in *Illuminations: Essays and Reflections*, trans. Harry Zohn, ed. Hannah Arendt (New York: Schocken Books, 1969), 247–248 n. 13, emphasis mine. My preliminary attempt to compare aspects of Benjamin's thesis to Alloway's radical 1959 proclamation on "the aesthetics of plenty" first appeared as part of the curatorial essay "American Pop: The Work of Art in the Post-Industrial Age" (Des Moines: Des Moines Art Center, 1990).

7 Benjamin, "The Work of Art in the Age of Mechanical Reproduction," 248.

8 "A Symposium on Pop Art," 39.

9 Ibid.

10 Ibid., 37.

11 Ibid., 41 and 42.

12 Ibid., 44.

13 Benjamin, "The Work of Art in the Age of Mechanical Reproduction," 218.

14 Ibid.

15 Ibid., 237.

16 Ibid., 238.

17 Ibid., 237–238. Benjamin's essay has attained mythical status within our own contemporary discourse. As a result, historical dada is regularly accessed through the critic's understanding of the movement.

18 There are numerous examples within the Berlin dada circle that indicate that members of the movement were consciously aware that they were participating in an in-depth analysis and criticism of how culture was constructed. However, historiographically sophisticated analysis of this dada center was not available at mid-century. For example, in the midst of Germany's postwar crisis, a figure like Berlin *Oberdada* Johannes Baader claimed that the war had never happened but was simply a fiction authored by the press. His essay "*Deutschlands Grosse und Undergang*" appeared in *Erste internationale Dada-Messe*, ed. George Grosz, John Heartfield, and Raoul Hauseman (Berlin: Kunsthandlung Otto Burchard, 1920), but was unknown until recently. Although Baader was probably the most brilliant of dada's cultural critics, his works and actions were initially written out of the history of dada. The mid-century publication of Motherwell's anthology evidenced other long-standing rifts within the community of the original dadaists. At the time, Tristan Tzara and Hülsenbeck were so diametrically opposed to each other's retrospective agendas that they refused to have their statements bound under one cover. Instead, their positions appeared as two inserts to the first edition.

19 "A Symposium on Pop Art," 38, 44.

20 Ibid., 44.

21 Ibid.

22 Ibid., 38.

23 Ibid., 39.

24 In a 1963 article, Barbara Rose would concur with such a perspective and openly insist that John Cage had provided a "common origin" for diverse practitioners of the "new dada." "Dada Then and Now," *Art International* 7, no. 1 (January 1963): 27.

25 See Estera Milman, "The Dada Myth," in *Dada Conquers! The History, the Myth, and the Legacy* (Taipei: Taipei Fine Arts Museum, 1988), 113–139.

26 John Cage, *Silence: Lectures and Writings* (Middletown: Wesleyan University Press, 1961), xi.

27 In the 1940s Eduardo Paolozzi made a number of pilgrimages to France to study Paris dada. The direct influence of Duchamp upon members of the British pop community is evidenced, for example, by the fact that Richard Hamilton produced a typographic facsimile of Duchamp's *The Green Box* in 1960 and Paolozzi based his *Moonstrips Empire News* of 1967 on Duchamp's notes for *The Large Glass* (as these were presented in Duchamp's 1924 multiple).

28 In 1963, when asked by G. R. Swenson if pop was "a bad name," Andy Warhol replied: "The name sounds so awful. Dada must have something to do with Pop—it's so funny, the names are really synonyms. Does anyone know what they're supposed to mean? . . . [Jasper] Johns and [Robert] Rauschenberg—Neo-Dada for all those years, and everyone calling them de-

rivative and unable to transform the things they use—are now called the progenitors of Pop." Andy Warhol, "What Is Pop Art? Interviews with G. R. Swenson," *Art News* 62, no. 7 (November 1963): 61.

29 For example, in 1962 Claes Oldenburg made a seamless transition from his experiments with assemblage, environments, and happenings into the ranks of the pop art community. Nevertheless, he intermittently maintained his affiliation with the "underground" through his continued interaction with the contemporaneous Fluxus collective. So too did other purported proponents of the democratization of the arts, such as Allan Kaprow and the venerated John Cage. Readers interested in Cage's own recollections of his relationship with the Fluxus "people" can turn to a December 28, 1991, interview with the composer. Ellsworth Snyder, "John Cage Discusses Fluxus," *Fluxus: A Conceptual Country*, ed. Estera Milman (Providence: Visible Language, 1992), 39–68.

30 See Richard Hulsenbeck, "Poe & Dada: A Debate," *possibilities 1* (New York: Wittenborn, Schultz, 1947), 41.

31 Ibid., 42, emphasis mine.

32 Harold Rosenberg, "The American Action Painters," *Art News* 51, no. 8 (December 1952): 25. This often-cited, remarkable statement has been misinterpreted as proformalist and even misattributed to Rosenberg's formalist rival, Clement Greenberg. See, for example, Abigail Solomon-Godeau, "The Armed Vision Disarmed: Radical Formalism from Weapon to Style," in *The Contest of Meaning: Critical Histories of Photography*, ed. Richard Bolton (Cambridge: MIT Press, 1989), 102. Having accused Aaron Siskind of assimilating Clement Greenberg's "doxology of modernism—the *ne plus ultra* of Anglo-American formalism—as the theory and ground of his work," Solomon-Godeau goes on to explain that such is the case because the photographer was "allied by both friendship and dealer [to abstract painters who had redirected action] from the political field to the field of the canvas." The author then cites this 1973 recollection by Siskind: "The only other thing which reassured me from the abstract expressionists is the absolute belief that this canvas is the complete arena of struggle, this is the arena, this is where the fight is taking place, the battle." Aaron Siskind, "Thoughts and Reflections," *Afterimage* 1, no. 6 (March 1973): 2. Such misunderstandings (or slips of the pen) are particularly odd in view of the fact that, in his 1952 essay, Rosenberg explicitly explains that "the new American painting is not 'pure' art since the extrusion of the object was not for the sake of the aesthetic . . . the aesthetic too has been subordinated . . . what matters always is the revelation contained in the act" ("The American Action Painters," 28), a statement that once again brings us back full circle to Hülsenbeck and dada. Curiously, when discussing the continuities and discontinuities between the new art and historical dada, Barbara Rose notes: "[Neo-Dada's] attitudes are very much unlike those of the gen-

eration that created Abstract Expressionism; these latter were literally men of 'action'" Rose, "Dada Then and Now," 25.

33 Hulsenbeck, "Poe & Dada," 41–42.

34 Ibid., 43.

35 Robert Motherwell and Harold Rosenberg, *possibilities I*, 1.

36 Rose, "Dada Then and Now," 23. A recent publication on neo-Dada concurs, to an uncanny extent, with perspectives evidenced in the early 1960s. See Susan Hapgood, "Neo-Dada," in *Neo-Dada: Redefining Art 1958–1962*, ed. Susan Hapgood (New York: American Federation of Arts and Universe Publishing, 1994), 11–65. Hapgood's references to historical dada coincide, almost to the letter, with those presented in the art press of the neo-dada period. Furthermore, as was the case for the majority of authors who addressed the topic in the 1960s, the recently published essay attempts to identify formal resemblances among the production of a select number of participants in the historical movement and sets of artifacts realized half a century later.

37 Rose, "Dada Then and Now," 23. On Schwitters and his misunderstood relation to dada, see, for example, Katherine Dreier, *Western Art in the New Era* (New York: Brentano, 1923), 120. Dreier, one of the founding members of the Société Anonyme, Inc., noted: "Only one painter besides Duchamp has expressed dadaism through the art of painting, Kurt Schwitters . . . and strangely enough, he rejects the appellation whereas Duchamp is counted a Cubist." Rose's use of the term "madcap" in relation to historical dada brings to mind a Dick Higgins anecdote: "In the 1950's, the journalistic image of Dada was considered to be the limit of the extremely crazy in art . . . Thus, early Happenings and fluxus (like the works of Rauschenberg and Johns) were often dismissed as 'neo-Dada.' This was, of course, extremely annoying for those of us who knew what Dada was or had been." Dick Higgins, "Fluxus Theory and Reception," unpublished ms., 1985, n.p.

38 "Dada Then and Now," 24.

39 Ibid., 27. Even as late as 1974, Alloway would insist that "Pop art and Happenings are often treated together as object-based and performance-based aspects of an environmental sensibility." *American Pop Art*, 127. Rose's essay provides further evidence of the extent to which dada's historical accomplishments were inaccessible to the art establishment of the 1960s. For example, reference to the dadaists' early twentieth-century experiments with event arts, simultaneity, chance procedure, and the integration of the receiver into the "artistic arena" (the primary formal devices employed by Cage at Black Mountain) does not appear in the art press of the neo-dada period. It is as if Cage, with his legendary 1952 event, is assumed to be "the first artist in history" to allow such concerns into his "creative compound" ("A Symposium on Pop Art," 39).

40 Jasia Reichardt, "Pop Art and After," *Art International* 7, no. 2 (February 1963): 42, cited in

Edward T. Kelly, "Neo Dada: A Critique of Pop Art," Art Journal 23, no 3 (Spring 1964): 192. Reichardt's essay on British pop includes her attempt to track the shift in definition of the term and suggests that even as early as 1956 (two years after Alloway coined the phrase), definitions of pop art differed among participating members of the Independent Group. In addition, Reichardt insists that for Richard Hamilton, the paradigmatic British pop artist, the term always referred to mass-media imagery repositioned by the artist within the institution of art, albeit on nonhierarchical terms. Also see Lawrence Alloway, "Pop Art Since 1949," *Listener* 67, no. 1761 (December 1962): 1085, cited in Kelly, "Neo-Dada: A Critique of Pop Art," 192.

41 In an unpublished 1970 interview by Kathy Rosenbloom, Boris Lurie, one of the founding members of the NO!art or Doom art collective, stated: "The direction we got into was one of personal and social protest in a so-called new form. In other words, not a form of Social Realism but one that depended to some extent on Dada, on violent expressionism, street art, graffiti . . . Little attention was paid to pure form." A transcript of this conversation is on file at the Smithsonian Institution Archives of American Art in Washington, D.C.

42 Kelly, "Neo-Dada," 194.

43 Ibid. An oblique reference to such crossovers can be found, for example, in a 1963 interview in which Andy Warhol refers to a form of imagemaking that brings Boris Lurie's pinups directly to mind: "My next series will be pornographic pictures. They will look blank; when you turn on the black lights, then you see them—big breasts and . . . If a cop came in, you could just flick out the lights or turn on the regular lights—how could you say that was pornography? But I'm still practicing with these yet." Warhol, "What Is Pop Art?" 61. Rigid lines of demarcation between those artists who entered the North American mainstream and those whose affiliations remained with the artistic counterculture of the period have since been set. For example, Wolf Vostell, a fellow traveler (alongside Allan Kaprow) in the NO!art collective as well as in the Fluxus community, recounted that, in the early sixties, Warhol "ran around New York taking in everything" and later incorporated Fluxus artist Jackson McLow's ideas about the new cinema into his own film production. Wolf Vostell, "No Blood . . . Please . . ." (1977), reprinted in *NO! Art*, ed. Boris Lurie and Seymour Krim (Berlin: Edition Hundertmark, 1988), 18.

44 Kelly, "Neo-Dada," 196.

45 Lucy Lippard, "New York Pop," in *Pop Art*, ed. Lucy Lippard (London: Thames and Hudson, 1988), 102–103.

46 Warhol, "What Is Pop Art?" 26.

47 Cited in Lippard, "New York Pop," 86.

48 For discussion of this response to pop, see Andreas Huyssen, "The Cultural Politics of Pop," in *Post Pop Art*, ed. Paul Taylor (Cambridge: MIT Press, 1989), 45–78.

49 Benjamin, "The Work of Art in the Age of Mechanical Reproduction," 237–238.

50 Ibid., 231. It is generally acknowledged that Benjamin's thesis also owed much to the political theater of Bertolt Brecht. As chance would have it, Warhol responded to Swenson's question "What is Pop Art?" with the following observation: "Someone said that Brecht wanted everybody to think alike. But Brecht wanted to do it through Communism, in a way . . . It's happening here all by itself . . . Everybody looks alike and acts alike, and we're getting more and more that way . . . I think everybody should be a machine. I think everybody should like everybody." Swenson then asked, "Is that what Pop Art is all about?"—to which the artist replied, "Yes. It's liking things." Swenson: "And liking things is like being a machine?" Warhol: "Yes. . . ." Warhol, "What Is Pop Art?" 26.

51 Benjamin, "The Work of Art in the Age of Mechanical Reproduction," 234, 240.

52 "A Symposium on Pop Art," 38.

53 For an informed and outspoken discussion of the demise of the pop art critic, see Stephen C. Foster, "Early Pop and the Consumptive Critic," in *Hand-Painted Pop: American Art in Transition, 1955–1962*, ed. Russell Ferguson (New York: Rizzoli, 1992). Foster closes his essay with the following observation: "It was not a problem for the artist, who was finally acculturated, nor for the spectator, who was finally enfranchised. Only criticism lost its conventional platforms. Embarrassed beyond endurance, idealistic criticism became a partner in a new modernism through which its idealistic intentions were degraded, but at the same time made purchasable, popular, and easy. Normal criticism witnessed a failure of 'problems'" (176).

54 Allan Kaprow, *Assemblage, Environments, and Happenings* (New York: Harry N. Abrams, 1966), 166. Alloway himself would later note, "The expansionist aspect of the earlier use of the term [pop art] became identified with Allan Kaprow's term *Happening* . . . The Happening stays close to 'the totality of nature,' whereas Pop artists work from the artifacts of culture and retain the compact identity of art no matter how extensively they quote from the environment." *American Pop Art*, 5. In truth, the origin of the term "happening" is still debated. Some scholars make note of the early use of the term on an international scale—for example, by German-based Wolf Vostell, who called his own events of the 1950s and 1960s "De-Coll/age Happenings." In 1963 Kaprow himself noted, "Although the word 'happening' is used increasingly in contexts which are as irrelevant to, as they are irreverent of, the art it designates, few have actually witnessed one or are aware of the variety of such events throughout the world. Speaking of my own now, their basis is in the collages and assemblages I did in the years 1953 to 1956, and this fact informs even their present character." Allan Kaprow, "A Service for the Dead," *Art International* 7, no. 1 (January 1963): 46.

55 Kaprow, *Assemblage, Environments, and Happenings*, 168.

(Re)Imaging the Grotesque
Francis Bacon's Crucifixion Triptychs

ROBERT NEWMAN

. . . the most characteristic quality of modern man: the remarkable antithesis between an interior which fails to correspond to any exterior and an exterior which fails to correspond to any interior.

Nietzsche, "On the Uses and Abuses of History for Life"

Of all the arts, painting is undoubtedly the only one that necessarily, "hysterically," integrates its own catastrophe, and consequently is constituted in advance as a flight.

Deleuze, *Francis Bacon: The Logic of Sensation*

The anomalous in Francis Bacon's triptychs engages us as viewers.[1] They both fascinate and repel, due primarily to their reconfiguration of symbolic structures based on reference to the body. This engagement functions both as defense, the need to assimilate and to master the threat of anomaly, and as subversion, the desire to shatter those symbolic structures in order to liberate the strange and the excessive from their confinement. We perform the former to preserve culturally articulated identities, to safeguard our inclusion in the social body. The latter constitutes an attempted act of recovery, a foray into what has been lost by absorption within the cultural sign system. The two functions are in continual dialogue as intersecting narratives between viewers and the images they view so that Bacon's triptychs, while suggesting the possibility of closure, simultaneously frustrate it. Like the Lacanian or Kristevan subject, which is continually rewritten in and through subjectivity, viewers are never where they were or where they will be, as identity now stands for the dizzying sea change of maskings we call the "self."[2]

John Berger has condemned what he considers a "lack of indignation which does not stir the conscience" in Bacon's art and contrasts it to Picasso's *Guernica*.[3] Berger's critical comment that we look at Bacon instead of going to Bergen-Belsen, substituting nonreferential insularity for referential experience, actually hyperbolically dramatizes the raw erotics of Bacon's works and their contesting of any fixed

position. Instead of inviting their viewers to historicize or moralize as *Guernica* does, Bacon's paintings induce panic. Their focus on the orifice, the hole, the place of drainage, deliberately negates attempts at hierarchical constructions. Despite his portrayal of sexual situations, the gender of Bacon's subjects is obscured, thereby heightening without resolving sexual tension. Their narrative impulses thwarted, viewers' eyes themselves become orifices, sucking the paintings in but unable to convert them. While *Guernica* renders its horror allegorical, directing its viewers toward consequence, the horror of Bacon's work is the power of the passive, the place where boundaries slip and direction falters.[4]

Bacon's grotesques undermine traditional readings of figural narratives that are characterized by a move away from the body as material surface comprised of flesh, bone, and blood to the body as relational symbol, possessing and reflecting meaning through contextualization. In effect, these readings place the material body *sous rature* in order to present it within an abstract paradigm, thereby centering the site of reading on an act of consciousness. Mythologizing or historicizing the body via narrative dresses it in a metalanguage that structures the gap between its surface and its content.[5]

As Michel Foucault and Elaine Scarry have shown, acts of civilization involve disciplining or controlling the body, one's own as well as those of others. This process effects a distance from or transcendence of bodies as a means of initiating or preserving power over them.[6] One means of attaining this distance is through the sublimation of the body into an aesthetic. The history of the female nude in painting and sculpture is but one example of this. We might call to mind the "Lestrygonians" episode of *Ulysses* in which Leopold Bloom, fleeing an encounter with Blazes Boylan, ducks into the National Museum and proceeds to examine the mesial groove of a statue of Venus to see if it possesses an anus. Not only the anus but the female genitalia were, in the vast majority of instances, covered or absent until the shock waves from Edward Weston's nudes reverberated into a general unveiling. In addition to sublimating the female form by erasing its "lowly" attributes, the absence of genitalia further objectifies the female, rewriting her body as removed from sexual capability, at least that which she herself generates. Instead, her sexuality is manufactured by the gaze of her observers who, compelled to inscribe themselves on her blank or hidden place, project sex where none is portrayed. The aesthetic appropriation of the female form is in dialogue with the voyeuristic one, repressing it only to encourage, in turn, its desire to fill the now-created empty space with phallic meaning.

Knowing the body means shutting off its interior under the guise of exposure, thereby permitting the knower to appropriate and reconfigure what he claims to have exposed.[7] The body exists as territory to be mapped, its boundaries drawn from the outside. The soft jumble of entrails and fluids are constructed as a rigid, definable whole, a working machine. Klaus Theweleit considers the roots of fascism in the fear of the inner body and ties fascism's rejection of the masses to a horror of the visceral mass within. Consequently, fascism elevates the hardened warrior, his disciplined exterior protecting against penetration from without or within. Despite its sexually charged politics, fascism, Theweleit asserts, is essentially anti-erotic, its emphasis on violence a reaction to a fear of the feminine, the Other within the rigid male body. The liquid images with which women are associated threaten to flood the boundaries of the male ego so that preservation dictates their eradication.[8] The preponderance of fascist costumes within the sexual margins of contemporary culture might qualify Theweleit's charge that fascism is essentially anti-erotic. The fact that fascist movements have promoted both family values and a strong homoeroticism evokes Foucault's considerations of repression creating new erotic sites on both mind and body and, ironically, expanding the possibilities of sexual pleasure. Such an incorporation of a threat to a preexisting phallic sensibility instead helps to constitute and to extend that sensibility.[9]

The problematics of this complex cultural encoding of and relationship to the body may be underscored through an exploration of the grotesque as a narrative form, particularly Bacon's reimaging of the grotesque as cognitive disrupter. I use Bacon's Crucifixion triptychs as an example of the eruption of the grotesque into high art and of a tendency of narrative to displace the very repression that it often evokes. By focusing attention on interiors, Bacon's triptychs demystify abstractions of the body and confute aesthetic and voyeuristic appropriations that ascribe value through mystification. Bacon's versions of the body posture these articulations of its significance as tenuous intersections of symbols rather than descriptions of something that possesses meaning in itself. Rather than a romantic attraction to the body as antisocial, prelapsarian gesture, Bacon's *lusus naturae* deconstruct the body as a model for bounded systems by presenting the unclassified and the unclassifiable. The marginal displaces the central, generating ontological insecurity. Unable to orient themselves in the physical universe produced by such narratives, readers and viewers undergo a process of estrangement whereby the homogeneous gives way to the hybrid.

Unlike the traditional grotesque that foregrounds the Other as threat, only to

eventually quell that threat and restore the Symbolic Order it temporarily dislodged, Bacon's grotesques also enmesh themselves at the edges of collapsing boundaries but do not permit these boundaries to be reinstated or enduringly reformed.[10] Their emphasis is on the carnivalesque, the motions of transgression, rather than the products of those motions. With them, we delve into the heterodox and its invasions of the Symbolic, causing our staunch pillars of reason to wobble. They peel our eyelids open and pin them back, and we watch ourselves repelling the uncanny threat and shoring up the borders it has transgressed. These movements are interminable and multidirectional, a continual dialogue of yielding and resistance in which each response adjusts its successor and readjusts its predecessors. The notion of genre as ideal model no longer pertains. Instead, this reimaging of the grotesque highlights the reconception of all genres as intrinsic, their protean perimeters manifested through the reading process.[11]

Rather than preserving the bodily dichotomy between interior and exterior, Bacon's paintings engage in a protean dialogue between inside and out which loosens that dichotomy and often causes the terms to exchange and reexchange places. The discovery of the x-ray by Roentgen in 1898 opened up the interior terrain of the human body and contributed to a reappraisal of what was properly inside and outside the body. Although this reappraisal detailed and explored this terrain as never before, it generally did so in metaphysically assimilative terms that maintained imposed moral divisions. The hidden interior, though now subject to empirical scrutiny, still intimidated the popular and literary imagination. In Thomas Mann's *The Magic Mountain*, Hans Castorp remarks that he feels as if he were gazing into the grave when looking at an x-ray. Robert Louis Stevenson's 1886 novella *The Strange Case of Dr. Jekyll and Mr. Hyde* enjoyed a recurring popularity, particularly in film versions. Dr. Jekyll's theory that the body is part of the mind produces Mr. Hyde, who emerges from within to overcome him and then must be destroyed. The interior is continually perceived as threat; when it bursts the confines of the exterior, it wreaks havoc and must be subdued (repressed) so that bodily, social, and cognitive order can be restored.[12]

Unlike its predecessors, the grotesque as reconfigured in Bacon remains transgressive. Although its focus on the abnormal follows the generic pattern, it inverts traditional narrative roles and subverts reconciliation through closure. The deformed are not subdued; they persist. Bodies are turned inside out like so much stuffing pulled from beneath a fragile skin. They are then restuffed and stitched up

before the seams again stretch and erupt, only to be resewn, ad infinitum. Each leak, each restitching, alters the texture of the surface.

In choosing Bacon's Crucifixion triptychs, the painting as narrative, to portray these transgressive depictions, I deliberately intend to underscore the radical disjunction inherent in the reconfiguration of the grotesque as intrinsic genre. A traditionally spatialized and static aesthetic is temporalized, a triptych implying a progression and an interactive commentary among its parts.[13] Furthermore, such an explicit juncture of the metonymic and the metaphoric comments on the figural genesis of narrative. My thinking is premised on the notion that the image is not divorced from narrative but reconfigures both the nature of narrative and itself as narrative. I resist the positing of narrative from a point of view similar to the Albertian single-point perspective, which fixes perception as atemporal, and I embrace W. J. T. Mitchell's contention that ideas are understood as images and that ideology equals iconology, contentions that help move us beyond Lessing's unyielding distinction between the discursive and the figural.[14]

Bacon, however, complicates any simple Aristotelian coding of his triptychs as narratives. By using oppressive framing devices like cages and platforms, he isolates his figures and limits continuities between panels. His comment to David Sylvester, "It helps to avoid storytelling if the figures are painted on three different canvases," reveals his interest in undermining narrative as product and exposing it as process.[15]

I wish to read Bacon's triptychs through the dialogic interaction by which I characterized narrative engagement at the beginning of this essay—the continuing dialogue of identity formation between reader/viewer and text, which consists of attempts to preserve and to disrupt the Symbolic. To do so, I wish also to apply Julia Kristeva's theory of abjection because, in its attention to thresholds, it knits together many of the points I have sketched above.

According to Kristeva, the Semiotic continually releases disruptive pulsions into the Symbolic, which must be in turn rejected so the stable identity imposed by the Symbolic can be maintained. This process of expulsion, a process inseparable from the provisional sense of identity it acknowledges, Kristeva terms "abjection." She finds signs of abjection in disgust and horror as reactions to the inability to transcend the base associations of the corporeal. The corpse, for example, is the most horrifying and cognitively disruptive indication of the body as waste: "If dung signifies the other side of the border, the place where I am not and which permits me to be, the corpse, the most sickening of wastes, is a border that has encroached

upon everything. It is no longer I who expel, 'I' is expelled. The border has become an object."[16] Awareness of the corpse confirms the fragility of identity, a disturbance of borders that threatens Symbolic integrity with a return to the emptiness which preceded it and which is its destiny.

Abjection is therefore neither subject nor object, but persists in the interface between these and other binary oppositions with which the Symbolic codes subjectivity and sociality. It manifests itself in ambiguous and transgressive states and in representations that signify the perpetual threat to the sense of self, against which the subject consistently responds. Kristeva departs from Freud's position by contending that the threats to identity are expelled rather than foreclosed.[17] They remain as unsettling reminders just outside the delicate sense of unity constructed by the Symbolic. Thus, abjection can be located in the ongoing dialectical process between the illusion of self and the subject's attempt to expel from itself what threatens this illusion.

Abjection resists rational distinctions formed by language and naming by inscribing itself in sites of the body, particularly those bodily holes that confuse the boundary between inside and outside and therefore between self and other. At these sites, what is inside the body is expelled to the outside and what is outside can be taken in. These orifices for elimination also constitute erogenous zones and thereby function as the scenes of generation and negation, attraction and repulsion, Eros and Thanatos. The process of abjection therefore follows a psychoanalytic design by tying identity formation to experiences of and through the body and to repressions of those experiences. It describes a dialogue between desire and loss that resonates most intensely in the ambiguous and transgressive. Abjection appears where boundaries are traversed and unity punctured so that the resultant breach threatens to widen and overtake the whole.

The titles of Bacon's Crucifixion triptychs suggest his intentions. Instead of a moment of transcendence, the crucifixion becomes the site of abjection. Rather than yielding stable abstractions, this metaphor points to shifting and incomprehensible pulsions and expulsions. What once thematized now destabilizes.

In response to an interviewer's statement that he is not concerned in his painting with commenting on the nature of man, Bacon responds, "I'm just trying to make images as accurately off my nervous system as I can."[18] Pointing to Bacon's materialist perspective, Dawn Ades reminds us that Bacon deliberately says "nervous system" rather than "soul" or "personality."[19] The distinction is important. By

inscribing the body directly onto the canvas, Bacon intentionally undercuts its cultural relation to the viewer. Bacon's figures are corporeal smears, discharges of energy, not products of aesthetic idealization. As hybridized, mutated forms that express the instinctive, somatic activity of the body beyond the control of intellectual will, they subvert anthropocentric and rational response. Through them, we see reason as product rather than producer of nature, mind as a function of body, and form as engendered by bodily not mental desire. Whereas the Renaissance Francis Bacon treated the universe as an encyclopedically ordered system, his twentieth-century namesake seemingly flings the entropic residue against his canvases where it splatters and howls. No wonder, then, that in Tim Burton's film *Batman* (1989) the Joker, agent of instability and havoc, destroys every painting in the Gotham art museum except a Bacon.

Bacon's paintings typically disable context, rupturing rhetorical and narrative unity. Figures themselves seem partially thawed in the process of melting and spilling like drainage into a sinkhole. Their twisted poses are usually localized within chairs, beds, tubular furniture, or a frame of lines and are separated from each other in discontinuous spatial arrangements. Relations between figures and between figures and their surroundings are simultaneously suggested and upset. The triptychs in particular establish linkages between panels by the very nature of their physical connection to one another. The resemblances between figures and contexts, however, are purposely dismantled so that narrative and narration are placed in combat. While Bacon's hybridized forms frustrate orthodox means of communication, their transgressive impulse communicates on a primal level beneath that of symbol and symptom. In doing so, they engage viewers in the dialogue of violation and expulsion that characterizes abjection.

John Russell aptly describes Bacon's prehensile, raw images of the body within their trapped spaces: "We feel . . . that we have penetrated to the inmost nature of human behavior, and that these people are betraying in the everyday traffic of life something of that instinctual violence which marked the great warrior Cuchulain in the height of battle. Cuchulain in the heat of the fray was said to twist round in his own skin to such an extent that at moments he was literally 'back to front'; and something of that sort happens to Bacon's subjects when he commits them to canvas."[20] Indeed, Bacon turns the body within its own skin, implodes and explodes it, turns it inside out and outside in. Rather than identifiable movements and interactions with categorical meanings, we are given smudged closeups of spasms and

shrieks. Furthermore, the few shreds of identification offered to viewers via figures reflected in mirrors or holding cameras implicate them as torturers as well as voyeurs.

The three Crucifixion triptychs, painted in 1944 (revised in 1988), 1962, and 1965, profane the sacred symbol and convert it into a free play of primal images. In Dostoevsky's *The Idiot,* Holbein's painting *The Body of the Dead Christ in the Tomb* causes Prince Myshkin to exclaim, "Why, some people may lose their faith by looking at that picture."[21] Bacon's Crucifixion triptychs assume no faith to be lost. Like Holbein's cold and bruised lifeless Christ, Bacon's figures are devoid of passion and sorrow. The human body, however, has become a flayed and trussed carcass hung in a slaughterhouse or a mindless, snapping devourer of flesh, awaiting the flinging of the next morsel.[22]

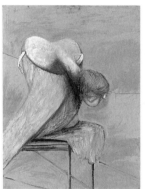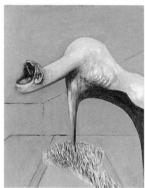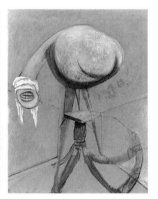

36 *Three Studies for Figures at the Base of a Crucifixion* (1944) by Francis Bacon. Oil and pastel on hardboard, each 94 cm × 74 cm., Tate Gallery, London. Courtesy Marlborough Fine Art, Ltd., London.

Three Studies for Figures at the Base of a Crucifixion (1944, 1988) counterpoints hybridized figures, Oresteian Furies facing left, a bowed seemingly feminine figure facing right. All three figures have phallic shapes, but while the figure in the left panel adopts a mourning pose with drooping head and neck, her two companions savagely snarl and wail, more phallic dentata than progenitors. The eyes of all of the figures are cloaked; they are explicitly bandaged in the central panel. The facial emphasis in the central and right figures is on the voracious mouths, which appear to pivot on their snakelike necks in an instinctive quest to consume. Any human attributes we might project onto the left figure collapse as we move across the triptych into the feral hiss and roar of the others. As Deleuze states, "Bacon's painting

constitutes the zone of indiscernibility, of undecidability between man and animal."[23] The narrative direction is confused. Moving left to right, our investment in the left figure is radically disturbed.[24] The material swathing her body is absent in her naked doppelgängers and her stable perch is contrasted by their unstable stances on narrow piano-leg appendages. Her sense of stasis becomes in them the inevitability of hobbling, stalking motion. In the central figure, the reflected arc of the table legs in the foreground associates its legs with those of a compass. Rather than tracing expansive circles, however, it is dramatically circumscribed, blindfolded and vicious, positioned in a corner with the ceiling pressing down.

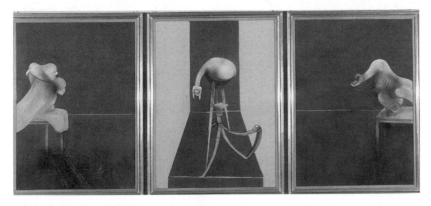

37 *Second Version of a Triptych* (1944, 1988) by Francis Bacon. Oil on canvas, each 198.1 cm × 147.3 cm, Tate Gallery, London. Courtesy Marlborough Fine Art, Ltd., London.

In the 1988 revision, the sense of entrapment in the central panel is enhanced by shrinking the red backgrounds of the two framing panels to a central stripe that contains the figure. Furthermore, a metal plate attached with two screws has been added as if fastening its torso to the wall behind it. The left and right panels have become more symmetrical than in the 1944 version, the figures pushed more to the outer halves of their respective panels. The right figure now sits atop a table like some horrific vase, but acquiring a stability parallel to its left counterpart. Through this structural symmetry, Bacon focuses increased attention on the figure in the central panel. The outer figures comment on it and mercilessly direct our gaze toward its blind panic.

The explicit conjunctions between crucifixion and abattoir in the 1962 and 1965 triptychs intentionally debase sublime appropriations of the body. Bacon's narrative progression retains a focus on the body by peeling it open. The outer shell, its

solidity and continuity providing a familiar sign system to which we attach symbolic representations, implodes to interior ooze. The amorphous, squirming remnants offer no explanations, yield no conclusions, and are horrifying precisely in the relationship the viewer imposes between their antecedent human forms and their unclassifiable remains.

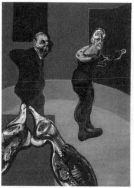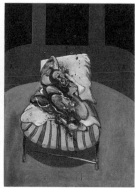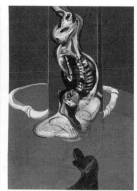

38 *Three Studies for a Crucifixion* (March 1962) by Francis Bacon. Oil with sand on canvas, three panels, each 198.2 cm × 144.8 cm, Solomon R. Guggenheim Museum, New York. Photograph by David Heald, © Solomon R. Guggenheim Museum, New York, no. FN 64.1700. Courtesy Marlborough Fine Art, Ltd., London.

Although *Three Studies for a Crucifixion* (1962) appears to read from left to right, the viewer is compelled to read also from right to left in a retrogressive attempt to understand, and thereby undo, the narrative devolution of the depicted body. The two figures in the left panel mark two stages of the descent, the turning upside down and inside out of upright human to hanging, animalistic carcass. As such, they bear a formal resemblance to Bacon's earlier imagery of the human body modeled on Eadweard Muybridge's stop-action photography from the 1880s.[25] The limbs stripped to bone and muscle at the lower left are echoed in the arms and hands of the man at the right of the panel. In the central panel, the body of the reclining figure begins turning inside out with the explosion of the top of the head. The bestial transformation is emphasized by obscuring facial features except for the grimacing teeth. Although the pose of the figure in the right panel suggests a thirteenth-century crucifixion by Giovanni Cimabue, which Bacon has said he thinks of as "a worm crawling . . . just moving, undulating down the cross,"[26] the canine incisors of the hanging carcass enhance the grotesque transgression that accompanies and contravenes this referent.

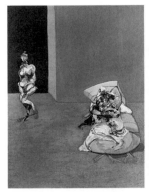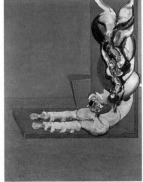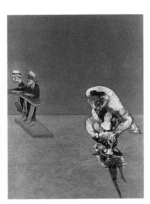

39 *Crucifixion Triptych* (1965) by Francis Bacon. Oil on canvas, 198 cm. × 147 cm, Bayerische
Staatsgemäldesammlungen, Munich. Courtesy Marlborough Fine Art, Ltd., London.

The humanoid figures facing center in the left and right panels of *Crucifixion Triptych* (1965) force the viewer's gaze toward the central panel in which the partially amputated limbs of the headless, gutted figure have been bandaged in splints. Rather than the writhing, feral erasure of sacrificial passion that we witness in the 1962 triptych, we view this figure as the end product of crucifixion. Bacon's stress on the material defuses impulses to construct symbol systems. The split torso displays its viscera as if for an autopsy. The bandaged splints seem less an ironic gesture than a means of constraint during the course of torture. There is no suggestion of spiritual transcendence, only a slumped pile of entrails. The two lurid but distinctly human figures in the right panel prop themselves on an altar rail as if it were a bar. Although the mangled forms in the left and right panels imply correspondence with the two thieves who shared Christ's fate at Golgotha, both are stamped with rosettes, like good cuts of meat. Only the Nazi armband that adorns the figure in the right panel introduces a specific cultural referent, and Bacon coyly manifests regret for this move, stating, "I wanted to put an armband to break the continuity of the arm and to add that particular red round the arm."[27] Ironically, at the site of the crucifixion, the viewer's Symbolic coherence is sacrificed. Instead of any sublime transcendence, we are transfixed in confrontation with the abject. "I wanted to paint the scream more than the horror," Bacon admits.[28] Horror reintroduces narration; the scream is pure disruption. The images we encounter in the triptychs confound attempts at representation because they distort established systems of order, inducing paradox rather than hierarchy. We view bodies transformed into a panoply of signs, but have no symbolic referents that we may attach to these signs.

Only in the light of interpretive reflection can we attempt to situate our responses, translating them back into the symbolic codes that had been so severely displaced. In the primal viewing scene, however, we answer these signs with fascinated, hysterical repugnance at the images we view and at the beast within us they call forth.

Such depictions of the body highlight Bacon's distinction from a modernist sensibility. Russell writes that Duchamp "was interested in process as a subject for painting, and in the way in which a human body makes a coherent structure when it walks downstairs, even if that structure is never revealed completely at any one moment in time. Bacon's objective is not to show successive appearance, but to superimpose appearances, one on top of the other, in ways different from those vouchsafed to us in life."[29] Bacon's postmodernist impulse springs from this disruption of a stable subject and from a simultaneous unmooring of a fixed site of perception.[30] Deleuze emphasizes Bacon's living reality of the body as a body without organs, not a coherent organism but consisting instead of thresholds or levels, a "body named hysteria." Bacon liberates the body from its socially articulated, semioticized condition—in effect, deterritorializing it. By painting the body as meat, Deleuze argues, Bacon voids distancing representations and releases direct presences beyond representation. In this manner, "hysteria becomes painting" and "abjection becomes splendor."[31]

Monique David-Menard's contention that the hysterical symptom is not a representation but a presentation is helpful for understanding the viewer's encounter with the abject in Bacon's painting: "The hysteric posits the object of her desire in the element of presence—as if it were there. . . . In hysterical symptoms and attacks, the subject uses plastic and figurative thought to try to achieve the presence of the desired object and to achieve a jouissance in which nothing will have to be represented—that is, acknowledged as absent."[32] By shattering mimetic and rational interactions, Bacon's triptychs engage this hysterical struggle while their physical structure simultaneously encourages a reimposition of representational narrative. What is present is so horrific in terms of mimetic and rational identification and representation that viewers' consequent hysterical desires, their presentations to themselves, seek substitutions that transmute the horror.

The hysterical fetishization induced by Bacon's paintings, however, differs radically in purpose and affect from Freud's theorizing about the nature of hysteria. Freud locates the basis of hysteria in a disgust with the body. He argues that this disgust produces a desexualization of the body so that erotic sensations deemed improper are repressed and their libidinal energy displaced. In a letter to Wilhelm

Fliess, Freud uses a corporeal trope to postulate repression as a rejection of memory: "To put it crudely, the memory actually stinks just as in the present the object stinks; and in the same manner as we turn away our sense organ (the head and nose) in disgust, the preconscious and the sense of consciousness turn away from memory. This is *repression*."[33] Rather than directing attention to repression and to unraveling the narrative that is repressed, Bacon attends to presence and to its disruption of narrative. Instead of assuming a disgust with the body, Bacon locates that disgust in the process of representation rather than in the body itself. Instead of the Freudian view in which hysteria desexualizes the body and displaces libidinal energy into a fetish, the hysteria induced by Bacon's paintings focuses libidinal energy on images of the body that transgress Symbolic signification, thereby creating infinite rather than fixed substitutions.

Bacon's triptychs, though they compound and confuse narrative direction, do nonetheless prompt narration as movement from one panel to another in an attempt to reconcile the three panels.[34] In doing so, they simultaneously disrupt the viewer's sense of self and induce attempts to compensate for that disruption. The intrusion across the boundary of the Symbolic motivates a response to expel that intrusion, a response that the images continue to undercut. The viewing process therefore becomes an oscillating dialogue of intrusion and expulsion across continually adjusting permeable boundaries, a foray into psychic dislocation.

Notes

1 Quoting Roman Jakobson's definition of the artist's task, "to make the ordinary strange," Jerome Bruner argues that, to be worth telling, "a tale must be about how an implicit canonical script has been breached, violated, or deviated from in a manner to do violence to what Hayden White calls the 'legitimacy' of the canonical script." According to Bruner, "It is not textual or referential ambiguity that compels interpretive activity in narrative comprehension, but narrative itself." "The Narrative Construction of Reality," *Critical Inquiry* 18 (Autumn 1991): 11. See also Hayden White, "The Value of Narrativity in the Representation of Reality," in *On Narrative*, ed. W. J. T. Mitchell (Chicago: University of Chicago Press, 1980), 1–23. The urge toward the anomalous as a basis of narrative also invokes Freud's thesis concerning the uncanny (1919) in which the familiar is alienated through the process of repression and returns as a double, "a thing of terror." Freud links the uncanny to the compulsion to repeat, a principle he develops and ties to the death instinct in *Beyond the Pleasure Principle* (1920), *The Standard Edition of the Complete Psychological Works of Sigmund Freud*, 24 vols., trans. and ed. James Strachey (London: Hogarth Press, 1953–1974), 17:217–256.

Hélène Cixous reads *Unheimliche* as a relational signifier that subverts representations of a unified reality. In this manner, it serves as a rehearsal of an encounter with death that is pure absence. "Fiction and Its Phantoms: A Reading of Freud's *Das Unheimliche* (The Uncanny)," *New Literary History* 7 (Spring 1976): 525–548.

2 Lacan claims that, due to the prevailing role of the signifier in the construction of the subject, the subject cannot be conceived as an objectively knowable thing, a "signified." Instead, the subject is formed in relation to unknown desire. "The Subversion of the Subject and the Dialectic of Desire in the Freudian Unconscious," *Écrits: A Selection*, trans. Alan Sheridan (New York and London: Norton, 1977), 292–325. Kristeva's explorations of the semiotic and the symbolic build on this idea. My *Transgressions of Reading: Narrative Engagement as Exile and Return* (Durham and London: Duke University Press, 1993) discusses this ongoing dialogue within the reading process and also considers abjection in relation to pornographic narrative.

3 John Berger, cited in Lawrence Alloway, "Points of View: Bacon and Balthus," *Art News and Review*, January 26, 1952, 7. Bacon distinguishes between the "violence which I've lived amongst" and "the violence in painting": "When talking about the violence of paint, it's nothing to do with the violence of war. It's to do with an attempt to remake the violence of reality itself. And the violence of reality is not only the simple violence meant when you say that a rose or something is violent, but it's the violence also of the suggestions within the image itself which can only be conveyed through paint." David Sylvester, *The Brutality of Fact: Interviews with Francis Bacon*, 3d ed. (1975; reprint, London and New York: Thames and Hudson, 1987), 81. Dawn Ades discusses this controversy in "The Web of Images," in *Francis Bacon* by Ades and Andrew Forge (New York: Abrams, 1985), 8.

4 In his recent *Francis Bacon and the Loss of Self* (Cambridge: Harvard University Press, 1993), Ernst van Alphen explores what he calls Bacon's "affective narrative" and concludes that the shattered sense of powerlessness the paintings induce in their viewers recalls an original inner-self experience.

5 Roland Barthes draws on Aristotle's belief that narrative imposes a plot (*muthos*) in his contention that narrative converts the chaos of history into the fiction of natural order. For Barthes, history and narrative are mythic in the sense that myth constitutes the process by which prevailing cultural forces impose images that shape the world to sustain their power. See *Mythologies*, trans. Annette Lavers (New York: Noonday, 1972). Mary Douglas argues that the body provides a basic scheme for all symbolism in *Purity and Danger: An Analysis of the Concepts of Pollution and Taboo* (1966; reprint, London: Ark, 1984).

6 Elaine Scarry writes: "Every act of civilization is an act of transcending the body in a way consonant with the body's needs. . . . Higher moments of civilization, more elaborate forms

of self-extension, occur at a greater distance from the body: the telephone or the airplane is a more emphatic instance of overcoming the limitation of the human body than is the cart. Yet even as here when most exhilaratingly defiant of the body, civilization always has embedded within it a profound allegiance to the body, for it is only by paying attention that it can free attention." Scarry goes on to demonstrate the torturer's dominance of the prisoner's body and voice, "All those ways in which the torturer dramatizes his opposition to and distance from the prisoner are ways of dramatizing his distance from the body," she asserts. *The Body in Pain: The Making and Unmaking of the World* (New York: Oxford University Press, 1985), 57. All of Michel Foucault's work, in one way or another, engages this issue. For this study, I am particularly indebted to *Discipline and Punish: The Birth of the Prison*, trans. Alan Sheridan (New York: Vintage, 1979). In many ways, Scarry and Foucault extend Freud's thesis in *Civilization and Its Discontents* (1930) that civilization forces the renunciation of instinct and makes humans into prosthetic gods. *Standard Edition*, 21:59–145.

7 Since I am employing a male model of the gaze, I use the masculine pronoun.

8 Klaus Theweleit, *Male Fantasies*, vol. 1, *Women Floods Bodies History*, trans. Stephen Conway, and vol. 2, *Male Bodies: Psychoanalyzing the White Terror*, trans. Erica Carter and Chris Turner (Minneapolis: University of Minnesota Press, 1987, 1989).

9 I am indebted to Dudley Andrew for pointing out these possibilities to me.

10 At the conclusion of his book on the grotesque, Wolfgang Kayser arrives at what he terms "a final interpretation," which he presents capitalized: "AN ATTEMPT TO INVOKE AND SUBDUE THE DEMONIC ASPECTS OF THE WORLD." *The Grotesque in Art and Literature* (1957; reprint, New York: Columbia University Press, 1981), 188. In their statements on the grotesque as transgression, however, Peter Stallybrass and Allon White point out, "What starts as a *simple* repulsion or rejection of symbolic matter foreign to the self inaugurates a process of introjection and negation which is always *complex* in its effects. . . . The point is that the *exclusion* necessary to the formation of social identity . . . is simultaneously a *production* at the level of the Imaginary, and a production, what is more, of a complex hybrid fantasy emerging out of the very attempt to demarcate boundaries, to unite and purify the social collectivity." *The Politics and Poetics of Transgression* (Ithaca: Cornell University Press, 1986), 193.

11 E. D. Hirsch coins the term "intrinsic genre" in *Validity in Interpretation* (New Haven: Yale University Press, 1967), 78–89.

12 This threat of the inside overcoming the outside is certainly on some level a function of antipathy toward disease. In a cancer-conscious—and now AIDS-conscious—age, the enemy within preys on, before annihilating, its host body, as in the film *Alien*. See, especially, Susan Sontag's *Illness as Metaphor* (New York: Vintage, 1979) and *AIDS and Its Metaphors* (New York: Farrar, Straus and Giroux, 1988) for fuller discussions of this subject.

13 Gotthold Lessing regards painting as incapable of narration because its imitation is static rather than progressive. According to Lessing, attempts to express stories in pictorial imagery rather than language lead painting into "abandoning its proper sphere and degenerating" into allegorical forms. *Laocoön: An Essay upon the Limits of Poetry and Painting* (1766), trans. Ellen Frothingham (1873; reprint, New York: Farrar, Straus, Giroux, 1969), x. Several critics have questioned Lessing's categorical distinction. See, for example, Roland Barthes, "The Rhetoric of the Image," *Image—Music—Text*, trans. Stephen Heath (New York: Noonday, 1977), 38–39; Nelson Goodman, *Languages of Art: An Approach to a Theory of Symbols* (New York: Bobbs-Merrill, 1968); W. J. T. Mitchell, *Iconology: Image, Text, Ideology* (Chicago: University of Chicago Press, 1986); and Wendy Steiner, *Pictures of Romance: Form against Context in Painting and Literature* (Chicago: University of Chicago Press, 1988). Steiner examines the empowering of the perceiver through such narrative factors as multiplicity and repetition in departures from the Albertian model of the Renaissance, which posited perception as atemporal.

14 Whereas Jennifer Pap's excellent essay in this volume reads cubism's redefinition of ekphrasis as an abolition of narrative, I prefer to reassess the meaning of narrative in ways similar to J. Hillis Miller's reassessment of allegory as "the eternal disjunction between the inscribed sign and its material embodiment." "The Two Allegories," in *Allegory, Myth, and Symbol*, Harvard English Studies 9, ed. Morton Bloomfield (Cambridge: Harvard University Press, 1981), 365. See also Craig Owens, "The Allegorical Impulse: Toward a Theory of Postmodernism," *Beyond Recognition: Representation, Power, and Culture* (Berkeley: University of California Press, 1992), 52–69.

15 Sylvester, *The Brutality of Fact*, 23. Van Alphen also poses this argument about Bacon's use of narrative. He writes, "There is never a clear interaction *between* figures in Bacon's triptychs" and "In the context of Bacon's polemic with the Western tradition of iconic representation, it is the inevitable consequence of representation, the tearing apart of the body, the destructive effect of reproductive mimesis, which the crucifixion betokens." *Francis Bacon*, 29, 93.

16 Julia Kristeva, *Powers of Horror: An Essay on Abjection*, trans. Leon S. Roudiez (New York: Columbia University Press, 1982), 3–4.

17 I have in mind here Lacan's proposal of "*forclusion*" as the French equivalent for Freud's "*Verwerfung*." Unlike repressed signifiers, foreclosed signifiers are not integrated into the subject's unconscious. See J. Laplanche and J.-B. Pontalis, *The Language of Psycho-Analysis* (New York and London: Norton, 1973), 166–169.

18 Sylvester, *The Brutality of Fact*, 82.

19 Ades, "The Web of Images," 10. Similarly, Gilles Deleuze writes: "Bacon is a painter of heads, not faces, and there is a great difference between the two. For the face is a structured spatial

organization that conceals the head, whereas the head is dependent upon the body. . . . As a portrait painter, Bacon thus pursues a very peculiar goal: *to dismantle the face*, to rediscover the head or make it emerge from beneath the face." *Francis Bacon: The Logic of Sensation*, trans. Daniel Smith (New York: Portmanteau Press, 1992), 17. I am grateful to Antony Van Couvering for permitting me to see an advance copy of this text.

20 John Russell, *Francis Bacon*, (New York and Toronto: Oxford University Press, 1979), 100.

21 Fyodor Dostoevsky, *The Idiot*, trans. David Magarshack (New York: Viking Penguin, 1955), 236. See Kristeva's analysis of this painting in *Black Sun: Depression and Melancholia*, trans. Leon S. Roudiez, (New York: Columbia University Press, 1989), 105–138.

22 Bacon stated of his 1962 triptych:

I've always been very moved by pictures about slaughterhouses and meat, and to me they belong very much to the whole thing of the Crucifixion. There've been extraordinary photographs which have been done of animals just being taken up before they were slaughtered; and the smell of death. We don't know, of course, but it appears by these photographs that they're so aware of what is going to happen to them, they do everything to attempt to escape. I think these pictures were very much based on that kind of thing, which to me is very, very near this whole thing of the Crucifixion. I know, for religious people, for Christians, the Crucifixion has a totally different significance. But as a nonbeliever, it was just an act of man's behavior, a way of behavior to another. . . . Of course, we are meat, we are potential carcasses. If I go into a butcher shop I always think it's surprising that I wasn't there instead of the animal. (Sylvester, *The Brutality of Fact*, 23, 26)

23 Deleuze, *Francis Bacon*, 18.

24 When painting his triptychs, Bacon usually begins with the left panel and works across to the right. Hugh Davies and Sally Yard, *Francis Bacon* (New York: Abbeville Press, 1986), 105 n. 19.

25 Bacon's *Study for a Crouching Nude* (1952) and *Two Figures* (1953) show most dramatically the influence of Muybridge's *The Human Figure in Motion*.

26 Sylvester, *The Brutality of Fact*, 14.

27 Quoted in Russell, *Francis Bacon*, 129.

28 Sylvester, *The Brutality of Fact*, 48.

29 Russell, *Francis Bacon*, 199.

30 Van Alphen considers Bacon a "double," a modernist aesthetically focused on perception and a postmodernist who "philosophically continues to displace the locus of perception." *Francis Bacon*, 49.

31 Deleuze, *Francis Bacon*, 39–42.

32 Monique David-Menard, *Hysteria from Freud to Lacan: Body and Language in Psychoanalysis*, trans. Catherine Porter (Ithaca: Cornell University Press, 1989), 110–111.

33 *The Complete Letters of Sigmund Freud to Wilhelm Fliess 1887–1904,* ed. and trans. Jeffrey Mousaieff Masson (Cambridge: Harvard University Press, 1985), 280. letter of November 14, 1897. In "Analytic of the Sublime," Kant writes, "There is only one kind of ugliness which cannot be represented in accordance with nature without destroying all aesthetic satisfaction, and consequently artificial beauty, viz., that which excites disgust. For in this singular sensation which rests on mere imagination, the object is represented as if it were obtruding itself for our enjoyment, while we strive against it with all our might." Immanuel Kant, *The Critique of Judgment* (1790), trans. J. H. Bernard (New York: Hafner, 1966), 155.

34 Deleuze asserts a circular rather than linear organization in the triptychs. *Francis Bacon*, 55.

Vision and after

Yet the cinema has a power which at first glance the Photograph does not have: the screen (as Bazin has remarked) is not a frame but a hideout; the man or woman who emerges from it continues living: a "blind field" constantly doubles our partial vision.

ROLAND BARTHES, *Camera Lucida: Reflections on Photography*

III

Interpretation
Photography

Introduction

DUDLEY ANDREW

Primers and surveys of film generally open their accounts with 1895. Naturally they list technological developments in the nineteenth century as part of the immediate prehistory of the medium, but the birth of cinema proper has been accorded the respect of the birth of Christ. This is year one of the New Testament.

Such an obvious and convenient chronology, however, is set up to be demolished by all sophisticated film scholars who examine the origins of the medium that concerns them. Some have held that the projection at the Grand Café represented just another in a whole series of similar entertainments before and after 1895, while others claim that the Lumière brothers merely gave shape to an idea that had been around a very long time, an idea that had taken other shapes and forms at other times and places.

The most influential thesis aimed at re-situating the birth of cinema was spawned in the early 1970s, under the tutelage of Pierre Francastel and Louis Althusser. Cinema was said to emanate quite directly from the cultural break of the European Renaissance. Specifically, the reshaping of the horizon of experience around the individual rather than around God—an effect of budding capitalism first felt in Florence, so the argument goes—produced, almost of necessity, the perspective system of representation. Ships' captains and pilots, plying the seas for discovery and barter, needed a reliable, mechanical system to map their course, a system that would spread out the world from their vantage point. Lenses were fashioned and single-point perspective was perfected to achieve just this. The results for designers and painters were astounding. And, given that the economic system of capitalism and the ideology supporting it have grown steadily stronger with the centuries, the cinema can only be a product of those systems. Its lenses Leonardo could have designed; they are there to "project" a world of "views" that are the property of the filmmaker who captures them and, in a deflected sense, of the spectator positioned to "grasp" them. The camera obscura, whose lens admitted a portion of the world into a cabin where the spectator might admire or trace it, seems a

direct forerunner of the film theater. And photography, relying on those same lenses, was thought of as an intrepid explorer, providing access across all the seas to unlimited visible experience, always from a human perspective of course.

I repeat these squibs of theories by Bazin, Baudry, and others as a reminder of the historical turn in film studies since the 1970s. The essays in this final section of *The Image in Dispute* participate in such a turn by refusing not just the transparent tale of the standard chronologies but also the appealingly clever theses that get beneath (materialism) or above (idealism) the facts of the matter. The origin of cinema, and of a culture for which cinema would become crucial, seems too complex to be accounted for by an idea or even by a science. This origin spreads out across a host of factors that Jacques Aumont and James Lastra contribute to enumerating.

Aumont searches for signs of a change in a climate necessary to the spawning of cinema, and he finds a wonderfully telltale one in the late eighteenth century when the *ébauche* (the preliminary study made by a painter) gives way to something quite different, the *étude*, or study after nature. As an identifiable and viable artistic product, the *étude* found acceptance by an artistic coterie and a supportive public, indicating the arrival of a style of seeing and of valuing the visible that photography would shortly satisfy. Scenes "caught on the run" or drawn from several angles testify to the ephemerality of light itself and dissolve a hierarchy of objects and events into singular moments viewed from singular perspectives—precisely the attributes photography and later cinema would exploit.

Sketches of this sort began to be sold even while the salons continued to exhibit solid, sun-drenched overviews of historical, religious, and mythological topoi where every object and event took its predestined place. In short, the battle over the proper subject and style of painting (a battle conventionally retold as the struggle first for a new realism and then for impressionism) ought to be seen as part of a revolutionary war involving all levels and countless practices of culture. Michel Foucault has tempted many of us to scan this epoch looking for traces of a fundamental change in human perception and understanding. Just consider the impact of Jonathan Crary's *Techniques of the Observer*, which identifies an immense epistemological shift on the basis of the replacement of the camera obscura by the stereopticon as the appropriate metaphor for vision.

The four contributions to this section likewise track the gestation of the modern age in the technologies of representation which that age uses; at the same time, they address what might be called their "semiotic consequences." Robert Ray's essay directly engages this issue, finding in the structure of the viewer's experience with

the photograph a relation to meaning utterly opposed to the classical conception. The very form of the photograph, he argues, calls for the aleatory, private eruption of sense that Roland Barthes would eventually dub "the third meaning." Rather than consider haphazard and tangential coincidences of sense to be supplementary to the ordered, public significance that images have always been thought to possess, Ray, following Barthes, puts the private first, declaring that photography has unleashed the haphazard, which in turn has liberated the viewer and the critic.

James Lastra finds some historical basis for this direction of thought when he sets Michelangelo's classical notion of meaning against the Dutch descriptive image that the Florentine master found inefficient, incoherent, and ultimately incomprehensible. Dutch painting may be the first cultural use of images in which sense perception runs ahead of the demands of language and thought. The Dutch taste for an excess of the visible may be the necessary cultural precondition for an interest in the sketch, hence in photography and cinema. Certainly most uses of images have always been—and will remain— rhetorical, following classical notions of readability, balance, hierarchy of elements, and so on; but the new media of automatically produced images has tempted artists and viewers to risk giving over the critical faculties to the interplay of a plethora of visual details and a private repertoire of visual experience. The modern age would value ingenuity more than accuracy in the processing of images, and Roland Barthes would become our most characteristic, because most unpredictable, citizen. A consummate reader, a man of literature, he would nevertheless help usher in an era of interpretation dispensing with language and open to the simultaneous stimuli of images. This, according to Ray, is the era of photography.

Of course, photography hardly marks the end of great shifts in the technologies of representation. Timothy Corrigan's essay stands as our conclusion because he addresses the "videosphere" head on. He seconds Régis Debray's recent opposition of video to film and of video culture—the videosphere—to the lingering photographic culture that has dominated this century. Where cinema effectively makes a record of the past that we can pore over, video is an "emergent action" in an "emergency geography," Corrigan asserts. One cannot read video as one does a photograph, for video refuses to be graphed, signaling body and energy but inconsistent knowledge. Consequently, the public sphere that video is in the process of forming would seem to be fundamentally destabilized.

Corrigan dramatizes the intersection of opposing image cultures by locating narratives that incorporate incommensurate technologies. One can find photogra-

phy serving the novel, the novel englobed by theater, plays turned into movies, and so forth. Cinema, in our era, has served as the omnivorous home for narratives of incorporation: photographs and home movies set within standard films, for example, actually disrupt the temporality of the experience. But until the arrival of video, this tension ultimately served the film experience, enlarging its domain in the process. Video, however, derails every movie that tries to assimilate it.

Standing at the threshold of a new image era, this anthology does so by reviewing the era we have just traversed, the era usually labeled modernist and the era for which the photograph and the cinema are the most characteristic types of representation. Even when Corrigan points to the arrival of a corrosively new type of image, he does so from within the filmed narrative, reminding us that the cinema remains reliable and not yet out of date as a place to entertain our culture's most troubling disputes, including the dispute over the cinema itself.

The Variable Eye, or the Mobilization of the Gaze

JACQUES AUMONT

TRANSLATED BY CHARLES O'BRIEN AND SALLY SHAFTO

Nothing about the cinema, neither its invention nor any of the detours of its history, has descended from the heavens, as our historicist age continues to discover. Twenty-five years after Jean-Louis Comolli's influential articles berating linear and idealist history in favor of a "materialist" history,[1] a genuine film history, although still in the early stages of archival exploration, has begun to establish new foundations.[2]

Whatever progress will be made in the historical study of film—and much can be expected in the near future, given the precedent set by the work of David Bordwell, Kristin Thompson, and Jean-Louis Leutrat—it remains difficult to speak in historical terms of the cinema as an art of representation—that is, in relation to the other neighboring arts. There are of course minimal demands easily satisfied. No one any longer employs hyphenated formulations suggesting a unilinear filiation such as "painting-photography-cinema"; fortunately neither does anyone still invoke the mediocre notion of "pre-cinema," which justifies the discovery of "cinematographic" procedures in Homer, the Bayeux tapestry, and Shakespeare. Less easy to overcome, however, has been the sense of what Comolli calls *différance*, a slowness or delay in the cinema's invention, even for those who feel strongly—with due respect to the "materialist" project—that the cinema was invented neither too early nor too late but right on time. Believing otherwise only encourages idle speculation on what did not occur. What I am proposing in this essay is clearly neither a history nor a survey of the cinema's invention, but rather an inscription within history of its invention and attendant circumstances—that is, the identification of what in my view are the enabling conditions of its enigmatic *différance*.

The history of the invention of photography is believed to be even stranger than that of the cinema, its delay being even more flagrant. Although the reaction of light on certain substances was known in ancient Egypt, its possibilities came to be exploited only thirty or forty centuries later. Thus the condition of possibility (I'm

not speaking about cause) for the invention of photography lies in the desire of a society, already engaged in producing images, for a new kind of image altogether different from their Egyptian avatars. Such was the case of painting at the beginning of the nineteenth century, and indeed the most direct determinants of photography's invention are evident in certain major ideological changes that affected painting around 1800. The crux of these changes may be dated to the period between 1780 and 1820, when a veritable revolution occurred in the status of the nature sketch: the *ébauche*, an attempt to register a reality predetermined by the project of a future painting, gave way to the *étude*, an attempt to register reality "just as it is" and for no other reason. By the beginning of the nineteenth century, the *étude* had become a recognized genre, and though disparaged within the Academy, it nevertheless penetrated the vocabulary of painters until it gradually became accepted by certain amateurs by the century's end, when its function was subsumed by other media. Despite being realized on location, the essential trait of the *étude* is not exactitude, for this had already been achieved by devices such as Canaletto's *camera ottica*, a photographic apparatus *avant la lettre* without film but with a reflex lens. The pertinent and novel characteristic of this new type of sketch is rather its rapid execution. Never to be retouched, the *étude* remains a work destined to capture a first impression that it fixes in a record of artistic directness. Canaletto, on the other hand, had used his apparatus to obtain an *ébauche* of a scenographic space, later to be recopied, amplified, and, most importantly, populated with human figures. Devoting a decisive article to this question, Peter Galassi observes the active mobility of the visual pyramid that founded the development of the *étude*: at issue is a conception of the world as an interrupted field of potential tableaux, scanned by the gaze of the artist who, exploring as he travels through the world, will suddenly stop in order to cut it up and "frame" it. For Galassi only a short step is required to recognize in the *étude* the key to the appearance of a photographic ideology of representation: the photographic apparatus as incarnation of this mobility finally discovered.[3]

To this thesis I wish to add but two remarks. The first regards the spectator of painting. In the history of painting, fragmentary as it is, spectatorship is conceived as a taking of an uninterrupted distance and the mobilization of vision; within that history, a critical shift occurs when a *trompe l'oeil* style of painting, particularly in evidence in the eighteenth century and functioning as a denial of the spectator's presence, gives way to a kind of painting that expressly assumes the spectator's gaze. What is important about such a transition is that the spectator of the nature *étude*

at least has the right and ability immediately to transfer the vision of the natural world that painting had intended to teach. This aspect of immediacy must be insisted upon because it alone signals the novelty of the *étude*. With the emergence of a concept of the picturesque in the sixteenth century, a transfer between viewer and painting became possible. But as Gombrich has clearly demonstrated, such a reversal profits only those bits of nature with a potentially pictorial aspect, those "natural beauties" whose discovery was conditioned by their capacity to be assimilated to the prevailing pictorial schemata. In contrast, the countryside seized by the eye of the painter of *études*, and then by that of the photographer, remains practically by definition a random piece of nature, since its pictoriality may be found anywhere.

Here we come to my second point: what has changed correlatively is the status of nature. It is true that nature is abundantly present in Renaissance and Neoclassical painting, but it is a nature that has been organized, arranged, and prepared with a purpose to express. Bluntly put, a text always underlies such a nature, and such a text, notwithstanding its origins, is always more or less near, more or less explicit, foregrounding all interpretations, providing a key to the true meaning. Frequently, the anterior text is scientific, as in the work of the Quattrocento and Cinquecento artists who, while depicting mountains, were careful to take into account the actual formations before them; the text could also derive from a cultural tradition—such as, notably, the Vitruvian triad of tragic, comic, and satirical decors; or the text could be clearly symbolic, indeed ultimately allegorical, according to the principle of "disguised symbolism" that Panofsky describes with regard to Flemish painting.[4] By 1800 this tradition was still far from finished, as is strikingly evident in the case of Caspar David Friedrich, whose landscapes nearly always convey a signified of a spiritual nature, more or less articulated in the paintings. Shortly thereafter, in the early nineteenth-century, landscape painting and later photography broke with this tradition, and nature becomes intrinsically interesting even though, or perhaps because, it says nothing.

This point strikes me as paramount. The genuine revolution represented by the adoption in Western painting of linear perspective has been much emphasized, and not without justification. There exists today, at least in the French literature on the question, a well-established tendency to link together perspective, humanism (to which was added around 1970 the phrase "bourgeois ideology"), and the Renaissance. But the upheaval represented by a change in the status of nature is equally important. Perspectival or not, the Albertian "window open onto the world" nonetheless opens onto a highly legible world, and painting continues to

deliver signifieds, to read nature as a book, and to discover in it symbols, human as well as divine. At the turn of the nineteenth century nature begins to exist independently of any anterior *text*, and this shift signifies a concomitant one in the entire function of the gaze.[5]

Consider the very function of the gaze with respect to the clouds and rainbows, the grottoes, ravines, and underbrush, featured around 1800 in so many paintings: the goal of rendering the natural world scrupulously as a theater of natural phenomena necessitates both an acuity of the gaze as well as an appetite for investigation and discovery. We must learn to see nature "just as it is." At issue is not some kind of objective truth: what after all could be more unreal than the rainbows of Constable or the clouds of Dahl or Delacroix, to say nothing of Turner?[6] What matters in this effort to seize a fleeting moment and, at the same time, to understand it as fugitive and aleatory—thus avoiding the paradigm of the "pregnant instant"—is the emergence of a new mode of vision, of a new confidence in seeing as an instrument of knowledge, even of science. This theme of learning by seeing and learning how to see corresponds to Gombrich proposing the "discovery of the visual world by artistic means," of a similarity between seeing and understanding.[7] This theme of the acquisition of knowledge through appearances belongs to the nineteenth century in general, and it belongs to the cinema as well.

"Feverish for reality," as Galassi says? Perhaps. But especially delirious for vision, thirsty for visible appearances and pure phenomena. This ideal mobility of the gaze will reappear in phenomenology, which theorizes the eye as moving in the visible world; more broadly, Merleau-Ponty maintains that a characteristic of the human body is to be simultaneously visible and seeing, plunged into a world endlessly available to vision.[8] Merleau-Ponty's notion will reverberate in the writings of André Bazin, who makes of the cinema's mobile and eminently variable eye the nearest equivalent of the gaze.

"Visible and seeing"—thus the man of phenomenology is by the same token the man of the cinema. It is not incidental that Béla Balázs used the phrase "visible man" as the title of one of the most beautiful books ever written on the cinema,[9] and the concept of the "all-seeing" man continues to haunt film theory, particularly in the work of Christian Metz, who coined this phrase. Taken from either end, whether object or subject, cinema aims to study the exact measure of man and his vision. Here the history of the cinema secretly catches up with the history of paint-

ing that I have just sketched, and it is in this context that I now wish to link two other fragments from the history of the variable eye. While both are outside of art or on its periphery, they are nonetheless related to vision and representation.

First fragment: the railroad. The changes that the railroad wrought not only in our perception of geography but also, and more profoundly, in our conceptions of space and time are well known. Just as it opened vast new spaces, the railroad likewise implied a new sense of time, nowhere more evident than in the standardization of the temporal calibrations measuring its operations. This new spatiotemporality involved not only the physical destruction of traditional spatiotemporality but also the replacement of an older morality, linked to nature with new values, such as the desire for acceleration or the wish to sever roots. The destruction perpetrated by the railroad was regarded as an ambivalent one, for at the beginning of the nineteenth century the railroad was often seen as a sort of technological guarantor of progress and of harmony between nations.[10]

The railroad, or rather the mobile machines associated with it—the passenger car and the locomotive—certainly shaped the popular imagination, and the camera, in certain respects, is not so different from the locomotive: both are metallic machines, typical products of the engineering imaginary of the time, and both transform a previously circular and spatially anchored movement into one that is circular and lengthwise. Moreover, both involve the transformation of a circular movement into a longitudinal one, of a spatially anchored movement into one of displacement.[11]

But the essential point here is that the train becomes the prototypical place where the mass spectator, the immobile traveler, appears during the middle of the nineteenth century. Seated, passive, transported, the rail passenger quickly learns to view the traversed countryside, the framed spectacle moving past. The experience of the first train journeys was sufficiently fresh when the cinema appeared that descriptions of the spectatorial experience in Hugo Münsterberg's famous book of 1916 unmistakably evoke the testimonies of nineteenth-century travelers.[12] That similarity, often commented upon, runs deep: the train and the cinema both transport the subject toward a fictional realm, toward the imaginary, toward the oneiric, where inhibitions are relaxed, at least in part. Freud and Benjamin concur that the subject of both the cinema and the railroad is a "mass subject," victimized by the anonymous and collective condition of being a spectator. Moreover, this subject lives on the edge, exposed as he is to the emotional shocks that the cinema delivers

as well as to the diverse jolts produced by the train.[13] This is a neurotic subject or one ready to become so—which is to say, modern. And the cinema, recognizing this fact, will gratefully make the locomotive its first star.

A mobile eye in an immobile body; these are the key elements that allow the train to substitute for the ecological spectator of landscape painting, the simple stroller discovering the surrounding world, a bizarre creature, handicapped—so much so that he will be compared to the slaves chained in Plato's cave—but at the same time gifted with the omnipresence as well as the omnivoyance also characteristic of the cinematic spectator.

There is an even lower common denominator linking the gaze of the "traveling" painter to that of the rail voyager: both have the capacity to bear a mobile and organized gaze upon the world. A characteristic paradigm emerges—that of the panorama, my second fragment.[14]

Only vestiges remain of what was one of the most popular nineteenth-century spectacles in Paris, Berlin, London, and Vienna, but it is worth recalling that until just before the turn of the century, in fact right up until the Great War, large crowds visited panoramas. Sheltered within gigantic buildings and constructed at great cost, these immense paintings required months of craftsmanship, sometimes years, and publicity rivaling that of any film superproduction.

Even a quick survey of the subjects of the panoramas painted between 1787— the year in which the Englishman Robert Barker filed his patent—and 1914 proves enlightening. Circular views of cities or the countryside were popular, and the banks of the sea enjoyed a special favor;[15] also important were complex fictional scenes, battles, and crucifixions.[16] Presenting static but nonetheless compelling images of nature's masterpieces, great historical events, and instances of contemporary patriotism, these panoramas could be easily analyzed thematically, which would involve simply enumerating the most common of nineteenth-century themes.

But the true importance of the panorama is to be found in the history of its apparatus.[17] The word itself derives from two Greek roots which together signify omnivoyance, a gaze embracing a vast region. This feature is essential to the panorama in all its variations and, notwithstanding the confusion of the etymology of the suffix "-rama," expresses a rather pretentious gigantism. Balzac had already scoffed at this hyperbolic particle in 1835 in *Le Père Goriot*. Within the general project, two principal approaches to the panorama have coexisted peacefully, insofar as they ignored each other. On the one hand, there was the European-style panorama,

consisting of a circular image contemplated from a small central platform; on the other hand, there was the American panorama, in which flat images unfold before a spectator.

This second type, indigenous to the Unites States—although timidly adapted in London and Berlin—is the one that demonstrates the most striking kinship with the railroad and the cinema. In a very important subgenre of this "moving panorama,"[18] the spectator is offered a trip down the Mississippi or into the Grand Canyon, and inevitably a vast picture—one exhibitor advertised a length of three miles!—slowly unfolds in front of an audience that imagines itself at the side of a boat or at the window of a train. To heighten the illusion, the image is occasionally framed with a decor evoking the interior of a railroad car. Here the situation so nearly approximates the cinema that there is no need to insist upon the similarity: a large-size moving image, an immobile spectator, and a spectacle of set duration, often quite long, reportedly lasting several hours in some cases. The early cinema needed only to adopt the idea as it already existed by installing cameras on authentic rail cars, as in the pre-1910 genre, the "railroad movie," also typically American. Here space is infinite, or so expansive that it might as well be. Such space, inexhaustible and unmasterable, exists only as a vast expanse.

The European panorama, on the other hand, is entirely different. Although small, its central platform nevertheless allows the spectator room to move and to shift his gaze. It thus reproduces two major experiences recounted in all of the travel narratives of the late eighteenth century: that of the horizon and that of the vanishing point. The beginning of mountaineering, the taste—ephemeral but ardent—for the ascension of bell towers, and the appearance of an entire vocabulary concerning seizures and vertigo all indicate the birth around 1800 of a new creature: the mountain climber. This climber experiences a panoramic view—also available in the travel guides and maps used by the tourist, a distant cousin—symptomatic of a mastery and exaltation that is precisely what the circular panorama desires to induce. At the same time, however, the spectator is also paradoxically enclosed and imprisoned: while his gaze embraces the entire space, the space itself is finite, obstructed, limited. Thus the panorama opens horizons, though the word "horizon" carries within its etymological origin—coming from the Greek *horizein* for "to limit"—a sense of limitation. Has it not been claimed, in a perhaps apocryphal anecdote, that the panorama was invented in a prison? And has not Bentham's famous panopticon been reproached for endowing a privileged spectator—a monarch or a bureaucrat—with omnivoyance?[19]

The panorama's spectator, as has been noted, is immobile. And if this spectator's omnivoyance is inscribed within the apparatus, it is in a paradoxical fashion: in the American mobile panorama, the gaze is dispossessed of space through an incessant movement; the panorama is even more menacing, since to replace a point of flight by a circular horizon is to deny the spectator the elementary liberty that the perspectival plane had conceded, the liberty of changing place, of not adopting the "preferred" point of view. The European circular panorama, on the other hand, incessantly nourishes the gaze, while also thoroughly enclosing it, thus actualizing the potential menace of perspective to its infinite vastness. Consider here a German garden of the early eighteenth century whose false landscape, painted behind a clearing in the vegetation, was entitled, *The End of the World*.

Thus the origins of the panorama, as Stephan Oettermann has rightly observed, lie in the Baroque *trompe l'oeil*, an apparatus that likewise encloses one's view and that—with a perspective traced for a single eye, that of the sovereign—realized to perfection the paradox of a gaze that is both master and slave.

Technically, the panorama pertains to painting. Extant documentation reveals that a single view required a veritable army of painters. In all its manifestations the panorama—a realist genre pitiless and exacting in its attention to detail—required a complete science of reality effects, a knowledge concerning the rendering of light, reflections, skin tones, and gestures.

At the same time, the panorama by virtue of its apparatus—if we leave aside for a moment its capacity for movement—partakes of theater spectacle and approaches the cinema. The overwhelming immensity of the panorama causes the viewer to lose a sense of his distance from the image, a loss ensured by the apparatus itself—always involved in a zone in relief, a "false terrain," yet another *trompe l'oeil* between the spectator and the painted surface. The viewing occurs over a long time—in any case, in and with time—whether narrative (as in the battles of the war of 1870) or descriptive (as in the urban and pastoral views already mentioned). And the image beyond the touch of the viewer becomes a nearly perfect snare for the gaze. If the cinema is above all an invention of spectacle, then the panorama is without doubt one of its most direct ancestors. Their consanguinity is reinforced in those traveling attractions of the early twentieth century, where the cinematograph coexisted with small, portable panoramas. Is it sheer coincidence that in 1900 Lumière wanted to construct a circular cinematograph?

Produced in the manner of a painting, the panorama was destined to be seen

like a movie. Paradoxically, however, a problem arises in the panorama's relation to contemporaneous painting, or, more precisely, history painting. The panorama suggests—even displays—two recurring, nearly permanent characteristics of this genre.

The first of these is a taste for grandeur, evident both in the scale of the images as well as in the choice of subject matter. While the themes of the panoramas are not identical to those given in the *concours* of the Prix de Rome, which are usually inspired by mythological sources, the panorama's devotion to "important" subjects characterizes the entire period, as revealed in the work not only of the academicians but also of Delacroix and Ingres.[20] This love of grandeur is also the love of quantity and detail; a sense of detail, as has been noted, is traditional in the bourgeois aesthetic. Here we return to the concept of absolute fidelity, a characteristic not valued, we recall, by the *étude* and particularly manifest in the nineteenth-century notion of systematic reconstruction, which developed out of the archaeological concerns of the previous century.[21]

The second characteristic of nineteenth-century painting is perhaps even more important and pronounced: the tendency to elevate and overemphasize the gaze to star status. From the end of the eighteenth century and up to and even beyond impressionism, many paintings imitated a typically solitary and all-powerful but also desperately limited gaze. Once again Friedrich comes to mind in his depictions of travelers who, like the painting's viewer, stare out as if transfixed upon a spectacle, desirable yet inaccessible, of a nature at last discovered.

I would like to highlight this second characteristic, for it involves a profound transformation, almost an overturning, of the traditional *étude* as previously discussed. Deriving possibly from the eighteenth-century *fête champêtre*, Friedrich's landscapes and the coeval nature studies nevertheless deviate in a significant way from this earlier genre.[22] In the oeuvre of Claude-Joseph Vernet, for example, the *fête champêtre* is an idyll, an eclogue, in short, a poem, and has little to do with nature. Most importantly, its spectator is elicited only in an indirect, mediated mode of a reading: he engages with the image little by little, and always at the price of intellectual labor (something that easily becomes the subject matter of a short narrative, as in Diderot's *Salons*). But by the early nineteenth century a shift has occurred, displacing the center of gravity from the object or scene depicted to the gaze upon them, and then ultimately to the bearer of the gaze, the spectator, who is occasionally doubled within the painting. Likewise, any textual mediation disappears: the painting now offers at the very least an invitation to complicity and much

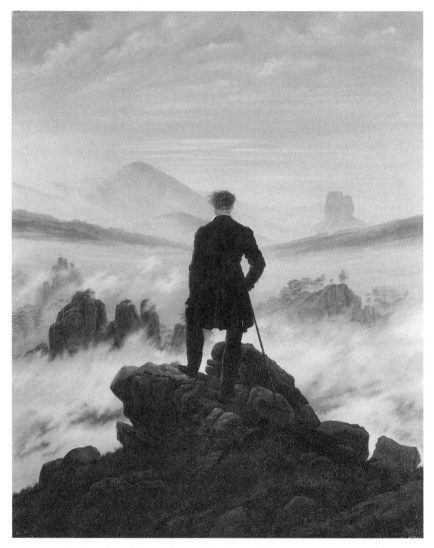

40 *The Traveller over the Sea of Mist* (1818) by Casper David Friedrich. Oil on canvas, 98.4 cm × 74.8 cm. Courtesy Hamburger Kunsthalle.

more—a revelation, dazzlement, communion. Summoned, interrogated under a variety of guises and means—including those of framing and mise-en-scène—the spectator is at last recognized as a gazing subject.

What then is cinema's relation, not precisely to the singular configurations just described, but to their common ideological denominator?

This question first belongs to the apparatus, and to the preeminence that it accords the gaze, but it concerns as well the very existence of such an apparatus. The term was originally proposed in the 1970s to expose the manner in which a film's material presentation and especially its circumstances of projection imply a broad ideological and fantastical project—one, in any event, dependent on the category of the subject that, in turn, the apparatus helps to support. A rough-hewn notion, it nevertheless reminds us of the great theoretical trailblazing of the past quarter century. Still, even leaving aside the excessive reactions that the word "ideology" can now provoke, the theory of the apparatus suffers from a major and, without doubt, a crucial vice: a lack of historical specificity.

What is called "the cinema" has in fact entailed throughout its history many different modes in the material presentation of the film to a spectator. It was inevitable that a concept of the apparatus aiming to encompass all of these modes ultimately had to be confronted with such a diversity. It is difficult to imagine a theoretical model other than the one where the spectator—captive and immobilized in his armchair—is also captured by the film, fastened to the screen in a play of seduction and identification. But this model, although popular, is hardly hegemonic. Excluding the case of the television spectator, there are—or have been—many contexts in which the spectator was neither captive nor captivated. Some obvious examples include the "nickelodeon," in which only the first rows were equipped with seats while the rear of the theater was a joyous clutter; movie theaters in the Middle East; the neighborhood cinemas of prewar Paris, unforgettably described in Raymond Queneau's *Loin de Rueil*[23]; the "drive-in," where the spectator, despite being hemmed in, does not lose consciousness of his body; and, finally, classroom screenings. One could say the same of the projector's position "behind the spectator," of the hall's supposed darkness, which was often far from being as dark as has been assumed, or, indeed, of the very existence of a hall at all. These circumstances, insofar as they are actually relevant, are perfectly contingent, and it is quite evident that the apparatus theory relies on them only for their demonstrative and signifying value. This explains why some circumstances are retained—immobility, obscurity, the projector in the back of the room, and the enclosed space of the theater—while others are forgotten, and why, once again, the notion of the apparatus should be recognized for just what it is: a theoretical model.

Rather than mount a formal attack on the notion of the apparatus, I would like to link it to my main object of study: the avatars of the gaze and its mobility during the period of the cinema's emergence. Here a brief parallel with painting is perhaps useful. It is remarkable that when painting began to be presented in the

form of detachable panels hung on walls, it was seen—despite the undeniable importance of phenomena like the private collection or the museum, and variations internal to museography in material conditions far more stable than those of the cinema. Then, too, spectators have changed enormously in their social identity and aesthetic attitude; still, a painting is typically seen with a certain freedom of posture, at a medium distance, under neither especially strong nor weak light, and with a generous temporal allowance in which the beholder may contemplate the painting or move to see it differently.

In other words, the type of pictorial representation that is most enabled by an apparatus of stable presentation would have to be painting and not the cinema. Nevertheless, it was the cinema, and not painting, which encouraged reflection on the concept of a single, generic apparatus; this paradox is significant. I spoke at the outset of this essay of a perceived delay in the invention of the cinema. Likewise, it is possible to speak of a delay in painting with regard to its self-awareness of the presentation of the apparatus, and there are numerous historical explanations for this particular delay, if it is one, which may be gleaned from a study of the pictorial apparatus. Only recently have art historians become interested in the effective conditions—material and otherwise—in which paintings were viewed.[24] How are we to explain that the cinema, and not painting, abetted such research? Perhaps for the single but all-important reason that the presentation of films is especially striking and significant.

How can a film's presentation and that of a painting be pertinently compared? Comparisons occur on essentially two levels, each leading to opposing conclusions. Leaving aside those special cases from paintings in relief to the first attempts at a holographic cinema, I begin first with the presentation of flat images in both media: painting and cinema participate in a "spectatorial geometry"—that is, not only the literally geometrical problems of the respective positions of the eye and image (up to and including cases, which have received much theoretical study, in which the viewer is too close, too distant, or too aslant), but also the more profoundly and sometimes conflicting perceptual phenomena resulting from the "double reality" of images. What matters for the moment is that, on the "geometric" level, gazing upon a painting or a film amounts to nearly the same thing, almost to the letter.

What is striking about the cinematographic apparatus and what distinguishes it from the hypothetical pictorial apparatus and has provoked critical scrutiny is precisely that aspect not deriving from geometry: namely, its lighting. In actual pre-

sentation situations, conditions are rarely uniform. Thus there exist rather dimly lit museums as well as film theaters that are not particularly dark, whether intentionally or not; researchers, moreover, take real pleasure in those innumerable limit cases where, for example, the unfortunate spectator, the wool pulled over his eyes, cannot distinguish between a brightly lit painting and a slide projection. But outside such indistinct locations and diverting examples, normal circumstances always permit an unambiguous distinction to be drawn between the film's projected light and the painting's pigment-covered surface. And here an entire progression of important observations basic to film theory throughout its existence becomes relevant: the film is a projected bundle of rays, an illumination, appearing wholly and instantaneously on the screen. If the dark room and immobile spectator have been retained as an absolute and universal model of cinematographic projection, it is primarily because such a model includes, in abridged form, this ensemble of striking traits.

But what matters even more about such a model is that it is founded on the perceptual reality of light, whose metaphorical possibilities it so completely exploits. The projector, camera, and eye are understood often too hastily as somehow mixed up together, but this is because such a mixture corresponds to ordinary understanding and because it is very difficult (I will not be the one to say otherwise) to dissociate the image of the ray piercing the night like a beacon from the idea of a gaze projected onto the world. In my view, the cinematic apparatus consists, above all, in a singularly meaningful trait: its ability to suck the gaze into the screen. At issue is not just the gaze among other lures—the narrative's role in the imaginary solicitation of the spectator is well known—but first and always the gaze. There is no need to insist upon this point, since the ravishment of the gaze is basic to "classical" ideas on the apparatus. I would like instead to emphasize, in a manner modified somewhat in relation to the orthodox account, that the cinema in its ensemble and beyond the concrete differences obtaining at any given moment is primarily a generic apparatus through which the gaze operates in a manner that is *durable*, working across a time span that may or may not be continuous, and therefore *variable*, working inside time, and ultimately *isolatable*. These three adjectives and the conditions to which they refer, together and separately, constitute the very definition of this "eye," the invention of which in the nineteenth century was modeled, as we have seen, on machines and spectacles that implied the same ubiquity and mobility, and they support my claim that film presentations occur in conditions more significant than those of paintings.

Fundamentally, I am saying nothing but this: the "all-seeing" subject, which has long been recognized as the cinema's subject, is a historically dated subject, arising in the period of modernity—and thus is in the process of disappearing, need we add. In other words, this spectator's omnivoyance is anything but neutral or a matter of pure "technique": it is accompanied by an accumulation of more or less distinct values and meanings associated with the variable eye, mobile and sovereign since the dawn of modernity.

I spoke a little while ago of the painter Friedrich and would like here to cite a certain "letter" from his friend Carl Gustav Carus, also a painter, sent supposedly to comment upon the famous *The Traveller over the Sea of Mist* (1818).[25] In the letter Carus discusses the mental repose experienced by the voyager while contemplating the world from the summit, the evaporation of the voyager's ego into an endless space, and in fact the dissolution of this ego in a supreme totality associated with divinity. There are other texts in which an absolutely and perfectly panoramic view is attributed to an essentially cynical and diabolical power, as in *Faust* and its offspring—like Bulgakov's admirable *The Master and Margarita*.[26] But in either case the same theme is found: that of a totally and magically immediate visual communication with the world. Furthermore, with the development of rapid transit, the eye will be imagined as an organ destined to "swallow" landscapes at the same speed with which the new transportation vehicles swallow kilometers and minutes. This theme of ocular digestion—which has lately turned into indigestion—is another contribution of the constellation of the variable eye, acquiring a nearly mythic status.

These themes—the magical loss of self in a gaze, the gift of a world in its immediacy, the bulimic capacity to see everything—are the very themes whose echo, more or less muffled, remain perceptible in the cinema, especially, of course, in the earliest cinema. Regardless of whether their pictorial destiny assumed other appearances, one thing is certain: these themes, much more than mere surface appearance would indicate, are the driving force of a visual modernity where cinema and painting converge.

My aim so far has been to establish the "mythological" inscription of the cinematic apparatus within the mobilized gaze, an inscription that designates the consubstantiality of the apparatus with the birth of modernity. But I also wish to mark the traces, the actual occurrence, of the variable eye within the domain of the *filmic*.

Consider, if you will, an idea that has the allure of the obvious: if the gaze is

mobilized, then it ought to transform itself—indeed, it effectively has transformed itself—into the behavior of that substitute for the eye which the camera immediately became. It was Vertov who thematized and popularized the camera-eye relation, but the idea nevertheless preexists in the concept of the camera-eye relation. The notion of the camera's mobility, while derivative at first—as in those instances in which the tripod was mounted onto a gondola, a train, or a chariot—very quickly evolved, becoming supple and subject to appropriation; Pastrone's famous *carello* was never just a chariot but a vehicle already adapted to its function as a bearer of the camera, the eye, making the superb camera movements in *Cabiria* (1914) already perfectly functional, particularly in their endless depth of field.[27]

Of course, the cinema contributes a strict definition "in time" of such mobility. The landscape painter represented only moments and fragments; the panorama and various cycloramas involved a more or less erratic, moderately constrained mobility, in which the trajectories of the gaze were limited, anticipated, and often carefully marked out. The cinema posed anew questions concerning spectatorship. What happens during a viewing? What is the relation between the time of looking and the time of the representation, between the time of the looking and the space of the representation? And in the asking, a new problem emerges: that of the rationalization, or, if you will, the management of a prolonged gaze. The cinema was born—and this is no small matter—as a machine to produce images, views that were continuous, unbroken, lengthy. From the outset filmic time was given as a time to which one submits and simultaneously as an acknowledged, identified time: unable to escape the time of projection, we nevertheless accept this time, recognize it as our own, and experience it as such.[28] This is the meaning of Jean-Louis Schefer's famous description of the cinema as "the only experience in which time is given to me as a perception."[29]

Great filmmakers have all been quite conscious of this essential fact. Consider, first, uses of the sequence shot, which are stylistically and aesthetically the most visible examples. When one thinks of such virtuosity, Renoir comes immediately to mind; everyone remembers the breathtaking opening shots of *La Règle du jeu* (1939) or their counterparts in a minor film like *Chotard et cie.* (1933)—shots that draw the eye into an immense traveling movement, making it cross barrier after barrier while traversing a vast space. But in such sequence shots the situation is rather obvious and the trajectories too ostensible; we would do better to consider the aesthetic of the long take as practiced by contemplatives and mystics like Ozu, Dreyer, and Ford. The fascination of the long take has always more or less resided in the hope

that in the prolonged coincidence between the film's time and real time, which is also the time of the spectator, there would occur some kind of encounter with the real. It is also very much the case that the long take was destined to endow with value the unimportant and seemingly mediocre or everyday. It would be a mistake to underestimate the extent to which the long take encourages an encounter with the real—by directing the gaze, fixing its modalities, its rhythm, by enclosing it surreptitiously, as Sam Fuller has observed of Wim Wenders' cinema. Perhaps the only long takes in which the gaze is authorized to endlessly wander arise in films of another type, those belonging to what is often called experimental cinema. But such cases derive from another, earlier aesthetic, where it is no longer a question of giving free pasture to the gaze, but of derailing and confusing it. Among all the filmmakers to whom I refer, however, the use of the long take entails anything but belief in a miracle: thus, to film in long take does not mean submitting to chance, but involves instead a thorough calculation on the level of mise-en-scène and cinematography. An opportunity for a miracle, a fleeting distillation of the real, resides in the spectator's experience and there alone.

Thus, despite their material differences, especially the aesthetic abyss between them, the long shot and the pan similarly provide the gaze with the illusion of liberty, while all the more radically enclosing it within a finite world, a universe of limited possibility. It is difficult to understand how Bazin could have erred so greatly as to consider the sequence shot the alpha and omega of spectatorial liberty. With hindsight we realize that his historical situation, a period of intense change, would have encouraged such a misapprehension. Despite his often stated concern for the spectator, Bazin is obsessed with the idea that a film can actually be a succession of events unfolding in space and time. Wishing to explain the properties of a work by its technique of fabrication and mode of production, he ultimately commits the "genetic" fallacy. If, as he proposes, the long take reveals something about reality, it is that an event occurred prior to the film, at the moment when the film came into existence, a moment of effective coincidence between the time of the camera and that of reality. For the spectator all that matters is the representation of such a coincidence.

One can even conclude that the cinema is abusively constrained within the space of representation, in spite of the impulse, characteristic of the postmodern, to identify the creative act within and as part of the created work, be it only through the use of a "direct" or a *vérité* style of filmmaking. What concerns us here is the way in which the cinema as an art form has privileged figures deriving from what I

refer to as the variable eye, the configuration of modernity par excellence. At issue, too, is the way in which this variability, solidified in a representation that includes time, is both more strongly inscribed and more completely ensnared.

Let us look more closely at the key topic raised above: the mobility of the camera. The essential concern is the extreme variation of the distance from the point of looking to the object looked at, a variation with which the cinema has never ceased to experiment in an abundant and playful fashion. At stake are the changes—the cinema, after all, has never stopped experimenting, even going to extremes—between the distance of the point of looking and the object looked at. It is easy to draw parallels: there is, for instance, a similar excitement and playful exuberance during the middle of the Quattrocentro and in Germany during the 1920s. In the first period, the possibilities of the new perspective technique were "tested" in an amusing yet quite serious fashion, to the point of including bizarre arrangements: recall the anecdotes concerning Uccello and the sweet madness of his *dolce perspettiva*; in the latter period, the possibilities of movement and distance were tirelessly explored.

Moreover, it was in 1920s Germany that the most astonishing eponym for this mobility was coined, the famous *entfesselte Kamera*, "the unleashed camera," which with the aid of flawless technique limitlessly extended the capacity for movement of the cinematographic eye. The phrase was invented with respect to E. A. Dupont's and Karl Freund's joint achievement in *Variety* (1925); there are shots filmed from the great Ferris wheel of an amusement park or, even more strikingly, from a flying trapeze. But what is astonishing is that these camera movements are never "justified" through reference to a character. Contrary to what in Hollywood will soon become a virtual rule, the camera here implies a gaze moving in complete autonomy from the characters, although of course not truly from the drama. In *Variety* the camera movements, numerous and expressive, underline and even produce the meaning of a scene; an example is the famous very rapid 360-degree pan, superimposed on Jannings' furious face after he discovers that he has been cuckolded. We no longer know who invented the "unleashed camera"; many claimed to have done so—Freund, of course, but also Carl Mayer, the scenarist of Murnau's *The Last Laugh* (1924), another film in which one discovers the same spinning effect on Jannings' face. Far more important than the question of authorial provenance is the act of unleashing itself, the fantasy of a camera enabled not only to see all, but also to see from anywhere. Contemporaries of this development were very conscious of it.

Consider, for instance, the following remarks of Otto Foulon made in 1924: "Is there a mode of representation as capable as the cinema of extending the scope of the visible until it nearly approaches the ineffable? Time and space no longer impose limits on the cinema. Without using a moving stage, radical changes in location are accomplished with a divine lightness, from the West to the Far East, and from the world of the infinitely great to that of the infinitely small."[30]

In the 1920s in Germany, but also in France, Russia, and even the United States, the camera operator, whose skills were recognized and celebrated everywhere, reigned supreme. Within the cinematic avant-garde, groups such as FEKS in the Soviet Union and the so-called "Impressionists" in France cultivated a style essentially based on a capacity for visual invention, often adopting an unprecedented point of view on the scene filmed.[31] Inventiveness and mobility are also two essential traits of the small genre of "city symphonies" created by Ruttmann, Vigo, and Vertov. In these imaginary urban portraits, the filmmakers operate in a mode of infinite fragmentation, using scraps in a more or less conscious response to the vague sensation of a metropolitan order still in gestation, founded on, to use a pun, a concept of circulation and decentering. Here the camera's eye is that of an explorer, clinical in the case of Ruttmann, engaged in Vigo or Vertov.

Despite occasional eclipses—as with the arrival of the talkies, which, notwithstanding an enormous outcry, still had the effect of paralyzing the camera—the camera continues its unleashing. In recent cinema this ideal of mobility has been realized in a variety of ways: the handheld camera, carried on the shoulder and popularized during the vogue for "direct" cinema in the late 1950s with the invention of the "Eclair," the Steadycam, and other similar prostheses; the invention of higher cranes, of more or less robotic apparatuses—like Michael Snow's in *The Central Region* (1970–1971) or Bill Viola's in *Ancient of Days* (1979–1981); or, on the contrary, totally miniaturized or "manualized" apparatuses, such as the astonishing *paluche* of Jean-Pierre Beauviala.[32] Most surprising of all is that this desire for mobility and unprecedented point of view seems to have never left filmmakers, who struggle ingeniously to explore yet additional possibilities. In *Mammame* (1986) Raoul Ruiz films a troupe of dancers in a way that exhaustively explores the most bewildering combinations of "impossible" angles. Especially notable are the quite disturbing shots in absolute low angle, in which the viewer is led to perceive as horizontal what must ultimately be understood as vertical. Given today's mechanization and increasing information glut, the camera's current unleashings suggest a different kind of writing, indeed a different project; the camera has now become a cold eye, com-

pletely void of all reference to the human that transported the cinema to its apogee. The variable eye, too, has entered the era of postmodernity.

Beyond the movement of the camera inscribed directly on the screen is the mobility manifest in an extension of the paradigm of "shot scale." Among the shots experimented with during the silent years, two are striking: the closeup; the extreme closeup, which—although used for filming almost anything—was typically employed for faces; and the extreme long shot, frequently used for filming landscapes.

What is a landscape? For filmmakers at the end of the silent period it was, above all, "a state of the soul." In his lyrical and passionate fashion, Jean Epstein often repeated this idea, and indeed the landscapes in *La Belle Nivernaise* (1924), *La Glace à trois faces* (1927), and *La Chute de la maison Usher* (1928) are just that. But perhaps I am accepting at face value the conception of "impressionism" to which Epstein was committed. There also may be a need to search for larger theoretical intuitions.

A chapter in Eisenstein's *Nonindifferent Nature* may help us out here: ten years after the sound revolution, the author retrospectively poses an equivalence between landscape and music, between the punctuation and illustration provided by certain landscape moments in a silent film and the lyrical commentary of music.[33] Landscape-as-state-of-the-soul, landscape-as-music—in both cases art, the art of the cinema, is "nature seen through a temperament." The cinema has caught up with painting, or perhaps rather has extended it.[34]

Furthermore, it is hardly surprising that the greatest theoreticians of the silent era, Balázs and Eisenstein, agree on this question, probably because of their common ties with Germanic culture. For it is in Germany—need we cite Friedrich again?—that the landscape within the art of painting retained the strongest charge of affect, poetry, and mystery, and it is in Germany as well that the landscape led to "visionary" and fantastic art—to the sumptuous dead end of Böcklin in contrast to impressionism, which hypostasized sensation. For these theorists a filmed landscape remains forever a mystery, a fantasy, a melody. Eisenstein will remember this first in his characterization of the "mist" in *Battleship Potemkin* (1925) and later, in a more perverse fashion, in his analyses of *Alexander Nevsky* (1938). For Balázs affect is primary: "The stylization of nature is the condition by which a film becomes a work of art. . . . The camera operator has the paradoxical task of painting, with the photographic apparatus, images of *Stimmung.*"[35]

What is striking in these conceptions of the filmed landscape, especially those

of Epstein, is that the camera—in taking a maximum distance, removing to a point at which a human presence in the image is no longer perceptible—thereby encourages a mental intimacy. The cinematographic eye thus establishes a distance, but only to be able to film up close. Balázs, with his strange "category" of physiognomy, may aid us with an explanation: "Just as time and space are categories of our perception, and thus are never dissociable from the world of our experience, so physiognomy always attaches to appearance. It, too, is a necessary category of our perception." Particularly admirable in the foregoing passage from *Der sichtbare Mensch* is the force of its terminology, redolent of an attempt to develop and enrich a Kantian project: in that 1924 study Balázs describes how the extreme distances separating landscape and face, long shot and closeup, join together and become equivalent. Exactly parallel passages may also be found in Epstein's "Bonjour cinéma" (1921), a collage of essays, poems, and drawings and another Kantian text in which faces in closeup become landscapes of wrinkles, eyelashes, and tears.[36] But it is in Dreyer's *La Passion de Jeanne d'Arc* (1928) that the best illustration of this concept exists; through excessive enlargement, objects acquire a sense of presence and menace in this film.

Once again we return, albeit furtively, to the closeup because in the great silent cinema of Europe the closeup, as much as the extreme long shot, testifies to the cinema's profound engagement with spatial freedom. And this is consequential, as it is easy to see the common root of the "extreme long shot" and the "extreme closeup": both assume a distance so excessive that the result is either a monstrosity or a malaise. In Epstein the telephone in closeup is akin to a tower, a lighthouse, a malevolent machine. More generally the landscape, as in Balázs' concept of *Landschaft*—for whom the word designates, as it did for Simmel, from whom Balázs pilfered it, the "antinatural" isolation of a fragment of nature achieved by the exercise of a human gaze—had its source in an old romantic fantasy in which the interchangeability of the countryside and the face mark both as bewitching or evil.[37] Furthermore, this monstrosity is felt not only by philosophers and poets but by most spectators too, as is proven by the reactions to closeups, documented over a twenty-year period. Such was the case beginning in 1895 with Edison's *The Kiss*, which, although involving only a medium camera distance, provoked feelings of disgust and was judged obscene.[38] Around 1900–1905, it was the "talking heads" of French and English films that provoked amusement and incomprehension. And even as late as 1915 Vachel Lindsay noted an apparently contemporary reference to the "dumb giants" that "in high sculptural relief" occupied the entire surface of the screen.[39]

While the landscape may have lost its malevolent overtones and perhaps all its emotional resonance in the cinema thanks to decades of the western, the closeup still remains deeply troubling. Pascal Bonitzer makes of the closeup one of his principal theoretical levers, basing his "heterological" conception of the cinema on it.[40] As a basic force of discontinuity and heterogeneity, the closeup serves as an eternal supplement to any drama or scene, a perpetual effect of dynamic cutting; this is an Eisensteinian theme on which Bonitzer elaborates.[41] We should recall that the closeup—with its excessive, perverse character—is but one of many various imaginable but coherent aesthetics that the cinema has inherited from the mobile eye of painting. Like its twin, photography, painting had won the right to promenade its eye through nature, but only at a respectful, reasonable distance. The camera pushes this right to an extreme, abusing it in fact; is the cinema's destiny to abuse painting? Thus the cinema's susceptibility to all forms of expressionism becomes visible when it assumes an incorrect distance—whether comic or tragic—and reveals itself to be either bombastic or too strong.

To conclude, I would like to offer a hypothesis concerning the history of the eye in film. In their excess, the extreme long shot and the extreme closeup imply a generic, abstract, quasi-inhuman eye. During the same period, if not always in the same places, there coexisted with this "inhuman" system another system, one founded on an affirmation of the potentially human source of any gaze. Forcing the issue, we might conclude that the cinema had developed the theme of the eye's mobilization in two opposing directions: toward the object and toward the subject.

Who gazes? While implicit in certain styles and schools (the "impressionism" of Delluc and his followers being the foremost example), the question actually goes beyond them all, providing the basis for a subjective cinema, and for each and every inscription in a subjective cinema. When a slight reframing in *La Glace à trois faces* or *La Femme de nulle part* (1922) clearly coincides with a shift in a character's gaze, we encounter the simplest and most evident degree of subjectivity, while at the same time recognizing the obvious fact that in the cinema this kind of inscription of point of view is produced, above all, through a character within a diegesis. In any event, such brief reframings are informed by exactly the same principle that underwrites the most spectacular cases of subjective camera. The fantastic film, which makes considerable use of subjective effects, exaggerates them to their limit. Consider, for instance, the very effective combination of wide-angle and Steadycam images in *Wolfen* (1981), which creates the highly subjective—and, what's more, quite

humanized—vision of the wolves. Through the frequent combination of these two processes, the "subjective" shot has become banalized and integrated into classical cinematographic language. It has become commonplace in serials, whether the made-for-television movie, the television series, or the outer-space adventure film, so utterly representative of ordinary cinema: recall for instance the perfectly computerized movements in *Star Wars* (1977), which are supposed to represent—at the cost of a flattening of "subjectivity"—the subjective vision of superheroic characters.

The carefully organized coincidence between the camera's point of view and that of the character has been studied at length by narratologists, for whom the camera remains less an eye than a materialization of a narrating instance. There have been attempts to apply Gérard Genette's notion of narrative *focalisation*, or, taking into account that a gaze is involved, to translate this notion as *ocularisation*, as François Jost has done.[42] A study of the cinema reveals narration's importance in any inscription of "subjective" point of view: whether or not the camera occupies the point of view of the character is something that the spectator usually cannot know except by virtue of the context. Here the context would include information supplied by montage, by off-screen space (which involves, among other things, the sound track), and especially by the narrative. In other words, what is typically referred to as the "subjective shot," which is perhaps more appropriately termed the "gaze shot," exists in the cinema only by means of markings exterior to the isolated image; the framing alone, even if mobile, is generally insufficient to indicate a character's point of view.

To understand the ways in which the cinema creates emphatic points of view requires a reconsideration of painting. Although only minimally narrative even in its most academic forms, nineteenth-century painting did not, however, hesitate to present remarkable points of view. Degas immediately comes to mind, for he specialized in decentered, acrobatic points of view; his decentered compositions sometimes approach eccentricity, suggesting willfully bizarre points of view. His framings are actually reconstructions of instantaneous moments. Like photographic imprints, they are constituted as "temporal" slices, and thus rely upon the cutting force of the frame. Once access to the limits of the eye's variability had been gained at the beginning of the century, Degas never put the eye into question. But the beginning of the manipulation of space is to be discovered even earlier in Manet, although in a less obvious and radical fashion. Francastel has described this painter's juxtaposition of spatial fragments in *The Dead Toreador* (1864), painted from an

impossible point of view on a field occupied by the spectator; the same occurs in *The Execution of the Emperor Maximilian* (1867), in which the group of soldiers seems to hover in front of the wall in the background.[43] Thus, by all accounts, in Degas as much as in Manet, painting achieves strong points of view that mobilize the entire image.

Film, on the other hand, is an entirely different case, for it does not allow much play with the geometrical coherence of space. Nevertheless, film, even beyond the demands of the narrative, exhibits every possible use of such methods, especially at the level of composition and what has been called *décadrage* ("deframing"). Perhaps if I offer in passing an example of such a marking of the subjectivization of the view in the cinema, I may leave it to the reader to come up with other instances. In *The Cloak* (1926), the FEKS filmmakers use on several occasions either a closeup or a medium shot of a character over a blurred background, violently agitated by more or less noticeable convulsions. Such is the case in the film's first episode, which reveals the hero dreaming; in that state, the hero "sees" the face of a mysterious woman, veiled behind a semitransparent fan, while in the upper right portion of the frame, mysterious black arrows create a zebralike pattern. In the following shot, the mystery is resolved: it is only shadows cast by someone juggling with clubs. This shot and others like it in *The Overcoat* and in other FEKS films, such as *The New Babylon* (1929), aim at and indeed achieve a sort of self-sufficiency in subjective effects. Such shots incontestably require little context to be understood, but they are also in corollary fashion more pictorial in the ordinary and slightly banal sense of the word.

The cinema could thus be described as a symbolic machine for producing points of view. Here it would perhaps be useful to adopt the expression "vantage point," suggesting a good and efficacious point of view; this is very much what the cinema aims to produce, one after another—points of view that are self-serving to the degree that they must be without rival, so that the spectator may be prevented from occupying anything other than the "vantage point" offered. And this is precisely why the film spectator—of the art film, at least, the "ambitious" film, dedicated to capturing and winning over the spectator—has been condemned to immobility, very much like the beholder of the panorama or the train passenger. Anything such a spectator might add to the representation would only diminish the perfection of a magisterial—a magisterially advantaged spectacle. Ironically, the motto of the variable eye can be said to echo that of the early photographers: "Don't move!"

Notes

Editor's Note: This essay originally was published as the second chapter of Jacques Aumont's *L'Oeil interminable: cinéma et peinture* (Paris: Séguier, 1989) and is the first excerpt of that book to be translated into English. In cases where the author cites a work that has been translated into English, the English version has been cited instead.

1 Jean-Louis Comolli, "Technique et idéologie," six parts, *Cahiers du cinéma*, no. 229 (May–June 1971): 4–21; no. 230 (July 1971): 51–57; no. 231 (August–September 1971): 42–49; no. 233 (November 1971): 39–45; nos. 234–235 (December–January 1971–1972): 94–100; no. 241 (September–October 1972): 20–24. Comolli's usage of the word *différance* is borrowed (and slighly altered) from Jacques Derrida, who had just recently coined it. For Derrida's original reference, see "La différance," *Théorie d'ensemble* (Paris: Editons du Seuil, 1968); and *Marges de la philosophie* (Paris: Editions de Minuit, 1972), 1–29.

2 Jacques Aumont, André Gaudreault, and Michel Marie, eds., *L'Histoire du cinéma: nouvelles approches* (Paris: Publications de la Sorbonne, 1989).

3 Peter Galassi, "Before Photography," preface to *Before Photography: Painting and the Invention of Photography* (New York: Museum of Modern Art / New York Graphic Society, 1981): 11–31.

4 For more on the *text* read in the representation of nature, see E. H. Gombrich, "The Renaissance Theory of Art and the Rise of Landscape," *Norm and Form: Studies in the Art of the Renaissance* (London: Phaidon, 1966): 107–121; Alexander Perrig, "Der Renaissancekünstler als Wissenschaftler," Funkkolleg Kunst (Weinheim and Basel: Beltz Verlag, 1985); Erwin Panofsky, *Early Netherlandish Painting: Its Origins and Character* (New York: Harper & Row, 1953).

5 Furthermore, in this context it is possible to be a materialist even in good standing, since at the end of the eighteenth century nature also changes, due to the gigantic enterprise of deforestation that occurred across Europe and involved developments like the importation of new kinds of trees.

6 Canaletto painted with a "camera," but it was Constable who made cinema.

7 E. H. Gombrich, "Visual Discovery through Art," *The Image and the Eye: Further Studies in the Psychology of Pictorial Representation* (Ithaca: Cornell University Press, 1982), 11–39. See also James J. Gibson, *The Ecological Approach to Visual Perception* (Boston: Houghton-Mifflin, 1979).

8 Maurice Merleau-Ponty, *Phenomenology of Perception*, trans. Colin Smith (London: Routledge and Kegan Paul, 1962).

9 See Béla Balázs, *Der sichtbare Mensch, oder Die Kultur des Films, Schriften zum Film*, vol. 1 (Munich and Budapest: Carl Hanser Verlag & Akadémiai Kiadó, 1982).

10 In the United States the train seemed specifically American because essentially democratic.

11 The engineer, the central character of the novels of Jules Verne at the end of the nineteenth century, is a supreme technician, someone who possesses both a vast scientific culture and a practical spirit.

12 Hugo Münsterberg, *The Photoplay: A Psychological Study; the Silent Photoplay in 1916* (1916; reprint, New York: Dover, 1970).

13 See Wolfgang Schivelbusch's eloquent chapter on the pathology of the train ride, leading to the traumatic neurosis described by Freud: the train provides a conditioning in nervous shocks. Wolfgang Schivelbusch, *The Railway Journey: Trains and Travel in the Nineteenth Century*, trans. Anselm Hallo (New York: Urizen Books, 1979). See also Charles Musser, "The Travel Genre in 1903–1904," *Iris* 2, no. 1 (1984): 47–59; Lynne Kirby, "Mémoire de D.E.A. [Diplôme d'Etudes Approfondies]" (Université de la Sorbonne Nouvelle, 1984).

14 On this topic see Stephan Oettermann, *Das Panorama: die Geschichte eines Massenmediums* (Frankfurt: Syndikat Autoren-und-Verlagsgesellesch, 1980); Walter Benjamin, "Paris, capitale du XIX^e siècle," *Poésie et Révolution* (Paris: Denoël, 1971), 125–171; Patrice Rollet, "Passage des panoramas," in *Paris vu par le cinéma d'avant-garde: 1923–1983*, ed. P. Hillairet, C. Lebrat, and P. Rollet (Paris: Association Paris Expérimental Editions, 1985); Joachim Paech, *Literatur und Film* (Stuttgart: Metzler, 1988).

15 There still exists in the Hague a panorama of Scheveningen from 1881 by H. H. Mesdag.

16 Examples include a 1911 battle of Waterloo and, curiously, a battle of Stalingrad installed in 1960 in Volgograd and still surviving.

17 On the apparatus, see Jean-Louis Baudry, *L'Effet-cinéma* (Paris: Albatross, 1978); Christian Metz, *The Imaginary Signifier: Psychoanalysis and the Cinema*, trans. Celia Brittan, Anwyl Williams, Ben Brewster, and Alfred Guzzetti (Bloomington: Indiana University Press, 1982).

18 Its English importer will baptize it frankly "moving pictures"—that is, "movies" *avant la lettre*.

19 Michel Foucault, *Discipline and Punish: The Birth of the Prison*, trans. Alan Sheridan (New York: Pantheon, 1977).

20 Godard's *Passion* (1982) reconstructs and reenacts as *tableaux vivants* a variety of history paintings, primarily from the seventeenth and nineteenth centuries (e.g., Rembrandt's *The Night Watch*; Delacroix's *The Death of Sarndanapalus* and *The Entry into Jerusalem*; and Goya's *The Third of May, 1808*).

21 For further reading on painting and spectatorship, see Wolfgang Kemp, ed., *Der Betrachter*

ist im Bild: Kunstwissenschaft und Rezeptionsästhetik (Berlin: Dietrich Reimer Verlag, 1992); Michael Fried, *Absorption and Theatricality: Painting and Beholder in the Age of Diderot* (Berkeley: University of California Press, 1980); Michel Foucault, *The Order of Things: An Archaeology of the Human Sciences* (New York: Pantheon Books, 1971); Jean Paris, *L'Espace et le Regard* (Paris: Seuil, 1965); Louis Marin, "Toward a Theory of Reading the Visual Arts: Poussin's *The Arcadian Shepherds*," in *The Reader in the Text: Essays on Audience and Interpretation*, ed. S. Suleiman and I. Crosman (Princeton: Princeton University Press, 1980), 292–324.

22 *Editor's Note*: The *fête champêtre* refers to a genre of painting that became very popular in France at the beginning of the eighteenth century. Deriving from the theme of the Gardens of Love in courtly medieval art, and later from Giorgione's *Concert champêtre*, this genre is linked historically with the shift from the academic pantheon of Raphael and Poussin to the more sensuous appeal of the Venetian and Flemish masters. The taste for this genre, also known as *fête galante*, can also be seen as a direct albeit minor result of the Quarrel of Ancients and Moderns. Watteau was undoubtedly the most reputed painter of this theme, and in 1717 he was received into the Academy "pour un tableau qui représentit une fête galante" (*Embarkation for the Island of Cythera*). It is worth noting in this context that the final *tableau vivant* in Godard's *Passion* is one of the *Embarkation for the Island of Cythera*, which Hanna wanders into while searching for Jerzy. The pastorals of Boucher and Fragonard are only very loosely associated with this genre, which quietly died out about 1740. Harold Osborne, ed., *The Oxford Companion to Art* (Oxford: Clarendon, 1976): 405.

23 Raymond Queneau, *The Skin of Dreams: A Novel*, trans. H. J. Kaplan (London: Atlas Press, 1987).

24 Art historians have only lately begun to take an interest in painting's relation to the abstract *archispectator*, a concept inspired by Genette's *architexte*.

25 Carl Gustav Carus, "Neun Briefe über Landschaftsmalerei 1815–1824," *Caspar David Friedrich: Auge und Landschaft, Zeugnisse in Bild und Wort*, ed. Gerhard Eimer (Frankfurt: Insel Verlag, 1974), 148.

26 Mikhail A. Bulgakov, *The Master and Margarita*, trans. Diana Burgin (New York: Vintage Press, 1995).

27 *Editor's Note*: Giovanni Pastrone (1883–1959) was a leader in the early years of Italian cinema. Frequently using the pseudonym Piero Fosco, he began producing and directing in 1908; six years later he finished *Cabiria*, which remains a landmark in the history of cinema.

28 The early film spectator was without any means of accelerating or slowing down the film, in radical contrast to today's "new images," where time is "interactively" masterable, and almost entirely manipulable.

29 Jean Louis Schefer, *L'Homme ordinaire du cinéma* (Paris: Gallimard, 1980), 209–221.

30 Otto Foulon, *Die Kunst des Lichtspiels* (Aachen: Karl Spiertz, 1924), 17. For more on the "unleashed camera," see also Bernhard Zeller, ed., *Hätte ich dans Kino!* (Munich: Kommission Kössel, 1976).

31 *Editor's Note*: In 1921 Grigori Kozintsev and Leonid Trauberg created FEKS, the Factory of the Eccentric Actor, a theater group intent on the creation of avant-garde and unorthodox productions. After producing a number of controversial multimedia stage representations, Kozintsev and Trauberg began to work in the cinema, and between 1924 and 1927 they made six films together. Begun in 1928 and inspired by the story of the Paris commune in 1871, *The New Babylon* (1929) was their first project financed by the Soviet government.

32 *Editor's Note*: For more on Beauviala's development of the *paluche*, see Janet Bergstrom and Alain Bergala, "Genesis of a Camera," *Camera Obscura*, nos. 13–14 (Spring–Summer 1985): 162–193.

33 Sergei Eisenstein, *Nonindifferent Nature*, trans. Herbert Marshall (Cambridge: Cambridge University Press, 1987).

34 "Nature seen through a temperament" is Zola's celebrated definition of art and is said to define the movement of naturalism in French literature.

35 Balázs, *Der sichtbare Mensch, oder Die Kultur des Films*, 103.

36 Jean Epstein, "Bonjour cinéma," *écrits sur le cinéma, 1921–1953*, vol. 1 (Paris: Seghers, 1974).

37 Consider the characteristically ecstatic pronouncements on this theme by Pasenow, the "romantic" hero of the first of Hermann Broch's three stories of *The Sleepwalkers: A Trilogy*, trans. Willa and Edwin Muir (New York: Quartet Books, 1986).

38 It remains obscene today in another sense: not for challenging the moral code but for exhibiting the bourgeois body of 1900, the improbable ugliness of which Bataille has eloquently described.

39 Vachel Lindsay, *The Art of the Moving Picture* (1915; reprint, New York: Liveright, 1970).

40 Pascal Bonitzer, "Le Gros Orteil," *Cahiers du cinéma*, no. 232 (1971), 14–23. See also Bonitzer, "Qu'est-ce qu'un plan?" *Le Champs aveugle* (Paris: Cahiers du cinéma / Gallimard, 1982).

41 Sergei Eisenstein, "Dickens, Griffith, and the Film Today," *Film Form: Essays in Film Theory*, ed. and trans. Jay Leyda (1949; reprint, New York: Harvest/HBJ, 1977), 195–255. See also Eisenstein, "Histoire d'un gros plan" (1946), *Oeuvres* (Paris: U.G.E., 1985), 6:23–39.

42 Gérard Genette, *Narrative Discourse: An Essay in Method*, trans. Jane E. Lewin (Ithaca: Cornell University Press, 1980); G. Genette, *Narrative Discourse Revisited*, trans. Jane E. Lewin (Ithaca: Cornell University Press, 1988); François Jost, *L'Oeil-caméra: entre film et roman* (Lyon: Presses Universitaires de Lyon, 1987). On the topic of *focalisation* and point of view,

see also J. Aumont, "Point of View," *Quarterly Review of Film and Video* 12, no. 2 (1989): 1\22; Keith Cohen, *Film and Fiction: The Dynamics of Exchange* (New Haven: Yale University Press, 1979); André Gaudreault, *Du littéraire au filmique* (Paris: Méridiens-Klincksieck, 1988).

43 Pierre Francastel, *L'Impressionnisme: les origines de la peinture moderne de Monet à Gauguin* (Paris: Librairie "Les Belles Lettres," 1937). Manet's *The Dead Toreador* is in the collection of the National Gallery of Art, Washington, D.C.; *The Execution of the Emperor Maximilian* is in the collection of the Mannheim Kunsthalle.

The End of Cinema?

An Afterword to Jacques Aumont's "The Variable Eye"

CHARLES O'BRIEN

The genealogy of cinema offered in Jacques Aumont's "The Variable Eye" anticipated what has become a major shift of focus in contemporary film theory, away from the disembodied gaze attributed to the classical spectator and toward a postclassical, corporeal glance. Consider Aumont's claims regarding the familiar notion that development of the cinema entailed a "delay" or "*différance*." Like photography, which emerged only circa 1830, centuries after crucial technological developments had taken place, the invention of cinema appears to have been long prefigured in the image technologies of the Renaissance and even earlier epochs such as Plato's Athens. For Aumont, however, the drama of the cinema's late emergence is illusory, an effect of the linear historiography that results from an exclusively psycho-technical account of relations between viewer and spectacle. Through analyses that place the cinema within contexts linked to a variety of artistic and cultural practices, Aumont argues that superficial continuities between the cinema and earlier image technologies conceal a fundamental, epistemic change.

In challenging an identity between the cinema and the visual culture of the Renaissance, Aumont takes issue with the "apparatus theory" elaborated by Jean-Louis Baudry, Stephen Heath, and others. Rather than presuppose the relevance of a tradition defined by the camera obscura and its monocular vision, geometrical perspective, and separation of viewer and spectacle, Aumont locates the cinema's origins in the early nineteenth century, when a variety of cultural practices—including photography, new genres in painting, and mountain climbing—signal the decline of the camera obscura model and the emergence of a new, "modern" mode of vision.

Moreover, contra critics, beginning with Baudelaire, who trace modern visual culture to photography, Aumont proposes that the key development occurred earlier—in painting, the art form most closely associated with the Renaissance. At issue is the transition just prior to the French Revolution from the *ébauche*, a painter's preparatory notebook drawing, to the *étude*, a "finished" sketch that at-

tempted to capture the impression of a transient facticity. In contrast to the *ébauche* (and its model, the Renaissance landscape), the *étude* sought not to render the world interpretable but to offer "revelation, dazzlement, communion—or, at least, an invitation to complicity." That a radical alternative to the customary separation between beholder and spectacle emerged in the venerable art of painting implied a change in the status of nature itself, which now had an artistic existence outside of any allegorical import. No longer a landscape organized by the telos of signification, nature had become the object of a gaze defined by "a thirst for visible appearances, pure phenomena."

Among the effects of a historiography organized around a nonclassical lineage defined by the *étude* is an emphasis on aspects of film history that have been marginal to contemporary film studies. Consider Aumont's discussion of the cinema of the 1920s, which serves as a principal source for examples of the cinema's link to the modernity of the preceding century. Far from complicit with a centuries-old dominant scopic regime, the late silent cinema was defined by a radical formal experimentation that profoundly challenged established modes of vision. In the 1920s, the "epoch of the camera operator's reign," filmmakers in Germany, France, the Soviet Union, and the United States explored the cinema's potential for an unprecedented mobility and visual inventiveness. Examples include Murnau's moving camera, Vertov's "kino-eye," the fragmented exposition of the "city symphonies" of Vigo and Ruttmann, Epstein's "impressionist" experiments in rendering fleeting subjective states, and even the continuity cutting of Hollywood comedies and action films. Such developments imply modes of engagement whose effects suggest the self-divestiture associated with rail travel, the panorama, and other characteristically modern experiences. Participating in modernity's shift in the center of gravity, from the object "not simply to the gaze but to the bearer of the gaze, the spectator," the cinema of the 1920s explored film's capacity to alter human sense perception itself.

Like Gilles Deleuze, another critic of recent film theory, Aumont seems to draw less on the semiological school that has defined academic film studies than on the work of theorists of earlier generations—in some cases the very writers whose authority had been challenged by the linguistic turn of the 1960s. Indicative are Aumont's remarks on the closeup. Whereas critics working from perspectives informed by semiology and psychoanalysis elaborated the notion of suture to situate the closeup as an element within an ultimately stable languagelike system, Aumont

returns to the work of Balázs and other writers of the interwar years to stress the closeup's irreducibly "disturbing" and asystematic character. Like Deleuze's "affect image," Aumont's closeup is potentially excessive with respect to the structures of intentionality that might be assumed to contain it.

One might also cite Aumont's invocation of André Bazin, who, like Aumont, argues for essential differences between the cinema's screen and the frame of Renaissance painting. Aumont, however, not only refuses Bazin optimism regarding the cinema's liberatory potential but proposes a history of visual culture marked by moments of fundamental change. Like Walter Benjamin and André Malraux, Aumont outlines a historiography of profound discontinuities, and thus differs from Bazin just as he differs from the apparatus theorists. In contrast to either Bazin's phenomenological viewer or descendants such as the "all-seeing subject" of Metz's *Imaginary Signifier*, Aumont's film spectator implies a "variable eye," subject to relentless processes of historical change. Evidence of the extent of such variability can be found in the history of the cinema's conditions of reception, which have been far more varied than those of painting, although its history is centuries shorter.

If the cinema's spectator begins with modernity, then what happens to that spectator if, as Aumont argues, the cinema moves toward its end? After all, ongoing developments in image technology indicate that the impact of modernity has begun to wane. The "schematized, synthesized, hypersignifying" forms of representation now prominent in film and television suggest that the variable eye, "the modern configuration par excellence," is now ceding place to a new "cold eye," "completely without reference to the human who embodies it." What exactly is involved here? Part of a broad survey of relations between cinema and painting, "The Variable Eye" only touches on issues of contemporary visual culture. At issue is clearly *not* a return to the separation of viewer and spectacle characteristic of classicism. Among Aumont's examples of today's "demobilized" eye is the cyberspace of certain video games, in which the surgical penetration of the subject that Benjamin described a propos of the age of mechanical reproducibility would seem to approach a limit. Here the viewer engages with a virtual reality to the degree that the notion of "textual mediation"—implying essential differences between subject and object, inside and outside—scarcely applies. Such "postmodern" modes of spectatorship are highly ambivalent insofar as the liberty made available by the interactivity of the technologies comes at the cost of erosion of the "natural" bodily experience that since the eighteenth century has been regarded as a site of resistance to

acculturation. While interactive aspects of the video player and other new technologies enable the viewer to "master" the time of the image, they may also enslave through forms of acculturation of unprecedented invasiveness.

Although rejection of the classical model is perhaps symptomatic of a post-cinematic culture, the cinema, as Aumont demonstrates, has always been less classical than assumed. It may be that the apparent unassimilability of contemporary film and video to classicism is simply provoking recognition of the cinema's always-already post-classical nature. Will it also inspire attention to the role of senses other than disembodied sight in the history of spectatorship? Aumont does mention the conversion to sound as a key condition of the regression from the radical formal experimentation of the 1920s to the homogenized theatrical aesthetic of the early sound film. But insofar as the embodied eye entails a vision that functions in conjunction with the other, "lower" senses, Aumont's thesis suggests the utility of renewed inquiry into the history of image-sound relations. In addition to assigning sound a substantial role in the shift away from classicism's abstract gaze and toward modernity's corporeal glance, such inquiry might complicate the notion that contemporary film and video signal exhaustion of the modern project. Indeed, current conditions and technologies—from "surround" sound in theaters to stereo-encoded videotapes and laser discs—suggest that if the image now implies a vision without reference to a human perceiver, physiological modes of spectatorship characteristic of modernity continue, although clearly not exclusively at the level of the image.

From the Captured Moment
to the Cinematic Image
A Transformation in Pictorial Order

JAMES LASTRA

Long ago we became accustomed to the idea that the emergence of photography decisively reorganized the field of visual culture and set the stage for the emergence of new forms of representation, new modes of pictorial production, circulation, and exchange, and, additionally, new forms of discipline and surveillance. Nevertheless, too often our accounts have construed photography and film rather narrowly, focusing on devices at the expense of the networks of assumptions and practices in which they are situated. More important than the invention of a simple device—the camera—the nineteenth century witnessed and responded to the emergence of an alternative *mode of picturing* to which photography and film were especially well suited, but to which they did not belong in any ontological or essential way. It was precisely on the field of the "picture" as a cultural category, rather than photography as a technology, that American culture sought to dispute the power and relevance of images in the nineteenth and early twentieth centuries. However historically specific, this dispute was by no means entirely new. Debates over the coherence and unity of pictures have occupied artists and critics for centuries, and previous instances are illuminating in their choice of problems and issues. In this connection, consider the following assessment of northern European (Dutch) painting attributed to Michelangelo:

In Flanders they paint with a view to external exactness or such things as may cheer you and of which you cannot speak ill . . . they paint stuffs and masonry the green grass of the fields, the shadow of trees, the rivers and bridges, which they call landscapes, with many figures on this side and many figures on that. And all this, though it pleases some persons, is done without reason or art, without symmetry or proportion, without skillful choice or boldness and, finally without substance or vigor.[1]

In other words, while still paintings, these images were not art. Indeed, one might reasonably say that they were not *pictures*.

As it happens, Michelangelo might just as well have been writing for the *American Amateur Photographer*. For photographic journals of the 1890s, the very same distinction between image and picture (art) came to the fore as groups battled over the definitions of both photography and artistic pictures. In some measure this was due to the dissemination of the Kodak hand-held camera, which greatly increased the number and variety of photographic images circulating in the culture. In 1894, for example, one critic of photography suggested that "some years ago, when amateur photography was in its infancy here . . . a soulless corporation extensively advertised a camera which only required a button to be pressed and pictures were made. The idea soon took root that there was nothing in photography, when it merely required the pressing of a button. It was apparent that any fool could do that."[2] In addition to the apparent lack of skill involved in photography, the resulting images also lacked proper subject matter and composition. Photography's capacity or even propensity to reproduce anything and everything ("stuffs and masonry the green grass of the fields, the shadow of trees, the rivers and bridges, which they call landscapes") and to render even insignificant objects "picturesque" tended to rob the image of the formal hierarchy necessary to be considered a picture. One critic, echoing Michelangelo's dismissal of Dutch painting, compares these visually dense images negatively with "the great masterpieces of art, [in which] we find that there is always a principle object or 'motif' to which everything else is subordinate."[3] Rather than exhibiting the mastery and purposefulness characteristic of Italian Renaissance imagery, these images exhibit a distressing lack of obvious human intervention. Indeed, one might say that these images seemed to consider the subject (both maker and implied beholder) *secondary* to the visible world.

Further debates over whether images made from the combined negatives of two or more exposures might still be considered "photographs," in light of the proliferation of single-exposure snapshots, or whether instantaneous photographs were pictorially "true" indicate that the mutually implicated categories of "photograph" and "picture" were open to vigorous debate and redefinition.[4] It is worth noting as well that visitors to a contemporary photography exhibition were overheard to comment that the images were "not at all like photographs" because they lacked the shiny surface typical of albumen prints and the "painful detail" of the overly sharp and undercomposed snapshot.[5] These disputes were in no small part spurred by the emergence of apparently "contingent" images in the realms of photography and film since, despite their growing acceptance as normal, such images failed to correspond to most existing pictorial norms. Thus, an examination of the historically

specific categories of perception and evaluation can illuminate broader questions of photography and film's relationship to picturing in general.

I will examine how a conflict over the nature and norms of picturing occasioned by the proliferation of instantaneous photography can inform our understanding of two developments crucial to the emergence of classical cinema: the emergence of a fully diegetic notion of "realism" based on the assumed separation of the spaces of representation and reception as well as the assumed obliviousness of the represented world to the fact of representation; and the emergence of a logic of pictorial combination that allowed for a temporally and spatially additive, unidirectional, and continuous connection of fragments into a coherent series. These two developments are, to be sure, not unrelated, as both are linked decisively to a particular notion of picturing that deploys spatial, temporal, and narrative fragmentation at the level of the individual material unit to produce a unity at the level of the series or combination.

Questions of pictorial immediacy, clarity, and narrative unity shared a common root in the representational strategies made possible by new technologies of visual recording, whether still or moving. Disputes over the definition of "good" or coherent still images intersect with early film culture in a fascinating and illuminating way. In fact, what were often considered incoherencies in the realm of the still image were simultaneously often understood to be positive characteristics for the moving image, enhancing its realism. Still-image coherence and filmic realism share a focus on the subject's apparent "secondariness" in both image production and reception, insofar as each rejects traditional pictorial unity and order. To understand the significance of this intersection, however, we need to think more about the boundaries of the period's visual culture, particularly its basic categories of perception, cognition, and evaluation, which together structure the fields of production and reception.

Scanning the written traces of early film culture, we notice that the single most persistent term of positive evaluation was realism. Catalogs, newspapers, and trade journals consistently praised movies as "realistic," no matter the genre. At times, the application of the term seems impossibly broad or random, as if, confronted with a series of new pictorial phenomena, those who sought to describe them were left without the appropriate terms of evaluation and fell back on the most general broadest and flexible category at their disposal. Nevertheless, within the category of realism lay finer distinctions—ones that may illuminate our present questions. While I take it for granted that stories of cinema's uncanny realism circulating

during the period of its emergence do not bear any direct correlation to spectators' actual credulity, they *can* be read as indices of the manner in which images might be understood to relate to their pictured referents. Schematically, these stories fall into three basic categories or modes of realism: pro-filmic (performance and staging), filmic (the process of inscription), and diegetic (the constructed fictional world).

In the first category fit all those tales of passersby who intervened in the pro-filmic stagings of events by film crews on location in the parks and main streets of America. Typical examples include a staged bank robbery, an assault, or a drowning that elicits a heroic intervention by an onlooker who mistakes the performance for a "real" occurrence. In the second, or filmic, category fit those accounts of films described as creating the impression that the spectator takes the place of the photographer. These accounts suggest that certain films seem realistic because of the circumstances of their inscription. Often the represented point of view, the implied peril for the maker, marks of "facture," or the location of the camera in a moving vehicle encouraged the spectator to place himself or herself at the scene—in the photographer's place. In the last, or diegetic, category fall those stories of people (often rubes or drunks) and animals who are fooled in the theater by the represented world and shoot, attack, or otherwise attempt to interact with that world— a species of trompe l'oeil. Again, these stories cannot reasonably be taken as records of actual spectatorial reactions, but rather as possible forms of image reference, each of which implies different rules for spatio-temporal construction.

The first category assumes that filmic representation simply entails the brute recording of completely prior events whose character alone accounts for the representation's realism. In these tales filmic inscription plays no part in the success of the representational illusion—realistic performances are simply duplicated in a transparent fashion. In the second, the act of inscription and the (former) copresence of operator and scene account for a film's realistic character. This realism assumes that the spatial and temporal dimensions of the representation are directly and indexically related to the realities of the space and time of the pro-filmic, and that the spectator effectively takes the camera's place. The last mode of realism assumes that it is only the represented world, pure and simple, whose plausibility and coherence matter, regardless of its relations to the actualities of pro-filmic spatio-temporal relations. Clearly, each of these categories conceives of the overall process of representation in a different manner, and within each category specific techniques of representation and narration are more or less likely to appear.[6] Each cate-

gory, as an implicit theory or logic of representation, predisposes one toward accepting certain forms of representational practice, and likewise may similarly orient reception in different ways.

The filmic and diegetic categories are most important for the present discussion since the latter describes the mode of representation typical of Hollywood. We will focus, however, on the former, on filmic realism, because it is singularly important to the emergence of new modes of image production and reception and, by emphasizing the image's indexical character, implies a relationship between beholder and event that differs from the classical pictorial norm—one that encourages a reading of the image as a record of an experience of vision, places the beholder in the same space as the represented event, and suggests that the represented world exists independent of the act of representation.

Despite this rather promiscuous application of the term realism, however, early accounts of the cinema *did* clearly differentiate between the staged and the unstaged scene.[7] Given that most films (excluding humanless views of natural phenomena like waves crashing on a beach) could never offer any secure grounds upon which to make such a discrimination unequivocally, we can never know for sure whether a scene was "actually" staged or unstaged—judgments one way or the other were made on the basis of specific textual features. Restricting my analysis provisionally to single-shot films, I will attempt to give a concrete basis for this interpretive judgment and then to demonstrate its significance for my more general questions.

One important series of articles from the period of early cinema splits all filmic material into records of "public happenings like the police parade in New York City, the morning drill of the King's House Guards in London, the Czar and his court on their way to church," and "the story picture"; another divides films into "those scenes from real life, such as military reviews, horse races, parades, automobile, railway, and steamship tours, stag hunts, . . . and the like . . . those taken from 'natural scenes' arranged by the photographer . . . these include fake robberies . . . and so on" and trick films.[8] Significantly, the first category in both accounts describes reality as analogous to a "parade," as an event that exists independent of the camera and whose essential characteristic is one of passage or "escape"—that is, the world continues to pass by us regardless of our interest in it. Such events offer themselves to the spectator in glimpses, in fragmentary form, passing beyond his or her directorial control. The "parade" mode is well represented not only by the many processional films, but also by films such as *Barque sortant du port* (1896), in

which, for example, the sudden appearance of a wave at the very end of the reel introduces an element of the unexpected when the random occurrence eludes the maker's control. The second category is well illustrated by *L'Arroseur arrosé* (1895), in which everything is clearly done *for* the camera and *in terms of* the camera. When the mischievous boy runs out of the frame, he is dragged back before the camera (and therefore the spectator) to receive his punishment. The participants in this comedy, supposedly acting in a spontaneous manner, nevertheless fully reveal the extent to which they are aware of the boundaries of the frame and are cognizant of performing for a conceptually and logically prior audience. Unlike the space of the parade, where one's view is determined by one's location with regard to an event that "passes," the space in *L'Arroseur* has been "infiltrated" or "saturated" by the camera and has become, truly, a pro-filmic space.

The difference between these two types of images is illuminated if not precisely described by Svetlana Alpers' conception of seventeenth-century Dutch visual culture, which she distinguishes from the better-known and more closely studied Italian, or Albertian, tradition. Alpers has argued that Alberti's great contribution was not Renaissance perspective per se, but the idea of the Renaissance *picture*, which is above all *legible* and unified; every pictorial element is a signifying element. Like the world in *L'Arroseur*, the world of the Albertian picture is wholly contained by the frame and is spatially self-sufficient and autonomous. In contrast to an "Albertian" film, which would start from the frame and build a world in relation to it, positing in the process an external viewer who "commands" its presence, the world of *Barque* appears to have an existence which is independent of the look of the camera and which the camera comes upon. It represents a world that is temporally and spatially without a priori hierarchy. Like "northern painting" as described by Alpers, it is constructed "as if the world came first."[9] Describing the use of the frame in Dutch art, she seems to be describing *Barque*: "The world . . . seems cut off by the edges of the work, or, conversely, seems to extend beyond its bounds as if the frame were an afterthought and not a prior defining device."[10]

In short, I believe these two types of filmic images likewise belong to different traditions of picturing and conceive of the act of picturing quite differently, eliciting and assuming different modes of spectatorial involvement. For example, in *Barque* the frame can be an index of the act of seeing by some embodied witness, whose vantage point on the event is both determined *by the event* and limited by it. Rather than representing a scene whose origin is an external, disembodied eye *for whom the representation appears*, and in terms of whom all the aspects of the image

are measurable, the frame in "unstaged" films seems to suppose a viewer who is part of the same world as the represented scene. More significantly, it produces an impression of the world as something that is *undergone,* unfolding beyond one's control. The world seems oblivious to the viewer's presence, presaging the sort of obliviousness feigned by the later classical cinema.

Of course, obliviousness is not meant literally here, since these events could easily have been staged and what counts as an indication of obliviousness changes over time and across contexts.[11] Although the distinction between staged and unstaged often recapitulated *actual* representational practice, there was no guarantee that staged events, such as Edison's views of American troops in the Philippines, would not be taken as actualities, or vice-versa. Obliviousness, whether actual or feigned, might best be thought of as a rhetorical effect wherein the represented world appears to have turned its back on the camera, going about its business without regard to the act of representation.[12] Compared with a more overtly staged, or more "Italian," picture, this image's properties would appear to be a function of the conditions of the world rather than a function of a logically, conceptually, and structurally prior observer.

"As if the world came first," indeed. In the late 1890s "bad" still photos and these "good" films shared a mode of picturing that assumed the essential "secondariness" of the spectator to the represented world. *L'Arroseur's* prior and external spectator, so familiar from the classical tradition of image making, has been replaced by a looker *in* the very world he or she observes. Of crucial importance here is the extent to which this secondariness is a function of a wide variety of forms of visual experience in the nineteenth century, how it is often a function of actual and almost banally practical exigencies of image making, and, in addition, how this simple mode of image production and interpretation organizes a wide range of representational assumptions and practices into a relatively stable hierarchy, just as Albertian pictorial assumptions exerted a decisive influence over all aspects of image making in their own domain.

By locating the roots of this emergent mode of picturing at least partially in the concrete conditions of image production and in popular forms of visual experience, I hope to give a more material basis to the conventions that characterize modern continuity cinema and at the same time suggest how these conventions are related to one another in an integral fashion rather than as an arbitrary collection of codes. In the wider visual context of railroad and subway travel, panoramas, parades, stereograph lectures, snapshots, Ferris wheels, and scenic cog railways—all of

which offered visual experiences whose character was determined by the spectator's literal location vis-à-vis a "changing" visual field—pictorial "secondariness" was utterly familiar. One saw what one saw by being transported through space or because the world moved past, beyond one's control. If passengers on a train failed to notice an object as they hurtled through the landscape, they could not, at will, readjust their framing—their visual experience was determined by forces beyond their control, and at times contrary to their own sense of visual importance. In such visual worlds, one "caught" images as best one could.

Unlike these other instances of spectatorial secondariness, the apparently contingent and captured *image*, proudly displaying its "chance" elements, its lack of spatial and temporal hierarchy, and its randomness somehow caused what might legitimately be called a representational "crisis." But, when all is said and done, these atypical and "bad" images were rapidly accommodated to (expanded forms of) the reigning norms. In fact, this mode of picturing, which implied a radically different relationship between subject and scene, and radically different logics of spatial coherence and construction, was dialectically absorbed by the dominant diegetic mode, and its irruptive aspects carefully segregated to particular, and generally marginal, visual forms. Nevertheless, the notion that visual experience could itself be captured had so permeated popular consciousness that early film producers, when describing movie production, proposed that audiences believed even staged events to have been "caught."[13] Although this claim may not tell us much at all about what actual audiences actually assumed, it at least tells us that producers understood realism to strive for that illusion.

Alpers' work allows us to focus on the sense in which films like *Barque sortant du port, Melbourne: les courses: sortie des chevaux* (1897), *Retour des pompes à la caserne* (1897), *Interior New York Subway 14th Street to 42nd Street* (1905), or *The Burning of Durland's Riding Academy* (1902) could be understood as a threat to ordinary image practice. Unlike, say, *Démolition d'un mur* (1896), *Sortie d'usines Lumière* (1895), or *L'arrivée d'un train en gare de La Ciotat* (1895), which could be said to have a certain unity of form because of an isomorphism between the material unit (the shot) and the representational unit (the event), the former group of films do not represent anything in its entirety, nor do they offer a suitably complete narrative trajectory, nor do they depict things with extreme legibility or with any sense of spatial or temporal hierarchy. These images cannot be said to exhibit any of the unities or logical consistencies appropriate to established forms of imagery, and yet they were enthusiastically accepted by audiences.

These fragmentary images, lacking the typical features of well-made pictures, could nevertheless be understood by spectators; they were simply taken to be a different *kind* of image—i.e., their fragmentary character could be thought of as *signifying* something. The leap to understanding their fragmentary character as an index of represented seeing, for example, was a part of a more general transformation of the image already in progress during the nineteenth century. If, as many historians claim, the nineteenth century saw the emergence within drawing and painting of a "new pictorial syntax," which broke with many of the classical image's norms, the cinematic image further pushed the boundaries of this syntax. Images like *Surf Pounding the Jersey Shore* (1896) or *Scenes of the Wreckage from the Waterfront, Galveston* (1901), whose formal properties (especially their apparent lack of narrative unity) would have put them beyond the pale of the acceptable in some contexts, were embraced by audiences and critics alike and celebrated for their astonishing newness. This acceptance, however, was not without precedent since its foundations had been laid in other regions of visual culture.

Inextricable from this mode of reading and to the valuation of secondariness in general were the various cultural understandings of photography circulating during the period. Particularly important is a sense of what exactly the category "photography" may have implied and how photographs might have been differentiated from other forms of imagery. Typically, nineteenth-century discourses surrounding photography pointed to the *cause* of the image as definitive of its uniqueness and its incoherence. Dominant causal metaphors included those of the shadow, or "pictures drawn by sunlight" itself. As Patrick Maynard has pointed out, these and other related metaphors located pictorial agency in the very objects photographed, which, in Fox-Talbot's words, could be "made to delineate themselves without the aid of the artist's pencil."[14] While the apparent passivity and automatic quality of the process secured for photography a pictorial status unique in its potential accuracy, it simultaneously introduced another dilemma by apparently eliminating the subject from the processes of image making. At its most radical, the camera made it possible, perhaps for the first time in history, to make a legible or meaningful representational image *entirely by accident.*[15] This unprecedented possibility seriously questioned photography's value as art (indeed, as a coherent image) because it emphatically asserted the subject's utter secondariness.

Early descriptions of the daguerreotype stress the highly accidental and arbitrary character of the images, mentioning "the extraordinary minuteness of details," "the slightest accidental effects of the sun," the "frightful amount of detail . . . every

stick, straw, scratch," asserting that "all the minutest [details] . . . were represented with the most mathematical accuracy" and that "every stone, every little perfection, or dilapidation, the most minute detail, *which, in an ordinary drawing, would merit no special attention*, becomes on a photograph, worthy of careful study."[16] Oliver Wendell Holmes reiterates this sentiment in a discussion of the stereograph, claiming that the "distinctness of the lesser details of a building or a landscape often gives us incidental truths which interest us more than the central object of the picture."[17] Unlike a picture, then, a photograph is an "all-over" sort of representation; there is, beyond conscious intention, a single standard of treatment for all the objects represented—seemingly insignificant objects are rendered in as much detail as human figures, effectively leveling the distinctions between intrinsically important and unimportant objects. In addition, the entire surface of the image is treated with and displays the same level of accuracy, detail, and texture, as opposed to "the great masterpieces of art, [in which] we find that there is always a principal object or 'motif' to which everything else is subordinate."[18]

Importantly, the metaphors cited above draw the beholder's attention to the moment or process of *inscription* and, in so doing, to the conditions of image production, while the descriptions emphasize the formal incoherence of images whose characteristics indicate no obvious purpose or significance. An "Albertian" photograph, in contrast, did not encourage one to think about its cause, since its legibility made it comparatively transparent. Photos like those described above, however, often displayed an excess or illegibility that encouraged a more "topographic" reading, a scanning of the entire image surface rather than the obvious subject. One read the peculiarities of the image as indices of the peculiarities of its inscription.[19] An image of this type was profoundly singular and, in that sense, very unlike a shot from, say, *Uncle Tom's Cabin* (1903), where the singularities of different takes of the same scene might not matter at all since each sought to embody a prior and relatively abstract narrative event. But these "illegible" images did not abruptly change the world's relationship to images in general, and writers were able to remotivate and assimilate photos by suggesting the camera itself as the agent of pictorial cause.[20] Nevertheless, as one account from 1895 suggests, "The ordinary photograph is rarely, if ever, a picture. It might be an admirable photograph by accident, but that is no satisfaction to the photographer when his own conscience tells him that it was not he but the camera that made it."[21] The maker's "passivity" seemed to negate the possibility of a photograph's being considered, culturally speaking, a *picture*.

Early accounts of the cinematograph similarly commented on the random and accidental *movement* visible across the entire image. The trembling of leaves in the background astounded people no less than the baby eating a *petit gâteau* in the foreground. What seemed remarkable was not so much the fact of movement, which they had undoubtedly experienced with the zoetrope and phenakistoscope, but its *quantity* and seemingly arbitrary character—the cinematic equivalent of the phenomena criticized by professional still photographers. Rather than see these phenomena as problematic, many early film advertisements *emphasized* random and obviously uncontrollable "effects": "The smoke of the pipe which the man is smoking is blown across the face of the screen, and slowly disperses in the air—a most remarkable evidence of the fidelity to nature of the Kinetoscope reproductions"; "As the boat reaches the water the spray is thrown in all directions, making this an unusually fine film for exhibiting"; "The waving of grass along the track side, the black smoke, and the clouds of dust that follow the train make very vivid effects."[22] Instead of attracting the criticisms directed at similarly "undisciplined" still images, films in which clouds and random motion proliferated in unprecedented abundance represented a quantum leap in pictorial specificity and instantaneity, changing forever the notion of pictorial immediacy.[23] Rather than indications of incompetence, these random signifiers had become appreciable themselves.

Fragmentation had similarly become a potential signifier of the photographic image's specificity and immediacy. Fragmenting an object, a person, or, best of all, an action stressed the impression that the depicted scene had been snatched from the very flow of reality, the random act of "framing" implying a disrupted continuity with something "beyond" the representation, and therefore, crucially, that unity and coherence lay beyond the individual representational unit. While obviously indices of incompleteness and of absence, such disruptions also came to function as indices of an image's production. As the missing limbs of a Greek statue, the distorted form of the ruin, or the worn surface of a Gothic cathedral all signified the passage of time, so newer forms of "lack" lent a historicity to fragmentary films. Lack of pictorial unity and subordination, overabundance of detail, and fragmentation, all of which speak a *loss* of mastery over the image and a basic illegibility, had themselves become legible, and basic ideas of pictorial cause and order had changed.

This new pictorial order and the logics of production and of reading that justified treating fragmentary images as legitimate pictures found their roots in other arenas of representational practice. Jacques Aumont has pointed to a histori-

cal development within painting he calls the "mobilization of the gaze," which describes the tendency that he argues emerged between 1780 and 1820 and flourished during the nineteenth century in both painting and drawing to destabilize the represented point of view.[24] Whatever the cause of their emergence, the paired tendencies that, first, represented objects considered in and of themselves unimportant and, second, used the frame as a sort of visual "scalpel" gained an unprecedented artistic legitimacy in these years. In a similar vein, Peter Galassi's influential essay *Before Photography* argues that the rise of such an aesthetic presents "a new and fundamentally modern pictorial syntax of immediate, synoptic perceptions and discontinuous, unexpected forms. It is the syntax of an art devoted to the singular and contingent rather than the universal and stable."[25] These are words which, no doubt, could be applied to many of the actualities of the early cinema period as well, and which set the stage for future developments in filmic syntax.

Characteristic of this new disposition toward artistic practice was a reconceptualization of both the world-to-be-represented and the relationship among the artist, the spectator, and that world. In short, the landscape or, in general, the visual world came to be imagined as a connected series of potential pictures that needed, principally, to be *framed* correctly. The very act of seeing, or of "framing," a pre-existent world accrued an artistic value it had not previously possessed. Likewise, artists reconceived their own work as a recording of immediate impressions directly in pictorial form. Aumont locates this shift in a change from the *ébauche*, or preparatory sketch for a painting, to the *étude*, which recorded an immediate impression not in view of future development or retouching but as an act of direct representation itself.

Implicit in the transformation from one mode of depiction to another was the belief that vision and experience could be artistic phenomena in their own right and that pictorial order and significance did not necessarily derive from the intrinsic importance of the represented objects, nor from the historic or inherently important nature of the depicted act or event. The unpopulated landscape (which Michelangelo derided), the architectural fragment (like John Linnel's *Study of Buildings* [1806]), the banal object (like Dürer's *Great Piece of Turf* [1503]), the narratively diffuse scene (like any number of American genre scenes from the 1800s), or the scene whose vantage point makes its ostensible subject illegible (like Corot's *View of the Colosseum through the Arches of the Basilica of Constantine* [1825]) could be an aesthetically significant image, provided it dramatized an experience of seeing. Such images might be thought of as justified or motivated by the presumed

presence of a looker whose *experience* was necessarily fragmented. Lack of pictorial hierarchy (the subordination of motifs) was reconceptualized not as evidence of a loss of mastery over the image, but as a function of the appearance of the world *as seen*.

If neither the Coliseum nor the Basilica were identifiable or legible in Corot's painting, this was because Corot and his implied beholder were part of the same world that these structures inhabited. They were therefore limited to concretely available, "actual" points of view rather than ideal and clarifying imaginary viewpoints. If the image lacked the clarity of one of Piero's townscapes, this was because the actual space offered no such "vantage point." Our view of the scene is limited by its material situatedness and intransigence. These are, to paraphrase Alpers, not "objects viewed," in which an external viewer is presented with a view of an object, but rather "views of objects viewed."[26] As such, they not only blocked certain interpretive stances, but also facilitated a new, more identificatory mode of image comprehension and a new logic of image coherence.

Corot's images of Rome, Turner's "pictures of bits," Degas' dramatically decentered compositions—none of these gave a traditionally legible or explanatory image of its subject. Dramatized instead is the act of vision or, more specifically, of *framing*. As Aumont and Galassi indicate, "the singular and contingent" as revealed solely by the act of framing introduced a specific valuation of "passivity" into art, later ratified by photography. No longer was pictorial dramaturgy of utmost importance, but now arranging oneself in relation to an unmanipulated world was considered "artistic." This value is emphatically supported by the earlier popularity both of voyages whose chief purpose was to seek the "picturesque" and of the Claude Glass—a convex mirror with which tourists would "hunt" and "capture" landscapes.[27] The metaphor of hunting was common in the attendant literature of the picturesque, its object being "to obtain a sudden glance, as [nature] flits past."[28] "Arranging oneself" in relation to an otherwise unmanipulated scene was part of the aesthetics of stereoscopic photography as well.[29] In short, these practices of vision presupposed an embodied and decisively secondary beholder.

In the same vein, early filmmakers were also likened to hunters; Félix Mesguich, one of the best known of the Lumière traveling cameramen, even titled his autobiography *Tours de manivelle, souvenirs d'un chasseur d'images*.[30] Trade journals often advised early filmmakers to adopt the attitude that the world was ultimately a reservoir of potential films that simply needed to be excised by the scalpel-camera. A writer for *Moving Picture World* suggested in 1907 that "it needs but little reflec-

tion to see that the world is teeming with subject matter for the cinematograph, and that the difficulty, if any exists, lies more especially in arriving at a selection that shall please the public."[31] A contemporary series of articles about the cinematographer amplifies the hunting metaphor by claiming that "Deer stalking . . . at present, means that a man takes a camera and goes out to hunt his prey."[32] The literalization of hunting and capturing metaphors encouraged producers and audiences alike, I believe, to think of certain pictorial features such as framing as indices of the *act* of inscription so that arbitrary framing, lack of hierarchy among the represented objects, or lack of strong, narrative clarity could be understood as traces of the very artistic act, framing or "capturing," itself. Unbalanced figures, ungainly poses and compositions, previously thought to disunify an image, were increasingly read as signifiers of immediacy, rapidity, instantaneity. In the act of reading textual absences as indices of inscription, we encounter one of the basic strategies of classical film narration—the motivation of discontinuities at one level (the material) to produce a continuity at another (a narrative).[33]

In response to the persistence of classical pictorial norms, writers offered concrete advice on how to avoid merely "capturing" the world descriptively. One typical account suggests that the photographer "take an idea, possibly a line of poetry or prose, and illustrate it."[34] This advice is decisive in distinguishing between the two modes, since it virtually guarantees a mode of composition and arrangement that is profoundly textual and rhetorical rather than descriptive. In addition, it ensures that the artist start (at least conceptually) from an idea and a communicative ideal that requires treating the visual world as a function or an expression of a preexisting verbal or narrative unity. Inscription, so important for the captured image, is insignificant here in comparison with staging. Clearly, we are not far removed from the shooting script of later film production, where textual unity resides at the narrative rather than the material level.

In contrast, the "*chasseur d'images*" subordinated his pictorial form to the event he sought to represent. Even in Lumière films like *Démolition d'un mur*, which Marshall Deutelbaum has described as enacting "operational processes" where the depicted process begins and ends when the film does, the *event* determines the form of the film.[35] In 1898, for example, Cecil Hepworth describes one typical mode of filmmaking as the subordination of filmic inscription to the intrinsic (and often chance) temporality of the event.[36] The development of many of early cinema's formal attributes, in fact, derives from this very practical exigency. A mode of representation generated by the conceptual subordination of the artist to the flow and

arrangement of a world beyond his or her total mastery develops an integrated, elaborate, and highly pragmatic set of strategies and conventions. Given that this mode encourages random and multiple sites of motion (sometimes advertised as "brimming with animation"), filmmaking practices were often organized in such a way as to maximize these effects. Hepworth even suggests stopping and starting the camera based on whether or not the event is passing through an interesting phase. Surely here the makers are literally at the mercy of the pro-filmic, which "ignores" them so that they must subordinate their image making to the vagaries of the world.

The staging of movement in depth, more or less along the "z-axis," is a practical solution in dozens of "arrival of a train" and "chase" films, to keeping the event, and the interest, within the frame for as long as possible. This also accounts for the fact that in some railroad films (like *The Black Diamond Express* [1897]) persons alongside the tracks wave handkerchiefs at incoming trains in order to elicit a similar, animated response from the passengers. Likewise, tracking shots, from a gondola or a train, and pans emerged as practical solutions to dilemmas associated with representing events and objects (scenery, the wreckage at Galveston Harbor, a cityscape, rapidly moving people) over which the filmmaker could not exert a "director's" (or painter's) control of mise-en-scène. Pans and the like often attempted to keep the "interest" within the frame as it moved away. It is hardly surprising that the first viewfinders, developed by R. W. Paul in 1896 and Wray and Hughes in 1897, responded to the needs of the *"chasseur"* and in the process linked this mode of cinema ever more closely to embodied vision.[37]

Even at the risk of redundancy, I cannot overstress the importance that the notion of capturing an image had in reshaping image practice. The overabundance of "infinitesimal and often meaningless detail" criticized by still photographers is a natural corollary to a mode dedicated to the "mobilized gaze," which understood framing (in both its spatial and temporal forms) as an essentially artistic act while it simultaneously abandoned the traditional artist's ability and desire to control and construct a legible and unified visual world. Using our categories of early film realism, we might suggest that the filmic had begun to supersede the pro-filmic as the primary site of representational activity. On-the-spot capturing replaced the aesthetic of staging realistic events for filmic duplication. Although the altogether satisfactory solutions to problems of "secondariness" achieved by films from *L'Arrivée d'un train en gare à La Ciotat* to *Sortie d'usine Lumière* to *Dublin, départ de la gare: panorama* (1897) demonstrate that we should be wary of taking the phrase "beyond

the control" of the filmmaker too literally, it seems fairly certain that filmmakers often felt themselves to be at the mercy of a fickle visual world.

The sudden entrance and exits of foreground figures and the extreme spatial juxtapositions that resulted from, say, filming street scenes—from *Police Parade in Chicago* (1897) to *The Burning of Durland's Riding Academy, Londres: Piccadilly Circus* (1896), *Washington, défilé de l'artillerie du District Colombia* (a.k.a. *Inaugural Parade for President McKinley* [1897]), and *Jérusalem, port de Jaffa, côté est* (1897), which strike us as startlingly random and pictorially daring—were a source of concern for early filmmakers. In this vein, Stephen Bottomore demonstrates that early filmmakers even advised hiring assistants to redirect passersby out of their normal paths so that they would not create the blurred and "ill-defined forms" caused by "foreground intruders." [38] Despite practicing a mode that sought to capture events *sur le vif,* lingering demands for pictorial clarity and unity spawned a desire for more directorial control.

Nevertheless, the proliferation of images of the sort in which the formal properties of the representation were subordinate to the formal properties of the event or object encouraged a profound reorganization of both production and reception practices. Despite the broad range of possible attitudes toward these images, the dominant logic uniting them all involved a new understanding of the image as represented *vision*. Extremely popular filmic genres like the phantom train ride, which recorded scenes from the front of a train, and Hale's Tours, which gave the spectator an amusement-park replica of an actual train journey complete with filmed scenery, amplified this connection. As Wolfgang Schivelbusch and Charles Musser have pointed out, both the railway journey and the travel film offered viewers a technologically mediated experience of temporally fluctuating, scenic space. [39] For the purposes of the present argument, it bears reiterating that the railway film, like the railway journey, presents an ever-changing visual world that is beyond the control of both maker and spectator and whose character, like that of the parade, is one of temporal passage or escape. The physically situated character of visual experience is powerfully emphasized in these films because the characteristics of the visible world are directly dependent upon and attributable to the literal, physical position of the camera/spectator. The genre of the film panorama (also often made from a train) further emphasizes this logic of production and reading as it simultaneously reinforces a mode of spatial construction familiar to the purchasers of stereograph series—the multi-image panorama. Crucially, all these forms rely on a logic of spatial (and temporal) construction where the whole is understood as a collection

of discrete but cumulative *looks*. Picturing is yet again clearly a function of the world seen.

The importance of the beholder's physical location as fundamental to image production came to be recognized throughout visual culture. For example, stereographer Thomas Starr King, in an 1859 guide to photographing the White Mountains of New Hampshire, suggests familiarizing oneself with an area in order to "learn not only just where the best *pictures are to be seen*, but also what a great difference is made in the effect of a landscape by a slight change of position on the road."[40] Clearly the creative act here is seeing—or, more precisely, positioning oneself in relation to the scene so that it "composes itself." The intervention of the artist is exercised only through framing. The equation of seeing with picture making is not, however, confined to those in the business of pictures, for even Emerson had said, "To the attentive eye, each moment . . . has its own beauty, and in the same field it beholds, every hour, a picture which was never seen before and which shall never be seen again."[41]

In other words, although experience is best understood as transitory, as fluid, each instant can be understood as an organized image. Its uniqueness is a property of the fact that it exists in flux, which it is beyond our power to arrest, yet it is recognizable *as* unique and as significant precisely through its being seen attentively, being *recognized* as a complete image. The exercise of keen vision transforms the banal into the significant or beautiful. The pertinence of Emersonian aesthetics is far from coincidental, and their influence was not restricted to intellectuals. In fact, photographer and critic Elizabeth Flint Wade, in a piece entitled "Artistic Pictures: Suggestions How to Get Them," uses Emerson to support the *traditional* aesthetics of the image by taking his "artistic eye" to be practicing a very traditional form of pictorial composition. Focusing on his belief that the eye can approach the flux of reality and "detach" an isolated, organized moment, Wade draws a parallel with classical pictorial subordination: "Emerson says that the virtue of art lies in this detachment, in sequestering one object from the embarrassing variety, and in this power of detaching, and to magnify by detaching, lies the quality and capacity of the artist."[42] The author's use of the word "detach" offers a good description of one of the new image's more disruptive characteristics. So readily understandable was his view of the eye's relation to the visible world that Wade presents the following Emersonian description of artistic vision without attribution: "In Nature, the artistic eye finds a new and ever-varying aspect, even in the most familiar places."[43] Wade uses these references in support of a theory of art that is based on "the great

masterpieces," where compositional unity and subordination reign supreme. The concept of artistic vision as propounded by Emerson, however, assumes that such subordination, if in fact an Emersonian image would display subordination, is not a function of the artist per se but of the flux of the world, which *itself* forms organized images that the eye "detaches."

"Detachment" could obviously be thought of as a form of absence rather than as a creative act, but some forms of absence could be read as indices of, for example, the physical conditions of their inscription. Textual *absences* can be read as signifying the priority of a world *beyond* the limits of the immediate representation, held down by the contingencies of one particular view of it. It is a small step to move from this reading to an interpretation that understands these absences as narrational restrictions or focalizations—as decisions to abstract certain information from a particular context and to emphasize it.

Given that indexical readings demand that textual presences be read as traces of absent causes—as clues, in a way—the entirety of the visual surface came to be charged with potential significance, and therefore a series of such images could easily become a mere succession of unique and disconnected units. For fragmentation to become explicitly narrational, another hierarchical mode, suitable to the fragmentary form, was required. In a filmed Passion play, for example, each material unit corresponded to a narrational unit, and thus the material disunities of shot succession were negligible because they simply replicated narrative articulations. Fragmentary films, in contrast, generally lacked the internal temporal or spatial hierarchy and closure of the Passion play and thus its narrative strategies. They also typically broke the isomorphism between material unit and narrational unit. In other words, the shot no longer presented an entire event, except by implication.

When a wave threatens the rowers in *Barque sortant du port* and the shot ends before we discover the outcome, we can only achieve closure inferentially, by supposing, based on our experience, what *probably* happened afterward. Alternatively, such incompleteness might lead us to suppose that we had been attending to the wrong aspect of the shot, missing its "real" point. In a classical film, the processes of shot succession would likely clarify the previous shot. Had *Barque* been immediately followed by a closer shot of the figures on the pier, the implicit hierarchy of the previous shot would have been reordered, and were we to cut back to the original shot scale, our attention would likely be focused on these figures rather than on the boat. Of course, a closer shot of the figures in the boat would ratify our original assumptions about the image and its narrative function. Similarly, a foreground

"intruder"—like the man in the derby who runs through the shot in *A Mighty Tumble* (1901), or the figures who cross the foreground of *The Burning of Durland's Riding Academy*, or the one who crosses *Jérusalem*—could become the focus of a series of shots had the next shot "answered" the first and completed its action. Redundancy between successive textual units is one of the primary means of establishing narrational hierarchies and suprasegmental unities.

Redundancy of character was one of the earliest means by which producers sought to unite a group of films into a continuous series. The early Ben Turpin and Happy Hooligan series allowed exhibitors to create multishot unities that would exhibit a continuity both logical and easily understood by audiences. The use of Rube and Mandy in a series of Coney Island films likewise provided a pretext for combining groups of views, while it simultaneously drew attention to a particular aspect of the frame. In short, the figures created an effect of foregrounding even when they appeared, literally, in the background of a scene. Foregrounding need not always be a narrative technique, but pictorial hierarchies that *were* explicitly narrational played an important part in establishing what Burch calls the "linearization of the iconographic signifier"—a kind of self-contained logic of image reading—while they also greatly facilitated linearity in editing.[44] Foregrounding was especially important to the combination of views because it provided a hierarchy of elements within the individual shot that needed to continue across cuts while drawing attention away from background elements, which could therefore be discontinuous.

The chase film is particularly interesting in this regard. In a such films as *Personal* (1904) and *Meet Me at the Fountain* (1904), the presentational mode of the "cinema of attractions" meets an emergent mode of narrative integration.[45] As the aspiring brides pursue the nobleman over a series of obstacles, the spectator is encouraged (indeed, required) to understand the series of shots as temporally successive glimpses of the "same" event—a continuous chase. What strikes modern viewers as unusual, however, is the fact that instead of cutting to the next shot after the nobleman exits the frame and we are aware of the pursuers (which is all the narrative requires), we remain with the same shot until every pursuer has cleared the obstacle. Tom Gunning correctly points out that this tendency reflects the persistence of a logic of *display* within a logic of narrative linearity. Although compositionally hierarchized, the chase narrative is not yet the dominant or determining logic of image construction or combination.

From the point of view of classical narration, such techniques appear residual and out of place, but for the present discussion they represent an interesting and

crucial point of transformation. Transgression of the frame by the moving characters accords with the fragmentary mode of image production, yet unity is here achieved by allowing the phenomenal event to "pass through" the frame in its entirety. Here, as in an apparently "captured" image, material representational form is subservient to event form, but the very idea of the unity of the event is itself an issue. Despite its gestures toward narrative linearity and succession, the event still retains a *phenomenal* rather than strictly narrative unity. Given their relative autonomy, individual shots could easily be removed or rearranged without disturbing the overall progress of the narrative. On the other hand, had the chase been handled by cross-cutting the pursuers and pursued in separate shots, the kind of causal and temporal linearity that would result precludes any textual rearrangement. Of course cross-cutting—or even shooting the nobleman's approach from one side of the fence with the pursuers in the background, and following it with a reverse shot showing his leap over it and his flight into (what is from this angle) the background—implies a radically different approach to the shot/event relationship, and what is more, to the shot/series relationship.

In both alternatives, the unity of the event (the chase) exists purely at the level of the narration and the text, not at the level of the phenomenal, "real" event. Like the famous example from *Henley Regatta* (1899), where shots of boats on the river are intercut with reaction shots of waving crowds from the river,[46] scenic space has been penetrated with little regard for the inherent unity of the phenomenal event, and a new narrative, point-of-view logic of seer/seen motivates the construction of a plausible, diegetic, but not necessarily real space and time.[47]

In comparison with D. W. Griffith's style, which deploys "linearized" frame cuts while still keeping the camera external to the space of performance, a camera that changes scale, moves in and out of the playing space, isolates significant details, and establishes hierarchies of vision (through POV shots and so on) can more efficiently control the flow of narrative information. A closeup of the villain secretly fingering a hidden knife or a bottle of poison effectively presents an important bit of narrative information while allowing the spectator to realize that the apparent victims are unaware of this fact—creating the hierarchy of knowledge essential to suspense. Accomplishing this in a full shot of both characters would require improbably clever staging or would otherwise stretch the bounds of plausibility. Hence, scene dissection and narratively motivated camera placement and framing were essential developments for Hollywood's generally omniscient style of narration.

To arrive at the highly mobile camera, multishot scene construction, and narrative omniscience characteristic of the mature classical cinema from *L'Arroseur arrosé* or *Barque sortant du port* required an enormous conceptual and practical transformation. The match-on-action cut, for example, so essential to classical scene construction, represents a full reimagining of cinematic space and time. This device assumes, in contrast to earlier narrative articulations, an event whose unity is *constructed*, which depends not at all on the unity of a "real" event or material unit and which is presented, crucially, in fragments. These fragments, because they are essentially incomplete, allow for a temporal articulation that is unidirectional and irreversible. Simultaneously, the irreversibility of the connection solidifies the unity of the represented event over the discontinuity of the material, drawing spectator attention almost entirely to the narratively important event, which provides the dominant, and often only, continuation or connection between shots.

I have tried to indicate the extent to which these conceptual developments derive from very concrete, material conditions of production—often from practical exigencies, beginning with the distinction between the staged and the unstaged film and moving to the cusp of the classical narrative. I believe that the unstaged film provided the building block for classical scene construction because it simultaneously linked a form of fragmentation that implied a disrupted continuity with a sense of the image as represented vision. What remained was a motivation for a new logic of spatial and temporal organization that was additive, diegetic, (i.e., independent of real space-time relationships), unified, and narrational. To that extent, the notion of images as represented (and often embodied) vision seems crucial.

The general logic of secondariness and especially of images understood as represented, embodied vision underwrote one of the cinema's most important protoforms, the stereograph travel lecture. Here the apparent contingency of any single image could be easily accommodated. The lectures of John Stoddard, Edward Wilson, and Burton Holmes illustrate that speakers often grouped a lengthy series of landscape views through the fiction of a journey.[48] They would often go so far as to create a spatially coherent world by linking landscape fragments through a spoken narrative, saying, for example, "We are now looking in the opposite direction from the last image."[49] The use of stereographs as the illustrative medium placed a strong emphasis on the implied presence of an embodied looker by way of an exaggerated sense of space and through a narrative that created the pretext of a subject who united and motivated the views. Even the relatively "undisciplined" character of

stereograph composition and syntax could be justified by appealing to the situated-ness of the vision it sought to represent.

It is not difficult to see how the lecturer/traveler functioned as a kind of "proto-narrator" in the early cinema period. Importantly, this implied a recognition of the continuity or unity of an image or series of images at a level beyond that of the in-dividual unit. In other words, the coherence or identity of any individual image might lie in its relationship to the series to which it is understood as belonging, whether explicitly, as in the travel lecture, or implicitly, in the case of the single "contingent" view, which is understood as a dramatization of embodied seeing. This interpretive heuristic was an important one in the development of cinematic comprehension because it allowed for a penetration of scenic space while simulta-neously denying that scenes were staged *for* the spectator. Street-scene films (like *New York* [ca. 1896-1897]) and rather typical parade films (like *Chicago Police Parade* and *Inaugural Parade for President McKinley*) illustrate how an *inability* to see and to comprehend could be an effective rhetorical device for signifying the experience of watching a parade from a physically specific location. The very contingency and incompleteness of the parade view effectively indicates the status of that view as *glimpsed* rather than displayed.

Nevertheless, the "secondary" but embodied spectator did not solve all of the narrational problems of the emerging narrative cinema. One of the primary forms of spatial penetration involved placing a viewer within the scene. A film like *The Story the Biograph Told* (1904) is particularly interesting in that we understand the peculiarities of an individual image's framing as indicating a represented experience of vision, and simultaneously as a view of an event that we have already seen from another angle. In attributing the qualities of a shot to the perspective of a character, *Biograph* mobilizes "represented vision" for explicitly narrational ends, using it as a form of focalization. While the "absences" or peculiarities of such images, I have ar-gued, were already typically interpreted as indicating represented vision, here this absence functions as narrative withholding. Decisively, too, the spectator no longer is encouraged to place himself or herself at the site of vision, but rather to attribute that vision to a character.

Perhaps even more significantly, the succession of two different points of view on a "single" event strongly reinforces the idea that a pro-filmic event really does exist independent of the act of representation. In other words, despite being overtly "staged," the use of the strategy of represented vision takes advantage of the appar-ent obliviousness of the event to the act of representation, but turns it to new ends.

Here the mode of realism is no longer filmic, as it is in the travel lecture or the single-shot actuality, but is diegetic. The spatio-temporal relations of shot to shot are not necessarily indexical, as they would be in the case of a truly unstaged film, but purely a function of their construction on the screen. In the case of a more classical use of point of view, the change in angle accompanied by continued action would imply that an event had simply continued across the cut and that it had a pro-filmic unity and coherence. Indeed, it would imply that there *is* such a thing as a pro-filmic event independent of its screen representation.

Almost from the start, cinematic authenticity had been linked to the "obliviousness" of the represented world to the act of representation and therefore to the look of the spectator. But how could a mode of representation that presupposed the spectator as the locus of textual intelligibility, which organized its texts in order to ensure predictable effects on the all-important, paying spectator, nevertheless create the impression that these were real, convincing, and unstaged events? In these cases, obliviousness is every bit as staged as any other aspect of the film, but it does provide a diegetic pre-text for a penetration of the represented space by a look, and it simultaneously establishes a hierarchy between audience, looker, and looked at, typical of classical narration. Here, despite the temporal gap between our first view and the subsequent view in the theater, we see the logic of the POV shot and its narrational possibilities *in nuce*, where obliviousness is clearly an indication of narrational focalization and hierarchy, as well as a textual indication of the event's authenticity and immediacy. Here, anticipating the classical film, space and narration have become subjective.

Many apparently "unstaged" films did, however, feature an explicit recognition of the camera-observer within the world of the representation, just as nowadays documentaries and news footage routinely show people reacting to the intrusive presence of the camera as a spectator. This form of spectator recognition should not be confused with the theatricality of *L'Arroseur*, since in these examples the observer is not marked as disrupting a world existing independently of the act of representation. The event still unfolds beyond the representer's control, but the participants recognize the presence of the camera's mechanical gaze. The more important criterion of authenticity is the sense communicated that the world shown is interfered with only by the act of looking.

Interestingly, still photographers had already begun to address the problem of creating the immediacy of an "oblivious" scene, without incurring the problems associated with "snapshots" or chance images, by mixing the structuring hierarchies

of "art" with the signifiers of immediacy, now detached from production-based causes. An 1895 account of this technique is particularly revealing. Significantly, the type of photograph that lends itself to these effects is not the photograph in general, the snapshot, or the narrative photo, but the "genre" scene. The writer could very well be describing the techniques of the classical cinema: "There should be nothing 'stiff' about a genre photograph, everything should appear true, no matter how carefully the artist may have composed the picture. In fact, the more carefully the composition has been studied, the more natural it will inevitably appear." The injunction to appear "natural" and not stiff is discussed in terms of careful posing, though not, of course the posing of *Arroseur*. In order to achieve the effect of immediacy, the writer offers one particular, concrete suggestion: "In arranging a group, a photographer should not hesitate to *turn the back of some of his figures toward the camera* if it will enhance the effectiveness of the composition."[50] It is a short step from here to the adoption of the ban on looking at the camera promoted vigorously by critics like Frank Woods after 1909.

In *What Happened on Twenty-Third Street, New York City* (1901), whose very title seems to signify "actuality," we can see both the "obliviousness" effect and what I understand as its dialectical absorption into an emergent cinema of narrative integration. The film begins as a typical street scene, with the typical density of action and lack of compositional hierarchy. Several people turn and look directly at the camera, acknowledging its real presence in the midst of their world. Coupled with the lack of significant action, this typically signifies an "unstaged" event. The looks toward the camera multiply and reiterate the observer's presence not as audience but as witness—an interruption or intrusion in the flow of the represented world. Finally, however, a couple emerge from the background who, unlike the others, do seem oblivious to the camera. The film ends, with the woman's skirts blown up, exposing her to the gaze of the (presumably male) spectator, whom she significantly acknowledges with a conspiratorial smile.[51] For the "accident" to be convincing and pleasurable, the fiction must be maintained that there is no prior beholder—that the event does not *presuppose* the spectator's look—as if, invisible to the woman, we simply "caught" this chance moment. Recognizing the signifiers or indices of authenticity, the filmmakers have *mimed* them and placed them within an authentic milieu. The embodied seer has become the "invisible witness" of later cinema. Adopting marks that had come to be recognized as indices of a particular situation of image production, the filmmakers employ them as devices for creating a break between the space of representation and the space of reception— that is, denying the copresence of image (represented world) and spectator.

Likewise, fragmentariness of action, once a kind of pictorial "noise" or excess, here creates an authentic background and will serve later cinema as the condition of possibility for the match-on-action cut. In this manner, the mark of an event's disunity becomes the material of what Noël Burch calls its "linearization." The incompleteness of an event is no longer a mark of representational disunity but of unity at another level—the promise that the next shot will complete it. Such a set of practices produces the fiction that there is indeed a pro-filmic event—an event that is whole and independent of this particular representation. The technological and the representational intertwine here, as concrete indications of the camera's physical relation to the event; they are remotivated as signifiers of the fiction of its absence. In effect, everything is still done *for* the camera but *as if* there were no camera. Only by way of such a shift in the basic order of the image could the cinema of narrative integration emerge. Sacrificing the specificity of the individual fragment and the identity of the individual image, suppressing a material *discontinuity*, allowed for the production of continuity at the level of the classical narrative.

Notes

1 Francisco de Hollonda, *Four Dialogs on Art*, trans. Aubrey F. G. Bell (London: Oxford University Press, 1928), 15–16; quoted in Svetlana Alpers, *The Art of Describing: Dutch Art of the Seventeenth Century* (Chicago: University of Chicago Press, 1983), 19–22.

2 John Bull, Jr., "Photography in America, as Viewed by an Englishman," *American Amateur Photographer* 7, no. 4 (April 1894): 144.

3 Elizabeth Flint Wade, "Artistic Pictures: Suggestions How to Get Them," *American Amateur Photographer* 5, no. 10 (October 1893): 441.

4 Articles in 1893 and 1894 asked, "Combination Printing: Is It Legitimate in Photography?" and "Are Composite Photographs Typical Pictures?" Before the massive dissemination of hand cameras, photographers commonly combined sections of more than one properly exposed negative during the printing process in order to achieve maximum clarity in an image whose elements (such as a sea and a sky) would required different exposures. They also frequently combined different partial images into a narrative whole otherwise impossible. See W. K. Burton, "Combination Printing: Is It Legitimate in Photography?" *Pacific Coast Photographer* 2, no. 5 (June 1893): 318–320; and H. P. Bowditch, "Are Composite Photographs Typical Pictures?" *McClure's Magazine* 3 (September 1894): 331–334. See also W. deW. Abney, "Are Instantaneous Photographs True?" *International Annual of Anthony's Photographic Bulletin* 2 (1889): 256–257.

5 Max Hilzberg, "Mechanical Aids to Artistic Photography," *American Amateur Photographer* 7, no. 5 (May 1895): 191–198.

6 This is not to say, however, that these categories are necessarily mutually exclusive. Indeed, it seems more likely than not that various combinations of these representational dispositions operate in any given situation.

7 See, for example, "How the Cinematographer Works and Some of His Difficulties," *Moving Picture World* 1, no. 11 (May 18, 1907): 165; and "Behind the Camera: Films 'Studied' Again," *Views and Films Index* 3, no. 20 (May 30, 1908): 8.

8 Ibid.

9 Alpers, *The Art of Describing*, xxv.

10 Ibid., xxv.

11 Michael Fried, *Absorption and Theatricality: Painting and Beholder in the Age of Diderot* (Chicago: University of Chicago Press, 1980). See especially "The Primacy of Absorption," chap. 1.

12 Alpers makes the point that lookers within a northern painting never look out of their world at the spectator because to do so would be a contradiction in representational terms. It is hardly difficult to make the leap to the practice in the classical cinema of avoiding the look at the camera.

13 "The Moving Picture Industry," *Nickelodeon* 1, no. 5 (1909): 132.

14 Quoted in Patrick Maynard, "Drawing and Shooting: Causality in Depiction," *Journal of Aesthetics and Art Criticism* 44, no. 2 (Winter 1985): 117.

15 On the history of the idea of the "chance" image, see H. W. Janson, "The 'Image Made by Chance' in Renaissance Thought," *De Artibus Upuscula XL: Essays in Honor of Erwin Panofsky*, ed. Millard Meiss (New York: New York University Press, 1961), 254–266.

16 *Literary Gazette* (London), July 13, 1839; Oliver Wendell Holmes, "The Stereoscope and the Stereograph," *Atlantic Monthly* 3, no. 20 (June 1859): 744; *London Globe*, August 23, 1839; Francis Frith, "The Art of Photography," *Art Journal*, 1859, emphasis added.

17 Holmes, "The Stereoscope and the Stereograph," 745.

18 Wade, "Artistic Pictures," 441.

19 The term "topographic" comes from Noël Burch, *Life to Those Shadows*, trans. and ed. Ben Brewster (Berkeley and London: University of California Press, 1990), 138–159, especially 152.

20 Maynard, "Drawing and Shooting," 119.

21 Max Madden, "Photography with a Purpose," *American Amateur Photographer* 7, no. 10 (October 1895): 442.

22 Maguire and Baucus catalog (1894), kinetoscope scenes; International Film Company catalog (ca. 1896); Edison Films catalog (July 1901), Northern Pacific Railway Series; in *Motion Picture Catalogs by American Producers and Distributors, 1894–1908*, ed. Charles Musser (Frederick, Md.: University Publications of America, 1984).

23 On the subject of represented smoke, among other things, see Stephen Bann, "Odd Man Out: Historical Narrative and the Cinematic Image," *The Inventions of History: Essays on the Representation of the Past* (Manchester and New York: Manchester University Press, 1990), 171–199.

24 Jacques Aumont, *L'Oeil interminable: peinture et cinéma* (Paris: éditions Seguier, 1989), 37–72; also excerpted in this volume. It is important to note that in contrast to Alpers' view of the classical tradition as necessarily double, Aumont treats the tradition as single. In addition, Anne Friedberg has used this phrase in her book *Window Shopping* (Berkeley: University of California Press, 1993). My sense of its importance includes both Aumont's meaning and Friedberg's more general application of the term.

25 Peter Galassi, *Before Photography: Painting and the Invention of Photography* (New York: Museum of Modern Art, 1981), 25. Certain of Galassi's claims in this essay seem highly problematic, especially his concern with photography's "legitimacy," but these need not impinge on the present discussion.

26 Alpers, *The Art of Describing*, 52.

27 See Malcolm Andrews, *The Search for the Picturesque* (Stanford: Stanford University Press, 1989), 39–73.

28 Ibid., 68.

29 Stereoscope literature teems with examples of suggestions concerning "what a great difference is made in the effect of a landscape by a slight change of position on the road" as well as claims that stereographs can, almost literally, place one in the spaces formerly occupied by the photographer. See, for example, Thomas Southall, "White Mountains Stereographs and the Development of a Collective Vision," in *Points of View: The Stereograph in American Culture*, ed. Edward Earle (Rochester: Visual Studies Workshop, 1979), 98; Albert E. Osborne, *The Stereograph and the Stereoscope* (New York: Underwood and Underwood, 1909), especially "Experiences of Travel with Stereographs," chap. 5.

30 Félix Mesguich, *Tours de manivelle, souvenirs d'un chasseur d'images* (Paris: Bernard Grasset, 1933).

31 "Hints to Film Manufacturers," *Moving Picture World* 1, no. 23 (August 10, 1907), 357.

32 "How the Cinematographer Works and Some of His Difficulties," *Moving Picture World* 1, no. 15 (June 15, 1907): 230. For further examples of this aesthetic, see also Valentine Blanchard, "The Procedure of the Painter and Photographer Contrasted," *Pacific Coast Photographer* 2, no. 3 (April 1893): 274; "Letters to a Friend: Who Wishes to Make Pictures with His Camera," *Pacific Coast Photographer* 2, no. 12 (January 1894): 473, 476; and "Composition," *Pacific Coast Photographer* 1, no. 6 (July 1892): 104.

33 This particular mode of image reading did not simply dominate, however, so when a photographer produced an image lacking in classical hierarchy and subordination, in uniformly

sharp focus, with no portrayal of a significant human action, critics were still likely to cry foul. A critic surveying an 1895 amateur photography exhibition complained that he "could not help noticing the painful efforts of the photographers to include as much unnecessary detail in each photograph as Zola will put in one of his novels." Hilzberg, "Mechanical Aids to Artistic Photography," 192. Many other writers reiterated these criticisms, claiming that photographs were too "graphically correct" and offered "too much infinitesimal and often meaningless detail." Leon van Loo, "Photography: What Are Its Possibilities in the Art Field Compared with Those of Painting?" *American Amateur Photographer* 7, no. 6 (June 1895): 269. The conflict between what I term the "modes of picturing" is consistently articulated here as a division between art and nonart, which is itself mapped on a distinction between narrative and descriptive forms.

34 Howarth Woodhouse, "Art in Photography," *American Amateur Photographer* 6, no. 4 (April 1894): 184.

35 Marshall Deutelbaum, "Structural Patterning in the Lumiére Films," *Wide Angle* 3, no. 1 (1979): 28–37.

36 Hepworth describes having an assistant with a stopwatch time events so that he could better judge when it would end and could adjust his cranking rate so that enough film would remain. Cecil Hepworth, *Animated Photography: The ABC of the Cinematograph* (n.p., 1897), 97.

37 See Stephen Bottomore, "Shots in the Dark: The Real Origins of Film Editing," in *Early Cinema: Space, Frame, Narrative*, ed. Thomas Elsaesser (London: BFI, 1990), 104–113.

38 Henry Hopwood, *Living Pictures*, quoted in Bottomore, "Shots in the Dark," 111.

39 Wolfgang Schivelbusch, *The Railway Journey: The Industrialization of Time and Space in the Nineteenth Century* (Berkeley: University of California Press, 1986); Charles Musser, "The Travel Genre in 1903–1904: Moving toward Fictional Narrative," in *Early Cinema*, ed. Elsaesser, 123–132.

40 Quoted in Southall, "White Mountains Stereographs," 98.

41 Ralph Waldo Emerson, quoted in Richard Rudisill, *Mirror Image: The Influence of the Daguerreotype on American Society* (Albuquerque: University of New Mexico Press, 1971), 17.

42 Wade, "Artistic Pictures," 441.

43 Ibid., 444.

44 Burch, *Life to Those Shadows*, 147.

45 See Tom Gunning, "A Cinema of Attractions: Early Film, Its Spectator, and the Avant-Garde," *Wide Angle* 8, nos. 3–4 (1985): 63–70.

46 See Elsaesser, ed., "Introduction to Part 1," *Early Cinema*, 15; Bottomore, "Shots in the Dark," 113 n. 30; and Georges Sadoul, *Histoire générale du cinéma*, vol. 2, *Les pionniers du cinéma: De Méliès à Pathé, 1897–1909* (Paris: Éditions Denöel), 135.

47 D. W. Griffith's ubiquitous "frame cuts," whereby a character's exit frame-right or frame-left occasions a shot change to a contiguous space, create a powerful sense of linear, causal irreversibility, but the camera rarely penetrates or dissects the space, leaving the unity of the *profilmic space* (whose left and right boundaries match the limits of the frame) intact, such that the space of performance, if not the event itself, still dominates the narrational strategies. While the import of Griffith's shots is always fairly clear (his spaces narratively hierarchized through careful foreground/background staging) and the shot-to-shot articulations "linearized" by character movement, the "externality" of the camera robs it of a potential function as a narrational tool.

48 Charles Musser, "Toward a History of Screen Practice," *Quarterly Review of Film Studies* 3, no. 1 (Winter 1984): 67. See also Theodore X. Barber, "The Roots of Travel Cinema: John L. Stoddard, E. Burton Holmes, and the Nineteenth-Century Illustrated Travel Lecture," *Film History* 5, no. 1 (March 1993): 68–84.

49 Edward Wilson, "How They Live in Egypt," *Wilson's Lantern Journeys* (Philadelphia: Edward Wilson, 1874–1886), 3:215, quoted in Musser, "Toward a History of Screen Practice," 69. Wilson's were probably the most widely used sets of slides and prepared lectures in the late nineteenth century, and they allowed even unpracticed and untraveled lecturers to give competent descriptions of imaginary journeys to other lands.

50 Hugo Erickson, "Genre Photography," *American Amateur Photographer* 7, no. 5 (May 1895): 202, 204.

51 Confounding any simple determination of the woman's or the spectator's scopic relationship, her smile acknowledges her complicity with the drama of erotic display. This point is of great importance for understanding the relations of sexual difference as constructed by the cinema, especially with regard to questions of voyeurism and exhibitionism, but does not necessarily alter the claims I make in this essay.

Snapshots
The Beginnings of Photography

ROBERT B. RAY

In the late twentieth century, the ubiquity of photography, especially as a document of certain events, has engendered a longing for both its earlier invention and its more extensive presence. We now wish that photography had always existed and that it had been everywhere. What did certain things look like exactly—the expression on Napoleon's face when Moscow first appeared in the distance? the hands of John Wilkes Booth, in hiding, waiting to assassinate Lincoln? the clothes worn by the Council of Trent? Einstein at the moment of completing the theory of relativity? More and more, to have not seen becomes equated with Walter Benjamin's definition of *catastrophe*: "to have missed the opportunity."[1]

Nothing encourages this desire for photographic evidence more than the cinema, which, as Jean-Luc Godard has pointed out, always provides, at the very least, a documentary record of a particular moment's objects and people: as Godard said about his own *Breathless*, "This film is really a documentary on Jean Seberg and Jean-Paul Belmondo."[2] Thus, if we want to know, for example, what Jean Harlow looked like less than a week after her husband Paul Berne was found dead in an apparent suicide, we have only to look at a scene from *Red Dust*, shot on her first day back on the set but edited without the closeups that her haggard appearance made unusable.[3] In fact, Hollywood's version of the cinema, what Noël Burch calls the Institutional Mode of Representation, dramatically stimulates the desire, and even the expectation, to observe everything.[4] By implicitly guaranteeing its audience the ideal vantage point for every narratively relevant event, by visually underlining (with, for example, closeups, rack focusing, and camera movements) every important detail or expression, Hollywood's "invisible style" accustoms us to expect photographic accompaniment for everything that might prove significant.

What about the origins of photography itself, its first moments of invention and use? What would they look like on film? What if, by the sheerest chance, we came across a roll of film containing a photographic record of just those things, but pro-

duced by a camera whose strange mechanism, an alternative to the lineage of our own, has been lost. Searching for a manual, we fall upon these remarks, which will serve as our instructions: "The past has left behind in literary texts images of itself that are comparable to the images which light imprints on a photosensitive plate. Only the future possesses developers active enough to bring these plates out perfectly."[5] Think, then, of each of the following sections as a snapshot of photography's beginnings, developed in terms of our current interests in texts, their ways of producing meaning, and their relation to what we still call "the real."

1

In the course of his first random stroll through the boulevards and the rue de la Paix, Lucien, like all new-comers to Paris, took more stock of things than of persons. In Paris, it is first of all the general pattern that commands attention. The luxury of the shops, the height of the buildings, the busy to-and-fro of carriages, the ever-present contrast between extreme luxury and extreme indigence, all these things are particularly striking. Abashed at the sight of this alien crowd, the imaginative young man felt as if he himself was enormously diminished.

Honoré de Balzac, *Lost Illusions*

In the twenty-year period from 1830 to 1850, when the hero of Balzac's *Lost Illusions* arrives in Paris, many of the features associated with "modern life" begin to appear for the first time: the metropolis, the daily newspaper, mass transit, the department store, the democratization of culture. In particular, between 1839 and 1842, three things happen: the word *photography* begins to be used for the first time in English and German,[6] the *physiologies* become the first best-selling mass-market paperback books, and Poe invents the detective story. What connects these three developments?

Dana Brand has argued that modern urban life provoked a crisis of "legibility."[7] As newcomers swarmed into the cities, abandoning their native surroundings that time, size, and tradition had rendered effortlessly comprehensible, anonymity became a condition that almost everyone experienced at some point during the day—in a remote *quartier*, visited for the first time on business; on an unknown street, turned down by mistake; in a neighborhood encountered in the morning rather than the afternoon. Inevitably, this dislocation encouraged crime: "It is almost impossible," Benjamin quotes a Parisian undercover policeman observing, "to maintain good behaviour in a thickly populated area where an individual is, so to speak, unknown to all others and thus does not have to blush in front of anyone."[8] In December 1840 Edgar Allen Poe explicitly connected crime to the illegibility of

the anonymous "man of the crowd," who like "a certain German book . . . does not permit itself to be read." That man, for whom Poe's literate narrator can discover no comforting classification, stands for "the type and the genius of deep crime."[9]

Thus, a proposition: what cannot be read threatens. The first sites of this new anxiety were Paris and London, vast metropolises where people could disappear without a trace, where (as in Balzac and Dickens, the great chroniclers of the potential anonymity haunting all urban identities) credentials, antecedents, and even names became suspect. The first clue connecting this experience to photography is geographical: photography was invented almost simultaneously in France (by Niepce and Daguerre) and in England (by Fox Talbot).

2

The Count de Lanty was small, ugly, and pock-marked; dark as a Spaniard, dull as a banker.

Balzac, *Sarrasine*

In *S/Z*, an analysis not only of Balzac's *Sarrasine* but of all popular narratives, Barthes repeatedly asks, how does Balzac know that Spaniards are dark, bankers dull? Barthes answers by proposing that the realistic novel works precisely to ensure that the source for such a sentence "cannot be discerned": "Who is speaking? Is it Sarrasine? the narrator? the author? Balzac-the-author? Balzac-the-man? romanticism? bourgeoisie? universal wisdom? The intersection of these origins creates the writing."[10] Barthes labels these formulaic expressions ("dark as a Spaniard," "dull as a banker") "cultural codes" or "reference codes" and traces their origin not to reality itself, but to representations of it: "The cultural codes, from which the Sarrisinean text has drawn so many references, will also be extinguished (or at least will emigrate to other texts; there is no lack of hosts) . . . In fact, these citations are extracted from a body of knowledge, from an anonymous Book whose best model is doubtless the School Manual."[11]

For Barthes, of course, the term "School Manual" functions as a metaphor for the imaginary collation of common sense, received ideas, and cultural stereotypes on which the Reference Code relies. In fact, however, something very like actual manuals, guides to the urban scene, did achieve enormous success in Paris between 1840 and 1842: the *physiologies*. The first mass-market, paperback, pocket-sized books, the *physiologies* proved enormously appealing to readers wanting an immediately legible account, however misleadingly simplified, of the cosmopolitan crowd. Roughly 120 different *physiologies* appeared during these three years, each

offering what historian Richard Sieburth has called "pseudo-scientific portraits of social types": "the Englishman in Paris," "the drinker," "the creditor and the retailer," "the salesgirl," "the deputy," "the stevedore," and so on.[12] As books, the *physiologies* were brief, averaging around 120 pages, with thirty to sixty illustrations.[13] While the *physiologies* were not typically comic, their format obviously derived from the same ethos that had spawned the caricature, a form which, in fact, dominated the books' visual style.

Whatever usefulness the *physiologies* purported to have rested on a single, profound faith in the reliability of appearances. As Benjamin observed of these books, "They assured people that everyone was, unencumbered by any factual knowledge, able to make out the profession, the character, the background, and the life-style of passers-by."[14] Dana Brand points out that the plot of Poe's "The Man of the Crowd" turns on the narrator's frustrated desire to "read" the people who pass his coffeehouse window. Having identified (at least to his own satisfaction) noblemen, merchants, attorneys, tradesmen, stock-jobbers, clerks, pickpockets, gamblers, "Jew pedlars," professional street beggars, invalids, prostitutes, and "ragged artisans and exhausted laborers of every description," the narrator becomes fascinated by the illegible man to whom none of the ready-made categories apply. Sieburth summarizes the *physiologies*' appeal: "They served to reduce the crowd's massive alterity to proportions more familiar, to transform its radical anonymity into a lexicon of nameable stereotypes, thereby providing their readers with the comforting illusion that the faceless conglomerations of the modern city could after all be read—and hence mastered—as a legible system of differences."[15]

This "legible system," as *S/Z* shows, is complicit with a culture's worldview: in Barthes' words, "If we collect all such knowledge, all such vulgarisms, we create a monster, and this monster is ideology."[16] But a recent *New York Times* article linking the persistence of stereotypes to their "usefulness" concludes that "the new explorations of the cognitive role of stereotypes find them to be a distortion of a process that helps people order their perceptions. The mind looks for ways to simplify the chaos around it. Lumping people into categories is one."[17]

3

We didn't trust ourselves at first to look long at the first pictures he [Daguerre] developed. We were abashed by the distinctness of these human images, and believed that the little tiny faces in the picture could see *us*, so powerfully was everyone affected by the unaccustomed clarity and the unaccustomed truth to nature of the first daguerreotypes.

Max Dauthendey, quoted in Walter Benjamin, "A Small History of Photography"

If the *physiologies* offered to make urban life more comfortable by first making it more legible, photography must initially have seemed part of the same project. Soon after its discovery, the new technology became part of the proliferating systems of registration and surveillance described in Benjamin's *Charles Baudelaire: A Lyric Poet in the Age of High Capitalism*. Fingerprinting, physiological measurements, and photographs recorded identity, enabled its tracking, and circumscribed its possible escape routes into anonymity. After photography, the kind of situation described in *The Return of Martin Guerre*, in which a man posing as a long-vanished husband fools an entire town, appeared decisively premodern.[18]

Like the *physiologies*, photography could boast a pseudoscientific basis and play into the late-eighteenth- and early-nineteenth-century rage for classification. But while the new technology seemed the ideal means of gathering the empirical data required by any system, almost immediately the first photographers noticed something going wrong. One historian cites Fox Talbot's surprise at what he found:

And that was just the trouble: fascinating irrelevancy. "Sometimes inscriptions and dates are found upon buildings, or printed placards most irrelevant, are discovered upon their walls: sometimes a distant sundial is seen, and upon it—unconsciously recorded—the hour of the day at which the view was taken." To judge from his commentaries, Fox Talbot enjoyed such incidentals. At the same time, though, they were troublesome, for they meant that the instrument was only partially under control, recording disinterestedly in despite of its operator's intentions.[19]

The *physiologies* had subsumed all idiosyncrasies under the rule of the controlling term: "the banker," "the Spaniard." Indeed, their format seemed derived from La Fontaine's dictum, "Nothing more common than the name, nothing rarer than the thing."[20] Photographs, on the other hand, swarming with accidental details unnoticed at the time of shooting, continually evoked precisely what eluded classification—the distinguishing feature, the contingent detail. In doing so, they undercut the *physiologies'* basic project, which photography now revealed to be committed exclusively to language as a way of understanding and ordering the world. What resisted the narrator's efforts to read the man of the crowd?—"the absolute idiosyncrasy of [his] expression."[21]

By showing that every Spaniard was not dark, every banker not dull, photographs effectively criticized all classification systems and ensured that any such system attempted in photography (e.g., August Sander's) would inevitably appear not as science but as art. In fact, while the longing for strictly objective, and there-

fore *exact*, representation had motivated photography's invention, photographs produced precisely the opposite effect—a mute ambiguity that invited subjective reverie. Quoting the semiotician Mukarovsky, Paul Willemen has proposed that "the signifying practices having recourse to images can thus be described . . . as 'designed to render things imprecise,' as a movement towards indeterminacy."[22] Thus, photography becomes yet another example of what Edward Tenner has called the "revenge effect" of all technology: a process designed for one purpose turns out not only to subvert that purpose but to achieve its opposite.[23]

4

Beyond the obvious facts that he has at some time done manual labour, that he takes snuff, that he is a Freemason, that he has been in China, and that he has done a considerable amount of writing lately, I can deduce nothing else.

 Arthur Conan Doyle, *The Complete Sherlock Holmes*

That the first detective story (Poe's "The Murders in the Rue Morgue") appeared in 1841, at the height of the *physiologies* craze, and that its author felt obliged to set his tale in Paris, a place he had never been, both suggest the existence of an underlying connection between the two forms. In fact, the detective story represents a transposition of the *physiologies*, an extrapolation from that earlier mode's purely descriptive purposes to narrative. Like the *physiologies*, the detective story offered to make the world, and particularly the urban scene, more legible. To do so, it relied incessantly on the very reference codes the *physiologies* had propagated. Thus, for Sherlock Holmes, physical evidence is always unproblematically indexical: "the writer" will inevitably display a shiny cuff and a worn elbow patch, "the laborer" a muscular hand, "the visitor to China" a particular Oriental tattoo.

Although the detective story arose almost simultaneously with the *physiologies*, it flowered only after their demise. In effect, it was not needed until later when it functioned as an antidote to photography. "Between what matters and what seems to matter," *Trent's Last Case* begins, "how should the world we know judge wisely."[24] By dramatically increasing the available amount of particularized information, photography not only undercut the *physiologies'* vulnerable, simplistic schema; it ensured that in every context where it intervened, distinguishing the significant from the insignificant would become treacherous. "The principal difficulty of your case," Holmes tells his client in "The Naval Treaty," "lay in the fact of there being too much evidence"[25]—precisely the problem, the proliferation of

meaning, for which Susan Sontag blames photography.[26] Thus, the first Sherlock Holmes story, "A Scandal in Bohemia," inevitably revises Poe: the new threat, which the detective must find and destroy, is no longer a purloined letter but an incriminating photograph.

And yet this story has another side, suggested, perhaps, by a coincidence of names and a convergence of ideas:

Holmes 1: The "distinctness of the lesser details of a building or a landscape often gives us the incidental truths which interest us more than the central object of the picture."

Holmes 2: "If I take it up I must consider every detail . . . Take time to consider. The smallest point may be the most essential."

Citing the first Holmes (Oliver Wendell), James Lastra proposes elsewhere in this volume that photography replaced the "Albertian" hierarchy of well-made *pictures* with an "all-over" *image*, where marginal elements appear as detailed as the nominal subject. The second Holmes (Sherlock, speaking in "The Red Circle") suggests the detective story's ultimate *proximity* to photography. For, in fact, Doyle's hero depends upon a photographic way of seeing which, like rack focus, redirects the gaze from foreground to background, and, like a pan, from center to margin. In "Silver Blaze," the thrill of hearing Holmes insist on "the immense significance of the curried mutton" and "the curious incident of the dog in the night-time" derives from having had one's attention shifted from the obvious (the gambler Fitzroy Simpson, the gypsies) to the marginal, which turns out, of course, not to be marginal at all. The Holmes stories, in other words, are the written equivalent of photographs, where apparently incidental details, like Barthes' third meanings, persistently replace the proffered *studium*. In the words of a mid-nineteenth-century writer, quoted by Lastra, "The most minute detail, which in an ordinary drawing, would merit no special attention, becomes on a photograph, worthy of careful study."[27] Substitute "ordinary novel" for "ordinary drawing" and "in a detective story" for "on a photograph," and the connection becomes clear. Then a discovery: two days after writing these words, while visiting London's Sherlock Holmes Museum, I discover *The Unknown Conan Doyle: Essays on Photography*, a book that reveals Holmes' creator as one of late-nineteenth-century England's most avid amateur photographers.[28]

To a certain extent, the detective story differed from its predecessor, replacing

the *physiologies'* intolerance for the particular with an insistence on its value. "Singularity," Holmes instructs Watson, "is almost invariably a clue. The more featureless and commonplace a crime is, the more difficult it is to bring home." What neither the detective story nor the *physiologies* can admit, however, is chance, accident, randomness—precisely those properties of all signifying systems, which, as Barthes' essay "Third Meaning" shows, photography radically enhances. Every photograph, even the starkly "impoverished" ones favored by advertising and propaganda, can occasion a reading that fixates on contingent details whose precise meaning eludes, at least temporarily, all readily available symbolic systems.[29] The survival of the *physiologies* and the detective story, on the other hand, depends on the *resistance* to the accidental's appeal: if the blonde Spaniard has no place in the *physiologies*, the random crime proves fatal to the detective story—and, as Borges' "Death and the Compass" demonstrates, to the detective who wrongly insists on interpreting it. By repudiating the hermeneutic impulse in favor of the accidental, Borges' story marks the triumph of the photographic sensibility and, by implication, its most characteristic incarnation: the candid snapshot. Momentarily overcome, the anxiety to interpret, which had prompted both the *physiologies* and the detective story, returns in *Blow-up*, where it is ironically evoked by exactly such snapshots that now reveal a crime. But while the movie cites the detective story form, it refuses to subordinate images to language, suggesting with its inconclusive ending that the need to explain must ultimately be abandoned.[30]

5

In the history of films, every great moment that shines is a silent one.

King Vidor, quoted in Joseph Cotten, *Vanity Will Get You Somewhere: An Autobiography*

Without its [inner speech's] function of binding subject and text in sociality [some system of shared meanings produced by shared codes], no signification would be possible other than delirium.

Paul Willemen, "Cinematic Discourse"

At the origins of photography, therefore, lies an intersection of related problems: the legibility of the surrounding world, the status of the detail, the relationship between image and language. For the *physiologies* and the detective story, rituals of the word's mastery over things, photography represents the other that must be contained. In the twentieth century, this contest finds a new site—the cinema.

Filmmaking has, from the first, been shaped by the answers proposed to a set of fundamental questions. How do we make sense of a film? What happens when we encounter a movie segment for the first time? How do we process cinematic information? During the experimental phase of Soviet cinema, Boris Eikhenbaum suggested, in an especially influential answer, that we accompany our film watching with an "inner speech."[31] In particular, inner speech makes the connection between separate shots. A useful example arises in the opening scene of *Born Free*, which cuts back and forth between a woman washing clothes in a river and a stalking lion, apparently intent on an unseen prey. With the woman and the lion never appearing together in any frame, the sequence culminates in three shots: the lion springs, the woman turns and screams, and the river rushes away, now littered with clothes and a spreading red stain. The scene's meaning is clear: the lion has killed the woman. That meaning, however, while an *effect* of the images, appears nowhere in them. It occurs only in the viewer's mind, whose inner speech responds to the movie's images and sounds with the linguistic formulation "lion kills woman."

The notion of inner speech reaffirms, in Paul Willemen's words, "the interdependence of the verbal and the visual in cinema."[32] Even the nonverbal is grasped in relation to the verbal, which translates it into our dominant meaning system, language. Significantly, the concept of inner speech arises with silent film and in a genre (propaganda) in which unambiguous communication is the goal. In that context, what is most feared is the capacity of images to produce not meaning but what Willemen calls "delirium." Without a verbal soundtrack to anchor the images and constrain their potential drift, and with the continuity rules still inchoate, inner speech had to rely on other visual elements for the verbal formulations that would bind the unrolling pictures into a coherent statement.

Recognizing the potential of images for ambiguity and imprecision, silent-era filmmakers structured their shots around formulaic characters, sequences, and even verbal expressions. The silent cinema, in fact, represents the single most important revival of the *physiologies*. There we again encounter the *physiologies'* basic assumption that every character type has its own unvarying physical embodiment: villains look villainous (with moustaches and squinting eyes), heroines look virtuous (with petticoats and blonde hair), and businessmen look businesslike (with suits and starched shirtfronts). Very early in the movies' evolution, filmmaking also gravitated to stock actions—the chase, the lovers' meeting, the deathbed vigil. In *S/Z*, Barthes designates such predictable sequences as part of the "proairetic code," that reservoir of generic actions such as "the stroll," "the murder," or "the rendezvous"

(Barthes' examples) that trigger ready-made inner speech; indeed, Barthes proposes that this "code of actions principally determines the readability of the text."[33] At its most extreme subservience to language, a silent film's image track would occasionally provide a *visual* translation of a stock phrase: *October*'s juxtaposition of the provisional dictator Kerensky with a mechanical peacock ("proud as a peacock") is only the most famous example of this device.[34]

Sound moviemaking did not abandon these formulae; it simply relied on newly developed strategies for making them subtler. Most useful were Hollywood's continuity protocols, founded on the two principles of matching and centering, both designed to overcome film's fundamental discontinuity. While the matching rules ensured that editing would connect shots by means of certain cinematic grammar, centering guaranteed that all mise-en-scène elements (e.g., lighting, framing, shot size) would visually underline narratively important events. To the extent that the continuity rules circumscribed the movies' images, regulated their meaning in terms of a single narrative, and vastly reduced their potential complexity, they became, like the detective story, *a means of policing photography*—and another example of language's control of the image.

While the notion of inner speech arises in film's infancy, Barthes' "third meaning" appears in its maturity. With its insistence on perverse readings that ignore, and indeed refuse, intended or contextually obvious significances, the third-meaning disposition clearly descends from surrealist tactics designed to reassert the autonomy and ambiguity of images: think, for example, of Man Ray's habit of watching the screen through his fingers, spread to isolate certain parts of the image; of Breton's advocacy of eating and talking during showings as means for reorienting one's attention to the marginal incident or detail; of Breton's weekend moviegoing:

When I was "at the cinema age" (it should be recognized that this age exists in life—and that it passes) I never began by consulting the amusement pages to find out what film might chance to be the best, nor did I find out the time the film was to begin. I agreed wholeheartedly with Jacques Vaché in appreciating nothing so much as dropping into the cinema when whatever was playing was playing, at any point in the show, and leaving at the first hint of boredom—of surfeit—to rush off to another cinema where we behaved in the same way . . . I have never known anything more *magnetizing*; it goes without saying that more often than not we left our seats without even knowing the title of the film which was of no importance to us anyway. On a Sunday several hours sufficed to exhaust all that Nantes could offer us: the important thing is that one came out "charged" for a few days.[35]

Both Barthes' "third meaning" practice and the surrealist strategies of film-watching amount to methods of *extraction, fragmentation*. In both, the individual segment, image, or detail is isolated from the narrative that would circumscribe it. "To a certain extent," Barthes proposes, the third meaning "cannot be grasped in the projected film, the film 'in movement,' '*au naturel*,' but only, as yet, in that major artifact which is the still."[36] Like the detective story, Hollywood filmmaking (still the international norm) "arrests the multiplication of meanings," as D. A. Miller argues, "by uniquely privileging one of them"—that set designated "significant" by the unrolling story.[37] In his autobiography, Barthes acknowledged his own "resistance to the cinema," attributing it to the "statutory impossibility of the fragment" in a continuous, "saturated" medium.[38]

Narrative, in fact, subordinates its images to the linguistic formulations they serve. "The sequence exists," Barthes writes of the action code, "when and because it can be given a name."[39] Thus, encountering a picture offering itself as "a still," we will immediately begin to imagine the missing story. Doing so typically involves a summoning of the received categories stored in inner speech, the "already-done," the "already-read."[40] If, for example, we were to come across the accompanying still from *Andy Hardy Gets Spring Fever*, to what plot would we imagine it belonging? A sad love story? A tale of vampires? A mystery? To the extent that any of these constructions would immediately limit the image's possibilities, we can make this proposition: in late-twentieth-century civilization, every image lies surrounded by invisible formulae whose inevitable activation reasserts our stubborn allegiance to language as the only means of making sense.

Artists have begun to play with this situation, implying the traps into which our preference for language leads us. Cindy Sherman's "Film Stills" have become the most famous case, a complex use of photography, disguise, and the word "still" to imply movies that do not in fact exist—and to snare the viewer into "explaining" the photographs in terms of the cinematic conventions (e.g., film noir, Antonioni-esque angst, Southern gothic) already available to inner speech.[41] Equally suggestive is Chris Van Allsburg's children's book, *The Mysteries of Harris Burdick*, a collection of fourteen captioned images, each purporting to be the single remaining illustration of stories never found.[42]

What is at stake with this relationship between language and image? The research tradition that Derrida calls "grammatology" posits that different technologies of communication occasion different ways of thinking. An oral culture, for ex-

41 Still from *Andy Hardy Gets Spring Fever.*

ample, relying entirely on human memory to store and retrieve its information, develops conceptual habits that would appear strange to us, the inhabitants of a fully alphabetic society. Grammatology further suggests that human history has seen only two major revolutions in communications technology: the first involved precisely this shift from oral to alphabetic cultures; the second, the transition from alphabetic to "electronic" or "cinematic," we are living through now.[43] What are the consequences, characteristics, and modes of an age of photography, film, television, magnetic tape, and computers? How will what we call "thinking" change with this technology?

It will be up to us to decide. And here the matter of language and photography intervenes decisively. To the extent that such deciding will require invention, the persistence of formulae becomes inhibiting. The "already-read" categories of the *physiologies*, the detective story, and inner speech seek to define the new technology (photography, film) in terms of the old (language), thereby restricting our capacity

304

to admit the full implications of the revolution surrounding us. Roger Cardinal calls this way of dealing with images the "literate mode," derived from "habits of purposeful reading of texts" and assuming that "the artist has centred or signalled his image in accordance with the conventions of representation" so that "the viewer's gaze will be attuned to that focal message and will ignore its periphery." The alternative, one that "focuses less narrowly and instead roams over the frame, sensitive to its textures and surfaces," Cardinal associates with "non-literacy and with habits of looking which are akin to habits of touching."[44] This way of putting the matter seems absolutely consistent with the tradition we might call, following Sontag, "against interpretation."[45] Surrealism, Barthes' "third meaning" essay, and photography itself have all explicitly evoked eroticism as an analogue for a new practice of the image. If that practice involves, as *Blow-up* suggests, a relaxation of the explanatory drive (our version of the will-to-power?), its motto might result from changing one word in the dictum thrown like a knife at the literary establishment almost thirty years ago, ironically by one who has become photography's enemy: in place of a hermeneutics we need an erotics, not of art, but of photography.[46]

Notes

1 Walter Benjamin, "N (Theoretics of Knowledge; Theory of Progress)," trans. Leigh Hafrey and Richard Sieburth, *Philosophical Forum* 15, nos. 1–2 (1983–1984): 23.

2 Jean-Luc Godard, "Interview with Yvonne Baby," in *Breathless*, ed. Dudley Andrew (New Brunswick: Rutgers University Press, 1987), 166.

3 Samuel Marx and Joyce Vanderveen, *Deadly Illusions: Jean Harlow and the Murder of Paul Berne* (New York: Random House, 1990), 224–225.

4 Noël Burch, "Film's Institutional Mode of Representation and the Soviet Response," *October* 11 (1979): 77–96.

5 Benjamin, "N," 32.

6 Ian Jeffrey, *Photography: A Concise History* (New York: Oxford University Press, 1981), 240.

7 Dana Brand, "From the *Flâneur* to the Detective: Interpreting the City of Poe," in *Popular Fiction: Technology, Ideology, Production, Reading*, ed. Tony Bennett (London: Routledge, 1990), 220–237.

8 Walter Benjamin, *Charles Baudelaire: A Lyric Poet in the Age of High Capitalism*, trans. Harry Zohn (London: NLB, 1973), 40.

9 Edgar Allen Poe, "The Man of the Crowd," in *The Portable Poe*, ed. Philip Van Doren Stern (New York: Viking, 1945), 107, 118. See also Brand's comment in "From the *Flâneur* to the Detective," 220–201.

10 Roland Barthes, *S/Z*, trans. Richard Miller (New York: Hill and Wang, 1974), 172–173.

11 Ibid., 205.

12 Richard Sieburth, "Same Difference: The French Physiologies, 1840–1842," *Notebooks in Cultural Analysis*, no. 1 (1984): 163, 167. See also Sabine Hake's chapter in this volume.

13 Ibid., "Same Difference," 170.

14 Benjamin, *Charles Baudelaire*, 39.

15 Sieburth, "Same Difference," 175.

16 Barthes, *S/Z*, 97.

17 Daniel Goleman, "'Useful' Modes of Thinking Contribute to the Power of Prejudice," *New York Times*, May 12, 1987, C10.

18 Natalie Zemon Davis, *The Return of Martin Guerre* (Cambridge: Harvard University Press, 1983). Also a film, directed by Daniel Vigne (France, 1982), 111 mins., for which Davis served as historic advisor.

19 Jeffrey, *Photography*, 12–13.

20 Quoted in Sieburth, "Same Difference," 184.

21 Poe, "The Man of the Crowd," 112.

22 Paul Willemen, "Cinematic Discourse—The Problem of Inner Speech," *Screen* 22, no. 3 (1981): 78.

23 Edward Tenner, "Revenge Theory," *Harvard Magazine*, March–April 1991, 26–30.

24 E. C. Bentley, *Trent's Last Case*, in *Three Famous Murder Novels*, ed. Bennett A. Cerf (New York: Modern Library, 1945), 1.

25 Arthur Conan Doyle, *The Complete Sherlock Holmes* (Garden City: Doubleday, 1927), 467.

26 "Because each photograph is only a fragment, its moral and emotional weight depends on where it is inserted. A photograph changes according to the context in which it is seen . . . And it is in this way that the presence and proliferation of all photographs contributes to the erosion of the very notion of meaning." Susan Sontag, *On Photography* (New York: Farrar, Straus and Giroux, 1977), 105–106.

27 Francis Frith, "The Art of Photography," *Art Journal* (1859).

28 Arthur Conan Doyle, *The Unknown Conan Doyle: Essays on Photography*, ed. John Michael Gibson and Richard Lancelyn Green (London: Martin Secker and Warburg, 1982).

29 Roland Barthes, *Mythologies*, trans. Annette Lavers (New York: Hill and Wang, 1972), 125, 127.

30 *Blow-up*, directed by Michelangelo Antonioni (Britain, 1966), 111 mins.

31 Boris Eikhenbaum, "Problems of Film Stylistics," in *Russian Formalist Film Theory*, ed. Herbert Eagle (Ann Arbor: University of Michigan Press, 1981), 62.

32 Willemen, "Cinematic Discourse," 64.

33 Barthes, *S/Z*, 262.

34 *October*, directed by Sergei Eisenstein and Grigori Alexandrov (Soviet Union, 1928), 103 mins.

35 Andre Breton, "As in a Wood," in *The Shadow and Its Shadow: Surrealist Writings on the Cinema*, ed. Paul Hammond (London: British Film Institute, 1978), 42–43.

36 Roland Barthes, "The Third Meaning," in *The Responsibility of Form: Critical Essays on Music, Art, and Representation*, trans. Richard Howard (New York: Hill and Wang, 1985), 59.

37 D. A. Miller, "Language of Detective Fiction: Fiction of Detective Language," in *The State of the Language*, ed. Leonard Michaels and Christopher Ricks (Berkeley: University of California Press, 1980), 482.

38 Roland Barthes, *Roland Barthes*, trans. Richard Howard (New York: Hill and Wang, 1977), 54–55.

39 Barthes, *S/Z*, 19.

40 Ibid.

41 Cindy Sherman, *Untitled Film Stills* (New York: Rizzoli, 1990).

42 Chris Van Allsburg, *The Mysteries of Harris Burdick* (Boston: Houghton Mifflin, 1984).

43 Jacques Derrida, *Of Grammatology*, trans. Gayatri Chakrovorty Spivak (Baltimore: Johns Hopkins University Press, 1976).

44 Roger Cardinal, "Pausing over Peripheral Detail," *Framework* (London), nos. 30–31 (1986): 124.

45 Susan Sontag, *Against Interpretation* (New York: Delta, 1966).

46 Sontag, *On Photography*, 14.

[Editor's note: An earlier version of this essay was published as the second chapter of Robert B. Ray's *The Avant-Garde Finds Andy Hardy* (Cambridge, Mass. and London: Harvard University Press, 1995).]

Immediate History

Videotape Interventions and

Narrative Film

TIMOTHY CORRIGAN

The emergence of videotape within the modern public sphere has pursued a fairly accelerated and dramatic trajectory: from the network broadcast of Richard Nixon's astonishingly personal plea on September 23, 1952, through the 1956 arrival of videotape as a commercial and industrial tool, there grew the art video and VCR culture in the sixties (including the rapid expansion of portapak camera culture after 1965), until video precipitated the latest political flashpoints of the 1990s, marking it as the most visibly expressive counterforce in the public domain. Increasingly, this historical path has defined and distinguished itself, intentionally or not, as an aesthetic and ideology of the private space and, more important for my purposes, a private or personal experience valorized and supported by its association with immediate perception.

Some valorization of immediate experience clearly extends, of course, back at least through late-eighteenth-century notions of spontaneous creative expression and through the various epiphanic measures of twentieth-century modernism: witnessed in early romantic claims of "original composition" or in the fragmented daily insights associated with the birth of an essay industry at that time, this insistence on the intelligent core of the single moment extends erratically across the nineteenth century and through both Joyce's characterization of history as "a shout in the street" and Walter Benjamin's formulation of the new work of art as mechanical reproductions generating the flashing insights of imagistic shocks. In "The Variable Eye," Jacques Aumont has rethought the very emergence of cinema in terms of a late-eighteenth-century aesthetic passage from the *ébauche* to the *étude*, the latter indexing a rapid and fugitive mobility of the look that alters "the entire function of the gaze."[1]

Videotape and its contemporary predicament describe, however, a dramatic shift in this tradition while pointing toward a significant redefinition of the public sphere that Jürgen Habermas, most notably, has worked to explain. In this action it offers the possibility of a different formulation of the relation between expressive

representations and historical perception. Indeed, for many both videotape and the temporal and spatial rethinking it provokes reflect and focus a larger crisis played out in models of contemporary or postmodern culture where the purported condensations of space and time, in what Lyotard has termed a "temporary contract," become linked to various emancipatory or apocalyptic visions of history. Some, like David Harvey, argue that this problematic of temporality is the central difficulty in making sense of the representation of contemporary history as it has evolved from Marx and Bergson. For him, the result has been "the production of fragmentation, insecurity, and ephemeral uneven development within a highly unified global space economy of capital flows," making it harder and harder, as with videotape representation, to react accurately to the material meaning of events precisely because they have been isolated in an immediacy without a contextual history.[2]

While my position here follows this shift into a contemporary culture of fragmented temporality, I will be more specific in my focus and less sweeping in my claims. My interest here will be to pinpoint something more than videotape's pervasive interaction of the private within a public and sociological arena. I plan to locate instances in which, as a much more fundamental action, videotape technology and certain videotape practices have recast the structure of private expression as *a functional figure capable of monitoring a public history and narrative through the force of immediate perception*. In both the positive and negative senses of this definition, videotape, I will argue, has come to represent and express an emergency geography where to associate images with the two dimensions of "instantaneous space" is to attempt to redefine images as emerging actions rather than as historical teleologies, as instant replays rather than as narrative flashbacks. Such a practice clearly both responds and contributes to the changing dialogic formations of a contemporary public sphere.

A Short History of Technological/Textual Intervention in Narrative Cinema

If the claims for instant knowledge have a long history, the polemics surrounding immediate perception and its relation to a narrative inscription are also not new. At least since the technological elaboration of depth perspective, the image has opened a space of visual temporality that has required some sort of narration or perceptual filling.[3] When technology and mass culture began to become integrated in the nineteenth century—integrated especially in terms of the immediacy of images perceived—the problematic of visual perception as a temporality became part of a larger negotiation: from Wordsworth's movement to reinscribe imagistic "spots of

time" within a narrative "recollected in tranquility" (opposing the purported sense-less stimulation of popular spectacles) to Adorno and Horkheimer's critique of a mass culture of immediacy (linked most commonly to movies and jazz), immediate sensations have been aligned with the threat of technology murderously conspiring against the (discriminating) human coherency of a narrative history.

Adorno and Horkheimer have probably stated the danger most famously: "A technological rationale is the rationale of domination itself. It is the coercive nature of society alienated from itself."[4] As with Benjamin, the movies become for them the focal point of technology's construction of culture; yet, unlike Benjamin's championing of the shock effect of mechanical reproduction, for them "the more intensely and flawlessly [the filmmaker's] techniques duplicate empirical objects, the easier it is today for the illusion to prevail that the outside world is the straight-forward continuation of that presented on the screen."[5] This illusory continuity of history as a present tense then transforms the human subject into an automaton who by definition acts and reacts to a narrative flow in which there is no critical en-gagement and hence no subjectivity to speak of: "All the other films and products of the entertainment industry which they have seen have taught them what to ex-pect; they react automatically."[6] In the shadow of the technoculture of fascist Ger-many, this consequent defeat of subjectivity is therefore very much a historical de-feat of the individual who, as in a fascist teleology, is positioned through these techno-narratives to surrender himself or herself to narrative moments always con-figured as a series of self-propelling emergencies of time and history:

In films, those permanently desperate situations which crush the spectator in ordinary life somehow become a promise that one can go on living. One has only to become aware of one's own nothingness, only to recognize defeat and one is one with all. . . . In some of the most significant German novels of the pre-Fascist era, such as Döblin's *Berlin Alexanderplatz* and Fal-lada's *Kleiner Mann, Was Nun*, this trend was as obvious as in the devices of jazz. What all these things have in common is the self-derision of man.[7]

While the historical anchoring of this crisis of technology, narrative, and sub-jectivity in fascist Germany would become the subject of a wide variety of contem-porary film work (from that of Claude Lanzmann to that of R. W. Fassbinder),[8] its common concentration of the issue on movie technology and its cultural impact needs broader historical contextualizing. However accurate assessments such as these might be from one angle of vision, they vastly underestimate the power of

mainstream filmic narrative to deflect or absorb the threatened danger and its critique: the power of filmic narrative has, historically, been its ability to usurp and assimilate various technologies and technological representations as a way of establishing precisely that human and historical depth and temporal coherence which its critics, such as Adorno and Horkheimer, see lost in a technological continuum of self-derision. Or, to put it bluntly, the movies have always succeeded—eventually—in creating the illusion of technology as the extension of the human subject in narrative action.

My argument here might be seen as adumbrating some of the larger points of James Lastra's contribution to this volume, "From the Captured Moment to the Cinematic Image," in which he describes how late-nineteenth-century technologies and particularly the photographic apparatus promoted "secondary" visual fields as fragmented, accidental, and immediate images; for Lastra, the challenge of classical cinema then becomes to renegotiate these potentially disturbing and subversive views as acceptable or legible narratives, or "good" images. Moving toward the other end of twentieth-century film history, I wish to emphasize the stake film narrative has regularly had, even after the development of a classical cinema, in renegotiating various technological signifying systems as they threatened traditional humanistic coherencies, legibilities, and viewing positions. The following brief historical mapping of engagements between film narrative and technological innovation will sketch some of these changing investments of movie technology in narrative and, most important, anticipate what distinguishes as absolutely radical certain recent videotape intrusions into film history. The examples—all too quick and cavalier, I admit—concentrate on the intersection of technological heterogeneity and narrative cinema, emphasizing an implied figuration of private and public life that, for both detractors and promoters, has marked the power of filmic narrative to position the individual within popular culture.

Especially in the first part of this century, print media (including certain silent intertitles) served to valorize and aestheticize the movies through a relation with a literary narrative or journalistic tradition. This tradition stabilized the image within a spatial and temporal continuity and promoted an interpretive integration of private life as being *read* into public history. The conclusion of Buster Keaton's *The General* (1927) is exemplary in this regard. After his heroic narrative adventure, Keaton (as Johnny) finally finds acceptance in the Confederate army and his lover's family, and, subsequently, his deadpan silent image becomes reframed within a family

album book. Here the narrative tension between intertitles associated with a literary tradition and visual images associated with a technological tradition (specifically dramatized through the identification of Johnny and his locomotive) is resolved when those images can, as a consequence of the narrative work, be printed within the hierarchical book of a family and public history.

The relations between verbal literacy and technological images would continue to indicate changes in cultural history: in 1941 the failure of a journalistic detective to recover the meaning of Citizen Charles Foster Kane marks a massive political and cultural crisis in which, as at least a related symptom, print gives way to the ambiguous textures of deep focus, dramatic editing, and numerous other filmic technologies that can now read, as André Bazin would argue and the immediate journalism of *The March of Time* would promote, as the transparencies of reality itself.[9]

Audial technology such as radio sound or other recording mechanisms counterpoint (often with irony) the narrative image as a way to establish a transcendent rather than interpretive space.[10] In this case, sound technology works to disembody public or imagistic bodies in the form of an invisible or universal voice, which, after the mid-1930s, has far more mobility in time and place than the visual image. The textuality of sound technology transcends the particulars of historical time and place. In 1952 *Singin' in the Rain* might be seen, from one interpretive angle, as depicting exactly this allegory of the usurpation of the image in the name of sound technology: at the conclusion of a narrative about the coming of sound to the silent film industry, Don, the hero at center stage, acts on his private feelings and urges an adoring audience and public to stop and bring back to that stage the heroine Kathy, the new love interest risen from the anonymous middle class of the audience but previously lost behind the image (where her voice was used for dubbing). Immediately following this reclamation of Kathy by Don and the audience, the film cuts, and she, as the figure of the "authentic voice," is reprojected with the hero Don on a public billboard that advertises the film just seen, retrospectively retrieving sound technology and the images it gives voice to as the *new* public image.[11] More bleakly but following the same technological hierarchy is an example available seven years earlier, the history of Mildred Pierce, the accused murderer. The title character is salvaged only through the erasure of that physical and economic presence she had exerted, which had so troubled a male world, yet the erasure is accomplished through the agency of the voice-off of a male detective representing the transcendence of the law.

Another new technology—and a seemingly democratic one—the home movie offers a more complicated case because of its technological duplication, on a smaller scale, of the film medium itself. When the home movie or some version of it—such as the local newsreel footage in Fritz Lang's *Fury* (1936)—enters a film narrative, this doubling of the film media usually works to reappropriate a public narrative as a private and incidental retextualizing of that primary public sphere. Whereas the first two examples of print and sound technology ultimately reinforce the textual impulse of film technology in its service of a public narrative, the home movie deviates in a mimicry that aims to reinvest that public narrative with a more personal authenticity—such as a lost past or narrative truth. Thus the very different tales of Lang's *Fury* and Oliver Stone's 1991 *JFK* share a public history rediscovered by a limited or personal apparatus and documented on the margins where the incidental reveals not the immediate but an ignored reality. In the first film Joe Wilson uses the closeups and freeze frames of a documentary camera to reveal the individual faces behind the public mass responsible for an erroneous lynching attempt; in the second, the Zapruder footage becomes the worked and reworked evidence of a different history for the Kennedy assassination. In both cases, alternative film technology bears the missing but central traces of a critical subjectivity or counterposition—Joe's now bitter suspicion of group identity and John Garrison's relentless fight with the official version of the event—whose resistance acts as a needed corrective within a remade public sphere.

In each of these cases, *different technologies are remade as narrative textualities*, each expanding, in Barthes' formulation of textuality, the scope of the "total reality" as legible, transcendent, and subjectively stable. This process of normalization extends in an accentuated way into the most recent technological avatars of HDTV and virtual reality. Technological representation might, of course, function in other ways, according to a variety of other positions and meanings.[12] It might, for instance, promote positions of difference rather than identification, or provide instrumental significances rather than textual ones. A technological representation, such as that of nuclear power, may function as "different" by highlighting an opacity that denies any understanding of workings and meanings (the image of the power plants themselves), while it promotes a futuristic (even apocalyptic) time. In accordance with Barthes' definition, technology in this case would oppose textuality. With the version of technology as instrumental in a social sphere—for example, word processing—technology becomes a fractured and mobile system whose meaning depends on its users and their aims; its meanings alter according to the users' situa-

tions and goals while its temporality becomes an aleatory and disjointed function of the changing parameters of a singular vision.[13] This would then be an example of technology serving textual activities but remaining distinct from them—a "hypertext," above or beyond traditional textuality.

With the dominant models of filmmaking, however, technology has quickly evolved—especially between 1915 and 1979—as a textuality itself, whose semiotic status abstracts and makes transparent not only the numerous concrete and social realities it represents but the very technology it employs.[14] (Most specifically this might be seen in the common and industrially supported tendency in movie culture to read technological techniques—tracks or types of framing, for instance— according to universally shared meanings.) Always bearing the traces of those often remarked ideological, economic, and psychological dimensions related to pleasure and power,[15] this transcending power of film technology as textuality has, furthermore, historically subsisted on two main narrative configurations of temporality: (1) an objective temporal continuity presenting a progressive or universal pattern of time (the usual definition of most classical cinemas) or (2) a subjective temporality which demands that time adjust to the relativity of place and so shifts the potential for historical coherence to the individual before or within the narrative (the common scheme of much modernist cinema and the signature of its hand-held camera techniques).

In this capacity, the technology of narrative cinema (both when standardized and when subversive) authorizes an enlarged, perceptually stable public sphere which, whatever shape its ideological geography may take, remains temporally coherent. As the product of textual technology, history through the cinema becomes the spatialization and "iteration" of time. An illusory version of Habermas' model, cinematic textuality and technology are bound together as the evolution of an integrated public domain whose negotiations follow a primarily spatial organization (in Habermas' terms, "a zone of freedom" or a "staged form of publicity") and a largely textual fabric ("opinion" or "publicness as a principle").[16] Both characteristics work to develop a temporal logic that creates a coherently communicative space made publicly legible as historical and narrative time. On the one hand, this public sphere might reflect the illusory enlisting of a mythical "public mass" in the rereading of its own history: technology becomes—from the multiple screen of Abel Gance's *Napoleon* (1927) to the technicolor of *Gone with the Wind* (1939)—the text of public power knowing its own history. On the other hand, the public sphere evolves in the modern cinema as a dialogue in which differences and discontinuities

can be bridged by the communicative potential of new visual and sound technologies or techniques: as in Kurosawa's *Rashomon* (1950) or Jean-Luc Godard's *Two or Three Things I Know about Her* (1966), technological representation emphasizes the fragmentation of place and perspectives across which the textual common ground of flashpans, overlapping sound, and jump cuts can communicate.[17]

As Derrida has suggested in his critique of Habermas, regardless of their dialogic aspirations, these formulations of different cinematic strategies remain, like the preceding examples of filmic technology as textuality, dependent on communication models (face-to-face or mediated) based in a communicative universality, technical textuality, or "iterability." According to Benjamin Lee, Derrida's critique would offer a crucial revision of Habermas' public sphere (and these cinematic formulas) by arguing that "no single model of communication can serve as a critical vantage point to assess the possibilities and deficiencies of different communicative media." Instead, this revision of the narrative of a public sphere urges "the generative implications of an expanded notion of textuality, of which face-to-face communication is only one possibility."[18]

Dovetailing with Oscar Negt and Alexander Kluge's recent attempts to redefine the terms of a contemporary public sphere,[19] these revamped models rely equally on spatial organizations as an oppositional or "open" place. But their central use of "experience" to delineate a counter public sphere anticipates the increasing and altered role of temporality and its reduction to immediate experience in forming contemporary modes of understanding and expression (in Kluge's case, with a subsequent commitment to television and video). Here the crucial role of the temporal immediate is, I believe, one of the possibilities that Michael Warner calls to our attention in his attempt to reconceive the abstractions of Habermas' public space as the *embodiments* of the contemporary scene.[20] Or to adapt it to the concrete vehicle that Habermas suggests for at least its liberal bourgeois phase, I would put it this way: if newsprint and journals act as a textual communal space that define the liberal public sphere at the end of the eighteenth century and if the cinema develops the textual illusion of an engaged mass public sphere within a coherent history in the twentieth century, today the temporal fragments of videotape have started to reconfigure in a massive way that sphere by releasing a temporal mobility that subverts the textual and spatial coherence of Habermas' model. As a form of bodily activity, such fragmentation refuses subjective stability and, as Habermas himself was aware, augurs the termination of traditional politics.

The Place of the Immediate: Videotape, Narrative, and the Public Sphere

Not surprisingly, then, contemporary narrative cinema has found videotape a particularly troublesome technology to incorporate. Indeed, recent film narratives of the putatively postmodern kind (those, for instance, of Jean-Luc Godard, Atom Egoyam, and Steven Soderbergh) have struggled with the more radical tendency in videotape so as to point up a basic resistance of this technology to a tradition of narrative textuality (with which these filmmakers are nonetheless aligned). Indeed the demonstratively wistful conclusion to Wim Wenders' *Until the End of the World* (1991) might be emblematic in its ferocious nostalgia for a way to escape the solipsistic immediacy of technologies associated with videotape through a return to textual narratives that position the self as part of a bucolically global public sphere. *Sex, Lies, and Videotape* (1989) similarly hearkens back to that lost, private, or missing subject that home movies sought out—rather than using video to project the dramatic technological revision of previously unseen or unimagined truths.

There are of course different material, economic, and sociological dimensions to videotape that help specify and explain these potential representational tendencies and their recalcitrance before cinematic textuality: its relative financial availability and social accessibility, its portability, its use of electronic signals and direct recording, and so forth. Rather than a figure of technological expansion and evolution, videotape has again and again responded to these conditions to define itself as an intrusion into, a dispersal of, or a reduction in both space and time at odds with the usual terms of narrative film. Here its tendency toward spatial reorientation has been most often noted, as it adumbrates the geographies of postmodern theory: the conflation of privatization and globalization as individuals might access and retrieve for their own private exhibition any number of foreign cultures through tape (video letters exchanged by Japanese and American students); imagistic miniaturization and condensation as both personal and public events can be gathered and reduced to a video monitor (the Gulf War fought across video screens in fighter planes, the packaging of issues and events on evening news programs, and so forth); and the radical mobility of subjectivity as the viewer and recorder have the option of playing themselves out in an almost endless number of situational positions (personal experiences, whether staged or real, make those experiences a series of multiple poses and backgrounds for a ubiquitous recording mechanism).

However, whereas these spatial configurations seem made for a redefinition of a traditional public sphere, the temporal remaking they imply alters even more pro-

foundly that sphere as it is fashioned in the cinema. Experiential time recorded ("as it is happening, not passing") is aligned with the theoretical capacity and allure of capturing every moment from potentially every angle ("the surveillance of every instant") to describe a space in which temporality seems to explode as an infinite number of experiential encounters with each single moment or temporal fragment of social life. Unlike the snapshot, this is not a Bergsonian or Proustian temporality crystallizing the flow of a coherent movement that might, for instance, be organized like the history of a family album. And unlike most versions of a public sphere (including Habermas'), temporality here does not provide a historical logic through which different spatial positions (usually dialogic) evolve toward a common ground.[21] The temporality of videotape signals instead a plethora of fragmentary instants always open to multiple perspectives and significances and therefore always in crisis, as an emergency. Unlike the representational "crisis" that Lastra has documented within the filmic images of early cinema, the temporal differences within videotape technology have made it more fundamentally resistant to absorption by "the dominant diegetic mode."[22]

These conditions and the postmodern perspectives they parallel have usually been formulated as descriptions of loss and collapse, a failure that much narrative cinema has tried to rectify according to its own narrative and commercial imperatives. Deleuze and Guattari's schizophrenic subject, de Certeau's notion of "the everyday," and Baudrillard's ecstasy of communication, for example, attempt to describe a new public body in an increasingly troubled public sphere whose first and most powerful emblem may indeed be the videographic apparatus.[23] Especially Baudrillard's characterization, however, suggests the historical conservatism at work in this new representational dynamic as apocalyptically and "obscenely" beyond a public sphere: from Baudrillard's point of view, videotape does indeed dramatize "the absolute proximity, the total instantaneity of things, the feeling of no defense, no retreat . . . it is the end of interiority and intimacy. The overexposure and transparence of the world which traverses him [the spectator] without obstacles. He can no longer produce the limits of his own being, can no longer produce himself as mirror. He is now only a pure screen—a switching center for all the networks of influence."[24] A representational technology that continually reframes itself as a visible technology and not a narrative textuality, however, videotape might be seen more accurately to be acting out the crisis of postmodern subjectivity within a significantly other dimension: it monitors the intensities and mobilities of these figures of collapse and intensification, and it does so without positioning itself

across the narrative and textual structures it participates in; as a technological representation, it is in fact a public monitoring of the temporal movements of private actions.

When one enlists this figure as a representational technology with its full social implications, there emerges a sense of the real significance that the videotape image might have as a part of a narrative and aesthetic redefinition of cinema's public sphere: rather than narrate *around* videotape images, avoiding them, the more radical direction for the cinematic narrative is to narrate concomitantly *within* videotape images a temporal variety of subjectivities. However reductive filmic appropriations of video images may commonly be, there exists, in the most provocative instances, videotape's ability to bear witness to the imperative to fragment and retemporize the spatial geography of that filmic image. Within its more rigorous presentations, the emergencies of time work to demand the continual reformulation of the textualities of public space.

In this way, certain contemporary film narratives have, I believe, forcefully embraced videotape's disturbing refusals to be textualized as a traditional temporal space. In *Henry: Portrait of a Serial Killer* (1990), for instance, the videotape image, paralleling the actions of this portrait of a subject without subjectivity, functions as the serialization of an always violent and violated point of view that refuses, together, coherent spaces and a narrative history—most unbearably witnessed and allegorized when the videotape camera records, without an operator, the brutal murder of a family at home, that Oedipal cornerstone for psychoanalytic models of textuality. Like the videotape image, the blank and lethal central character in the film can be everywhere, a widely circulating discourse that invades and violates private spaces. Like videotape, Henry describes an absolutely reduced world locked within the frame of a self-reflecting vision. In relation to Henry and to videotape, time disappears into the immediate and arbitrary, for it is structurally defined as the unpredictable reciprocity of an emergency situation in which to see and to act become fiercely and ecstatically bound up only with the present moment.[25]

Immediate History and Emergency Geographies: *Mortal Thoughts*

While in *Henry* the videographic apparatus, the narrated body, and its sudden unpredictable murder all coincide in tautly unpredictable image, in Alan Rudolph's *Mortal Thoughts* (1991), videotape, narration, and murder coincide as a much more reflexively ideological, because monitored, figure. Despite its graphically marginal presence within this odd murder mystery (all the more unremarkable when set

against Rudolph's other hyperrealistic films), videotape in this case describes the critical representational measure that explains narrative itself as a lie subject to monitoring and repositioning. Narrated as an interrogation or textual "iteration" being videotaped by two police detectives, the story recounts the brutal physical harassment of a wife and a friend by the former's recently murdered husband. When the detectives refuse to accept the logic of the woman's narrative explanation of her own innocence, she screams toward the conclusion of the film, "What you want is a lie," and the detective replies, "Yeah, I want a lie." That "lie" whereby Cynthia might both admit to the murder but deny it as *really* a murder—dramatizing how the representation of truth becomes a shifting matter of moral position rather than an essence—anticipates the sudden reversal of the conclusion when Cynthia reveals herself as innocent of murder because she is willing to take responsibility for the death of an oppressively violent husband.

As a dark parody of the narrative textuality of a movie like *Mildred Pierce* (1945), the entire narrative of *Mortal Thoughts* should be characterized not in the traditional terms of the "flashback" but according to the contemporary videotape method of structuring time and meaning as an "instant replay." At one particularly explicit point, the detective stops her: "Did you hear what you said? '*We* could've got rid of him.' I can play it back for you." Because her testimony is videotaped through the monitor in the foreground of the image, this potential for instant replay emphasizes the climactic reseeing and retelling of the story by Cynthia as the continual framing or reframing of her position within the present moment of her own changing image: it demonstrates the epistemological potential of revising in terms of "the unseen" by serially replaying the same image. Just before the concluding reversal occurs, Cynthia leaves the police station, passing her friend Joyce (wife of the murdered husband) on her way into the interrogation room; outside in her car she confronts her image in the rearview mirror. Instantly the missing history is replayed through her eyes: James' attempted rape, her killing him in self-defense, and Joyce's refusal to drive him to the hospital in time to save him. "Oh my god what am I doing," she whispers and then returns to the interrogation room where her face is seen staring directly into and through the videotape image/monitor. The detective appropriately announces this as a different beginning for a history that can now be instantly replayed and remonitored: "Let's get started," he says.

Here the critical extension of the critical moment—as opposed to the purported postmodern condensation of time—takes the form of an emergency place-

ment of the subject in the public sphere. The excessive physical brutality that defines these women's always desperate place within a public sphere suggests the material limits of an institutional textuality across this terrain. Survival throughout the narrative becomes a physically ferocious and necessarily contingent temporal imperative, and in these final sequences it becomes a narrative "emergency" in its effort to turn against the narrative with its textual "motivations" as well as against the "inscriptions" of a specific subjectivity. Unlike most precedents (both in filmic and conventional uses of videotape within film), in this case that temporal impera- tive initiates a sudden and immediate repositioning of Cynthia as an agent who ac- tively retrieves the technology of videotape in order to refuse the victimized place within which public textuality had positioned her. Before the now obtrusive tech- nology of the videotape apparatus, the history of the immediate in *Mortal Thoughts* becomes the retaking of history as a temporal emergency apart from the logic of the filmic narrative. While the opening and closing sequences of the film are home- movie clips of two young girls (presumably Cynthia and Joyce) playing through a grainy innocence, that nostalgia for a narrative harmony, indexed fittingly as the subjectivity of a past technology, is precisely what the emergencies of contemporary geographies will not allow if figures like Cynthia and Joyce are to reinvent their re- lationships and spheres of action. For these spheres of action must continually re- imagine their relationships to a public sphere as a responsibility constantly *monitor- ing* the narrative geographies within which it must act.

What this film and my argument call attention to are the crucial distinctions in the emergence of videotape within film culture as the measure of the possible roles videotape can or should play in contending with the larger narrative traditions that filmic representation has largely capitulated to in its formation of contemporary public histories. While always involving commercial and other institutional pres- sures that must compromise any radical claims, newer hybrid expressions operate not through assimilation or recuperation but through their exploitation of the ex- treme *temporal* possibilities within the interaction between the filmic and the videotape images—whereby the resulting narrative envisions historical agency as the instantaneous remaking of narrative history. In this sense, certain theoretical shifts seem in order: if Benjamin signaled the extraordinary cultural potential within the cinematic image, the important debates that have surrounded Haber- mas' public sphere may now help us recognize the videotape image as possessing certainly different but equally massive cultural potential. This is hardly a vision of another utopian image transcending time, but an argument that videotape repre-

sentation insists, in pervasive and unique ways, that a narrative history must now constantly be *refigured around and through* an extreme temporal mobility.

What a cultural flashpoint like the Rodney King trial has made clear is the constant struggle to recover videotape representation within a hermeneutical narrative (what happened before, after, and in the temporal gaps). If videotape has become the chief imagistic force in making a public sphere and narrative history an emergency geography today, that public history is nothing other than a public hermeneutic project: always and immediately to monitor and tactically question the narratives it proposes.

Notes

1 The myriad examples since 1800 deserve to be distinguished: the fragmentary sparks of inspiration associated with the aesthetics of Keats and Shelley, for instance, are rooted in a romantic culture informed by a Rousseauian conception of the spontaneity and innocence of nature; by the twentieth century, for individuals as diverse as Hart Crane and F. T. Marinetti, technology becomes a metaphor for the perception of instantaneous energy. With such historical distinctions in mind, I would point to the connections between Jacques Aumont's argument and my own, his more pessimistic perspective on postmodern culture notwithstanding. See Jacques Aumont, "The Variable Eye, or the Mobilization of the Gaze," in this volume.

2 David Harvey, *The Condition of Postmodernity* (Oxford: Basil Blackwell, 1990), 296. Lyotard's phrase comes from Jean-François Lyotard, *The Postmodern Condition* (Minneapolis: University of Minnesota Press, 1984), 66. Anne Friedberg's *Window Shopping: Cinema and the Postmodern* (Berkeley: University of California Press, 1993) also forefronts this issue of temporality and specifically in the context of the development of a "mobilized virtual gaze."

3 Michael Fried, for example, has argued one version of this "perceptual filling" as a play between absorption and theatricality in eighteenth-century painting. See Michael Fried, *Absorption and Theatricality: Painting and Absorption in the Age of Diderot* (Berkeley: University of California, 1980). William Galperin more recently counters those dynamics by demarcating a visual activity at the beginning of the nineteenth century when the image refused spectators an easy place, requiring that a temporal and narrative action surround that image. See William Galperin, *The Return of the Visible in British Romanticism* (Baltimore: Johns Hopkins University Press, 1993). Closer to my concentration here, Miriam Hansen has noted further alterations in the temporal and spatial relations elicited by contemporary image technology: "We are on the threshold, if not already past it, of yet another major transformation of the public sphere: the new electronic media, in particular the video market, have changed

the institution of cinema at its core and made the classical spectator an object of nostalgic contemplation." Miriam Hansen, *Babel and Babylon: Spectatorship in American Silent Film* (Cambridge: Harvard University Press, 1991), 3.

4 Theodor W. Adorno and Max Horkheimer, "The Culture Industry: Enlightenment as Mass Deception," in *Dialectic of Enlightenment* (1944; reprint, New York: Continuum, 1987), 121. One must be careful about overstating Adorno's resistance to technological reproduction. As Thomas Levin has shown, Adorno's indictment of technology and film in "The Culture Industry" involves far more than a blanket critique of modern reproductive techniques; in other contexts, Adorno could be extremely sympathetic to the possibilities inherent in mechanical reproduction. See Thomas Levin, "For the Record: Adorno on Music in the Age of Its Technological Reproducibility," *October*, no. 55 (Winter 1990): 23–48.

5 Adorno and Horkheimer, "The Culture Industry," 126.

6 Ibid., 127.

7 Ibid., 152–153.

8 Anton Kaes examines the history of fascism in relation to filmic representation in *From Heimat to Hitler: The Return of History as Film* (Cambridge: Harvard University Press, 1989). See also my discussion of Fassbinder's *Berlin Alexanderplatz* (1980) and *The Third Generation* (1979) in "The Temporality of Place, Postmodernism, and the Fassbinder Texts," *New German Critique*, no. 63 (Fall 1994): 139–154.

9 Bazin's commitment to both a reality principle and a literary heritage makes him an unusually astute respondent to this period in film history, as it gathers up much of the imagistic/literary evolution from the silent era and leads toward the semiotic images of the French New Wave. T. Jefferson Kline's recent study of that new wave, *Screening the Text: Intertextuality in New Wave French Cinema* (Baltimore: Johns Hopkins University Press, 1992), is a testimony to the persistent power of a textual or literary tradition within cinema history. Also pertinent in this context are the discussions, in the first two volumes of Scribner's *History of the American Cinema*, of the use of print for titles and intertitles in early cinema: see Charles Musser, *The Emergence of Cinema: The American Screen to 1907* (New York: Scribner, 1990); and Eileen Bowser, *The Transformation of Cinema: 1907–1915* (New York: Scribner, 1990).

10 Probably the most inclusive of perspectives on the significance of sound technology to film history is *Film Sound: Theory and Practice*, ed. Elizabeth Weis and John Belton (New York: Columbia University Press, 1985).

11 See Peter Wollen's *Singin' in the Rain* (London: BFI, 1993), in which his discussion of the public sphere permeating the film emphasizes the connection between the production of the film and the Popular Front politics that were then becoming the object of the McCarthy hearings.

12 In addition to characterizing technology as being in the service of textuality, other assumptions, figures, and social relationships can be found in Jacques Ellul's *The Technological Society* (New York: Knopf, 1964) and *The Technological System* (New York: Continuum, 1980). More provocative and more recent studies are *The Technological Imagination: Theories and Fictions*, ed. Teresa de Lauretis, Andreas Huyssen, and Kathleen Woodward (Madison, Wisc.: Coda Press, 1980); and *The Myths of Information: Technology and Postindustrial Culture*, ed. Kathleen Woodward (Madison, Wisc.: Coda Press, 1980).

13 This description coincides with Lyotard's discussion of the epistemology of modern science and technology as paratactic games.

14 Stephen Neale, *Cinema and Technology: Image, Sound, Colour* (Bloomington: Indiana University Press, 1985); and David Bordwell, Janet Staiger, and Kristin Thompson, *The Classical Hollywood Cinema: Film Style and Mode of Production to 1960* (New York: Columbia University Press, 1985).

15 The relation of pleasure, power, and cinematic technology has been the cornerstone of many ideological and industrial analyses since Jean-Louis Baudry's landmark essay, "The Ideological Effects of the Basic Cinematographic Apparatus," in *Apparatus: Cinematographic Apparatus, Selected Writings*, ed. Theresa Hak Kyung Cha (New York: Tanam, 1981), 25–37.

16 Jürgen Habermas, "The Public Sphere," in *Jürgen Habermas on Society and Politics: A Reader*, ed. Steven Seidman (Boston: Beacon Press, 1989), 235–236.

17 This temporal legibility operates in the cinema both institutionally and textually: just as a common strategy in any given film is to make narrative elements comprehensible retrospectively (back through the temporal history it creates, as, for instance, in a plot of self-discovery), so too does the industry (especially Hollywood) work to make the reading of individual films more stable through the repeated and standardized productions of a history of certain kinds of movies, plots, characters, and so on (genre films being the most evident example).

18 Benjamin Lee, "Textuality, Mediation, and Public Discourse," in *Habermas and the Public Sphere*, ed. Craig Calhoun (Cambridge: MIT Press, 1992), 416.

19 Kluge and Negt's best known statements of this position can be found in *Geschichte und Eigensinn* (Frankfurt: Zweitausendeins, 1981), and *Öffentlichkeit und Erfahrung: Zur Organisationsanalyse von bürgerlicher und proletarischer Öffentlichkeit* (Frankfurt: Suhrkamp, 1972).

20 Michael Warner, "The Mass Public and the Mass Subject," in *The Phantom Public Sphere*, ed. Bruce Robbins (Minneapolis: University of Minnesota Press, 1993), 234–256.

21 See Nancy Fraser, "Rethinking the Public Sphere: A Contribution to the Critique of Actually Existing Democracy," in *The Phantom Public Sphere*, ed. Bruce Robbins (Minneapolis: University of Minnesota Press, 1993), 1–32. Fraser has approached the contemporary public

sphere on a much broader sociological and political ground. Although she never addresses temporality specifically in her discussion, I find in her argument—especially about alternative histories and competing publics—much that parallels and dovetails with the spirit of my attempts here to rethink Habermas' pubic sphere in terms of changing contemporary conditions and possibilities. Her position on strong and weak publics and on the shifting relations of civil society to the state points toward my suggestion that an alternative temporality need not presume the traditionally coherent and transcending space of a public sphere.

22 See James Lastra, "From the Captured Moment to the Cinematic Image: A Transformation in Pictorial Order," in this volume.

23 See Gilles Deleuze and Felix Guattari, *Anti-Oedipus: Capitalism and Schizophrenia* (Minneapolis: University of Minnesota Press, 1984); and Michel de Certeau, *The Practice of Everyday Life* (Berkeley: University of California Press, 1984).

24 Jean Baudrillard, "The Ecstasy of Communication," in *The Anti-Aesthetic: Essays on Postmodern Culture*, ed. Hal Foster (Seattle: Bay Press, 1983), 127.

25 For a superb extended reading of this film, see Jeffrey Pence's "Terror Incognito: Representation, Repetition, Experience in *Henry: Portrait of a Serial Killer*," *Public Culture* 6, no. 3 (Spring 1994), 525–545.

About the Contributors

Dudley Andrew is the Angelo Bertocci Professor of Critical Studies at the University of Iowa, where he directs the Institute for Cinema and Culture. In 1995 his *Mists of Regret: Culture and Sensibility in Classic French Film* was published by Princeton University Press, which also brought out his *Film in the Aura of Art* in 1984. He is the biographer of André Bazin (Oxford University Press, 1978).

Jacques Aumont teaches aesthetics—particularly of film and painting—at the Université de la Sorbonne Nouvelle and the Ecole des Hautes en Sciences Sociales. His recent published work has concentrated mainly on the relationships between film and other kinds of images: *Du visage au cinéma* (1991), *Introduction à la couleur: des discours aux images* (1994), and (as editor) *La Couleur en cinéma* (1995). *La Théorie des cinéastes* will be published in 1997.

Timothy Corrigan is Professor of English and Film Studies at Temple University. His most recent book is *A Cinema without Walls: Movies and Culture after Vietnam* (Rutgers University Press, 1991). Earlier publications include *New German Film: The Displaced Image* (University of Texas Press, 1983) and an edited volume, *The Films of Werner Herzog: Between Mirage and History* (Methuen, 1986).

Anke Gleber teaches German film and literature at Princeton University. She has published on images of women in Nazi cinema, the figure of the flaneur in twentieth-century German literature, travel literature of the Weimar Republic, the Weimar Kino-Debatte, as well as articles on Arno Schmidt, Thomas Bernhard, and Heiner Müller. Her book *The Art of Taking a Walk: Flanerie, Literature, and Film in the Culture of Weimar Germany,* is forthcoming from Princeton University Press.

Sabine Hake is Professor of German at the University of Pittsburgh. Her book publications include *Passions and Deceptions: The Early Films of Ernst Lubitsch* (1992), *The Cinema's Third Machine: Writing on Film in Germany 1907–1933* (1993), and *German National Cinema* (co-authored with Katie Trumpener and forthcoming from Routledge).

James Lastra is Assistant Professor of English at the University of Chicago. He is currently completing a book entitled *Inscriptions and Simulations: Technology and*

the American Cinema and researching another on Luis Buñuel, surrealism, and ethnography in interwar France.

Estera Milman is Founding Director of Alternative Traditions in the Contemporary Arts, Curator of Intermedial Arts at the University of Iowa Museum of Art, and Adjunct Associate Professor of the History of Art at the University of Iowa. She is the author of *Dada and New York: Historical Realities/Historiographic Illusions* (forthcoming from Macmillan) and serves as general editor for the historiographic series Modern Studies: An Interdisciplinary Approach to the Art of History (G. K. Hall & Co.).

Robert Newman is Professor and Chair of the Department of English at the University of South Carolina. Author of *Transgressions of Reading: Narrative Engagement as Exile and Return* (Duke University Press, 1993), he is currently at work on a book entitled *The Culture of Family Portraits*. He edits the series Cultural Frames, Framing Culture for the University of South Carolina Press.

Charles O'Brien is Assistant Professor of Film Studies at Carleton University in Ottawa, Canada. The author of many articles on interwar French cinema, he is currently working on a book about film culture in France after the Liberation.

Jennifer Pap is Assistant Professor of French at the University of Denver. Her research centers on visual-verbal relations as manifested in the work of modern poet-critics. Her projects include a study of the idea of landscape in the poetry and the art criticism of poets such as Apollinaire, Reverdy, Ponge, Jaccottet, and Bonnefoy.

John Durham Peters is Associate Professor in the Department of Communication Studies at the University of Iowa. His numerous articles interrelate media studies, social theory, and intellectual history. In 1995–1996 he received an NEH fellowship for his book on communication and mass communication in modern thought.

Lauren Rabinovitz teaches American studies and film studies at the University of Iowa. The author of *Points of Resistance: Women, Power, and Politics in the New York Avant-Garde Cinema, 1943–1971* (University of Illinois Press, 1991), she is completing a book on gender practices, urban spectatorship, and the origins of cinema. With Greg Easley, she is developing an interactive turn-of-the-century amusement park for CD-ROM.

Robert B. Ray, Director of Film and Media Studies at the University of Florida, is the author of *A Certain Tendency of the Hollywood Cinema, 1930–1980* (Princeton University Press, 1995) as well as *The Avant-Garde Finds Andy Hardy* (Harvard University Press, 1995). He also belongs to The Vulgar Boatmen, which has released three CDs.

Sally Shafto, after several years of working at the Williams College Museum of Art, has returned to graduate school to pursue an interdisciplinary Ph.D. in film studies and art history at the University of Iowa.